Let this book be laid before Beihong's grave in lieu of white flowers.

—*Liao Jingwen*

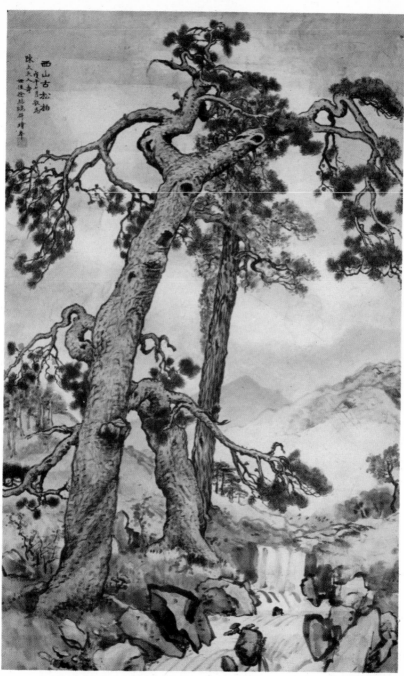

Ancient Pines and Cypress in Beijing's Western Hills
Traditional Chinese painting, 1918

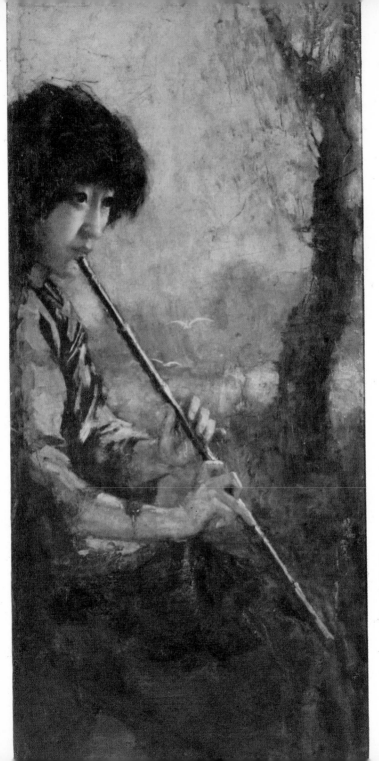

Playing
the Flute
Oil paintin
1926

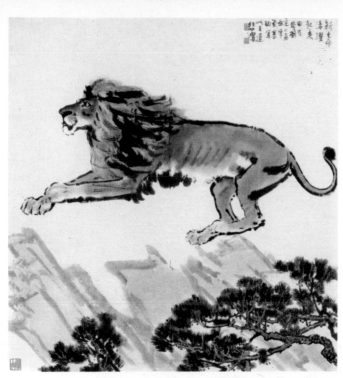

Bouncing Lion
Cub *Traditional
Chinese painting,
1934*

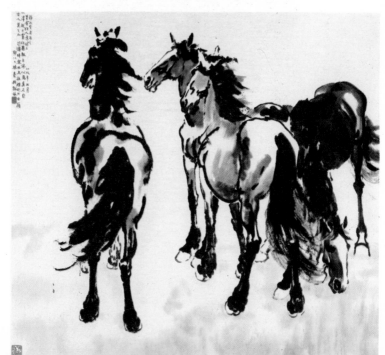

Horses
*Traditional
Chinese
painting,
1940*

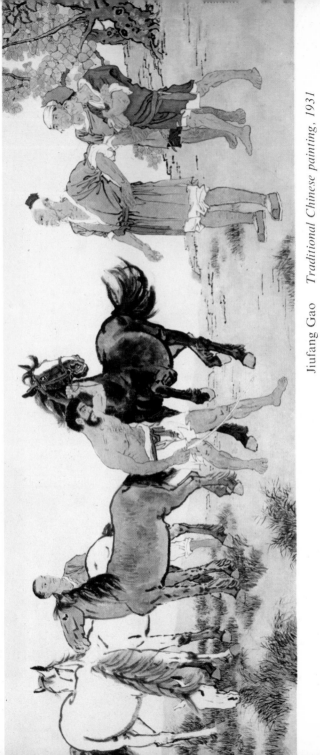

Jiufang Gao *Traditional Chinese painting, 1931*

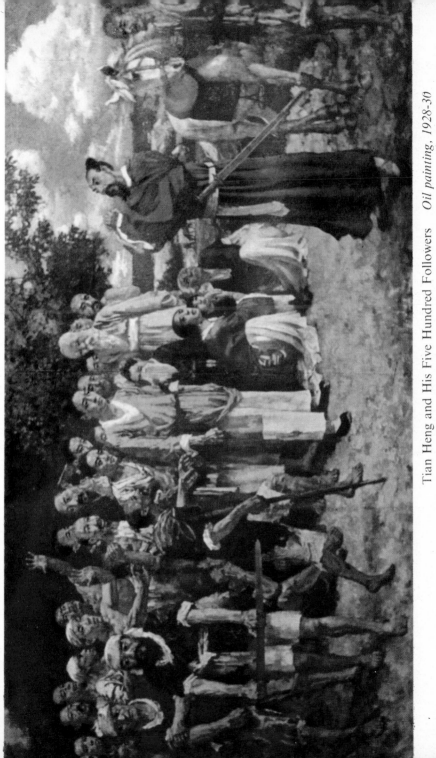

Tian Heng and His Five Hundred Followers *Oil painting, 1928-30*

Xi Wo Hou Oil painting, 1930-33

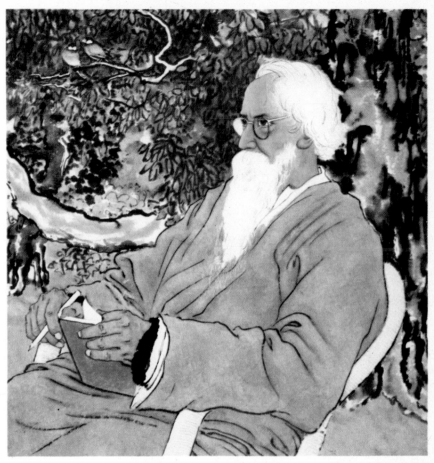

Portrait of R. Tagore *Traditional Chinese painting, 1940*

The Foolish Old Man Who Removed the Mountains *Traditional Chinese painting, 1940*

XU BEIHONG

—Life of a Master Painter

By LIAO JINGWEN

Translated by Zhang Peiji

FOREIGN LANGUAGES PRESS BEIJING

First Edition 1987

ISBN 0-8351-1551-8

Copyright 1987 by Foreign Languages Press
Published by Foreign Languages Press
24 Baiwanzhuang Road, Beijing, China

Printed by Foreign Languages Printing House
19 West Chegongzhuang Road, Beijing, China

Distributed by China International Book Trading Corporation
(Guoji Shudian) P.O. Box 399, Beijing, China

Printed in the People's Republic of China

Part one

Chapter I

As evening mists descended lightly, soft black wings of night covered the earth. All was quiet except for the rushing water in the river.

The broad river meandered through the fertile plains of southern Jiangsu Province, carrying to Nanjing and Shanghai such farm produce and handicrafts as peasants in Jiangnan* produced by the sweat of their brows. Huge clumsy junks moved slowly, grey ribbed sails bellying out. Small steamers chugged past more rapidly, churning up layer upon layer of snowy foams to beat drearily against the river banks.

The river was submerged in the deepening dusk, heaving rhythmically as if trying to dissipate its fatigue. Myriads of stars twinkled quietly; the crescent moon made its appearance from behind a nearby mountain and moved slowly across the dark blue sky.

From a small cottage on the river bank came the shrill wail of a newborn baby, followed by the popping of firecrackers and the barking of dogs here and there. Inside the cottage, a grey-haired midwife was using a pair of old scissors to cut the baby's umbilical cord by the light of a dim lamp.

A faint tired smile flickered across the face of the new mother. "This is my son," she said to herself happily. "How he takes after his father! I hope he'll grow up to be a painter, too, like his father."

It was in this riverside village that Xu Beihong was born late on the night of July 19, 1895. As the river here was spanned by a stone bridge called Jitingqiao Bridge, the village had come to be known as Jitingqiao. Situated fifteen kilometres to the west of the wide expanse of misty Lake Tai, the picturesque village lay within the jurisdiction of Yixing

* Regions south of the lower reaches of the Yangtse River.

County, Jiangsu Province, and boasted more than fifty households. The local people lived a simple, unsophisticated life.

The riverside cottage in which Xu Beihong was born had been built by his grandfather Xu Yanggeng. He had come as a worker to the village following the failure of the Taiping Rebellion*, in which he had been a participant. In this cottage, Xu Beihong passed the poverty-stricken days of his childhood and early youth. Nevertheless, he later reminisced nostalgically:

> Though the cottage we lived in was humble, we had South Hill as our natural screen and the ribbon-like rivers around us. The sun and moon as well as frost and snow all added to the beauty of this Jiangnan region of rivers and lakes. We enjoyed the companionship of fishermen and woodcutters. Cocks crowed and dogs barked in eager response to each other. Nature always provided us with infinite marvels.

Xu Beihong's father Xu Dazhang, also known as Xu Chengzhi, had been fond of painting since childhood. As he was too poor to afford a tutor, however, he learned painting by self-instruction, and later became a locally known painter. He also excelled at calligraphy, seal-engraving, and writing, and earned some money by giving private lessons and selling his calligraphy and paintings in the village. Among the extant seals engraved by him, some bear inscriptions to express his feelings and ideals, such as: "Part farmer, part scholar, part fisherman and woodcutter;" "Home is where there is the sound of reading;" "The tender heart of a lover, the guts of a hero;" "Sell a painting done in my leisure hours, rather than crave for ill-gotten money."

His calligraphy, characterized by bold and vigorous strokes, could be seen hanging in temples far and near. His figure paintings were executed in an exact and vivid manner.

Coaching the Son Under a Pine Tree is a figure painting done in his thirties. It depicts Xu Beihong chanting his lessons at a desk while his

* The nationwide peasant uprising which took place in the mid nineteenth century under the leadership of Hong Xiuquan.

father sits behind him, fan in hand, absorbed in listening.

Few people in those days could paint figures with such exactness and vividness. His flowers, all drawn with freehand brushwork under the influence of the Ming painter Xu Wei and the Qing painter Ren Bonian, were fresh and elegant. His landscapes were also realistically done. His *Ten Scenes of Jingxi*, now in the possession of a Yixing private collector, depict such beautiful sights in Yixing as Zhanggong Cave and Shanjuan Cave.

Testimony that the magistrate of Yixing County thought highly of Xu Dazhang's scholarship can still be found in the county annals now kept in Yixing Library. Xu Dazhang, who despised rank and honour, and sought no personal distinctions, refused to have any dealings with officialdom. Once, upon hearing that the county magistrate wanted to look him up in person to call upon a man of virtue and ability, he is said to have hidden himself in a temple. He lived a simple, tranquil life without worldly desires to show his disdain for fame, riches and honour. He revealed this feeling in a long poem inscribed on the painting *Coaching the Son Under a Pine Tree*, in which he writes:

With no talent to benefit the world, I feel very ashamed;
Let me work on the inkstone as on a farm to turn out calligraphy and paintings.
When I can't express the inner thought in my broad mind,
I play the fool by keeping company with wind and moon.

When Xu Beihong began to take lessons in Chinese from his father at the age of six, he wanted to learn painting at the same time. His father did not agree. Once, when he read of the bravery of Bianzhuangzi mentioned in *The Analects of Confucius*, he asked his father, "Why was Bianzhuangzi called brave?"

"Because he could kill a tiger, the king of beasts," answered his father. "Yes, he was incomparably brave."

The father related the following story: In the Spring and Autumn Period of Chinese history, there lived in the State of Lu a very, very brave man named Bianzhuangzi. It happened that he caught two tigers single-handed. When the State of Qi, which was then about to invade the State of Lu, heard of it, it cancelled the attack in fear of the brave man

5

Bianzhuangzi.

This little story set young Beihong wondering what a tiger looked like. While poring over the yellowed pages of the book, he simply could not calm down. Living in a remote village as he did, where there was no zoo, nor even a picture of a tiger available, how curious he was to picture the appearance of the kingly beast! One day he managed to have someone draw him a picture of a tiger, from which he began to copy quietly.

Soon after, his father discovered what he had been working on. He asked, "What's this?"

"A tiger," Beihong answered smugly.

"It looks more like a dog than a tiger," said his father coldly. "You should study hard," he added with tenderness. "To be a painter, you should first of all be learned. So you must form the habit of learning diligently." Then he continued in all seriousness, "A painter has to observe material objects with his eyes. How can you paint a tiger without ever seeing a real tiger?"

At the age of nine, Beihong, under the careful guidance of his father, had already finished reading such ancient Chinese classics as *The Book of Songs, The Book of History, The Book of Changes, The Book of Rites, The Four Books* and *Zuo Qiuming's Commentary on "The Spring and Autumn Annals."* At that time, with the help of his father, he began each day to copy one of Wu Youru's figure paintings and *jie* paintings*.

Wu, a most celebrated painter of book illustrations at the end of the Qing Dynasty, could crowd into a foot of space such details as high buildings and pavilions, insects, fish, birds and beasts, rare flowers and grasses, and even thousands upon thousands of soldiers and horses. He thus became the teacher who introduced Beihong to the career of painting. His father, however, stressed the importance of painting from life and wanted him to paint his parents, brothers, neighbours, and beggars.

Beihong's father was a very strict teacher. All year round, he daily watched his son learn to read, write and paint, never relaxing his efforts

* A genre of traditional Chinese painting, with architecture like palaces and mansions as the subject and meticulously executed with the help of a ruler.

even during the busy harvest season. As a result, Beihong could help to put colours into his father's paintings and write Spring Festival couplets for the villagers even at the age of ten.

Sometimes, his father would take him for a stroll along the river bank to allow him to feast his eyes upon nature. The brilliant sunrise, grotesque-shaped rocks, green bamboos and mountain vapour, dreamlike morning mist and fishing boats — all these touched young Beihong like sweet music. He fell in love with nature.

As foreign imperialists continued to ravage China and the Qing government grew more and more rotten, the countryside grew impoverished and large numbers of peasants, small traders and handicraftsmen went bankrupt and were forced to leave their native land. Beihong's father, unable to make ends meet by selling his calligraphy and paintings, had to toil on half a hectare of melon patch from morning till night. Young Beihong helped his father with the farm work.

Since the Xu family owned no buffalo to till the land, they often had to borrow one from a neighbour. To make repayment, Beihong would often herd the buffalo for the neighbour. The scene of Beihong searching for wild flowers over a hill or by a river while the animal was grazing in the fields was always to remain in his sweet recollections of childhood days. Sometimes, when the fields went dry, he would bend over a water wheel to pedal it with both feet until his soles were crimson from exertion.

Spring comes early in Jiangnan. Every year, when spring breezes had turned the young leaves of mulberry trees behind the cottage fresh green, Beihong's mother would begin to busy herself raising silkworms so she could make some extra money to subsidize the family expenses.

At that time, school education was being initiated all over the region. Not only did children from well-to-do families enter school; even families in straitened circumstances managed to send their children to school. Young Beihong felt envious at the sight of other children gleefully going to school with satchels on their backs. Many friends and relatives tried to talk Xu Dazhang into sending Beihong to school, saying, "Painting is no money-maker! How can you expect your son to live on that?"

In poverty-stricken old China, the art of painting would get one

nowhere. An artist could hardly make a living or find a job through painting. Xu Dazhang's hard lot was just one case in point. He could do nothing but sigh softly at the kind advice of his friends and relatives.

Nevertheless, Beihong's failure to attend school did not make him feel inferior or lonely. He had his own paradise where he enjoyed the company of other children who had likewise been shut out of school. They worked and played together, and together they dreamed of travelling to the wide world far away from their riverside cottages.

Whenever there was a village opera in honour of certain gods during a festival, in the midst of the fitful sound of gongs and drums, Beihong would force his way into the crowd of spectators or perch high up on a tree branch to watch the performance. Occasionally, he would go to town to listen to storytelling in teahouses. There, sitting among the big crowd of swarthy, honest peasants and sniffing the pungent smell of their low-quality tobacco, he would listen with rapt attention to the veteran storytellers vividly narrating such ancient Chinese novels as *Outlaws of the Marsh*, and *Romance of the Three Kingdoms*. Like the grown-ups, he would also shake his head and sigh deeply in hearing something touchingly sad.

The heroic characters in drama and fiction, characterized by their knowledge of what to love and what to hate, found their way into his heart like limpid spring water flowing into arid earth, moistening his heart and accelerating the growth of his character. With excitement and reverence, he would paint such heroic characters from memory, cut them out with scissors, paste them on bamboo sticks, and run about the village holding them aloft, with crowds of children following at his heels and eyeing him in admiration. Beihong would often call together his childhood pals and take them to the hills to cut bamboos with which to make knives, spears and sticks to practise *wushu* (martial arts). Every morning, as soon as they got up at the crack of dawn, they would go running around the village twice. They would bathe in the river whether it was hot summer or cold winter. Beihong never relaxed his efforts to build up his physical strength and willpower, dreaming of some day becoming a chivalrous *xiake**, always ready to unsheathe his sword to

* A person adept in martial arts and given to chivalrous conduct (in olden times).

8

help the weak and oppressed like heroic characters in operas and novels. He even engraved an elaborate seal for himself with the inscription: "A poor *xiake* of Jiangnan."

As there were no photo studios in the countryside, it was then a general practice for well-to-do bereaved families to hire a painter to make a portrait of the deceased as a memento to be used at sacrificial rites. Every time Dazhang was invited out to do such a portrait, Beihong would stay at home with his playmates to put on an opera on a makeshift stage formed of chairs and desks. Sometimes they imitated what they had already seen on the stage, sometimes they acted what they themselves had adapted from storytellers. Sometimes Beihong's mother and some of the neighbours also came to watch the performance. However, the performance was put on without the knowledge of Dazhang, who was of a frugal, prudent and serious nature. So, during each performance, one of the children would be assigned to keep watch outside the village. The moment he caught sight of Dazhang returning home, he would hurry back to inform his pals. Within minutes the stage would miraculously vanish and all the children would scurry to the riverside to wash away the colours from their made-up faces. Once, the boy on lookout happened to doze off, leaning against a stump. The "poor *xiake* of Jiangnan," draped in a scarlet quilt cover and raising his sharp sword high in the air, was barking, "Stay your hand, scoundrel!" when Dazhang suddenly appeared below the stage. Like a hurricane, his appearance swept away all traces of fun and merry-making. The children stood rooted to the ground as if possessed and shrank back quietly to one corner, awaiting a towering rage. But the self-disciplined father did not get angry, nor did he even utter a word of reproach. Sighing a deep sigh and pointing to the face-painting colours, he merely said, "Poor folks like us can't afford these colours!"

From then on, the boy quit playacting.

At harvest time, Beihong would sleep every night in the melon patch to guard against hedgehogs sneaking in to eat watermelons. While the shadow of night was stealing in upon the dark green vines, the high vault of heaven looked so beautiful and tranquil, so deep and boundless! The moon slid in and out of clouds, as if playing hide-and-seek with the stars. Meanwhile, Beihong's imagination also soared skyward, and he

9

saw beautiful fairy tales unfolding one after another before his mind's eye.

When the curtain of dark night was drawn aside and the sleepy sun was gradually rising, the tempting melons were loaded and piled hill-high in cargo boats anchored at the riverside in front of Beihong's house. The boats moved away with swelling sails and soon became dark specks in the distance. Beihong stood gazing gloomily at them until they completely disappeared from view.

Like most country women, Beihong's mother had a superstitious belief in gods. During fast days, she would put on a clean starched cotton dress and mount the luxuriantly wooded southern hill to pay homage in the Buddhist temple, and offer incense to the Buddha. On the way, mother and son saw a continuous stream of men and women devotees moving along with bags slung over their shoulders, some even wearing straw sandals. Beihong's mother, looking unusually serious and holding Beihong by the hand, plodded uphill step by step together with the other pilgrims until finally they saw the temple looming in the midst of a riot of greens. The pious mother kindled her incense and candles, and knelt before the huge Buddhist image, murmuring. She was praying for the safety and well-being of her husband and children. Her slim body, prostrate on the ground, kept quivering as if she were facing a trial before the Buddha. While looking up at the half-closed eyes of the Buddha and wondering at the faint smile flickering around the corners of his mouth, Beihong wished for a heavenly kingdom where people could live a happy life without privations and sufferings. He remembered how his nextdoor neighbour, a very old woman, had often cried when she had no rice to cook, and how his mother had ladled out some rice for the old woman although she herself had little. The temple bells began to toll long and loud, pealing their melancholy reverberations, as if the unfortunates were pouring out their grievances. An indefinable feeling of sorrow crept over the child.

Chapter II

Time passed by like the rushing water in the nearby river, and calamity after calamity stalked the hapless. The growing corruption of the feudal government and stepped-up foreign aggression against China brought ever greater suffering. Reduced to poverty, Dazhang reluctantly sold a small portion of his treasured melon patch, which enabled the family temporarily to ride out the crisis and keep hungry children from starving. But what about the future?

Lying in bed, Beihong asked himself sadly, "What can I do to help my father, to help my poor family?" He gazed out the window at the pitch-dark sky, moonless and starless. A lurid flash of lightning leaped out of the clouds, followed by the muffled rumbling of distant thunder. Then another flash of lightning lit up the small room. Closer thunder crashed. Rain came down in torrents.

It rained more and more heavily. The water in the river continued to rise and, having lost its usual calmness, became turbulent. People were worried. Dazhang looked grimly up at the sky. But it seemed as if innumerable cracks had suddenly appeared in the sky from which rain poured out day and night until the river brimmed with water. It would soon overflow its banks. People shook their heads, sighed, and went out in spite of the rain to offer prayers in the temple against the imminent disaster.

But turbulent, turbid water soon ran over the river banks, and surged to engulf everything on its way — walls, windows and eaves. The village of Jitingqiao was submerged in a vast sea of water. The local inhabitants, taking along the old and the young, fled to remote higher ground.

After the flood receded, they returned to find themselves face to face with cold and starvation again. Dazhang found it no longer possible

to live on his local calligraphy and paintings, so he decided to try his luck in other localities, taking Beihong with him. Thus the thirteen-year-old lad accompanied his picture-selling father to lead a vagrant life.

The region around Lake Tai is known as a land of fish and rice. But, due to natural and man-made calamities, as in other places, many there were becoming poorer and poorer. While trekking along, father and son earned some money by painting portraits, landscapes, flowers and plants, and animals on hanging scrolls, and by engraving seals and writing Spring Festival couplets. Sometimes they lived in the house of some honest countryfolk, sometimes they put up at an inn or temple.

Soon they reached the lakeshore city of Wuxi. The busy city, which had been forced open by the unequal treaties imposed on China by foreign imperialists, very much impressed and irritated Beihong. The shops, decorated with lanterns and colourful streamers, had all kinds of imported goods for sale, ranging from such daily necessities as porcelain, piece goods and silk cloth to children's toys. The shop owners advertised them as "low-priced, high-quality" goods. Beihong saw graphically China's weak position, the dumping of foreign goods, and the scrambling for Chinese markets between imperialist powers. He also saw group after group of shabbily dressed beggars trudging past the ominous-looking *yamen*.

After pushing their way through the throngs in the busy street, father and son walked into a quiet lane to seek lodging at a small hotel. Following at their heels were a father and daughter who lived by singing. The girl wore a glossy plait and had delicate pale features. The father, wearing a long gown of faded blue, carried a *huqin** under one arm. He was grey at the temples and looked travel weary. Clasping his hands to make an obeisance, he addressed the hotel guests, "Ladies and Gentlemen, I consider myself most fortunate to meet you here by chance. Now please listen to my litte girl sing you a song!"

The hotel rang with the sound of the *huqin,* and the little girl started singing a Jiangnan folksong in the form of a lyrical ditty:

> The crescent moon and long shadows
> Make us tramps think of home,

* A two-stringed Chinese violin.

Where merry fish swim in the village pond
And fragrant bean flowers grow on the trellises.
....
The dull moon in the cloudy sky,
The rugged road over the hilly land
Make us tramps think of home.
Oh,
How lovely are the hills and rivers at home.
....

The plaintive song and *huqin* touched the hotel guests and made them feel nostalgic. Beihong felt as if he were back at his riverside home. Sails receding in the distance, the whitecaps, the mulberry trees at the back of his cottage, his mother's repeated words of advice at parting — all these reappeared in his mind like dreams.

The *huqin* stopped abruptly at the end of a long-drawn-out syllable. The singer ran her soliciting eyes swiftly from the face of one person to another and then back again. Dazhang immediately slid a dime into her hand, and the others also fished out coins from thin purses. Beihong was moved to tears. What multitudes with the same tragic lot as himself were struggling along on the verge of starvation!

One day, as father and son were wending their way back to the hotel at dusk, Dazhang caught sight of a large crowd of people in front of a teahouse. Pushing his way through them, Beihong saw a young woman sitting on a door-step weeping. He learned from some of the onlookers that after her husband's recent death, the helpless woman had been deprived of her home by her landlord. She had put up a shed near the city gate to sell cups of hot tea to eke out a living.

Who would have thought the son of the teahouse owner, together with a gang of young ruffians, would burn down her shed! The young woman kept wiping away the tears on her face with the back of her hand. The baby at her breast stared at the onlookers with bright eyes, and now and then it reached out a tiny hand to toy with its mother's unkempt hair.

Hot with resentment against the injustice, Beihong boldly entered the teahouse with Dazhang at his heels. They intended to talk the teahouse owner into showing kindness and compensating the young woman for her loss. The corpulent, creamy-faced boss at first looked at them, eyes narrowed to mere slits, as if he were listening attentively, then

13

grinned hideously, and picked up a tea-cup to throw at Beihong. It hit Beihong square on the head; blood trickled out of his thick, dark hair. Had he been acting on the stage at home, he would have instantly raised the sharp sword to penetrate the villain's heart. But now he was utterly helpless. The wound left a permanent scar.

In face of a cruel and painful reality, Beihong rapidly matured. The wandering life of an artist brought Beihong into constant contact with lower-class society and the working people, enabling him not only to understand people's suffering and sympathize with them, but also to know a great deal about national affairs. The Revolution of 1911 had stirred his young heart, but it was soon followed by the tangled wars between the imperialist-backed warlords. Worried about the destiny of his country, he would attach his sealed inscription "A poor *xiake* of Jiangnan" to his painstakingly executed paintings, complete with the handwritten phrase in lieu of his signature: "A lad of the Divine Land."

Year after year, father and son passed their vagrant life in the trials of hardship. Beihong would spread the paper on the desk and rub the ink stick against an inkstone for his father, watch him start to paint and wield the brush, and listen to him talk volubly about things past and present. He was thus imperceptibly influenced by the art of traditional Chinese painting. He not only became his father's assistant, but also tried to create a style of his own. By collecting the life-like drawings of animals attached in those days to packs of "Pirate" brand cigarettes, he gradually acquainted himself with the appearance of various beasts of prey. Later, he was fascinated by some Japanese illustrations of animals and tried to paint by copying these illustrations. When he came across replicas of works done by some outstanding 19th-century European painters, he was inspired by their scrupulous modelling, bright colouring and lyrical rhythm. It engendered in him the unformed idea of going to Europe to study painting. But he was confronted with a grim reality. As a result of long years of roving life, his father fell seriously ill, suffering from dropsy, and grew extremely weak. Father and son had to return to their hometown.

Chapter III

Wandering from place to place, Beihong had seen a great many imposing mansions but, in his eyes, none of them could be compared with the lovely cottage in the village of Jitingqiao. Now, drawing near he could already see wisps of smoke curling upward from his kitchen chimney. He knew his mother must be busy cooking supper and that he would soon meet her and see the home he had long dreamt of. What a lot of things he wanted to tell her!

As the ailing father, who had difficulty walking, was being helped through the cottage door, Beihong's mother hurried out from the kitchen in astonishment. She fixed her wide eyes upon her husband as if sizing up a stranger, tears trickling down her ashen cheeks. Without saying a single word, she buried her face in both hands, and wept bitterly.

From then on, the seventeen-year-old Beihong alone bore the heavy burden of supporting the family. As he was already known for his painting in the surrounding areas, he received invitations to teach drawing from three schools in Yixing County, namely, Women's Junior Normal School, Siqi Primary School and Pengcheng Middle School. He accepted all three. As Yixing County is a region of rivers and lakes, it was convenient and cheap to go by boat to the three schools, which were over twenty-five kilometres from his cottage. But, in order to save money for his father's medical treatment, Beihong would go to work on foot instead. Often he would get up at midnight to make his journey under the moonlit sky until the sun slowly rose in the east. Walking quickly through the damp field paths, he was burdened at the thought of his father's illness. Recollections of scenes of hazy moonlight and his childhood life as a cowherd were later to appear repeatedly in his picture scrolls.

The Xu family sold everything that could be sold to pay Dazhang's medical expenses. One day, however, when Beihong was about to go out to attend a neighbour's wedding, his mother brought him a paper-wrapped parcel, and opening it carefully, produced a brand-new silk jacket. She whispered to Beihong as if she were divulging a big secret.

"Though I used to raise silkworms before I was married, I've never worn a silk dress in my life, nor have my folks at home been dressed in silks. But I had long been wishing to make a silk jacket for my firstborn son. I had this wish fulfilled before you returned home."

She spread out the unbleached silk jacket. Her pale face was flushed with excitement and a timid faint smile flickered around her meek eyes. Beihong looked at her face in surprise. He had never seen her look so beautiful and happy.

"Mother, why not sell it to pay for father's medical treatment!" he said, looking down.

Her face instantly clouded over as if a beautiful dream had suddenly evaporated before her eyes. She muttered with quivering lips, "Sell it? No! I've always thought that some day I'd see you wear it...."

Beihong finally put on the silk jacket in deference to his mother's wish, and went out to attend the wedding. The jacket fit him nicely. People at the wedding found the handsome young man looking even more handsome than ever before.

But life never stops playing mischievous tricks. In the midst of the jubilation at the wedding, an old man sitting next to him inadvertently dropped a cigarette butt onto his silk jacket. Beihong was unconscious of it until he was startled by smoke and the pungent smell of burning silk. He hastily put out the burning with his hand only to find a hole in the silk jacket. He came home in great dejection, feeling ashamed to meet his mother. This incident irritated him so much that he vowed never in his life to wear silks or smoke cigarettes. After he won fame as a painter, whenever his students or friends made him a present of a silk garment he would lay it aside without wearing it. He would wear instead a jacket made of grass cloth, even in the unbearably hot summer of southern China.

Beihong's father was confined to his sickbed for two years before he breathed his last. As he lay dying, he reached out his shaky thin hand to

take hold of Beihong's and said, "We father and son are both painters. Latecomers surpass the oldtimers. You should catch up and surpass me and all the elder generations. Remember that only through diligent study can you master your profession. No matter how hard life is, never bow to bigwigs as your granddad said." His words were drowned by a fit of gasping and his dull eyeballs were riveted on Beihong.

In the dead of night, the sky was pitch-dark and heavy-laden; the moon and stars had gone into hiding somewhere. Inside, a small oil lamp burned. Its dim flickering light cast Beihong's shadow upon the body of his father, whose face was sallow like that of one fast asleep, perfectly calm and composed.

Beihong stared fixedly at his father. He remembered how his father had first taught him to use the brush as a child. He also remembered that once, his father, seeing a house he had painted was out of perpendicular, had said seriously, "A house like this is uninhabitable!" He also remembered how, when they were still knocking about, his father had often offered money out of his own scanty income to help out the poor whom he came across on the way. When eating a meal, father and son would try to let each other eat more. Often Beihong's father would empty what little there was in a dish into Beihong's rice bowl. Once, when they saw a big stone lying in the way, Beihong's father was afraid that people or vehicles might stumble over it, so he told Beihong to join him in removing it to the roadside. He seemed again to see his father panting hard and bending low, carrying the stone with him. He reflected sadly: His father had not only given him life, knowledge, and painting skills, but also deeply influenced him with his lofty character in generosity, modesty, industry, frugality and honesty. Every progress on his part, slight as it was, had been a cause of his father's infinite joy.

But his upright and hardworking father had died wretchedly. He had died in the prime of life and left him a fatherless orphan.

In order to give his father a proper burial, Beihong had to write to ask for a loan from an elder by the name of Tao Liufen, a small medicinal-herb tradesman in the neighbouring County of Liyang. Tao not only sent the money, but came in person to help with the funeral arrangements and attend the burial rites. The funeral was a very simple

affair. The small procession consisted only of the family members, some relatives and friends. As shovelful after shovelful of earth was tossed into the pit, Beihong felt as if he himself were also being buried.

Chapter IV

After his father's funeral, Beihong decided to leave home for Shanghai to seek a half-work-and-half-study opportunity. He wrote to ask for help from a fellow townsman, Xu Ziming, a professor at China College in Shanghai, and sent him some of his works. The warmhearted Xu Ziming recommended these works to Li Denghui, president of Fudan University, who had a high opinion of them and promised to arrange a job for Beihong. Xu Ziming wrote to tell Beihong to come to Shanghai without delay.

Beihong immediately began to pack his things for the journey, and resigned his teaching post at the three Yixing schools. When he was leaving, Zhang Zufen, a teacher of Chinese at Women's Junior Normal School, kindly came to say good-bye and offered the following words of encouragement, "You're young, clever and diligent, so you have a bright future. Remember: Though one should not be arrogant, one should have a lofty and unyielding character. I haven't got any gift for you, so take these encouraging words instead."

Beihong looked at his colleague, a man many years his senior, and saw sincerity and solicitude in his wrinkled face. A deep sense of gratitude welled up. He always bore the parting advice in mind and regarded it as a motto for himself. Even in his later years, he would say with deep tenderness, "Zhang Zufen was my first bosom friend!"

In the summer of 1915, the twenty-year-old Beihong, in a long cotton-cloth gown and a pair of white cloth shoes[*], arrived in Shanghai — a city with a round-the-clock active life. Skyscrapers, varied shops, forbidding yamen, heavily guarded foreign firms, dance halls,

[*] It was formerly a custom in China for people to wear white in time of mourning (for deceased parents).

night clubs and gambling dens — all these formed colourful embellishments in the eastern metropolis. Here in this dazzling city, hunger and unemployment existed side by side with luxury and dissipation.

Beihong went with Xu Ziming of China College to see Li Denghui of Fudan University. A man on an important mission, Beihong was tense and serious, walking with lowered head and seldom talking to the cheerful friend beside him. He was already planning how to make use of his spare time after work hours so that he might continue to study painting. Xu Ziming was Beihong's senior by many years, and of great stature; walking beside him, the under-nourished Beihong appeared even smaller.

In the president's office of Fudan University, Li Denghui gazed intently at the young man in country attire for a long while. With a perplexed look on his face, Li seemed to be digging into his memory for something he had long forgotten. He said to Xu Ziming in a quiet whisper, "He still looks like a mere child. How can he work?"

Xu Ziming argued heatedly, "As long as he's talented, you shouldn't bother about his age!" Then he continued at the top of his voice, "Besides, he resigned his teaching post at three schools just to come here!"

Li was silent.

Not long afterwards, Xu Ziming accepted a position at Beijing University and left Shanghai. Beihong wrote Li several letters, but got no reply.

The unhappy hot summer days passed by in great anxiety. In order to kill time, Beihong often visited the sales department of Commercial Press, where he would read books standing. At night, in the dim light of the hotel room, the melancholy youth would think of his hometown, his mother and his brothers and sisters.

As the autumn wind gradually yellowed the leaves of the roadside trees and sent them scattering to the ground, Beihong began to face the threat of cold and hunger. He loitered about the streets strewn with fallen leaves, and lamented over the twists and turns of his life. Just at

20

this moment of great distress, a letter arrived from Xu Ziming in Beijing, telling Beihong to pay a visit to Yun Tiejiao, editor of *Fiction Monthly*, to ask for a job. The letter aroused new hope. He immediately called at Yun's office, taking along some of his paintings as well as Ziming's letter. He informed Yun that he was very hard up and badly in need of a job. Yun kept Beihong's paintings, promised to do his best to find him a job, and asked him to come back to hear a reply in a couple of days.

Autumn rain drizzled incessantly, weaving a cold net to cover the whole earth. Beihong had no umbrella, but he still had to go out to hear the reply in spite of the rain. It was National Day, and the streets were noisy with gongs and drums and colourful with newly erected *pailou**. Here and there, people were holding celebrations. The thoroughly drenched Beihong appeared before Yun, his thick dark hair dripping with rainwater.

"It's all set!" Yun said, beaming with excitement. "Commercial Press has agreed to take you on to draw illustrations for primary and middle school textbooks. You can move in to Commercial Press dormitory in a day or two."

Beihong was relieved. His breathing became more even and his heart ceased pounding. On his way back to the hotel through the wet streets, he had to expose himself from head to foot to the cold wind and rain. But he looked at the screen of storm and the overcast sky with a feeling of contentment. He had temporarily become heedless of cold and hunger.

By the dim lamplight of the hotel, Beihong wrote a letter to his mother, telling her not to worry about him because he had found a job. He also wrote to Professor Xu Ziming to give him the same information and express thankfulness for his help.

Back at the hotel, just as he was undressing for bed, a hasty knocking was heard. As he quickly opened the door, he saw Yun standing before him with a parcel in his hand.

Yun said in a flurry, "The whole thing's fallen through!"

Beihong took the parcel, hurriedly opened it, and found inside, in addition to his own paintings, a note written by someone called Zhuang

* A decorated celebration arch.

Yu, bearing the following comment:

"Xu Beihong's paintings are ineligible."

Beihong shivered all over and his heart seemed to have split open. Seized with despair, he recklessly rushed to the bank of the Huangpu River. He had been suffering severely from homesickness, joblessness, cold and hunger. The sudden disillusionment was the last straw. He had given up all hope and was prepared to end his youthful life in the rolling waters of the Huangpu River.

The muddy river lashed at its bank with a muffled booming sound. Foreign merchant ships and war vessels loomed in sight everywhere on the river, steam whistles shrieking. Beihong felt he was losing his breath; his whole body was being consumed by fire. He pulled open his jacket to let the storm beat against his chest. It was not until a chill went up from his heels to gradually spread all over his body that he finally came to. He thought of his father's deathbed testament, his own duties and unrealized aspirations, his mother, his brothers and sisters. He whispered to himself, "It takes a courageous man to be able to hold out against overwhelming adversity!"

He moved with leaden steps to return gloomily to the hotel.

The shrewd hotel keeper knew from Beihong's facial expression that there was no longer any hope for him to find a job. He knew that Beihong was already one week in arrears with the rent. Fat and swaggering, he went up to Beihong and declared with greedy eyes, "Young man, I've let somebody else take your bed tonight."

Beihong knew right away what he meant. He told the hotel Keeper apologetically that since he was unable to pay the arrears of rent he would leave him his bedding roll as a pledge.

Coming out of the hotel, he loitered about the damp and cold streets. He looked around blankly. His feet instinctively carried him homeward to the village of Jitingqiao.

The weather-beaten small cottage in Jitingqiao stood as firm and erect as before. But the Xu family had become even poorer. Beihong's brothers and sisters had had to discontinue their studies at school, and were now doing farm work. Clad in her coarse cloth dress, his mother looked even more emaciated. Like all mothers in the world, she quietly

swallowed the bitterness of life without telling her son about it. Nor did Beihong disclose his troubles to her. They both kept to themselves what was on their minds.

Beihong did voice his griefs and anxieties to a benevolent rural herb doctor named Fa Desheng. Fa very much appreciated Beihong's talent and was willing to help him financially. But how could one like him, eking out a living by practising folk medicine, provide a substantial sum? He comforted and encouraged Beihong and told him to wait. He called together some of his friends in the hamlet, honest handicraftsmen, and they each gave a donation to the fund for financing Beihong.

Beihong took the money with tears, and for a long while he could not calm down. He knew all these fellow villagers had reached out their generous hands to help him in spite of their own straitened circumstances. What great efforts, therefore, must he put into his work and study to repay their care and love in future? He vowed to himself to live up to their expectations.

Chapter V

It was the first Chinese New Year's Eve Beihong had spent at home since his father's death. A Mr. Tang, a fellow townsman dealing in silk cocoons, happened to be leaving for Shanghai to do business, so Beihong accompanied him there, having decided to go to Beijing via Shanghai to look for a job.

It was still snowing after Chinese New Year, but the fields had already turned green. Tang and Beihong left the village of Jitingqiao and walked along the highway braving the wind until they reached Wuxi, where they took a through train to Shanghai.

In Shanghai, they put up at a hotel. While Tang was out all day to do business, Beihong would stay alone in the hotel to read and paint.

Snowflakes came down thick and fast from the murky skies, danced in the cold wind and landed quietly on housetops, trees and streets, coating the landscape with a layer of shiny silver and tidying and beautifying the disorderly street scene. Beihong took out his painting materials and sketched a watercolour snow scene. In this small picture, thick snowflakes whirl in the air and all housetops and interlocking twigs of roadside trees are covered with white while pedestrians hurry along the slushy sidewalks shivering and huddling their shoulders with cold. Beihong set it in a frame and hung it on the wall. He was going to ask Tang to take it back with him to Jitingqiao as a gift to Mr. Shi, a friend of Fa Desheng's who had been generous enough to give Beihong much financial aid.

There came a knock at the door. Beihong opened the door to let in a well-dressed middle-aged man. He was thin-faced and wearing a long silk gown and a mandarin jacket. He had come to find Tang to discuss the silk business. He sat down to wait for Tang to come back and smoked. Through the curling smoke, his eyes caught the snowscene

picture hanging on the wall. The more he looked at it, the more fascinated he was. Nodding his head again and again, he remarked, "It's so lifelike. What a rare excellent piece! May I ask who painted this picture?"

"I did," answered Beihong casually.

The middle-aged man eyed the skinny and pale Beihong and said, "You look like a teenager. Who would have thought that you could have such unique skill! May I buy this picture from you?"

Beihong told him that he could not sell it because he had decided to give it to somebody else as a gift. Then the man asked again, "Could you tell me where you're going?"

"Beijing," answered Beihong without hesitation.

The visitor went on in a solicitous tone, "Right now it's extremely cold in Beijing. You're not wearing enough clothes to protect you from the cold. Why not stay on in Shanghai to find an alternative!"

Beihong insisted, "No, I can't. Besides, I'm eager to see the grand palaces in Beijing!"

Just then, Tang came back. A heated discussion started between Tang and the middle-aged man about silkworm cocoons and market quotations. Beihong left the hotel to do a little shopping in town.

Dusk began to deepen soon after Beihong went out. When he came back to the hotel after dark, the visitor was no longer there. Tang told Beihong that the middle-aged man was Huang Zhenzhi of Wuxi, a wealthy merchant and a lover of art and an expert collector of calligraphy and paintings. After seeing the snow-scene picture, he had determined that Beihong was a promising young man and was willing to offer Beihong financial aid so that he might be able to stay in Shanghai. Beihong yearned for Beijing and was anxious to get there. But Tang persuaded him to stay in Shanghai, saying that Beihong would have no certainty of getting a job in Beijing; what awaited him there would be unpredictable. Beihong accepted the aid offered by Huang Zhenzhi and moved to take up his quarters at Xiayu Club.

The club was run for businessmen. Beihong was able to live in a room which Huang had originally rented from the club to be used as a lounge where people sat and smoked. In the club, there was a gambling room which was open from dusk till dawn. Beihong saw crowds of

people around the table frantically gambling away their fortunes like dirt, and heard, in the midst of the clinking of silver dollars, people laughing, shouting and cursing. He was thoroughly disgusted by this and ran out of the hotel as if escaping from a plague. At first, he loitered in the streets. Later, he enrolled in a night school to learn French. When the last gambler had left after daybreak, silence would reign again at the club, and Beihong would then bend over the huge gambling table with his paint brush.

Time slid through Beihong's industrious fingers hour after hour, day after day, month after month until it was winter again. Xiayu Club was getting a face-lift in preparation for the busy gambling period at New Year, so Beihong had to move out to live in the dormitory of a newly acquainted friend named Huang Jingwan, a shop assistant at the Commercial Press sales department. Beihong had often visited the sales department to read books standing, and in the course of time he and Huang had become friends. Huang, several years older than Beihong, was a very kindly person. He did not in the least slight Beihong because he came to the sales department only to read and never to buy books. He even sometimes lent Beihong a helping hand when Beihong was in trouble.

It happened at the end of the year that Huang Zhenzhi found himself on the verge of bankruptcy, having lost great sums of money through gambling. He could no longer give money to Beihong. And because Huang Jingwan had to support his aged mother with his meagre income, Beihong saw fit not to ask him for a loan. Desperate, he painted a horse and mailed it to Gao Jianfu and Gao Qifeng, two brothers running an art store in Shanghai called Shenmeiguan. Both brothers were well-known painters of the Lingnan[*] school. Soon after, Gao Jianfu wrote Beihong a letter in reply, in which he praised the horse painting and said, "You outshine even the ancient Han Gan."[**] Gao Jianfu decided to have the horse painting published by Shenmeiguan. Meanwhile, he also asked Beihong to create for Shenmeiguan four

[*] A geographical name referring to the area covering Guangdong and Guangxi.

[*] Han Gan was an eighth-century Chinese painter, distinguished for drawing Buddhist images supernatural beings, figures, flowers and bamboos, and especially horses. He attached much importance to painting from life.

traditional Chinese paintings of beautiful women.

Beihong had only five coppers with him, and it would take him at least a week to finish drawing the four pictures. Early in the morning, he would go out into the misty streets on a rumbling stomach. With the dawn, the busy night market vanished, and all shops fell into a deep slumber except the steaming snack counters, selling savoury light refreshments like soya-bean milk, fritters of twisted dough, *shaomai*[*] steamed stuffed buns and noodles with spareribs. Beihong held a copper in his hand. He felt as if he were holding a gold brick and was afraid of losing it because he had to depend on it for a day's work and live on it for a long day and night. Finally, he stopped before a stall selling glutinous rice balls and fritters of twisted dough. The vendor scooped up a handful of steamed glutinous rice from the rice bucket, wrapped it up in a piece of moistened white cloth, then rolled it with both hands until it soon became a ball. Glutinous rice is sticky and takes a long time to digest. Beihong chose to eat it because he thought it would appease his hunger longer. Due to hunger, his heart would palpitate and the hand holding the paint brush would feel like jelly. But he held on.

By the sixth and seventh days, Beihong had spent his last copper and had nothing to live on. The hand holding the brush began to tremor and refused to be dictated to. His eyes grew dim, and numberless dark specks swayed before them until he leaned his head on the table. Soon the swoon was over, and he raised his head and took up the brush again. Then came another swoon, and again he leaned his head on the table.

The four pictures of beautiful women were finished at last. The day he took them to Shenmeiguan, there was a raging snowstorm. The biting wind swept the wet flakes of snow against his face, and they stuck to his thick hair and thin clothes.

The janitor at Shenmeiguan stuck his head out of the window and said loudly to Beihong, "It's snowing. Mr. Gao won't be coming!" He banged the window shut.

"Will he be here tomorrow?" Beihong asked with anxiety.

"Tomorrow is Sunday, a regular holiday for him!" said the janitor behind the closed window.

[*] Steamed dumplings with the dough gathered at the top.

Beihong could do nothing but leave the four pictures with the janitor. Unbearable hunger made him feel faint. He took off his thin cloth jacket in spite of the freezing weather and handed it to a gruesome pawnshop.

On his way back, Beihong was attracted by an advertisement. Aurora University was taking in new students. He plucked up his courage to sit for the entrance examination, and was admitted. But how could he who even had difficulty getting food and clothing raise enough money for the tuition fee? Finally he decided to borrow money, in spite of his embarrassment, from a less than wealthy fellow townsman named Ruan Zhaiguang.

A small tradesman in the silk reeling business, Ruan was a sincere and kind man, with whom Beihong had got acquainted through the introduction of Tang. Beihong now went to visit Ruan, and when they met, he came straight to the point. Ruan at once promised to lend Beihong twenty dollars, and was very much delighted at seeing the latest works Beihong had done and brought with him. Ruan gave Beihong enthusiastic encouragement and had him stay for supper — the first decent meal Beihong had had in ages. Many beautiful possibilities were again kindled in his mind.

It was then a custom for the president of Aurora University to interview each new student. At the call of the name "Huang Fu," Beihong went inside. "Huang Fu" was the pseudonym Beihong had adopted when he signed up for the entrance examination in honour of the two Huangs (i.e., Huang Zhenzhi and Huang Jingwan), his benefactors. When the president inquired of Beihong about the record of his former schooling, Beihong was touched and reminded of his sorrowful past. He was a jobless man, an orphan, a much-tormented twenty-one-year-old. He had been a farmer, a teacher, a tramp, but he had never had any regular schooling. He was eager to pour out his tale of misfortune, but his lips quivered without uttering any sound as though he were choking, and tears came rolling down his cheeks. The president's eyes fell on the pair of white cloth shoes Beihong was wearing. He asked with concern, "For whom are you wearing mourning?"

Beihong answered choking with emotion, "My father." More tears

came, and he burst into a sob.

The president said gently to comfort him, "Study hard! diligence can make you forget your sorrow."

Beihong was thus formally admitted. He began his studies in the French Department. By trying to master French, he meant to prepare himself to go to France on a work-study programme whenever he could get such a chance. As he had no lesson Thursday afternoons, he would make use of the free time drawing sketches. He would draw himself by looking in a mirror, or sketch some of his fellow students.

One day, while he was doing a sketch, a letter arrived from Gao Qifeng. He quickly opened it, and found inside it not only words of praise for his talent, but also a fifty-dollar royalty on the four pictures he had sent. Beihong put down the brush, went out hurriedly to see Ruan at his home and cleared up his debt with the newly acquired money. Ruan was very much pleased, and he recommended Beihong to some of his friends to give painting lessons to their children.

Chapter VI

One day, Beihong saw in the newspapers an advertisement put out by Mingzhi University seeking a portrait of Cang Jie[*]. He painted a portrait to answer the ad, hoping to earn some extra money to subsidize his living expenses.

Ancient Chinese books described Cang Jie as possessing "four eyes radiating divine light." Young Beihong painted, according to descriptions given by these books, a hairy-faced giant with long hair hanging down his shoulders and a coat made of tree leaves draped over his body, and two pairs of overlapping radiant eyes under his bushy eyebrows. The picture, a watercolour one metre in length, won the great admiration of professors at Mingzhi University. The university authorities decided to invite Beihong to lecture on painting, and immediately dispatched a car to bring him to the campus.

Ji Juemi, superintendent of the university, who had been respectfully waiting in his office for Beihong, asked in perplexity when he saw the arrival of a very young person, "Hasn't Mr. Xu Beihong arrived yet?"

"I'm Xu Beihong."

"Then, who is it that did the portrait of Cang Jie?"

"I did, of course."

"Oh, oh, I thought, I thought..." the fat superintendent stammered.

"Sir, do you mean I'm trying to pass myself off as the real painter?"

Beihong was a bit offended.

"No, no," the superintendent denied right away. "I little... I little

[*] A legendary figure in China credited with the invention of the written Chinese language.

expected that you'd be so young."

"Yes, sir, I'm not a teacher, but a student at Aurora University."

"I've been thinking of asking you to do a few more portraits of Cang Jie, each with a different posture," the superintendent smiled. "The pay will be excellent."

"I'm very sorry," said Beihong, "but I haven't got time now. No, not until the summer vacation. If you're in a hurry, you can try to find someone better qualified than myself."

"No, no," the superintendent replied hastily. "The professors here all speak highly of your picture. We'll wait for you to come again during the summer vacation."

Time passed quickly and soon it was summer. Having passed the end-of-term examination, Beihong took along some light luggage to live in a guest room at Mingzhi University. A well-lit room with a southern exposure, it held a big painting desk and a rich supply of painting colours. Beihong had never in his life lived in a place with such excellent conditions for painting.

His fellow students said to him jokingly, "Beihong, you never had it so good! From now on, you'll stay put at Mingzhi University doing your painting!"

"These are rich men running a school and pretending to have high taste," Beihong explained in all seriousness. "They've an axe to grind, but I've got a purpose of my own. I won't be staying there permanently. Besides, wherever I go, I'm always 'a lad of the Divine Land' and 'a poor *xiake* of Jiangnan.' "

At that time, there had been set up in Mingzhi University an academic society called Guang Cang Xue Hui, which often invited celebrities and scholars to give lectures. Beihong was thus enabled to make the acquaintance of some well-known scholars of the day, such as Kang Youwei and Wang Guowei. In addition, exhibitions of private collections of inscriptions on ancient bronzes and stone tablets as well as calligraphy and paintings were often held by the university. This offered Beihong an excellent opportunity for study and enabled him to draw direct knowledge from China's ancient masterpieces in painting.

Beihong deeply respected Kang Youwei for leading thirteen hundred intellectuals in submitting a memorandum to Emperor

31

Guangxu of the Qing Dynasty in 1895 to ask for political reforms. But he very much deplored his failure to follow the trend of the times and his final royalism. Beihong was nevertheless attracted by Kang's erudition, and treated Kang, who always gave warm encouragement and help to young students, as his own teacher. Beihong also had free access to Kang's extremely rich collection of books and rubbings from stone inscriptions, which engendered in him a profound interest in calligraphy.

Beihong painted a great deal during his stay at Mingzhi University. In addition to the portrait of Cang Jie, he painted figures, landscapes, flowers and birds, animals and even some stage scenery. These works give indications of his attempts to integrate the Western art of chiaroscuro and perspective to express space and volume in Chinese painting.

Ji Juemi very much appreciated young Beihong's talent and treated him courteously and thoughtfully. As the university then happened to be in need of an official to take charge of the student dormitories, Beihong recommended for this position a friend named Cao Tiesheng, an unemployed young man. Ji gladly accepted the recommendation.

Cao Tiesheng came from Liyang, a county next to Beihong's native place Yixing. Beihong had come to know Cao in Liyang back in the days when he and his father were still wandering from place to place to sell their paintings. At that time, seeing that Beihong was very studious, Cao had presented Beihong with the replicas of paintings by some European masters. Cao was an easy-going intellectual, who was slovenly dressed and was given to drinking, but had a strong sense of justice and was ready to speak out against the powerful on behalf of the bullied. His nickname *Wubang* (meaning "without a stick") had been derived from the popular saying, "A poor man without a stick is bullied by even a dog." Of the many people at the university with whom Beihong had come into contact, Cao was the only one with whom he could get along well. They had come through the same bitter experience: unemployment and poverty, and possessed the same character: readiness to speak up against injustice. They often spoke heart to heart, and Cao often spoke to Beihong about his strong aversion to some of the university regulations such as banning the students' contact with the outside world;

the incompetence and arrogance of the university doctor; and the idleness and mediocrity of certain well-paid professors.

One day, Cao had a drop too much outside the university. When he came back still tipsy, he bitterly attacked the university authorities, right to the face of Ji Juemi, for ruining the younger generation. The pot-bellied superintendent looked askew at someone beside him and said in a mild tone, "Mr. Cao's drunk! You'd better put him to bed quickly!" Late that very night, someone threw out Cao's luggage, evidently by order of the superintendent.

Beihong gave Cao money to cover travelling expenses to Hangao, and he himself decided to quit staying at the university. He had originally planned to paint eight portraits of Cang Jie in varied postures, but he finished only four of them, leaving the remaining four roughly sketched and unfinished. Later, when the university went out of existence, people lost track of these pictures.

Mingzhi University paid Beihong sixteen hundred dollars in cash. Equipped with this money, he decided to make his voyage to Japan to start his study of foreign painting.

Chapter VII

Close to Hardoon Garden there lived an elderly man named Jiang Meisheng. Like Beihong, he came from Yixing and was an old-type scholar well versed in the Chinese language. He held a professorship in Chinese at Datong College. Beihong got acquainted with the Jiangs through the introduction of another fellow townsman named Zhu Liaozhou. Zhu was a well-known personage in Yixing. During the Revolution of 1911, Zhu, a revolutionary-minded and physically strong young man, had led a group of young people in doing away with superstitions, smashing up whatever Buddhist images they found in Yixing temples. Now he was a teacher of physical culture at Wuben Women's High School in Shanghai. His younger brother Zhu Yizhou, who was later to go to France to study, was also an intimate friend of Beihong's.

Beihong had been engaged to a girl at the age of seventeen through the arrangement of his parents. As his father was then critically ill, Beihong, who always showed filial piety for his parents, did not think it fit to disobey his father's wish. The young wife, a poor peasant girl from a neighbouring village, was physically weak and often fell ill owing to congenital deficiency. She gave birth to a boy called Jiesheng. Unfortunately, not long after Beihong came to Shanghai for the second time, she died of an illness. Later, the baby also died of smallpox.

Jiang Meisheng had two daughters. The elder one was already married; the younger one, Jiang Biwei, who had been betrothed to a young man of a Cha family in Suzhou at the age of thirteen, was still unmarried.

Once the nineteen-year-old Jiang Biwei came to know Beihong, she often involuntarily compared him with her betrothed — a middle school student in Suzhou and a son of a declining government official's

family — only to find a world of difference between them. She had been gradually attracted by Beihong and secretly fell in love with him. Beihong did not perceive it until her mother informed her that she was to be married into the Cha family the next year. She suddenly burst out crying.

Jiang Biwei's slender figure, fair complexion, delicate facial features and glossy, thick hair all made a good impression on the artist. But due to his deep grief over the death of his father and wife and his earnest devotion to painting, Beihong had little time to spare for other things. By the time he was ready to make his voyage to Japan, he still had not yet had a talk with her alone. But her tender and loving gaze at him did sometimes pull at his heart.

Upon hearing of Beihong's imminent departure for Japan, Jiang Biwei felt a great longing to accompany him. But because of misgivings caused by her previous betrothal, all she could do was painfully keep her longing to herself. However, the worldly wise Zhu Liaozhou had seen clearly what was going on and volunteered to act as a go-between.

One day, he asked Jiang Biwei, "Suppose somebody offers to take you abroad with him, would you say yes or no?"

Jiang Biwei realized instantly that Beihong was the man in question, so she said unhesitatingly, "Yes!"

As it was impracticable to break off an engagement in a family and society dominated by feudal ethics, the only way for her to resist it was to elope. She quietly left behind a farewell letter to her parents, in which she gave the excuse that she had left home quickly because life was utterly meaningless and she was considering suicide.

The pretty girl's deep love for him and her brave fight against the arranged marriage greatly enchanted Beihong and aroused in him a high sense of responsibility. He lost no time in procuring a passport for each of them. In May 1917, the two lovers embarked at Shanghai on a steamer bound for Japan to begin their life together.

The Jiangs were greatly shocked by the sudden disappearance of their daughter, and they even wept at the discovery of her farewell letter. But both parents understood their daughter; they reasoned that, instead of committing suicide, she had probably gone abroad with Beihong. In spite of this, they still considered her elopement a great disgrace to the

Jiang family and assumed they would be subject to public censure. The Jiangs, therefore, had to declare falsely that their daughter had died of a sudden illness. To prevent the Cha family from discovering the truth, they bought a coffin and had it filled with stones and placed in a temple in Suzhou.

The steamer, belching a plume of black smoke, sailed over the rolling Pacific. Beihong, wearing a Western-style suit, and Jiang Biwei, in a broad-sleeved short coat and a silk skirt, were leaning on the ship railing and gazing ahead at the faintly visible neighbouring country. Beihong recalled the history of cultural exchange between China and Japan, and visualized in imagination how Japan had sent students to study in China. Jianzhen, the eminent Chinese monk, had attempted as many as six voyages across the sea in order to give lectures in Japan. Jiang Biwei, seeing that Beihong was silent, also said nothing, but she snuggled up to him.

In Tokyo, they rented a room in the house of a Japanese family and the landlady took care of their meals. While the beautiful city of Tokyo was a worldwide attraction to tourists, the twenty-two-year-old Beihong was strongly attracted by the varied and colourful Japanese paintings.

He daily spent his time visiting collections of Japanese paintings, and was glad to discover that Japanese painters had rid themselves of the old habit of adhering to the ancients. They had achieved beauty, depth and richness, especially in flower-and-bird paintings, through the careful observation and description of nature. Beihong liked the printed copies of Japanese paintings for their exquisite variety. He often lingered in Japanese bookstores and art shops, and would buy whatever books or art replicas he liked regardless of their costs. He would often come back home hugging a pile of books and paintings.

"Biwei, come quick and take a look!" he shouted in high spirits. "These prints are just as good as the originals!" His eyes sparkled with a rare lustre.

Knitting her eyebrows, she said with a note of complaint, "You're always buying books and paintings. If you go on like this, we'll soon be broke. What if we should some day become wanderers in this foreign land without even money for our home trip?"

But Beihong could never find it in his heart to abandon his eager pursuit of art or dampen his enthusiasm for books and paintings. At first Jiang Biwei used only gentle words of persuasion, and when that failed, she started to quarrel and even fiercely wrangle with him.

Jiang Biwei keenly perceived that Beihong was devoted solely to art; she complained to herself that he was in love with art rather than with her. She thought herself very unlucky. On the other hand, Beihong thought that he must save money to buy books and paintings even though on an empty stomach. He believed that Jiang Biwei would gradually be able to understand him, and hoped that she would eventually come round to his way of thinking to become a lover of art as he was.

He failed to discover and realize that this dark shadow would not only be indelible but grow larger and darker.

By the end of their six-month-sojourn in Tokyo, they had used up almost all the money they had. Beihong had spent most of their money on books and paintings. Finding it no longer possible to stay on in Tokyo, they decided to return to China, and so came back to Shanghai by steamer at the end of the year.

The Jiangs were very happy about the simultaneous return of their runaway daughter and son-in-law even though the exposure of the sham coffin had incurred the reproach of some friends and relatives. Little did they know, however, that a rift had already begun between the young couple.

Chapter VIII

Beijing was the academic and cultural as well as the political centre of China. Beihong, who had always longed for a chance to visit Beijing, called on Kang Youwei in Shanghai to express his desire to go to Beijing to find a job. Kang gave him encouragement and told him to visit a good friend of his in Beijing named Luo Yinggong. Luo, a celebrity in Beijing, was a learned old-style scholar with a very large circle of friends. Kang immediately wrote a letter of introduction for Beihong to deliver to Luo personally.

In December 1917, Beihong and Jiang Biwei took a steamer sailing from Shanghai to Tanggu. In order to economize on travelling expenses, Beihong had booked two third-class passages on the steamer. Those travelling third-class were mostly impoverished labouring people and down-and-out intellectuals. Beihong, who had himself been brought up in poverty and vagrancy, did not think it unusual to be travelling third-class. Living a simple and frugal life and being willing to associate with the lower-class society, he had a deep sympathy for labouring people. But Jiang Biwei, who had been born of a well-to-do family, found it intolerable, face-losing and beneath her dignity to mix with lower-class society, let alone to stay in the same cabin with them. Again she felt that Beihong loved art better than her. She simply could not understand why Beihong begrudged paying several tens of dollars for a first-class passage for her while spending hundreds of dollars on works of art. She felt extremely sad and resentful. During the whole passage, she seldom talked to Beihong unless spoken to.

Upon their arrival in Beijing, Beihong, armed with Kang Youwei's letter of introduction and some of his paintings, went to call on Luo Yinggong. Luo was pleasantly surprised to see Beihong's paintings, and he immediately wrote a letter of recommendation to the Education

Minister Fu Zengxiang, in which he called Beihong a man of extraordinary talent. He suggested that Beihong be allowed to pursue advanced studies in France whenever the Ministry of Education made new arrangements to send students abroad to study.

Fu, a Sichuanese, thin and medium in stature, was an amiable scholar, whose hobby it was to collect books. After reading Luo's letter of recommendation, he asked Beihong smilingly, "May I have a look at your paintings?"

Beihong went to the Ministry of Education to hand in a selection of sketches, watercolours and paintings in the traditional Chinese style. Fu acknowledged Beihong as a very promising young man, and gave him warm assurances.

"It's a pity that the European war is still going on," he said, "so you must wait a little bit. We'll never forget you or leave you out when the time comes for us to send students to France."

Beihong was very much struck with the Education Minister's sincerity and lack of bureaucratic hypocrisy or equivocation.

While waiting in Beijing for a chance to go abroad, Beihong made the acquaintance of a tall young man named Hua Lin, who was very active in the cultural circles of Beijing and often wrote pungent articles for local newspapers and magazines. As a bachelor, he had rented a three-bay wing-room in an old-style compound in Fangjinxiang, Eastern City, Beijing. Now he let Beihong take up half the space, and they became next-door neighbours. Through the introduction of Hua Lin, Beihong paid a visit to Cai Yuanpei, president of Beijing University, who, as an elder, best knew how to appreciate and promote young people of talent. He greatly admired Beihong's paintings for their vigorous style and strong national features, and invited him to be a teacher at Beijing University Art Research Association. That enabled Beihong to obtain a temporary foothold in Beijing.

The city of Beijing and its ancient culture made a tremendous spiritual impact on Beihong. The crimson palace walls, magnificent halls, buildings and pavilions with colourful golden decorations, towering ancient cypresses, tall straight lacebark pines... all these radiate with the flavour of ancient culture. In the Palace Museum, Beihong saw a rich array of ancient paintings, pottery and porcelain,

bronze ware, and jade articles, which broadened his artistic horizon.

He pointed out, "Chinese painting has now reached the depths of decadence." And he ascribed the main cause of the decadence to "conservativeness." He wrote with feeling, "It is really a great shame and humiliation to lag behind our ancestors of a thousand years ago." He proposed lofty aspirations for rejuvenating Chinese painting and hoped that Chinese painters would have outdone the ancients by the end of the twentieth century.

Beihong's opinion won the warm admiration of the painter Chen Shizeng, son of the poet Chen Sanyuan. Chen Shizeng, who was also a teacher at Beijing University Art Research Association, often had discussions with Beihong about poetry and painting, and sometimes they together went to the Palace Museum to feast their eyes on masterpieces of ancient Chinese painting. Once, they stood enchanted before *Through the River Valley,* by Fan Kuan, a distinguished painter of the Song Dynasty. The next day, Beihong brought his students to the museum specially to see this picture.

"Look!" said Beihong pointing at it. "Painters of the Song Dynasty strove for realistic painting, but also paid great attention to spiritual likeness. Fan Kuan lived in Taihua and all about him he saw grand high mountains, so what he painted were mostly mountain peaks rising one behind another. Dong Yuan, a painter of Nantang[*], lived in Jiangnan, so what he painted was mostly flatland scenery. Both imitated nature, so they could paint truthfully and give people a feeling of authenticity."

Chen Shizeng stood by nodding approval. Beihong continued with zest, "I think the works of some Tang painters like Wu Daozi, Cao Ba, and Wang Wei, although they have not been handed down, must have been exceedingly marvelous because their contemporaries spoke of them with such high praise. Imagine how we would be overwhelmed with admiration if their paintings were to appear before us! There's painting in Wang Wei's poetry, so his painting scrolls must have been extremely fascinating. The works of the Tang painters Li Sixun and Yan Liben, which are now still in existence, are lifelike and graceful. The

[*] One of the ten states during the Five Dynasties lasting from A.D. 937 to 975, and occupying parts of today's Jiangsu, Anhui, Fujian and Jiangxi provinces.

pictures of beautiful women done by the latecomer Zhou Fang are rare masterpieces too...."

Beihong mentioned the ancient painters with great facility, as if enumerating his family valuables, and there was real joy in his face. Chen Shizeng, who was familiar with Beihong's disposition, knew that Beihong would talk endlessly when he was in a happy and excited mood. Beihong said to him, "I'm most fed up with Dong Qichang of the Ming Dynasty and the four Wang landscapists*. Dong was a big bureaucrat who used his personal influence to start a very pernicious common practice. While one could be a painter without knowing how to paint from life and without modelling oneself after nature, one could never be a painter without knowing the various styles and schools of ancient painters. Dong took pride not only in his high position, but in his vast wealth as well. He was a big bureaucrat, a big landlord, and a big art collector. But the pictures he painted were nothing but opportunistic decadent works by a man of letters. The four Wangs, like Dong, painted lifeless, stereotyped landscapes of the government-sponsored type. But even today some people are still praising such paintings to the skies and trying to imitate them exclusively."

At this, Chen Shizeng smiled, "Beihong, your views on painting, like the man that you are, show a clear distinction between what you love and what you hate. But imagine how difficult it is to clear away the old customs and start a new trend."

Beihong replied, "I know I'm still too young, but the responsibility for initiating a new stylistic trend now rests upon the shoulders of us young people." Then, running his eyes over the students around him, he continued, "For over three hundred years, ever since the end of the Ming Dynasty, Chinese painting has been following the same dull old practice. Yes, we did have a few outstanding painters during this period, but as a whole, Chinese painters have become conservative. They demand that each and every stroke should be patterned after the ancients. They have absolutely no vitality or initiative, and have become rigid in both thinking and painting. Art should catch up and develop with the times,

* The four Wang landscapists were Shimin, Wang Jian, Wang Hui and Wang Yuanqi of the early Qing Dynasty.

41

and the number one enemy of art is complacency, slavish imitation of the ancients and conservativeness. In order to enrich and develop our national painting, the younger generation of painters should make every effort to derive good techniques from Western painting on the basis of the traditions of our ancient painting. That's why I'm longing for a chance to go to Europe to study art."

The students, moved by his eloquence, had been listening with rapt attention.

"Beihong, it's late," Chen Shizeng reminded Beihong. "We're to see Cheng Yanqiu perform in the opera this evening."

"Oh, yes!" Beihong remembered the theater tickets sent by Luo Yinggong, so he concluded his fervent talk.

Whenever the famous Beijing opera actor Cheng Yanqiu was to give a performance, Luo Yinggong, an ardent propagator of this art, would book several rows of front seats to entertain his friends. Luo liked Cheng's talent, so he gave him lessons in calligraphy and poetry, wrote librettos for him, and helped him understand the content and characters of the opera in which he was to play.

Later, Luo also manged to have Cheng take the Beijing opera master Mei Lanfang as his teacher. Luo was known for enthusiastically fostering young talent. Had it not been for his loving help, Cheng's talent might have been permanently stifled. Beihong was touched by Luo's love of talent and spirit of self-sacrifice and was also attracted by Cheng's art, so every time Cheng was to appear on the stage, Beihong would attend without fail. He became one of Cheng's most enthusiastic spectators. It was at this time that Beihong began to cherish an interest in Beijing opera, and he gradually also learned to sing a few lines.

But Jiang Biwei hated the opera. She refused to go to the theater with Beihong, nor did she want to sit alone at home. She bitterly censured Luo for "flattering Cheng Yanqiu."

"H'm!" she said sarcastically, repeating Beihong's question. "What's meant by Luo Yinggong flattering Cheng Yanqiu? That only explains the fact that men of letters are normally bohemians!"

"Biwei," explained Beihong with patience, "it's true that Luo Yinggong thinks highly of Cheng Yanqiu's talent. He's not a pleasure-seeking man. He's fostering a bright pearl of art, a talented Beijing opera

artist, so that Beijing opera won't run out of proponents."

"Art! Artist! None of your high-sounding excuses!" she said angrily. "You've simply joined in the game of flattering an actor!"

"Oh, Biwei..."

Beihong had the painful feeling that three was something dividing them, a huge gap between them in their attitudes towards art and artists. Jiang Biwei was as annoyed as Beihong was unhappy.

However, Beihong's interest in Beijing opera did not suffer. He continued to see Cheng's performances, and often Mei Lanfang's performances. Not only was he fascinated by the superb art of Beijing opera, he was also pleased by the emergence of numerous talented people in this field.

Viving in the narrow compound of Fangjinxiang, Beihong was much harassed by the small, biting midges which abounded in Beijing in summer. Fortunately, Beijing University was organizing teachers and students to go to Xiangshan Mountain for the summer holidays. Beihong signed up for the trip.

Xiangshan Mountain is five hundred and fifty-seven metres above sea level at its highest point. Nestling against the mountainside stands Biyun Temple, a quiet, elegant spot with pavilions and pagoda courtyard painted in gold and colours, and white marble door-steps and carved balustrades. Great trees tower into the skies and a stream ripples before the front gate of the temple.

During the Qing Dynasty, a temporary dwelling place for the emperor was also built on the mountain. The whole place was later looted and burned by the Anglo-French Allied Forces[*] and the Eight-Power Allied Forces[**], which reduced most of the buildings there to

[*] From 1856 to 1860 Britain and France jointly waged a war of aggression against China. The government of the Qing Dynasty was then devoting all its energies to suppressing the peasant revolution of the Taiping Heavenly Kingdom and adopted a policy of passive resistance towards the foreign aggressors. The Anglo-French forces occupied such major cities as Guangzhou, Tianjin and Beijing, plundered and burned down the Yuan Ming Yuan Palace in Beijing and forced the Qing government to sign the humiliating Treaties of Tianjin and Beijing.

[**] In 1900 eight imperialist powers, Britain, the United States, Germany, France, Russia, Japan, Italy and Austria, sent a joint force to attack China in their attempt to suppress the Yihetuan Movement. The allied forces of the eight powers captured Dagu and occupied Tianjin and Beijing. In 1901 the Qing government concluded a humiliating treaty with the eight imperialist countries.

debris. Beihong, with his colleagues and students, hiked around the mountain and pondered the past, grieved by the decline of China. He stood long among the ruins.

It was the eve of the May 4th Movement of 1919.[*] The Russian October Revolution had already succeeded, but the European war was still going on. Most Chinese intellectuals were concerned about the future of the nation. Cai Yuanpei, President of Beijing University, advocated "incorporation and freedom of different thoughts" as the guiding principle for running the university, which made it not only the centre of academic research, but also the cradle of the burgeoning new cultural movement.

Articles and speeches by Chen Duxiu[**], Li Dazhao[***] and Lu Xun[****] became the main topic of conversation among all people.

[*] A country-wide anti-imperialist, anti-feudal, political and cultural movement influenced by the Russian October Revolution and led by intellectuals having the rudiments of Communist ideology.

[**] Chen Duxiu (1880-1942), a native of Anhui Province, studied in Japan in his early years. In 1915, he was an editor of *New Youth;* in 1916, he was a professor at Beijing University; in 1918, he, together with Li Dazhao, started the publication of the *Weekly Review* to advocate new culture. He became a radical democrat at the time of the May 4th Movement. In 1921, when the Chinese Communist Party secretary-general, he formed an anti-Party group. Consequently, he was expelled from the Party in 1929.

[***] Li Dazhao (1889-1927), a native of Hebei Province, was the first Marxist in China and one of the founders of the Chinese Communist Party. In 1913 he went to study in Japan. After his return to China in 1916, he became editor-in-chief of the Beijing newspaper Morning Bell and later director of the library and concurrently professor of economics at Beijing University and editor of *New Youth*. He started the *Weekly Review* to give active leadership to the May 4th Movement. Upon the foundation of the Chinese Communist Party, he took charge of Party work in North China, and was elected member of the Party Central Committee at the First and the Fourth Party Congresses. In 1924, he was arrested by the warlord Zhang Zuolin and hanged.

[****] Lu Xun (1881-1936) was a contemporary Chinese writer, thinker and revolutionary. He studied in Japan in his early years. In May 1918, he published the short story *A Madman's Diary,* which laid the foundation for the new literary movement. At the time of the May 4th Movement, he took part in editing *New Youth* and stood in the van of the anti-imperialist, anti-feudal new cultural movement.

The new cultural movement had a tremendous impact upon the intellectuals of those days, Beihong among the rest. There on the door-steps of Biyun Temple, he and some teachers of the university would often sit in threes and fours, discussing means of saving the country and the people and also talking about their individual aspirations. Although they had not yet understood or accepted Marxism-Leninism, they did accept the slogan of "democracy and science" as something which they hoped might save China.

Beihong did not let a single day pass without painting. During the summer holidays at Biyun Temple, he painted a great many landscapes. Serene and deep forests, limpid water from the mountain spring, floating white clouds, gauzy mists — all these beautiful things of nature offered him new enlightenment and inspiration.

Not long afterwards, the Ministry of Education began to send students abroad, but, to his great indignation, Beihong did not find his own name on the list. He wrote Fu Zengxiang a sharply worded letter to reproach him for not keeping his promise. Beihong grew impatient when he received no reply. So he went to see Luo Yinggong.

Luo said with a sigh, "Minister Fu has already got your letter. He's greatly offended."

Beihong, still in agitation, answered, "If Mr. Fu's unwilling to send me abroad, why should he have given me the promise? I wouldn't be arguing with him if he were just an ordinary person. But he's a scholar, and I took it for granted that a scholar like him wouldn't cheat me."

Luo was speechless.

On November 11, 1918, the First World War ended. The news set the whole nation rejoicing. Soon after, word came that the Ministry of Education was to send another batch of students abroad. Cai Yuanpei wrote to Fu Zengxiang to put in a good word for Beihong. Fu promptly replied that he would fulfil the promise he had previously made.

Many years later, in recalling this episode Beihong was to write:

Because I spent ten years wandering far and wide, I know how difficult it was for me to seek education. I shall forever remain indebted to Huang Zhenzhi and Fu Zengxiang for their kindly help. I shall never forget them.

Chapter IX

In March 1919, warm raindrops were falling over the vast Huangpu River. The river wharf was crowded with noisy throngs of people. Holding umbrellas of various colours, they were reluctantly seeing off their friends or relatives bound for distant places.

A Japanese steamer was about to weigh anchor, and from the deck came the clanking of the chain cable. The twenty-four-year-old Beihong, who had elbowed his way to the ship railing, waved his black broad-brimmed hat to his friends and relatives. Jiang Biwei was nestling close to him with a smile on her face. She raised her arm to wave a silk handkerchief to her parents standing among the crowds of people.

It was only after repeated considerations that Beihong had decided to take Jiang Biwei along to Paris with him. He knew it would be difficult for him to support two persons with the government allowance he was to receive as a student studying abroad. But he hoped that Jiang Biwei, like himself, would be affected by the prevalent artistic atmosphere after she arrived in the world centre of art. He earnestly hoped that Jiang Biwei would develop a love for art, fling herself into the cause of art and devote herself to the promotion of China's culture and art, and that they would thus become not only partners in life, but also friends with a common goal. Beihong stopped looking back on the fierce bickerings of the past and hoped to forget about them entirely.

Arriving in London in early May, Beihong and Jiang Biwei immediately went to visit the British Museum. When they saw the relief sculpture of the ancient Greek Parthenon, Beihong felt intoxicated and said, "Oh, why not let me come face to face with it gradually! Now that I've planted myself in front of it so suddenly, I feel completely stupefied." The galloping war-horses sculptured in relief were astonishingly spirited and stout, and the young girls' movements lithe

and graceful, their dresses folding like real silk rather than stone sculpture. Beihong was drunk with it.

After a one-week tour in London, they arrived in Paris in mid-May, 1919. In Paris, May is the season of soft breezes and fragrant flowers. At the sight of the familiar Arc de Triomphe, he felt the joy of having fulfilled a long-cherished wish. But he also realized that he was bound to meet with difficulties and hardships in his future studies, and that he must courageously forge ahead. Soon after his arrival in Paris, he learned that the great May 4th Movement had broken out in China, and was greatly concerned about his country and people. He strengthened his resolve to help end China's humiliation and win credit for his motherland.

As soon as he settled down in Paris, Beihong went with his wife to visit the Louvre museum. Some of its important exhibition rooms were then still closed pending the return of many famous masterpieces, moved to other places during the war for safe custody. A throng of thoughts crowded into Beihong's mind as he gazed at Leonardo da Vinci's *Mona Lisa*.

Beihong lingered in the room devoted to J.L. David feeling riveted by David's pure and strict style of painting. He stood touched before David's oil painting *The Oath of the Horatii*. It depicts the solemn scene of the three Horatius brothers vowing before their father to fight the enemy to the end before they leave for the battlefield. The father, holding in his hand three swords and three arrows, is solemn and dignified while other family members sit overcome with grief.

The works of many Western masters filled Beihong with awe and a sense of humility. He realized that he had painted in China not because he was good at painting, but because he wanted to earn a living, and that since he had often done Chinese painting with freehand brushwork, he lacked precision in observing and portraying objects. His undisciplined hand often followed no rules, uncontrollable as an unbridled horse. He resolutely decided to temporarily stop his Chinese-style painting, and devote himself instead to studying and imitating the works of Western masters. Several months later, he entered an art academy. He found it difficult to orient himself to the new style at first, but gradually learned its rules. Then he sat for the entrance examination of the Ecole

47

Nationale Superieure des Beaux-Arts in Paris. He was admitted and studied under the direct tutorship of its president. The president was a well-known historical painter distinguished for his smooth and natural style and particularly well versed in portraiture. He very much liked Beihong, a hard-working student from a distant land, and so enthusiastically took upon himself the task of instructing him in person.

With the gradual restoration of French art museums to their former appearance, many famous works were transported back to Paris for exhibition. Beihong would spend his after-school hours visiting the museums and carefully examine the artistic attainments and the style and features of each master. When he stood looking at the enormous oil painting *Massacre at Chios* by the famous mid-nineteenth century French Romantic Eugene Delacroix, he was so deeply moved he could not help shedding tears. This painting, with its realistic powerful scene, breaks through the conventional constrained practice. It clearly portrays the atrocities committed by Turkey against the Greeks, and graphically narrates in the language of oil the innocent victims' accusations.

Beihong was strongly attracted by many masterpieces at the Louvre. Among them was Theodore Gericault's *Raft of the Medusa*, which depicts the survivors of the shipwrecked crew huddled together on a drifting raft. On the verge of death, they catch sight of a ship in the distance. Some begin cheering, some break the good news to their dying companions, while some are still in the depth of despair, some, half submerged in the sea, are already dead. Another attraction was Gustave Courbet's *The Artist's Studio*, which portrays, in addition to the painter himself working on a picture, the painter's friends and the model he has invited to sit for him.

The life of a student studying abroad was hard, but especially so for Beihong, who had to feed two mouths with the government allowance he alone was entitled to. Fortunately, commodity prices in Paris then were not too high, and the cost of living there was about the same as in China. Beihong and Jiang Biwei rented a room in the Latin Quarter, and food did not cost them too much because they cooked meals themselves. Usually Jiang Biwei did the cooking while Beihong took care of dish-washing. The mutual help and care, and the extremely simple and poor

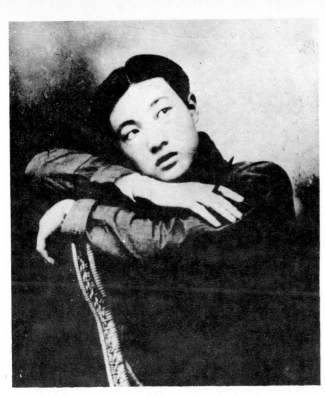

Xu Beihong at age seventeen

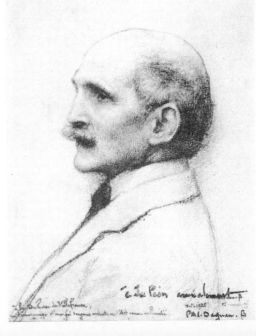

Portrait of Dagnan-Boveret *Sketch*

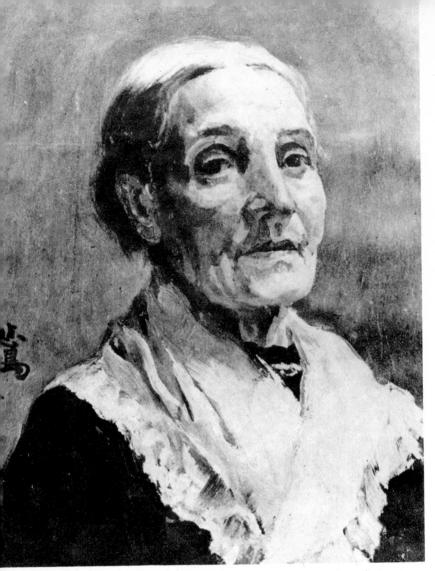

An Old Woman *Oil painting, 1922*

Fondling a Cat *Oil painting, 1924*

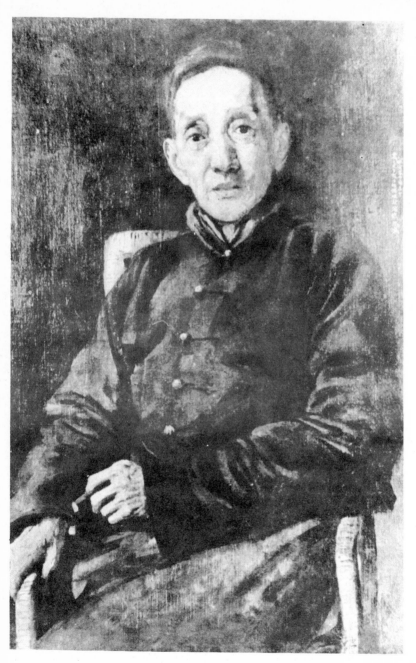

Portrait of Huang Zhenzhi *Oil painting, 1926*

News from Home *Oil painting, 1920s in Paris*

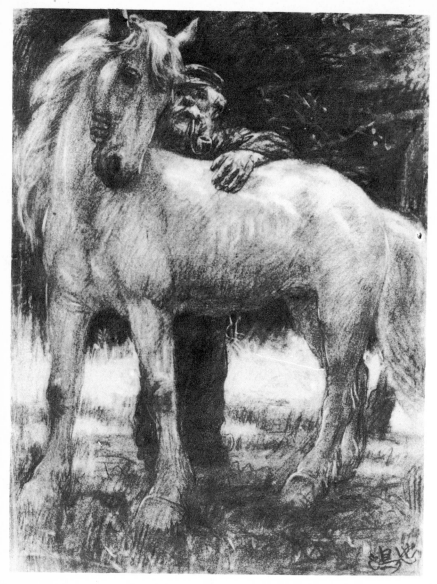

Groom and His Horse *Sketch, 1920s*

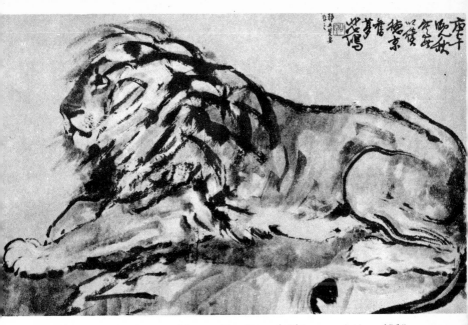

Lion *Traditional Chinese painting, 1930*

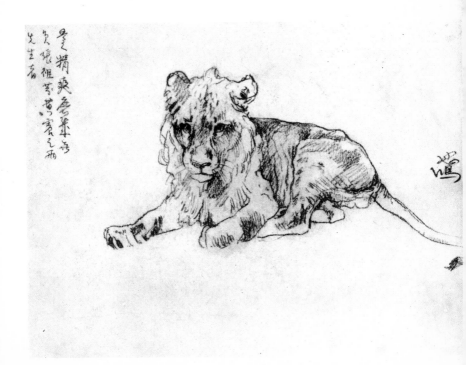

Lion Cub *Sketch, 1922*

Back View of a Female Nude *Sketch, 19..*

Male Nude *Sketch, 1924*

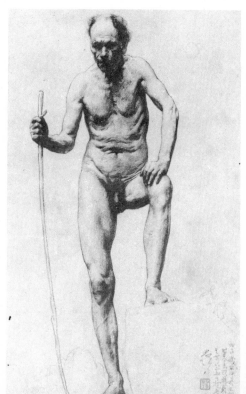

student life suited them both. If there was occasional trouble, it was all due to Beihong's inveterate hobby. Whenever he came across books or pictures he liked, he would invariably buy them with the money squeezed out of living expenses. Sometimes he would be content with a meal consisting only of bread and water.

One day, when Beihong was immersed in his books and pictures, Jiang Biwei, who had been sitting nearby, grumbled with a worried look, "Well, I'll probably never see better days again if I go on living with you." She sighed dramatically.

Beihong said nothing, but looked at her remorsefully. He could neither put the blame on her nor provide an explanation for himself.

"To keep silent is your only shield. You think it will make for domestic peace?" She was irritated. "If you were really rich, I wouldn't care how many books or pictures you want to buy. The problem is you're now a poor student. It's time for you to control your hobby."

Beihong stared at his wife very nervously. "Biwei," he said in a very cordial tone, "I've told you again and again that I love painting to the marrow. I hope you understand me."

Jiang Biwei arched her eyebrows and said impatiently, "I just can't understand why you still think of buying those dispensable books and pictures when you can hardly afford three meals a day!"

"They're what I'm most in need of!" No sooner had Beihong said this than he saw Jiang Biwei lift up her eyebrows again. So he lost no time to add soothingly, "Biwei, don't you want to learn music? Some day when you fall in love with music, you may become as crazy as I am. Art is full of so much charm that it can deprive you of all self-control...."

Jiang Biwei seemed to lapse into quiet meditation, her face softening. She was then attending a junior middle school, where she planned to acquire a smattering of French before she began to specialize in music. She would often think of the organ she had played at home in her childhood and the flute she was now carrying with her.

While Beihong was trying to straighten his wife out with the spirit of enterprise, he also came to know a number of very enterprising students.

These ambitious young people would often get together to talk about the future of China and their individual troubles, and to speak their

minds and sentiments. Beihong greatly wished to see China step onto the road of prosperity, democracy and science. At this time Beihong also came to know Zhou Enlai and He Changgong, who had come to France as working students. Young Zhou Enlai had already distinguished himself as a proletarian revolutionary.

In the early winter of 1920, when the well-known French sculptor Dampt and his wife held a tea party, Beihong was invited. Those attending the party were mostly cultural celebrities of modern France. Mrs. Dampt went out of her way to introduce Mr. Dagnan-Boveret to Beihong, as "France's greatest contemporary painter."

Beihong had long been an admirer of Dagnan-Boveret's works, such as *In the Forest, Blessing Bread, Recruiters, Mother's Tears, Misfortune, A Cameramen's Wedding,* and *Vaccination,* which portray the human inner world by means of an extremely well-knit, refined and succinct artistic language. That Dagnan-Boveret was so amiable and composed, without the slightest air of self-importance, greatly added to Beihong's feeling of affection and respect for him.

"Sir," said Beihong respectfully, "I'm very eager to be your student."

Viewing the young man from remote China, Dagnan-Boveret judged from his simple, unadorned speech and clothing that he was undoubtedly a sincere and diligent student. Dagnan-Boveret's judgement was correct, for thanks to his years of experience in creative work, he had acquired a keen insight into human minds. He immediately gave Beihong the address of his studio, and told Beihong to visit him at his studio every Sunday morning.

On the first Sunday morning, Beihong walked through a lingering morning mist towards Dagnan-Boveret's studio. While hurrying through the broad boulevards of Paris, he recalled the old days in his home village when he was still young and naive and had to walk a long distance to his teaching simply because he had a family to support. Now, the more he studied, the more shallow he found himself. He realized how appropriate was the old Chinese saying, "Study, and you discover your own deficiencies in knowledge." He began to seek after knowledge and skill like a hungry man seeking after bread and water.

Dagnan-Boveret was a very hard-working man. In his late years, when he had already won fame, he would as usual go to work at his studio early in the morning, even on Sundays. The moment he saw Beihong, he looked very cheerful and began to show Beihong his own paintings and some rough sketches hanging on the wall. Beihong was impressed by his remarkable skill, his exquisite brushwork and lifelike portraiture as evinced in his vividly executed *A Mademoiselle*. Dagnan-Boveret, then aged sixty-eight, zealously recounted to Beihong the story of his early life.

"I became Corot's student at the age of seventeen. He told me that one must have sincerity and self-confidence and must not give up truth for personal reasons. I've always abided by his instruction, and for fifty years I've never let it leave my mind." He smiled and added, "Now that you've come here to study, I must first of all present you with Corot's advice."

"Sir, I'll never forget it," said Beihong, moved. "We've an old saying in China, 'Where there is whole-hearted dedication, there is a way.' Is that what you mean by 'sincerity'?"

Dagnan-Boveret burst out laughing and said, "Yes, yes! There you are. You must concentrate your attention and go all out, and besides, you must be confident of achieving your aim. As to 'not to give up truth for personal reasons,' you need no explanation. Is that right?" Dagnan-Boveret riveted his sharp eyes on Beihong.

"Yes," Beihong was convinced, "art must first of all defend truth, and art itself is the embodiment of truth!"

Dagnan-Boveret nodded again and again and smiled merrily until his thin body swayed. He had obviously been very much pleased by what his Chinese student had said.

Then he carefully looked over the paintings Beihong had brought, sheet by sheet, and praised Beihong for the efforts he had made.

He encouraged him by saying, "The study of painting is something very arduous. I advise you to beware of vain boasting and not to be satisfied with small achievements." He added, "After making a sketch, you must remember its features so that you can make the same sketch again from memory. Then you correct mistakes in the new sketch by comparing it with the old one. Doing one sketch in this way is as good

as doing three sketches. You can thus get twice the result with half the effort."

Beihong made quick progress by following his teacher's advice.

Studying under the president of the Ecole Nationale Superieure des Beaux-Arts, Beihong was soon promoted from the sketch class to the oil class because of the excellent results in his studies. But a new trouble he faced was lack of money to buy painting materials and oils. So he had to cut down on his extremely low living expenses, and allay his hunger with two slices of bread and a glass of water each meal. He thus gradually laid aside a little money.

Since the Ecole Nationale Superieure des Beaux-Arts in Paris had no class in the afternoon, Beihong would spend his spare time painting models at a privately run art institute, where each time he had to pay one franc to get in. On the way home, he would often go by a roundabout way to visit the riverside bookstands on the Seine and browse among books and pictures there. His daily schedule was fully packed.

He would often go to the race course to paint from life. He also studied the dissection of horses and accumulated thousands of rough sketches of horses. All that laid a very good foundation for his later paintings of horses, such as horses standing, drinking, and galloping and horses in herds.

In the spring of 1921, a grand national exhibition of works by celebrated painters of modern France was held in Paris. On the opening day, Beihong lingered around the pavilions all day on an empty stomach, carefully studying and comparing the exhibits. He was oblivious of his hunger, and did not know that it was snowing hard until he came out of the exhibition centre. A piercing wind gave him a sudden shiver, and because he was not wearing an overcoat, he started shuddering all over. It was then that he suddenly felt the unbearable hunger; he quickened his homeward steps in face of the snowstorm. On the way, he felt an excruciating stomach pain and would have fallen to the snow-covered ground had he not stopped to lean against a wall.

Beihong remained a chronic sufferer from intestinal convulsions the rest of his life. Whenever he had an attack, he would experience the same intolerable pains and his cheeks and lips would lose colour and turned a ghastly pale. That, however, did not stop him from painting.

On one of the sketches he did at that time, he put the following inscription, "How can those who view this picture know what unbearable pains I suffered at the time of painting it?"

This picture is now in the collection of the Xu Beihong Memorial Hall in Beijing.

Chapter X

In the summer of 1921, Beihong's abdominal pains worsened. Meanwhile, owing to the turbulent political situation at home, the Chinese government suspended allowances for Chinese students abroad. Beihong, suffering from poverty and sickness, could do nothing but go to Berlin — since the German mark had depreciated due to post-war inflation, the French franc was several times more valuable in Germany.

In Germany, Beihong saw paintings and sculptures by several German masters, which greatly broadened his horizon and made him realize that although he had seen many artistic works in France, many more remained to be seen in Germany. But he also discovered that some highly gifted German painters were doing slipshod and grotesque pieces of work.

During his two years' sojourn in Berlin, Beihong would daily spend over ten hours painting, summer and winter. At that time, he was most enthusiastic about Rembrandt's works, and would go to the museum to copy them. Every day he would copy for ten hours at a stretch on an empty stomach. He exercised extraordinary care and skill in copying Rembrandt's *Second Wife*. He did learn from the copying, but he was unable to apply it to his own works. He needed to make even greater efforts; however, he still felt he had made no progress and was inwardly worried. What was the cause of it?

Though unable to discover his real handicap, Beihong did not slacken his study. He had been fond of painting animals since childhood. Now he found that the arched fences around the caged wild animals in the Berlin Zoological Garden facilitated sketching them. He would go to the zoo to sketch the lions, which he particularly liked, whenever the weather was decent and he had no models to paint.

Beihong continued to pursue art at any cost. He would stay in the zoo all day until closing time. He carefully observed the lion in the erect, lying, jumping and various other postures, carefully studied its bodily structure, and sketched it meticulously the way he had done the horses at the French race course. Sometimes, he stood watching for a long while and was in such a trance that other visitors took him for being possessed. In order to watch the complete daily life of the lion, he did not even tear himself away from it at mealtime. When he felt hungry, he just took a deep breath and went on drawing. When the keeper came round to feed the lion, its gobbling sound stimulated and tantalized him and added to his already intolerable hunger. Still, his mind set on the lion, he continued to watch the movements of the wild beast in the act of devouring food, and to wield his feverish brush.

Conscientious work always pays. Later he was to show the same facility in drawing from memory a lion in its various postures as in drawing a horse, and he was to produce a great many works with a lion as their subject.

Beautiful pictures were then being printed in Germany. Beihong, poor as he was, would buy them with borrowed money. His narrow bedroom was full of such pictures, and he found it the greatest pleasure he had ever had to sit and sleep among them. Jiang Biwei, however, sat by with a worried frown.

"Well," she heaved a heavy sigh, "I think you're out of your mind!"

"Biwei," Beihong's eyes brightened with excitement, "look how beautiful these printed pictures are! As good as the originals, and yet so cheap! It's a once-in-a-lifetime chance!"

"What are you going to do about the debts we've built up? We're sitting on top of a sinking ship, and some day we'll drown, I'm afraid!"

"Hey!" said Beihong cheerfully. "Why so pessimistic? There's a proverb which says, 'Heaven always leaves a door open.' So long as we work hard, we'll overcome all our difficulties. Life always makes way for the strong!"

"I'll never persuade you, for you have your own philosophy of life. But you've got to think of me. Look at this lousy violin of mine!" She picked up the violin from the desk and gave it a twang, "Can I learn

music on this violin?"

An apologetic and agonized look suddenly came over Beihong's face. Jiang Biwei had begun to learn music theory in Paris, and after she came to Berlin, she had bought this violin and had since been taking lessons from a German tutor. Beihong saw the justice of her complaint, and said to himself, "I should manage to buy her a good violin. Yes, by all means, I must buy her a good violin!"

Soon after, when he came across many works in an art shop by contemporary famed artists which were very inexpensive, he was again seized with an irrepressible desire to buy them. But, having had no money to pay his tuition fees for ten months, he really could anticipate no income whatsoever. And there was no longer any one from whom he could borrow money. He thought of asking help from the Chinese embassy in Germany, but he hesitated, afraid of being rejected. He tossed about in bed all night and could not fall asleep.

Early the next morning, he plucked up courage to call at the Chinese embassy where he was received by the ambassador himself in a magnificent hall. Beihong explained the purpose of his visit directly. He told the ambassador how wonderful the pictures were, who the painters were and how little they would cost in terms of foreign currencies. He asked the ambassador for a loan to buy the pictures. In order to win the confidence of the ambassador, he suggested that the pictures be left with the Chinese embassy as a pledge until he came to redeem them by repaying the loan with money borrowed elsewhere. Nodding his head, the ambassador said reassuringly, "Wait until I've sent somebody to check with the bank to see if there's any surplus money left."

Beihong knew the ambassador was using official rhetoric. He left the embassy unhappily and went to talk it over with some fellow Chinese students in Germany such as Zong Baihua and Meng Xinru. They eventually raised a loan for Beihong to buy two of the oil paintings, both of which are now in the custody of the Xu Beihong Memorial Hall.

Beihong also wrote a letter to Kang Youwei and others at home calling on them to raise a fund of forty thousand dollars to purchase a large number of famous paintings by foreign artists so that a gallery of foreign art could be set up in China. (At that time the prices of paintings in Germany were tens of times lower than their actual value.) His appeal

failed to call forth any response. Later, in recalling this event, he wrote, "It's a pity that my words fell on dead ears, but Zong Baihua, not being a warlord, had little money to finance the project."

In the early spring of 1922, though the weather was still cold, some good news from Paris gave Beihong much warmth. First, as word came that the Chinese government was to resume sending tuition fees to Chinese students studying abroad, he would soon be able to return to Paris to continue his studies. Secondly, a bookstore and an art shop in Paris almost simultaneously remitted him royalties totalling some thousand francs. Holding the money orders in his hand, he blurted out loudly in excitement, "Biwei, Biwei, I can now buy you a good violin!"

Jiang Biwei, who had been reading Guy de Maupassant's *The Diamond Necklace*, raised her head in perplexity and looked at the money orders in his hand in happy astonishment.

"Biwei, let's go down town right away," said Beihong dragging at her hand. "The money will be used exclusively to buy a violin for you. I won't touch a single cent of it, no, not a single cent!" He repeated his words joyfully.

They reached the busy city centre. Jiang Biwei, in her excitement, had soft, charming smile on her face. They patiently stepped into one shop after another to make careful selections and comparisons until they finally came across a second-hand violin put up for sale at a commission shop. It had a beautiful tone and excelled any of the new violins they had looked at.

Beihong said loudly, his face lighting up with delight, "Biwei, how lucky you are! A good violin like this is very hard to come by!"

But, knitting her eyebrows slightly, she hesitated.

"But it quickly! Do buy it quickly!" Beihong tried to hurry her up.

"No," Jiang Biwei said in an undertone, as if she were still pondering over something unutterable.

"What's the matter? What's the matter with you?" Beihong asked eagerly.

But Jiang Biwei kept quiet as if there were something on her mind.

"H'm!" Beihong said in irritation. "What are you thinking about?"

"I've been thinking about, I've been thinking about," she muttered,

"the beautiful fur coat which we saw just now hanging in the showwindow of the clothing shop on the other side of the street. It looks just my size and will fit me nicely. And it costs no more than this violin. If I buy this violin, I'll have no money to buy the fur coat."

"You've long been thinking of buying a good violin, haven't you? Why do you suddenly change your mind?" Beihong asked anxiously.

"Why? You should understand why," she was suddenly angered. "In Paris, in Berlin, I've been going about in public places without even an ordinary overcoat, let alone a presentable one. It's so embarrassing."

Beihong was stunned by her words, which, like a hurricane, had swept away all his joyfulness. He still wished to persuade her to buy the violin because study should take precedence over clothing. But he knew his wife had a willful disposition and once she had set her mind on something, nobody could ever change it. He lapsed into silence and let her make her own choice.

Jiang Biwei bought the fur coat in preference to the violin. As she walked complacently beside her husband wearing the fashionable, glossy fur coat like a noblewoman, Beihong seemed to see clearly for the first time how different were their pursuits in life and how incompatible their aims. He also had a first presentiment that some day they might part company. An indescribable feeling of vexation gripped him.

At that time, a Chinese student named Zhang Daofan, who had been learning painting in London and was then touring Germany, came specially to visit Beihong to express his personal admiration. Soon afterwards, he also went to Paris to learn painting. Being an ostentatious, Guizhou-born dandy, he was in no mood for studies; he admired the material civilization of Europe and regarded his going abroad to study as a new feather in his cap — something which might bring him higher social status. As an art student, he was less than talented. He was later to become head of the Kuomintang special agents after his return to China. When he first met Jiang Biwei, he very much liked what he saw. From then on, his stealthy, calculated encroachment upon Beihong's private life began.

Chapter XI

It was the spring of 1923 and the trees along the broad boulevards of Paris were budding. Beihong and Jiang Biwei had come back to Paris. How fortunate it was that the Chinese government had now resumed sending Beihong the long-suspended tuition fees!

"Beihong, you mentioned the proverb 'Heaven always leaves a door open.' I never believed it in the past, but now it does seem to contain some truth." Jiang Biwei, walking next to Beihong, wore an unusually genial smile. .

"Absolutely! Man must have enough confidence to overcome adversities in life. He should first not be disheartened or hang back morally!" said Beihong while stepping on the shadows of the trees on the sidewalk. "I believe anybody can take the way to success, only he must have a strong willpower to stay on the path."

"Then you believe you yourself can open the way? You can surely achieve success in painting?"

"Of course I can! I believe in my willpower and ability. I'll never give up in spite of all reverses. How about you?" He raised his head to look at his wife.

"Well!" she replied pensively. "I'll keep on learning the violin!"

Beihong resumed class at the Ecole Nationale Superieure des Beaux-Arts. Every Sunday morning, Beihong would again call on Dagnan-Boveret at his studio to receive instruction from him.

"Sir!" Beihong respectfully addressed Dagnan-Boveret, whom he had not seen for twenty months. "When I was in Berlin I did the best I could, I never slackened my studies. But, in spite of that, I still find I've made no progress at all." The moment he met his teacher, Beihong immediately made a clean breast of his misgivings.

Dagnan-Boveret closely examined the sketches and oils Beihong

had done in Berlin and expressed appreciation of them. Nevertheless, he said in a resolute tone, "You must continue to do strict and precise sketching. When you paint the human body in oils, you must pay attention to the different small parts and understand all the minute details. Don't indulge in bold, dazzling touches."

He rose to his feet, and while slowly pacing up and down in the spacious studio and looking at Beihong, he said, "Of course, more painstaking efforts are still needed. One must have the habit of bearing hardships, for without experiencing hardships, one often lacks great aspirations. The greatest writers in the world have always been men of strong determination and will. That's why they can speak out on behalf of all humanity...."

In that year, Beihong's oil *An Old Woman*, previously done in Berlin, was one of the selections put on display at the national exhibition of paintings held in France. The painting was well received.

At the Ecole Nationale Superieure des Beaux-Arts, Beihong passed the final examinations with honours in the history of painting, the theory of painting, anatomy and perspective, but he did not rest on his laurels. The young man who had devoted himself body and soul to the cause of fine arts now had a deeper comprehension of the old saying, "Study, and you discover your own deficiencies in knowledge." Ordinarily, he would paint at either the Ecole Nationale Superieure des Beaux-Arts or other art academies, or he would go to the Louvre to copy oils. On Sundays, he would be happiest because he could meet Dagnan-Boveret at his studio, listen to his instruction and encouragement, and even meet some of his old friends. These were usually elders between seventy and eighty years of age, who would often get together to critique paintings or chat about historical anecdotes.

Meanwhile, Jiang Biwei was studying music. She had hired a violinist of the Opera in Paris to give her regular private lessons on the violin and music theory.

Not long afterwards, the Chinese government again suspended the tuition fee, and Beihong and his wife were once more confronted with financial straits. They were compelled to move to an attic on the sixth floor of a building. There was an elevator in the building, but those living

in the attics were prohibited from using it. Beihong again became a part-work-and-part-study student. Apart from taking lessons, he did show-window decorations or drew book illustrations and separate pictures for bookstores. Jiang Biwei did some embroidery for a general goods store.

One warm, serene evening, when they were having a very simple supper, Jiang Biwei suddenly said with knitted brows and infinite worry, "How can we go on living like this? Always worrying about the next meal. Even rats can always have food stored up for the next day. How about us?"

"I still believe the old saying, 'Heaven always leaves a door open,'" Beihong said optimistically. "I don't think I'll be cowed by any difficulty!"

"But nobody can work on an empty stomach! Besides, we can no longer ask the bookstores or the general goods store to give us credit in advance!"

"Biwei, don't worry," Beihong comforted her. "I can write to my friends to ask for a loan...."

The serene night changed. As a howling wind swept over the housetops and heavy rain pelted the windows, the skylight in the attic began to rattle. Rainwater was leaking down, and soon torrential rain came splashing into the room, crashing the glass panes to the floor. Startled by the terrible scene before them, Beihong and his wife hurried to pick up things from the floor and put them on the bed and the table. The rain and hail lasted more than an hour.

They had a hard night. After daybreak, Beihong went in haste to see the landlord, who responded coldly, "Mister, needless to say, you have to pay for the loss!"

"But it's a natural disaster!" Beihong tried to reason against the unfair treatment. "I didn't break the glass; why should I pay for it?"

"Mister, you'd better go back and take a look at the rent contract we've signed!" said the landlord.

Beihong hurried up to the attic and opened the contract, which read, "Tenants shall compensate for any damage to the house whatever the cause."

The money that Beihong had asked his friends to lend him arrived in time. It was just enough to cover the compensation for the fifteen glass

61

panes smashed by the hailstones. Beihong remained as destitute as before.

Nevertheless, Heaven always leaves a door open. It happened that when Chinese Consul General in Paris Mr. Zhao Songnan, who came from the same province of Jiangsu as Beihong, heard of Beihong's poverty, he sent Beihong a letter with a gift of five hundred francs, although they were strangers to each other. It was indeed a timely assistance! Beihong paid a visit to Zhao Songnan and painted a portrait of Mrs. Zhao in oils to express his gratitude.

Chapter XII

It was autumn, 1925. Leaves on the giant French plane trees of Paris were yellowing. Beihong, too, was attaining maturity in his art. He had done many exercises focused on the human body, including sketches and oils, which laid a solid foundation for his later works. Among the oils this period were *Playing the Flute, The Honeymoon, News from Home, Longing* and *Fondling a Cat. Playing the Flute* and *News from Home* were the best received while *Longing* was bought by an intimate friend of Dagnan-Boveret's.

One day, Beihong came across an oil painting of *Ophelia* done by Dagnan-Boveret, and was immediately attracted by it. In this oil painting, Dagnan-Boveret is keen enough to catch the very moment shortly before Shakespeare's Ophelia, grown distracted because of her disappointed love, falls into a brook, and gives prominence to the extremely painful mental state of the pure young maid. Ill-fated Ophelia is sitting absent-minded in the forest with violets, nettles and daisies in her hands. Her long, soft golden hair is hanging down over her shoulders, and her eyes are glistening with sorrow, taking a last look at life.

Beihong lingered before the exquisite painting, and was for a long while unable to tear himself away from it. How eager he was to possess it! But since he could hardly afford even his three daily meals, how could he raise such a sum of money to buy it? It would be mere wishful thinking. But believing that human effort can achieve anything, Beihong asked the shop keeper to reserve the picture for him so that he could come back to buy it as quickly as possible at its full price. The shop keeper promised to hold the picture for not more than three months.

Beihong, with full confidence in himself, started running about trying to raise a fund to buy the picture. It was no easy matter. It

happened then that an overseas Chinese from Singapore named Huang Menggui, a native of Fujian, was thinking of returning to Singapore. He had a high opinion of the gifted young Beihong, and hearing that Beihong was trying to raise a fund, he strongly advised Beihong to go to Singapore to sell paintings. Eager to raise the fund, Beihong immediately accepted the suggestion and hastily left for Singapore with Huang while Jiang Biwei stayed in Paris.

In Singapore, through the introduction of Huang Menggui, Beihong came to know the overseas Chinese business tycoon Tan Kah-Kee and painted a portrait of him in oils. Tan paid Beihong twenty-five hundred dollars in cash.

Beihong immediately remitted the money to the art shop in Paris, and became the owner of Dagnan-Boveret's *Ophelia* as he had long wished to be. (The picture is now in the custody of the Xu Beihong Memorial Hall in Beijing.) Beihong was happy beyond description. And, in order to repay Tan's kindness, Beihong painted oil portraits of Karl Marx and Leo Tolstoy and presented them to Amoy University, of which Tan was the founder.

Beihong also did portraits of other leading overseas Chinese in Singapore. Sometimes he worked feverishly, but he did earn a substantial sum, which would be enough to last him and his wife several years in Paris.

But Beihong did not return at once to Paris. He hurriedly left Singapore for Shanghai, longing for his motherland unseen for six long years.

Shanghai was still a hell for the poor and a paradise for the rich. China was then torn apart by imperialist-backed rival warlords and people could not live in peace. All that increased Beihong's concern for the future of the nation.

He called on Tian Han, a warm-hearted writer. Tian Han treated him like an old friend at their first meeting. Like old friends, they talked freely, castigated the evils of the time, and gave vent to their feelings. Thus began a lifelong friendship. Tian Han held a party to welcome Beihong, in which he introduced Beihong to Guo Moruo and other notables of the art and literary circles in Shanghai.

Beihong also visited Kang Youwei and Huang Zhenzhi and painted the portrait of each of them to express his gratitude.

During his stay in Shanghai, Beihong did not forget his wife in Paris. In spite of the occasional disharmony between them, there was a strong attachment born of their seven-year marriage. After he saw her in a dream, he wrote a poem entitled *A Dream About My Wife*, in which he says:

> *Knowing that you must have just gone to sleep,*
> *I linger, looking at my own shadow.*

"At first," Jiang Biwei later wrote, "I thought I would be lonely and bored after he was gone. I did not know that, on the contrary, I would have a grand good time.... I often went to cafés, shows, and films and had chats with such gentlemen as Zhang Daofan, Xie Shoukang, Shao Xunmei and Chang Yu. And I also learned to dance and attended evening banquets and dancing parties." The attentions shown by Zhang Daofan in particular made her feel how agreeable they were to each other, how similar their interests were and how identical their attitudes towards life were.

Their intimacy had then become the talk of their friends behind their backs in Paris. Beihong, far away in China, had no knowledge of it at all. He had the kind and even the naive heart of an artist. He never suspected his wife.

From then on, Jiang Biwei's violin lay in a quiet corner of her room, covered with dust.

Chapter XIII

Beihong stayed in Shanghai for three months.

In March, when southern China was clad in spring, Beihong set out for Paris.

Due to the long journey and the more than six months of separation from his wife, Beihong was very anxious to meet Jiang Biwei. But the first thing the radiant-faced Jiang Biwei asked at meeting him was, "How much money have you brought back?"

Beihong told her the truth: Though he had earned much money in Singapore, he had also spent a lot in buying books, calligraphy and paintings in Shanghai. But what little money he had brought back was still quite enough to last them a year in Paris. Thereupon, vehement words of anger, complaint and reproach descended upon Beihong like a storm. Beihong said no more, enduring her emotional outburst quietly. His silence only exasperated her.

"Keeping silent is your magic weapon!" She snapped. "You think it can subdue me, eh?" she screamed at the top of her lungs. "How many more wretched days am I going to live with you?"

"Biwei," Beihong finally spoke again, "I've told you I don't know how many times that I love painting to the marrow and I can never change. I hope you'll understand me. Why do you still raise hell with me?"

"You're always giving me the same old story," She shrieked. "You love painting to the marrow, you love painting to the marrow, but you never love me! You're body and soul with painting."

"Biwei, I'm a painter, how can I help loving painting? Why are you always so against painting?" said Beihong in his usual gentle tone.

"You're terribly disappointing! I thought we should bank all the

money you had earned by selling your paintings so that we could live a more decent life abroad for quite a few more years, but you" She broke down and wept. But after a short while she raised the question, "And you didn't even bring here the books, calligraphy and paintings that you had bought in Shanghai? Does this mean you intend to go back soon?"

"Of course I hope to go back soon. It is for the sake of our national rejuvenation and national glory that I've come abroad to study!" Beihong was worked up. "The situation at home is falling apart, and I feel responsible to our homeland."

"We don't even have a decent home after so many years of married life! We've got no money, no property, and yet you keep harping on about painting, motherland and so on. I'm really sick and tired of it! Besides, I'm not unpatriotic, I also hope that our country will become rich and strong, but we shouldn't let ourselves always live in such wretched poverty...." She was choked with tears.

Beihong was in no mood to speak again or to comfort her. Wranglings like this could only give him agony and vexation and were utterly senseless. Again he engrossed himself in painting.

That summer, Beihong toured the Belgian capital Brussels, where he visited the art museum to copy. As in the past, he would daily work over ten hours at a stretch on an empty stomach.

At that time, near the place where he lived the ground had been dug four or five feet deep to repair the sewers. Every time he came back hungry from the museum, he would be assailed by the stench from the sewers and have to pass the place holding his nose. But he would find the stench less offensive every time he came out after eating his supper. Having the same experience for a number of days made him realize that hunger sharpens one's senses while comfort dulls them. He was reminded of the ancient saying, "A destitute poet writes good poems."

In the spring of 1927, Beihong and his wife went on a tour of Switzerland and Italy. This was his second trip to Switzerland. He had made his first trip there in the winter of 1919 at the invitation of Yang Zhongzi, a highly gifted scholar with whom Beihong had become acquainted in Paris and who was later to become president of National Conservatory of Music upon his return to China. Yang, who was then

studying music in Switzerland and lived with his Swiss wife on the northern bank of Lake Geneva, liked to associate with Beihong because he himself was an expert on epigraphy, calligraphy and painting.

In Milan, Florence and Rome, Beihong fully enjoyed great works by the master artists of the Renaissance. The works of da Vinci, Michelangelo and Raphael overwhelmed him with wonder and admiration. Standing before da Vinci's famous mural *Last Supper*, Beihong seemed to hear it echoing with Christ's words, "Verily I say unto you that one of you shall betray me."

Da Vinci had taken three years to finish the mural. He rejected the earlier convention of separating Christ's betrayer Judas from the eleven other apostles, and instead placed all of them together, depicting the dramatic scene without any affectation. Christ's declaration that one of those present is betraying him greatly shocks his apostles. Christ, who is speaking, alone forms the calm centre. His melancholy reconciliation to his fate makes a sharp contrast to the surprise, sorrow and indignation of his apostles. Judas the betrayer, however, is stupefied. His body is leaning backward with fear, his hand grasping the money bag convulsively and he desperately attempts to keep calm.

Beihong very much appreciated Michelangelo's representative work *Four Unfinished Captives* (i. e., four unfinished statues of slaves). Michelangelo always used the human body to embody the soul and was masterful in expressing pain. The four forms are struggling out of their shackles in vain. Their writhing bodies and their tense desperation give the impression that the marble itself is issuing a cry for emancipation from enslavement. He was also greatly impressed by Michelangelo's frescos on the ceiling of the Sistine Chapel with their incomparable portrayal of the movements, airs and strength of the figures.

Chapter XIV

It was April, 1927. Beihong went to the railway station with trunks of books and paintings, of which some had been bought with money saved by living a frugal life. Some were his own exercises and works, and many were oils he had copied, such as Delacroix's *Massacre at Chios*, P.P. Prudhon's *Crime Pursued by Vengeance and Justice*, Jordaens' *Abundance*, and Rembrandt's *Second Wife*.

Casting a last glance at the Louvre and the Arc de Triomphe, Beihong left Paris with as much feeling as he had brought to Paris eight years earlier.

Eight long years had left him such rich memories that on the voyage across the turbulent Atlantic, his life seemed to remain behind in Paris. He seemed to be turning over an eight-year diary and reading from it paragraph to paragraph, entry to entry. When those days of privation, hunger and illness flashed through his mind, he was astonished and seemed to see for the first time how he had overcome so many adversities with great stamina. He could never forget his French teachers, such as Dagnan-Boveret.

On the ship, Beihong met the Chinese physicist Yan Jici, who had been awarded a doctor's degree in science by the French government. Beihong greatly admired the Chinese scientist, whose scientific treatise had won him nation-wide distinction in France. He gladly sketched a portrait of Yan and wrote on its margin the inscription in French, "Lumière de la science."*

Beihong landed at Singapore, where he again did portraits for overseas Chinese. It was not until he had earned enough money to set up a home in Shanghai that he took ship at Singapore for Shanghai.

* Light of science.

The far-off Huangpu River and China came into view; his heart beat violently; he was filled with the joy of homecoming. How numerous were the undertakings he was going to pioneer! Chinese painting must be developed so that it could again shine in the world treasure-house of art, helping to raise national prestige and win credit for the Chinese people. This was his long-cherished wish now soon to be fulfilled. He was ready to shoulder the heavy burden now that he was back in China.

The steamer gave an abrupt violent jerk followed by the clanking of its anchor. It had pulled in to shore. The celebrated playwright Tian Han, standing among the throng on the wharf, kept waving energetically his old broad-brimmed hat in the air and shouting, "Beihong! Beihong!"

Beihong squeezed his way ashore through the endless stream of people, held Tian Han's hand in a firm grasp, and said, "I wasn't long coming, was I? I didn't let you down!"

His myopic eyes glistening behind lenses, Tian Han said grinning from ear to ear, "Beihong, when I got your letter telling me of your imminent return to Shanghai, I was too excited to sleep. From now on, we'll cooperate with each other. Just imagine what a lot of work is waiting to be done!" His heavy Hunan accent remained intact.

The brilliant sunset clouds, glowing like fire in the sky, had dyed the river red. Looking at the rolling waters of the Huangpu, Beihong could not help thinking of that terrible evening twelve years past when the wind and rain struck mercilessly at his young chest. Those twelve years had gone by like running water, and what a great change had taken place in his life! No longer wretched and helpless as in the past, he had come back home like a soldier ready for action and ready to open up the cause of art in China.

The Huangpu River was still rolling on incessantly, without the slightest change. Like the rest of China, it, too, had sunk into an abyss of misery. Beihong saw shabbily dressed beggars everywhere.

On the way home, Tian Han told Beihong that he was trying to restore Shanghai Art University and needed Beihong's support.

"Of course," Beihong replied cheerfully, "I'll do my best to support you."

Shanghai Art University was a privately run institution with

departments of fine arts, drama and so on. Its president was Zhou Qinhao, who had once studied oil painting in Japan. Now, due to financial difficulties the university was at a standstill and President Zhou had also quit. Tian Han, who was a professor of foreign literature there, was making every effort to re-open it. Teachers and students at the university all had a strong sense of loyalty.

"Beihong," said Tian Han glowingly, "from now on, you're on its board of directors. What do you think of that?"

"Of course I agree!" answered Beihong with a hearty laughter. "Since we've the same ideas and aims in the matter of art, we belong to the same camp and should support each other."

"Fine!" Tian Han declared loudly. "Let Shanghai Art University be a fortress for us to carry out education in realistic art!"

"Right! In order to rejuvenate the fine arts in China, it has become our duty to clear away what is rotten and unwholesome"

Beihong's eyes shone with a fiery glow as if trying to illuminate the road the men were stepping on, and to light a fire in the art and literary circles of China.

Beihong began to settle down in Shanghai. He rented a newly built house in Xiafeifang, a lane on Avenue Joffre. The house was by no means spacious, and became all the more crowded when Jiang Biwei's parents moved in to live.

In October of the same year, Jiang Biwei also came back from Paris. She was wearing a new dress in the latest Paris style, and lying aslant on her head was a flannel beret decorated on its brim with a small red velvet rose.

It happened that on the very day she arrived, Beihong was giving a speech at Shanghai Art University at the invitation of Tian Han.

"Aiya," Jiang Biwei complained, "can't you postpone it to some other day?"

"No, the notice is out already," Beihong explained patiently.

"Why not cancel it for today?"

"No. If I did, the students would be disappointed, and Tian Han would be disappointed too. Besides, I'm going to promote the sale of tickets for a stage play and a Beijing opera to raise money for the benefit of Shanghai Art University." He fished out his outmoded pocket watch

to take a look at it and said, "It's getting late. I must hurry up." He walked out in haste, without even turning his head.

"Well," Jiang Biwei sighed softly, "he never understands me or cares for me, even though I'm now with child!"

Chapter XV

Shanghai Art University, which Tian Han had been trying hard to revitalize, was banned by the French police hand in glove with the Kuomintang. This was not merely because the school was behind with the rent, but primarily because there were Communists working and studying there.

The indomitable Tian Han decided to make a fresh start. He made preparations for the new Nanguo Art Academy, to which Beihong gave active support and help, offering voluntary service as head of its painting department.

The building housing Nanguo Art Academy was a rented house in Lane 371, Rue Sieyes (now Yongjia Road), of the then French Settlement. For lack of funds, the academy had only a small staff of teachers including Hong Shen, and Ouyang Yuqian. People like Wu Zuoren, Liu Ruli and Liu Yisi were then students of the painting department. To save money, the academy had all its general affairs taken care of by students and did not employ a single janitor.

At the time when Tian Han was working to preserve Shanghai Art University, Wu Zuoren, a young student from Suzhou, signed up for an examination for admission to its painting department out of admiration for Beihong. He had seen the university's enrolment advertisement in the newspapers listing Beihong's name as one of its directors. After school opened, as the university was still at a standstill and no teachers had arrived to give lectures, the students sketched plaster figures in the classrooms. Wu did not know how to use a charcoal pencil to make rough sketches until he learned from fellow students. A month later, when he heard that Beihong was coming to the university to give a lecture, he and his fellow students were overjoyed.

After the lecture, Beihong went to each classroom to see how the

students were doing. Accompanied by Tian Han, he went from senior to junior classes and carefully examined the students' exercises one by one. He suddenly halted before a sketch exercise done by a first-year student. Imperfect as it was, the brushwork showed evident nimbleness and precision. Beihong lifted his sharp eyes to make a search among the students around him, "Who did this sketch?"

As nobody answered, he asked more loudly, "Who is Wu Zuoren?"

A nineteen-year-old youth walked out from behind the crowd quietly and somewhat bashfully. Tall and thin in stature, he looked both shy and timid, "I'm Wu Zuoren."

Beihong praised him, gave him his home address, and told him to call on him on Sunday. After that, under the painstaking cultivation of Beihong, Wu soon grew up. When the university was closed, Wu transferred to Nanguo Art Academy, where he got still more guidance from Beihong.

As head of the painting department, Beihong moved his own books on painting and pictures to the academy so that his students could have free access to them. He also moved his painting paraphernalia from the cramped house in Xiafeifang to a spacious studio specialy provided for him by the academy. Every day he stayed at the academy to do his teaching and painting.

He gave his students very strict training in sketching because, to his mind, drawing was the basis of all plastic arts and only a strict training in it could prepare them to paint from life and know the laws of modelling. He demanded high precision and ruled out even the slightest deviation in sketching. He also stressed the importance of refinement, selection and generalization, and paid much attention to volume, structure and the sense of substance and space. He advised his students to "acquire brevity for the sake of harmony, and to discard the trivial for the sake of the exquisite," and to grasp both "the overall" and "the exquisite and minute."

While he was teaching, he began to plan out and work on the large oil painting *Tian Heng and His Five Hundred Followers*.

The material of this painting was drawn from *Records of the Historian*, a history book written by Sima Qian of the Western Han Dynasty, first century B.C. Tian Heng was a descendant of a noble

family of the State of Qi. When people all over the country rose in response to the first armed peasant uprising organized by Chen Sheng (?-208 B.C.) and Wu Guang (?-208 B.C.) against the tyranny of the Qin Dynasty, the Tian family were among the rebel forces. After Han Gao Zu, founder of the Western Han Dynasty, defeated all his opponents and unified the country, Tian Heng and his five hundred comrades-in-arms held out on an isolated island*, although the State of Qi had already been conquered. Hearing that Tian Heng was enjoying great popular support, Han Gao Zu was afraid that he might be the cause of future trouble, so he issued an imperial edict to the effect that if Tian Heng surrendered he would be made a duke or a prince, otherwise troops would be dispatched to kill all the islanders. In order to save the lives of the five hundred islanders, Tian Heng, together with two subordinates, left the island for the capital of Han Gao Zu. However, when they were fifteen kilometres away from the capital, Tian Heng committed suicide by cutting his own throat. He instructed his subordinates in his dying words to cut off his head and present it to Han Gao Zu to show his refusal to suffer the disgrace of capitulation and also to save the lives of the five hundred islanders. Han Gao Zu gave him a princely funeral and granted the title of captain to the two followers, who, however, committed suicide inside Tian Heng's sepulchre during his burial. Han Gao Zu then sent someone to summon the five hundred islanders to surrender, but they, upon hearing of Tian Heng's death, all killed themselves by jumping into the sea. Sima Qian says, "How great are Tian Heng, a man of high moral integrity, and his men, who followed him to the grave out of admiration for his righteousness!"

While Beihong was indignant at the corrupt Kuomintang and the aggressive imperialists, he also saw some people who were low enough to fawn on the Kuomintang and foreigners in pursuit of personal fame and gain. In reading the biography of Tian Heng in *Records of the Historian*, Beihong noted few around him as uncompromising as Tian Heng. He was still more touched when he read the regretful question raised by Sima Qian in his *Records of the Historian*, "Why is it that while there is no lack of good painters, none have attempted to paint the

* Now called Tian Heng Island in Shandong Province.

righteous act of Tian Heng?" A sense of unshirkable responsibility urged Beihong to paint the picture. He decided to give prominence to the high moral integrity of "refusing to be tempted by wealth and high position, or to be subdued by the display of great force," and to ruthlessly denounce, by means of this main theme, the cringers before the Kuomintang and imperialists.

He chose the scene of Tian Heng bidding farewell to his five hundred men with which to play up their indomitable spirit. The solemn-faced Tian Heng folds his hands in a bow to say farewell to his heroic men on the island. His eyes, instead of being miserable and sorrowful, shine with dignity, determination and confidence. Of the men, some are quiet, some are worried and sad, some are indignant and object to his departure, and one lame man is lunging forward perhaps trying to stop Tian Heng from going to see Han Gao Zu. The horse, already saddled and ready for the journey, stands on one side twisting its neck restlessly while heavy clouds hang low.

In painting this large picture, which measures 198 cm by 355 cm, Beihong had to exert every effort. Every figure in it had its model, of which he made an exact sketch before painting it on canvas. Besides teaching, he would devote his time every day to painting Tian Heng in the art studio academy, going home late in the evening. It took him more than two years, from 1928 to 1930, to finish the work.

When he had just begun to work out the composition of the painting, Nanjing's Central University had invited him to be a professor in its painting department. Beihong accepted the professorship on condition that he would continue to teach at Nanguo Art Academy, to which Central University agreed. So Beihong had every month to divide his time equally between the two institutions. From then on, while working on *Tian Heng and His Five Hundred Followers,* Beihong would travel to and fro on the Shanghai-Nanjing railway line.

Early one morning, as he was about to go out to catch an early morning train to Nanjing, Jiang Biwei stopped him and complained, "During your half-month stay in Shanghai, I didn't see you at home for a single day. You were out all the time at Nanguo Art Academy. You take Nanguo for your home, and your home for a hotel!"

Beihong explained patiently, *"Tian Heng and His Five Hundred*

Followers is such a large painting that I simply can't do it at home. Besides, once I've got started, it's very hard for my thought and pen to stop. Without such enthusiasm, painting itself would be done for. I hope you can understand me. As a painter's wife, you should understand.'

"But, why are you doing such a big painting? Why are you working on such a subject matter? Why don't you paint something light like bananas, apples and other still lifes like those fashionable painters are doing nowadays?"

"I told you long ago my purpose in doing this painting. Every man has a share of responsibility for the destiny of his country. Why do you shut your eyes to the national crisis now confronting us?" Beihong could hardly suppress his disgust with her.

"Hah, I shut my eyes? All right, I don't care for my country while you do!" Jiang said in anger. "It'll do you no good to do this kind of painting now! I know you have let yourself be influenced by Communists like Tian Han!" She continued after a slight pause, "I can never put up with your fooling around with Tian Han! You must break with Nanguo immediately and permanently."

She dashed out like a gust of wind.

Beihong looked at his watch with anxiety. There was only half an hour before the Nanjing-bound train was to depart. He rushed out towards the railway station.

After Jiang sped out of the house, she hired a taxi which took her straight to the front gate of Nanguo Art Academy. She barged into Beihong's studio fuming with rage and gave orders for all his books, calligraphy, paintings and painting paraphernalia to be packed into the taxi. Tian Han then happened to be giving performances in other localities together with colleagues of Nanguo Society. Surprised to see what Jiang was doing, Tian Han's mother asked, "Mrs. Xu, what's the matter?"

"I don't want Beihong to come to Nanguo again!" Jiang barked.

"Then, does Mr. Xu know about this?"

"He's gone to Nanjing!"

"Won't you wait until he comes back? He and Tian Han are good friends. They're making joint efforts to run this academy. How can he

quit?" said old Mrs. Tian almost pleadingly.

"I don't care about all that. All I know is that he takes Nanguo for his home, and his home for a hotel. I just can't stand it. Besides, we're moving to Nanjing soon."

"Well, Mrs. Xu, how can you say that? Every wife wants her husband to be enterprising and to do his bit for his country! Mr. Xu is capable and talented, and is in the prime of life. Is it right to keep him at home every day?..."

"It's none of your business." Biwei said. "Anyway, I don't want him to come again to Nanguo! Has Nanguo given him any benefit? Not a cent! He even has to pay his car fare with money out of his own pocket!" She made off truculently.

Beihong was not informed of all that had happened until two weeks later when he returned to Shanghai from Nanjing.

"Why are you interfering with my work?" Beihong shouted at her.

"Sure I'm interfering! I'm late, I ought to have interfered earlier! You must quit Nanguo right away!" she thundered.

"I can never quit Nanguo! Especially when it is now in great difficulties, and the students all need me!"

"Why not say Tian Han needs you or the Communist Party needs you!"

"You must stop being so willful," said Beihong looking at his angry wife. "Tian Han is my good friend. We've the same ideas and aim in matters of art. Together we are running a school and fostering a younger generation of artisits of China. It's our common duty to defend this position — Nanguo. I'll never betray him. Quitting Nanguo means betrayal."

Jiang grew still more agitated, "All right! Now that you can't betray him, you can betray me! I want a divorce!"

"Biwei, keep cool, no more of these hard words! You and I are no longer children." Beihong was struggling to suppress his anger.

"Here are two alternatives for you to choose from. Either you quit Nanguo, or you divorce me!" she yelled.

That evening, Beihong could neither work nor sleep. Late into the night, he kept pacing to and fro in his bedroom and treading heavily as if he were angry at the floor.

Divorce? It had never occurred to him before, but neither had it occurred to him that he should quit Nanguo, his like-minded friends and favourite students. "Why is she always meddling in my work and my favourite pursuit?" He thought, talking to himself as he paced. "Evidently it's wrong to live with her. We're poles apart in our interests and favourite pursuits, in our ideals and aims in life, even in disposition."

"Divorce!" the voice again echoed in his ears. "Shall I be bound by these fetters?" he asked himself, considering seriously for the first time the question of ending it. Ruminating, he heard the squall of the baby which had been sleeping soundly beside his wife. A sense of family responsibility and a deep affection for his son put him in mind of the miseries a divorce would bring.

He remembered how twelve years past Jiang had boldly run away with him and how they had sailed across the rolling Pacific to enter into life hand in hand. "But, in any case, I mustn't quit Nanguo!" he demanded of himself resolving not to accept the ultimatum.

Tian Han, who had learned of the furor, sympathized with Beihong in his awkward predicament. At the studio, he made it clear that Beihong's marriage must be preserved.

"Beihong, it's all right, you must simply quit Nanguo!" said Tian Han, extremely sorry. "I sympathize with you, I understand you, I won't blame you. I believe our friendship will never be severed."

Beihong was mute, lips quivering and tears struggling in his eyes. The students standing around him, who had all been eager to urge him to stay, now hung their heads in silence.

Beihong, shaking Tian Han's hand firmly, said, "Although I'm separated from Nanguo, I'll continue to give support to your work. Our friendship will never be severed...."

Chapter XVI

An express train on the Shanghai-Nanjing railway line was running at full speed towards Suzhou. Beihong stared with melancholy eyes at the swiftly retreating houses, thatched cottages, trees, farms....

"Beihong, my sham coffin filled with pebbles might still be in that Suzhou temple!" Jiang remarked loudly, flaunting their brilliant exploit, and laughed heartily. Fellow travellers sitting around her all cast curious glances at her.

Beihong slightly knitted his brows. He thoroughly understood how arrogant the woman sitting next to him had become. He was utterly disgusted and did not say a single word.

Ever since he had quit Nanguo, Beihong had been very sad. At that time, a gentleman in Suzhou named Yan Wenliang had specially invited Beihong to go on a sight-seeing trip to his town. Beihong was not interested, but Jiang, glowing with success, persuaded him to go, for she thought the beautiful scenery would open him up and heal his wound. On top of that, Yan Wenliang had repeatedly urged him to go. So they finally set out.

The train was speeding westward, reminding Beihong of another train trip from the past.

Not long after their return to China, Beihong and Jiang had also taken the same express train in going back to visit his hometown. During his eight-year sojourn abroad, images of his hometown had often broken in upon his dreams. In Paris, while he was loitering gloomily on the banks of the Seine, he had time and again thought of the river flowing past the front gate of his family cottage at home. Now he had come back to visit his hometown. The ever-flowing river, the beloved cottage, the trees before and behind the cottage — all remained the same as before except that his brothers and sisters had grown bigger and his

mother older. Her hair had turned frosty and her face had been furrowed by hardship and anxiety. But her eyes glistened, reflecting the happiness, consolation and joy of a mother who sees her son returning successful from afar. She still smiled the gentle yet timid smile, as if afraid that happiness might suddenly take wing before her eyes.

His fellow villagers, who had been his childhood playmates, all crowded around him excitedly. Being honest peasants and handicraftsmen, they smiled, laughed and talked loudly to Beihong in a thick local accent. He was intoxicated with the warm welcome.

Crack! It was the sudden, sharp report of a rifle; bang! another report. While people were scurrying in all directions for shelter, Beihong was quickly dragged into a barn by a pair of brawny hands. He discovered that the man who had pulled him was a boyhood friend. The rifle-fire gradually ebbed and at last all calmed down again. They both emerged from the barn.

"H'm!" Beihong's friend heaved a sigh. "Life's so hard these days! People go looting when they can find no way out."

The man was a skillful craftsman making all kinds of exquisite articles from bamboo strips. Glancing at his brawny hands, Beihong recalled how in their childhood days they had cut bamboos together to make swords, spears and sticks and how he had cherished the ridiculous dream of becoming "a poor *xiake* of Jiangnan." Now, more than twenty years had gone by, but the people were still in the abyss of misery, and he could do nothing about it.

Upon his return to Shanghai from his hometown, Beihong fell into a depressed mood. The lopsided booming of Shanghai was in sharp contrast to the poverty of the countryside. After the failure of the 1924-27 Revolution, reactionaries at home had stepped up their collusion with foreign imperialists, political darkness reigned over the whole country. In art, this darkness found expression in the unchecked spread of formalistic paintings completely divorced from reality, such as paintings of the abstractionistic school, the futuristic school and the wild animal school.

Classical Chinese painting was on the verge of dying out because of the common practice of imitating the ancients and the prevailing doctrine of "back to the ancients." In face of this counter-current,

Beihong could have taken the line of least resistance, i.e., he could have swum with the current of the time. But his patriotism and strong sense of responsibility made him speak bravely—a firm rock in midstream. He severely attacked the fantastic, anti-realistic, formalistic, new-school paintings, and advocated that art should seek wisdom and truth. He hoped that artists would start with realism. And he himself unswervingly carried out his own views in both teaching and painting. However, he was handicapped by the shackles of his home, his infinitely troublesome home....

The violent jolt of the train as it came to a stop interrupted Beihong's meditation. The train had arrived at the Suzhou railway station. As he looked out of the window, he saw Yan Wenliang, who had rushed to the station specially to greet him, waving his hand to him again and again.

Yan was an oil painter of great attainments. His oils were distinguished by sober colours and fine touches. He was not only a skillful realistic painter, but also an earnest teacher of painting. He had set up a privately run painting college in Suzhou and had trained many students.

Suzhou Painting College was situated in Canglangting, a scenic spot. The first thing Yan did was to take Beihong to the college to show him around, and invite him to give a speech and do some paintings. (The portrait of the college janitor which Beihong then sketched is now in the collection of the Xu Beihong Memorial Hall in Beijing).

Later, when the newly built auditorium of the college was inaugurated, Beihong painted a large scroll to be hung vertically in its parlour to express his good wishes, on which he wrote the inscription in four big characters, "A firm rock in midstream," plus another inscription in small characters by its side, "J.A.D. Ingres says, 'Sketching is the exercise of art.'" The friendship between Beihong and Yan was to last unabated throughout their lives.

Yan also took Beihong on a sight-seeing trip to the scenic spots in Suzhou. As the saying goes, "Above is paradise, below are Suzhou and Hangzhou." It is indeed no exaggeration to compare beautiful Suzhou to paradise. Suzhou gardens, exquisite and delicate, epitomize the special charm and poetic flavour of Eastern art.

Beihong considered his trip to Cold Hill Temple especially unforgettable. This temple owes its world-wide renown to the following poem "Mooring by Maple Bridge at Night" written by the Tang poet Zhang Ji:

The moon sets and crows caw in the frosty sky,
A fisherman's light by the riverside maples glimmers sadly before my
* eye.*
From Cold Hill Temple beyond the city of Suzhou,
The midnight bell is beckoning me here in my boat.

The temple courtyard is quiet and has many trees and stone slabs. The huge, imposing bronze bell still hangs high overhead.

Not far from the temple lies a broad river spanned by a stone arch bridge called Fengjiao Bridge. This must have been the place where the Tang poet Zhang Ji moored his boat! The setting sun was quietly daubing the discoloured bridge with brilliant lingering light, and two or three wooden boats were sailing. Standing fascinated by the side of the bridge, Beihong, no longer depressed, experienced a great spiritual uplift. The beautiful rivers and mountains of China always gave him comfort. Such was the compensation an artist in distress received.

Chapter XVII

Under the management of Jiang Biwei, the Xus moved to Nanjing and took up lodgings in the living quarters of Central University on Danfeng Street. The two-storied, old-style house was also inhabited by three other professors of the university and their families. The Xu family, including Jiang's parents, was alloted four rooms in the house. In addition, the painting department of the university gave Beihong another two rooms as his studio. The monthly salary Beihong received was three hundred dollars in cash.

Jiang was satisfied with the excellent pay and their stable life. But she did not in the least perceive how she had already hurt Beihong's feelings. Beihong did not like his present life at all. He deeply cherished the memory of Tian Han and he also thought of his colleagues at Nanguo Art Academy and Nanguo Society.

During the days immediately following his move to Nanjing, Beihong often recalled the friendly, harmonious and yet militant life at Nanguo Art Academy. He remembered that once, when Nanguo Society sponsored performances to raise funds for the academy, the students had put on the play *The Painter and His Sister,* which describes how a poor painter suffering from cold and hunger in severe winter is unable to paint a model for lack of a heating stove. At the end of the show, one person's warm clapping outlasted by far that of the rest of the spectators.

When Liu Ruli, a student painter who had played the part of the hero, peeped out through an opening in the curtain, he found that it was none other than Beihong. Beihong went backstage to congratulate the performers and firmly grasped Liu's hand, saying, "What a wonderful performance! It describes just the kind of life I lived in Paris as a painter."

Beihong also remembered that when Nanguo Society staged Tian Han's plays *A Story of Suzhou* and *The Death of a Star*, he had not only attended their performances, but also put forward suggestions about the stage scenery, and costume designing, and also actively tried to promote the sale of the admission tickets to help raise funds for the academy.

The varied and colourful life of Nanguo Art Academy could exist now only in his memory. His only solace was work. Every morning he would set out early for the university, enter the classroom punctually, stop to watch every student's easel and give directions, and sometimes personally improve the students' paintings. The students always greeted the presence of the strict professor with respect.

In teaching sketching, Beihong always laid emphasis on the principles of "Better square than round, better clumsy than clever, better dirty than clean." The human body looks round on the whole, but each round surface is composed of numerous square surfaces just as each arc is formed of a number of straight lines. In order to show that something round has its substantiality, weight and volume instead of being level and smooth as in a photograph, a painter must have recourse to square surfaces.

Likewise, "Better clumsy than clever" means that though it is good for a painter to be clever, and that while it is possible for a clumsy painter finally to achieve cleverness, cleverness alone will only tend to insubstantiality and superficiality. The same is true of "Better dirty than clean." While it is good for a picture to be clean, to concentrate on cleanness alone will end in the loss of many good qualities. The three principles put forward by Beihong were all meant to aid beginners to take the correct path in art. He believed that students of art, like students of science, instead of seeking shortcuts, should study hard without fearing difficulties and proceed in an orderly way, step by step.

He also emphasized the contrast between light and shade. He instructed his students to always find the lightest and darkest points, the second lightest and second darkest points, and so on, contrasting them repeatedly and carefully. He instructed them to pay attention to the connecting line between light and shade to strengthen the sense of volume, increase the variety of colours and combine and unify them through analysis and synthesis.

85

Beihong's scientific educational ideas and methods were the crystallization of not only his experience of study and painting, but also of the tremendous efforts he had exerted in promoting the cause of Chinese fine arts. During the period of time when he was teaching at Central University, apart from continuing to paint the huge oil of *Tian Heng and His Five Hundred Followers,* he devoted all his time to guiding and fostering his students.

It was not easy for Beihong to advocate his scientific views in the old China, under a melee between the warlords. He was subjected to all kinds of slander and attack. But he persisted in advocating his views and painstakingly fostering a well-grounded younger generation.

In 1929, when the Kuomintang government in Nanjing held the first national art exhibition, Beihong refused to take part in it. Meanwhile, he opened up an argument against the noted poet Xu Zhimo (1891-1931), who disagreed with Beihong's denunciation of the works on display at the exhibition.

Beihong brought forth his argument in an article entitled *In Perplexity,* in which, after enumerating the names of many outstanding French realistic and romantic masters and their great achievements, he says, "Renoir is vulgar, Cezanne is shallow, Matisse is inferior... yet they are enjoying temporary popularity through the manipulation of art dealers The dignity of art is eclipsed, and people are vying with each other for the current fashion." He goes on in indignation, "Our 'revolutionary' government, by virtue of its natural gift of strategy, great planning and far-sightedness, has collected opium and gambling taxes and other miscellaneous levies totalling ten million dollars to establish a colossal art gallery displaying in its ten spacious pavilions the paintings of Cezanne and Matisse bought at three to five thousand dollars each. (As a matter of fact, one could make as many as two such paintings for each hour.) All that is as much a waste of revenues as buying imported morphine and heroin"

In another article entitled *Still in Perplexity,* he writes, "If form ceases to exist, can one still speak of art?" He also points out the "falsehood" of formalistic art, saying that "the true and the false should not be confused" and that only by painting truthfully can a painter give people a sense of beauty. He abhors the falsehood of official-style

painting. He writes that "we can only distinguish between the true and the false," but "cannot distinguish between the false and the false." He adds enthusiastically, however, "I only hope that our dear artists will carefully study and watch nature."

At the time, the painter Li Yishi wrote in support of Beihong. Li says in the article *I Am Unperplexed,* "I think Mr. Xu Beihong's attitude is that of a real artist After studying Western painting for more than twenty years, I really still cannot quite understand the works of Cezanne and Matisse. If my son should want to learn from their style of painting, I would surely give him a sound beating."

Chapter XVIII

Summer in Nanjing is extremely hot. Gusts of hot dry wind sent the dust on the roadside flying.

When Beihong was working out plans for the summer holidays, Huang Menggui, then head of the Education Department of Fujian Province, invited him to go to Fuzhou, the provincial capital, to paint. Beihong, in company with his student Wang Linyi, who was to look after him on the way, took a boat to Fuzhou via the Taiwan Straits.

In Fuzhou, the two old acquaintances talked fully about what had happened since they parted company in Singapore. No sooner was Beihong given accommodations than Huang suggested that Beihong paint *Cai Gongshi* in oils. Huang told him that in 1926, when the Northern Expeditionary Army was advancing towards North China along three routes, the Japanese had attempted to halt the advance by creating chaos in Jinan. Cai Gongshi, a native of Fuzhou, had been deceitfully arrested and murdered by the Japanese when he came out to negotiate with the Japanese in the capacity of diplomatic special envoy. The incident, which then aroused nationwide indignation and protest, has been known historically as the May 3rd Massacre.

Beihong painted the image of the unyielding Cai Gongshi standing before the Japanese troops.

As soon as Beihong finished the painting, the provincial Education Department inquired of him how much he expected to be paid. Beihong declined any payment without hesitation, but he expressed the hope that the provincial government would send abroad to study one of his best students, who wished to specialize in oil painting in France. The request was immediately granted.

Beihong at once wrote to Lu Sibai, his student, to inform him of his decision to send him to France and tell him to get ready for the journey.

When Lu Sibai, slim, clever, and distinguished in his class, received the letter, he was disturbed — at once happy and uncomfortable. He was happy about his unexpected stroke of luck, but uncomfortable at the thought of his classmate Wang Linyi, who had not been given the same opportunity. After thinking it over, Lu decided that Wang rather than himself should be the one to go to France. He wrote to Beihong to speak his mind frankly.

After receiving Lu's letter, Beihong pondered long over the matter and could not decide which one should go. He showed the letter to Wang Menggui to ask his opinion. Wang was impressed by the letter and decided to give two reservations. Both students would go to France.

Beihong was profoundly grateful. Both students studied well in Paris and achieved splendid results. Later, after their return to China, Lu was to become a noted oil painter and for a long time professor and head of the painting department at Central University; Wang was to become a noted sculptor and for a long time professor of National Art College, professor of Central Institute of Fine Arts and head of its sculpture department. Both have devoted themselves heart and soul to art education and fostered a great many talented students.

During Beihong's sojourn in Fuzhou, Chen Zifen held an exhibition of his paintings. Beihong lost no time in going to visit the exhibition and there made Chen's acquaintance. Chen was adept at seal-engraving and at flower-and-plant paintings with double-hook strokes.* He greeted Beihong excitedly in mandarin with a heavy Fujian accent. "Mr. Xu, it's an unexpected honour for you to visit my exhibition. I'm eager to hear your advice."

Chen, a few years younger than Beihong, looked quite sincere and honest.

"There's no advice to speak of," Beihong said modestly. "Let's

* In traditional Chinese painting, outlines of objects are often made with lines called hook strokes. They are also called double-hook strokes because they are mostly done in pairs, upper and lower, and right and left. This technique is often applied to making delicate paintings of flowers and birds.

learn from each other! Your seal-engraving is excellent, and your double-hook-stroke flower-and-plant paintings are masterly."

"So, you approve of double-hook strokes, do you?" asked Chen cheerfully.

"Yes," answered Beihong, "double-hook strokes are essential to traditional Chinese painting, but they are best applied to life drawing. We should use them to make accurate pictures of objects, and at the same time vary their application in accordance with the variation of objects. We should in no way stick to the ancient conventions. We should try to develop and create new techniques of double-hook strokes...."

Fuzhou is a warm city in southern China with year-round flowers and fruits. Diligent Beihong, who would never let go any opportunity for study, did many life drawings of flowers and plants with double-hook strokes. On his accurately and meticulously done drawings, he carefully put down notes in small characters indicating the colours of flowers, leaves, stamens and pistils, and calices. Every time he went to see Chen at home, Beihong would take along a big folder of pictures of various kinds of flowers and plants he had drawn with double-hook strokes in charcoal, pencil or pen. Together they would examine them and have discussions. A close friendship thus developed between them. Later, Chen had more than twenty seals specially engraved for Beihong.

Chapter XIX

In September 1929, on the recommendation of Cai Yuanpei, Beihong was invited to be president of Beiping College of Art. On his return to Nanjing from Fuzhou, he immediately set out for Beijing (then called Beiping) by himself.

How the ancient city — the cradle of the May 4th Movement — had enchanted him and brought him hope! Now, standing again below the wall of Tian An Men, he heard the echoes of history and was filled with emotion. Ten years had passed since he left Beijing in 1919. Although many revolutionary forerunners had sacrificed their lives for the benefit of the people, the city remained politically and academically as reactionary, rotten and backward as it had been ten years before.

Beiping College of Art, too, was extremely conservative. Beihong was confronted with two alternatives: enjoy the secure job of college president on a monthly salary of five hundred dollars by going with the tide, or run the risk of losing his job by fighting it. Regarding it as his duty to promote Chinese art, Beihong did not hang back to seek temporary ease. He chose the second alternative, fully aware of the great difficulties he would face. He boldly brought up suggestions for renovating the college. He violently denounced those preaching the doctrine of "back to the ancients," and attacked lifeless, conventional, stereotyped, scholarly paintings. He advocated imitating nature and innovation within traditional Chinese painting. He also called upon Chinese artists to learn new techniques from Western painting and combine them with the fine traditions of Chinese painting to create a new, true-to-life Chinese painting. He was also non-conventional about the employment of personnel. When he had discovered Qi Baishi's high achievements in traditional Chinese painting, he personally called upon the old painter, who was then in an extremely isolated position, and

decided to invite him to be a professor of the college.

Qi Baishi, then already sixty-seven, had begun life as a carpenter. His works not only reflect such qualities as high refinement and generalization peculiar to Chinese painting, but are also full of vitality. Through repeated observation, he painted lively shrimps and crabs, croaking frogs, dragon-flies hovering over lotus leaves, lovely chicks, and landscapes with local flavours. His works are both rich in national character and free from the patterns set by the ancients. At a time when it was a prevailing fashion for painters to model themselves after the ancients, Qi Baishi stood alone in Chinese painting, which greatly gladdened Beihong and won his high praise.

When Beihong, aged little more than thirty, and Qi met for the first time at the latter's studio at Kuache Hutong, Xidan, they felt like old friends at a reunion. They exchanged opinions about painting, poetry, prose and seal-engraving, and found they shared the same views on a great many things. But when Beihong expressed his wish to invite Qi to be a professor at Beiping College of Art, Qi politely declined. A few days later, when Beihong paid a second visit to Qi to bring up the same invitation, Qi again graciously declined. Beihong, however, did not give up. He went to invite Qi for the third time.

Qi was moved. He said frankly, "Mr. Xu, it's not because I'm unwilling, but because I've never been a student at a modern school, much less a teacher at such a school. I haven't even taught at a primary school or a middle school, so how can I teach at a college? In case the students should act mischievously, an old man like me would topple down to the ground and never rise."

Knowing where the shoe pinched, Beihong told Qi that instead of giving lectures, all Qi had to do in class was to demonstrate painting. He added, "I'll keep you company in the classroom. In winter, I'll get you a heating stove, and in summer, I'll get you an electric fan, so that you won't feel uncomfortable."

Qi promised to have a try.

Early the next morning, Beihong went personally in a horse-drawn carriage to bring Qi to the college. Qi, dressed in a loose-fitting satin robe and carrying a walking stick, got in the carriage with Beihong. The four-wheeled carriage, drawn by a lean horse, moved along slowly in the

narrow lane. Inside the carriage, Qi sat solemnly, with a look of self-absorption on his face reflecting his uneasiness. The carriage rumbled past broad thoroughfares and the busy downtown area until it stopped with a slight jolt before the gate of Beiping College of Art. While the students gathered at the gate were greeting him with warm applause, Qi nodded to them in acknowledgement.

Escorted by students all around, Qi and Beihong entered the classroom. Brushes, ink, paper and inkstone had already been laid out on the desk, but Qi produced a few brushes he had bought with him. He raised a brush cautiously and meditatively, moved it very slowly, as though each stroke demanded great care and precision. His brushwork was extraordinarily refined and terse. The students' eyes closely followed each and every movement of his painting brush. His adroitness in manipulation different strokes and regulating the thickness and wetness of ink had achieved the artistic effect of "grasping both the overall and the exquisite and minute," as Beihong put it.

After the painting was finished, Beihong started an informal discussion between Qi and the students.

"Don't learn or imitate mechanically. One should follow one's own way, and the important thing is to be natural...," said Qi, running his eyes over all the students. "A flower about to blossom should be deep-coloured, and a flower about to wither should be light-coloured. Don't paint plum blossoms with circles, for those who do so are not real artists...."

Beihong got in the same carriage to escort Qi home. The carriage moved more quickly this time as if both the lame horse and the slothful driver had been infected by the joyful mood of the two gentlemen. When they arrived at the gate of Qi's house, at Kuache Hutong, Beihong helped Qi out of the carriage. Qi said with such agitation that his voice quivered, "Mr. Xu, you're very kind, you didn't fool me at all. From now on I can be a college teacher. I ought to kneel down to express my thanks to you."

Hardly had he finished saying this when he began to fall on his knees. Beihong hastily stopped him, his eyes brimming. Aften that, the two famous masters became bosom friends and their friendship lasted the rest of their lives.

The Beijing of the 1920s was extremely backward in art as well as in politics. The conservatives not only refused to accept, but actively opposed Beihong's propositions about the innovation of Chinese painting. Even the employment of Qi as professor of the college turned out to be a target of open censure.

"Even carpenter Qi has become a professor here!"

"Xu Beihong does everything according to his own personal likes and dislikes. Who knows what a nice mess he's going to make of this college?"

There was an eruption of rumours, slanders, and deliberate obstructions, as well as open and veiled attacks. Beihong was greatly frustrated. Feeling isolated and helpless, he quit the college in anger.

Leaving for southern China, Beihong went to say good-bye to Qi. The depressed old painter picked up the brush and made Beihong a painting of *Visiting a Friend in the Moonlight,* in which an old man wearing a robe and carrying a stick is the painter's self-portrait. He sadly inscribed two poems on the picture:

(1)

I couldn't refuse the offer; thrice you called on me,
But I knew a worthless old painter I am.
Under the full moon by the breezy sea,
Stick in hand I go visiting Xu Xi in my dream.*

(2)

Not a day passes without my thinking of thee,
Who knows when our happy reunion will be.
There is divine power on earth, I believe,
Although an evil wind still rages beyond the lacebark pine.

Attached to the first poem is a note in small characters which reads, "When Mr. Xu bade me farewell before he left Yan*, I asked him where he was going to stay in southern China. He answered, 'I'll be in Shanghai when the moon is full, in Nanjing when it is waning.'"

The following poem was inscribed by Qi on a landscape he

*A famous painter of the Nantang period, who was skilled in painting flowers, fruits, trees, grasses, insects, fishes and birds, and was greatly admired by his contemporaries for this unrivalled talent. Qi Baishi likens Xu Beihong to Xu Xi in the poem.

presented to Beihong:

I learned to paint landscapes in my young days,
To amuse myself rather than to win admiration.
When my skill is the target of public condemnation,
Mr. Xu of Jiangnan is the only one to speak up for me.
He calls the strange works of my heart and hand
Miracles of supernatural beings rather than of man.
Worthy is this man who speaks alone against the multitude,
His act makes my wan face sweat with gratitude.

After Beihong returned to the south, he kept up a constant correspondence with Qi Baishi. Qi would mail to Beihong his latest works, for which the latter always paid him. During those days, Beihong bought a large collection of fine works by Qi, who, then full of energies, had attained complete maturity in his art.

At that time, Qi had not yet had a collection of his paintings published, though he had spent some money in lithographing two hundred copies of his collected works to be distributed as gifts to his friends and relatives. In order to publicize Qi's artistic achievements, Beihong made a recommendation to Zhong Hua Book Company to publish such a collection. Shu Xincheng, one of those in charge of Zhong Hua Book Company, was a learned and righteous scholar of noble mind; he had always supported Beihong in his various endeavours and now generously promised the publication. Beihong personally did the editing and wrote the preface.

When Qi received the published collection and payment, he was beside himself. He thought of Beihong with greater confidence and gratitude.

* Ancient name for modern Beijing.

Chapter XX

After his return to Nanjing, Beihong resumed his professorship in the painting department of Central University. But Wu Zuoren and others, who had been attending classes in the painting department as auditors were expelled by the university on grounds of their contact with leftists and their suspected illegal activities.

Wu Zuoren came very anxiously to see Beihong, saying, "Mr Xu, Central University has announced our expulsion. What can we do?"

Beihong responded, "How totally unreasonable!" Then, after a little pondering, he continued resolutely, "You go to France! Go to Paris to learn painting!"

Wu, fatherless since childhood, had been depending upon his widowed mother and eldest brother for support. He had hardly enough money even to continue his studies in China; how could he afford to pursue his studies abroad? He had never dared even to think of study abroad. He looked at his teacher in bewilderment.

Beihong, knowing the mind of the poor young man, said, "I'll try to find a way out for you. Go to Paris first, and the rest will take care of itself, Anyway, you won't starve."

Since it was a regulation of the Kuomintang Ministry of Education that only those possessing a university degree were allowed to apply for a passport, Beihong could do nothing but tell Wu to go to his former teacher Tian Han to seek help. "That's easy!" said Tian Han grinning from ear to ear. He reached out his hand to open a filing cabinet, took out a sheet from among a pile of blank diplomas of Nanguo Art Academy, and filled in Wu's name. Then, after Beihong managed to boook a cheap passage for Wu, the latter set out from Shanghai on an ocean-going steamer.

Arriving in France, Wu was admitted to the same school where

Beihong had studied — the Ecole Nationale Superieure des Beaux-Arts. But he lived a life of dire poverty there. When mealtime began at the school canteen, Wu would not dare to go in early. It was not until all the best food had been sold out and empty cups and plates were lying about in disorder that he would walk in bending his head and buy a dish of mere potatoes to allay his hunger. As time went on, he even ran out of money to buy potatoes, and had to write to request assistance from Beihong. Beihong immediately asked someone to acquire Wu a scholarship at the Belgian Royal Academy of Painting. Consequently, Wu transferred from Paris to Brussels to continue his studies. He did not fail, however, to live up to Beihong's expectations, and graduated with honours as a top student from the academy. Since his return to China, he has been successively professor of the painting department at Central University, dean of Beijing Art College, president and honorary president of Central Institute of Fine Arts. He has been carrying forward Beihong's ideas on painting, and throwing all his energy into promoting the cause of Chinese fine arts.

Beihong, besides teaching at the painting department of Central University, continued to work energetically on the oil painting of *Tian Heng and His Five Hundred Followers*. But he was still being harassed by his disquieting family. In spite of the son and daughter, domestic discord continued to exist. That Jiang Biwei could not bring herself to understand and approve of Beihong's intense love for art had already become an irreconcilable contradiction between husband and wife. They still often quarrelled over the question of buying books and paintings.

Once, Beihong bought a seal stone for thirty dollars. He was overjoyed as if he had found a treasure, and as soon as he came home, he called out to his wife. "Biwei, come and look, I've bought a nice-looking seal stone".

How eager he was that his wife would share his joy! Jiang came up, took over the stone, looked at it and asked, "How much did it cost?"

"Thirty dollars!" Beihong told the truth.

Jiang abruptly raised her arm and fiercely tossed it at the spittoon. As the stone fell crack into the spittoon, Beihong went over quietly, bent

over to pick it up and found a corner of it broken.

The episode did not end with Beihong's silence. The next day, Jiang, as if by way of retaliation, went to the finest store in Nanjing and there spent the same amount of thirty dollars in ordering a long velvet gown with golden patterns. Later, she persistently demanded that Beihong make an oil painting of her dressed in the shiny long gown as if she wanted to permanently brand her anger in his memory. While unhappily moving the brush, Beihong could not help feeling sad that the young girl whom he had loved ten years before had forever gone out of existence and that facing him now was but an arrogant and willful woman.

In 1930, in spite of his unhappiness, Beihong finished painting *Tian Heng and His Five Hundred Followers* and began to work out the composition of the traditional-style Chinese painting of *Jiufang Gao*.

This painting draws its subject material from a story in the Chinese classic *Lie Zi*. According to this story, there lived in the Spring and Autumn Period a man named Jiufang Gao, who had a great ability to see the good points of horses. One day, Prince Mu of Qin said to Bo Le, the famous judge of horses, "You're getting old. Do you have any sons or grandsons to inherit your ability?" Bo Le said with a sigh, "Some of my offspring can judge horses, but none can recognize a fleet horse capable of a thousand *li* a day. But a friend of mine by the name of Jiufang Gao is as good a judge of horses as I am, although he's only a common labourer." Prince Mu was pleased and ordered Jiufang Gao to find him such a fleet horse. Jiufang Gao spent three months examining numberless horses in various places until he finally found a black mare to his liking. When he came back, the Prince asked, "What colour is the horse that you've found?" Jiufang Gao answered, "Yellow." "Stallion or mare?" asked the Prince again. "Stallion," answered Jiufang Gao. The Prince sent someone to lead in the horse, but he was greatly disappointed when he saw that it was a black mare. He said to Bo Le, "If Jiufang Gao can't even distinguish the sex and colour of a horse, how can he tell a good horse from a bad one?" Bo Le said with a deep sigh, "O Your Majesty! When Jiufang Gao looks at a horse, he sees the essence but not the dross, he sees the interior but not the exterior. He sees what he wants to see, and ignores what he doesn't want to see!"

At this, the Prince ordered the black mare put to the test, and it turned out to be the best horse available.

The story afforded Beihong food for thought. It reminded him that numerous real talents were being stifled under Kuomintang rule without any opportunity to put their ability to good use. It made him realize again how arduous it was to guide and foster a person of talent, as had been shown by his own personal experience. Meanwhile, he also remembered how he himself had once been driven to the brink of suicide in the Huangpu River. The story stimulated his creative desire, and he decided to paint *Jiufang Gao* to vent his pent-up frustration over stifled talent.

The traditional-style Chinese painting presents the vivid image of the simple and honest labourer Jiufang Gao concentrating his attention on the horses before him. The black mare is neighing and lifting its steely legs as if itching to run in view of a patron appreciative of its ability.

Beihong had become a skillful horse painter, and the horses he painted were invariably wild ones galloping without reins and bridle. But in this painting, he made an exception of the black mare by having it harnessed. When someone asked him why, he answered with a smile, "Horses, like men, are willing to serve those who can appreciate them, but not those who are muddleheaded."

While Beihong was concentrating all his energies on teaching and painting, Zhang Daofan, who had already become a ringleader of the Kuomintang special agents, again called at the home of the Xus. Zhang came deliberately to see Jiang Biwei when he knew Beihong was out teaching, just as he had often done in Paris whenever he knew Beihong was taking lessons at school. He knew how to make use of every opportunity available. Wearing a trim Western-style suit and giving off the smell of a foreign-made perfume, he smugly crossed the threshold of Beihong's house.

That evening, as soon as Beihong came home from the studio, Jiang said with an irritated look on her face, "I didn't know until today that you've a soft spot in your heart for somebody! No wonder you stay away from home all day saying you're making a large painting!"

"What's that?" Beihong could not understand what she was driving at.

"You thought I didn't know!"

"What's the matter? Could you speak more clearly?"

"Isn't there a girl student called Sun Duoci?"

"Yes," said Beihong, "she's an auditor in the painting department."

"She paints very well?"

"Yes, she's clever. She seems to have a gift for painting."

"You love her?" Jiang raised her head and looked into Beihong's eyes with a stern stare.

"I'm fond of her talent. You know I'm fond of all bright, hardworking students. She's been doing exceedingly well in her studies. Though she's only a beginner, she's made exceptionally good progress."

"H'm, so it's all true!" Jiang muttered as if both to herself and to Beihong.

"Biwei, what rumour have you heard?" Beihong said soothingly. "As husband and wife, we two have gone through thick and thin together. I'll never abandon you. You should in no way be suspicious. As for Sun Duoci, I like her as a distinguished student and I'm trying to make a useful person of her to our country. You might just as well regard her as a boy student of mine."

No matter how hard Beihong tried to explain away her doubts and appease her, Biwei turned a deaf ear to him.

Sun Duoci had been born and brought up in an old-type intellectual's family in Shouxian County, Anhui Province. Quiet and unsociable, she was a very common girl of slender build, not particularly beautiful. Among the distinguished students Beihong had taught, many had been boys, but few had been girls like Sun Duoci. The following year, she was admitted to the painting department after passing the entrance examination with full marks.

Usually, when teaching in the classroom, Beihong would walk up to the students' easels to check over their exercises one by one, point out their merits and demerits, and offer them tips on how to make improvements. He would repeat this every couple of hours. Every time he approached Sun Duoci's easel, he would find she had been doing very well, meticulously following her teacher's instructions. Beihong, who always had a great liking for talent, would sometimes be so greatly

pleased that he would say a few words of praise and encouragement. Strangely, however, these words would soon find their way to Jiang's ears.

The despicable spying on Beihong was all manipulated by Zhang Daofan. As a ringleader of the Kuomintang special agents, Zhang had obedient underlings in the painting department as well as in other places. They were always ready to report to Jiang Biwei on Beihong's doings, stopping at no lies and embellishments. The already disharmonious family was now facing utter ruin.

Chapter XXI

In 1931, Beihong took advantage of the summer vacation to visit Nanchang. As soon as he arrived there, the local press carried stories of his presence. He was called upon by endless visitors, of whom the majority were young art lovers seeking guidance.

Fu Baoshi, who was later to become a famous painter, was in straitened circumstances; he had been staying at home without a job. One night, when he was absorbed in painting by the dim light of a kerosene lamp, someone's fist started banging hard on his door.

"Baoshi! Baoshi! Open up! Open up quick!"

It was the voice of a good friend. Fu hastily opened the door and his good friend excitedly said. "Master artist Xu Beihong's here in Nanchang. Go and see him quick! Maybe he can help you...."

Early the next morning, armed with his paintings, Fu hurried to Beihong's hotel room, but found it packed with visitors waiting for an individual interview with Beihong. When Fu's turn came, Beihong could not have a long talk with him because of the many people still coming in to see him. Beihong, however, quickly glanced over Fu's paintings and told him to leave them behind and come again that evening.

When Fu was home, his wife asked eagerly, "Did you see Xu Beihong?"

"Yes, I did."

"What did he tell you?"

"He told me to leave behind my pictures and go to see him again this evening."

"Aha!" There was a flash of hope in her eyes. "Did he discover your talent?"

"I don't know."

"Then, did he say the same thing to other visitors?"

"Probably not," Fu answered after some reflection.

That evening, when Fu called on Beihong at the hotel, Beihong treated him like an old acquaintance. Beihong was greatly struck by his talent.

"You haven't got any schooling, nor any teacher. Then how did you manage to learn painting?" asked Beihong, curious at such a feat.

Fu, who had been an apprentice, an umbrella worker and a primary school teacher, stared at the wall in front of him with far-away eyes as if he were watching all the events that had taken place since his boyhood. He began to narrate his personal history slowly and in a low voice.

"When I was young, there was on the street where my home was a shop specializing in mounting pictures. They mounted many pictures by well-known painters, such as Shi Tao and Shi Xi. I often went to this shop to take a look at the pictures, carefully imitate them in my mind and memorize them, and then apply the techniques I had learned to my own draft sketches. As time went on, I got to know the shop keeper well, and we became such good friends that he allowed me to do the copying at his shop."

"Did you often go out to draw from life?"

"Yes, I did. I love the beauty of mountains and rivers. It gives me pleasure to watch and paint their changes under different weathers." Fu, who had at first been rather reserved and uneasy, now spoke with increasing ease and relaxation.

"Then, how did you learn from books?" asked Beihong pointing at the pile of manuscripts Fu had brought. "Where did you get all the rich materials?"

"Well, there was also on the same street near my home a second-hand bookstore, where I often went to read books standing. The store owner gradually found I was diligent and had sympathy with me. He gave me permission to enter his stackroom upstairs. That's how I came to read books on ancient inscriptions, calligraphy and paintings."

Fu's personal story touched Beihong and set him thinking. Beihong saw in Fu his own reflection. Fu was a diligent man of talent driven to the brink of ruin by unemployment and poverty. He was a piece of glittering gold buried in ashes! Beihong, rising to his feet, said to Fu, "I should like to look at more of your pictures. I'll be coming to see you tomorrow!"

When Fu returned home, he told his wife everything. She was thrilled, but also a bit anxious. She immediately started to clean up the

103

only small room they had. She decided to make the bedroom-cum-studio as neat and bright as possible, to clean out all the dust that had been accumulated for years. "Maybe from now on we'll have better luck!" she said to herself while cleaning up the room.

"Aiya, what am I going to wear?" she said, ashamed at the patched-up blue cotton dress she was wearing.

"Never mind, the one you're wearing will do," said Fu looking at his loving wife. She had been sharing a life of poverty and adversity with him without a word of complaint and yet he had not been able even to afford her a decent dress. All he could do now, was comfort her by putting on an air of cheerfulness.

"But, he's a great master. Is it all right for me to meet him in this patched-up dress?" she asked apprehensively.

Just then, they heard a knock at the door. "Aiya, Xu Beihong is here!" While saying this, she hurriedly went to hide herself in a big wooden cabinet by the wall. The old cabinet was now empty after the many paintings Fu usually stored there had been taken out to be viewed by Beihong.

Beihong entered the room in haste. Without taking the offered seat or drinking a mouthful of the tea, he said, "Let me see the pictures first!" He immediately opened pile after pile of Fu's pictures, the vast number of which served to attest to his painstaking effort.

"Really, it's an irrefutable truth that genius comes from much perspiration," said Beihong to himself while appreciating and commenting on the bold, unrestrained brush strokes.

Fu's wife was then peeping out through a chink from inside the cabinet. She found that Beihong was wearing a white, grass-linen, long gown, which seemed also to have a patch on its back. She also found how modestly and amiably Beihong was talking. Then she heard Beihong asking her husband, "Is your wife out?"

"Er, er...." Fu stammered without finishing the sentence.

Taking advantage of the opportunity when Beihong was bending to look at a picture, Mrs. Fu walked out quietly on tiptoe from inside the cabinet.

"Here she is." Fu, pleasantly surprised, made the introduction to Beihong, "This is my wife."

After exchanging a few words of greeting with her, Beihong continued to look over the pictures. One, two, three ... ten, fifty, one hundred, two hundred It was lunch time. How was she going to

104

entertain the honourable guest? She could not afford a banquet, but potluck would be much too unpresentable and unworthy of Master Xu. She walked into the street carrying a bamboo basket, and soon came back with some steamed stuffed buns and rose cakes.

"Mr. Xu, please excuse us for not treating you to something better than this."

Beihong, however, exclaimed, "Oh, steamed stuffed buns, and rose cakes. It's a double delicacy!" While eating, he lavished praises on the food to allay the embarassment of the host and hostess and to liven things up.

After the meal, the hostess asked Beihong to make a painting and started preparing liquid ink from an ink stick.

"Madam, what would you like me to paint for you? You just name the theme!" Beihong asked.

She answered without reflection, "A duck!"

Beihong readily agreed, which gladdened her heart all the more. She had many times thought of buying a duck as nutritious food to build up the health of her overworked and under-nourished husband, but for lack of money her wish had never come true. An old saying goes, "Draw a cake to satisfy hunger." So why not draw a duck now to build up her husband's health? The happy thought came to her while she was watching Beihong paint the duck.

Beihong wielded his brush, and in an instant, there appeared on the paper a duck with unfurled wings, so vividly portrayed that it seemed ready to fly off the paper. He also painted in a few reeds with thin ink, and inscribed the picture with "Presented to Mrs. Fu for her correction."

She hung up the picture on the wall and, together with her husband, enjoyed looking at it for quite a while. Around midnight, for fear that it should be dirtied by dust, she rose from her bed to put it away quietly in the wooden cabinet.

Mrs. Fu laughed up her sleeve when asked about the painting's disappearance, and said, "Legend has it that once when a certain man added eyeballs to a dragon he had painted on the wall, the dragon flew away from it. Our duck may also have flown away from the paper!"

"Really? What a pity! What a pity!" Fu said with regret written

large on his face.

"You silly bookworm!" she sniggered, "I put it away in the cabinet!"

Husband and wife exchanged a look and burst into hearty laughter.

Coming out of Fu's home, Beihong went straight to Jiangxi Provincial Governor Xiong Shihui's residence. Beihong had never considered it a pleasure to call on politician. But now he had to do it for the sake of Fu's prospects. After handing in his visiting card, he was ushered into a spacious parlour where he was politely received by Governor Xiong.

"Mr. Xu, I'm greatly honoured by your visit to our province!" greeted Xiong.

"Governor Xiong," said Beihong right to the point, "I've come here to see you because I've discovered a talent in your province."

"What kind of talent?" asked Xiong eagerly.

"He's painter Fu Baoshi!"

"Fu Baoshi? Never heard of him," Xiong shook his head with doubt. "What is his occupation now?"

"He's unemployed, but he's a man of great talent and ability...."

"Mr. Xu, you mean to find him a job?" Xiong interrupted Beihong.

"No. In my opinion, your province should foster him and send him abroad to study, for instance, in Japan, so that he can broaden his horizons and get into touch with foreign art...."

Xiong said with a sign of reluctance on his face, "That's something very difficult. Only a few can go abroad to study, only a few." He ended his sentence with emphasis.

"But, talents like Fu Baoshi are still fewer. Governor Xiong, he's a talent of your province, an extremely rare talent. Some day, when he is famous, he'll make extraordinary contributions to Chinese fine arts."

Xiong, however, remained non-committal. He tried to turn aside the topic of the conversation by saying politely, "Mr. Xu, I've heard your illustrious name for a long time. Please come to my home for dinner tomorrow if you don't mind. I'll get paper and brushes ready. If you're in the mood for it, please paint me a galloping horse. I'll treasure it like a piece of rare jade."

106

"Please excuse me from your dinner because with many people calling on me I've little time left. But I'll send you the picture," answered Beihong graciously.

Xiong, obviously pleased, was all smiles and personally sent a carriage to take Beihong back to the hotel.

The next day, Beihong sent someone to take to the Governor the mounted picture of a galloping horse that he had brought to Jiangxi with him, plus a letter asking the latter to give Fu one thousand dollars to enable him to further his studies in Japan.

Xiong hung up the picture on the wall and viewed it with eyes narrowed to mere slits. An assistant standing beside him remarked, "Governor, it's excellent!"

Xiong, beaming with satisfaction, reclined comfortably in an armchair in his quiet enjoyment of the picture. All of a sudden, however, he frowned and began reading aloud over and over again the couplet inscribed on the picture:

> *Tell me what use you have for your sturdy legs,*
> *Running all day for life-sustaining hay!*

Xiong then happened to be a little lame after suffering an injury in a fall. "What does it mean? Isn't 'sturdy legs' a dig at me?" Xiong asked his assistant suspiciously, his forehead still more contracted.

The assistant, who happened to have a good knowledge of calligraphy and painting, explained, "No. That can never be what Xu Beihong means. I've seen the same inscription on many other paintings by him. It's not something directed against you, but an inscription he often puts on his paintings."

"Oh, oh," Xiong felt relieved.

Xiong eventually decided to provide Fu Baoshi with money to study in Japan, which contributed greatly to the latter's future successes.

It was Beihong's habit to tour places of historic interest and scenic beauty wherever he happpened to be. During his sojourn in Nanchang, he travelled with a few friends to Qingyunpu — a Taoist temple where the Qing Dynasty painter Zhu Da, alias Badashanren, had lived the life of a hermit. The temple, which is very tranquil inside, houses an image of

Badashanren and his calligraphy and paintings. The high-cheekboned image of Badashanren sitting erect with eyes closed in contemplation is extremely lifelike. In the courtyard, there is a giant osmanthus tree with a trunk three arm-spans around and a height of more than forty feet. Standing in the ancestral shrine of the temple are wooden images of past Taoist priests and benefactors to the temple.

Beihong, greatly amazed by the true-to-life wooden images in the shrine, asked the people around him about the name of the sculptor, but none could tell. It was not until he inquired of one Liao Tiyuan that he knew the sculptor to be a folk artist named Fan Zhenhua. Liao said, "The Fans have been sculptors from generation to generation. They've carved most of the images in the big temples of this province. Fan Zhenhua, of the present generation, is even more remarkable. The figures he carves out of wood are vivid and lifelike."

Beihong asked, "May I look him up?"

Liao answered, "He's living in the countryside, but often comes to town. Every time he's here, he stays at Shuiguanyin Temple. You can meet him there."

A few days later, Beihong, accompanied by Liao, Fu and several other friends, went to Shuiguanyin Temple to call on Fan Zhenhua. It was a hot summer day; the sun was blazing overhead. Upon their arrival at the temple, they found Fan having a nap, shirtless and snoring thunderously. Seeing the callers, a young apprentice, who had been working on one side, was about to awaken his master when Beihong stopped him. Beihong stood waiting for a long while, but Fan still did not wake up. So he had to leave. However, he asked Liao and Fu to buy on his behalf from Fan a carving of the head of a farmer and of a buffalo respectively.

Beihong had the greatest esteem for Fan's superb skill, but he also had sympathy for the sad plight of such a talented man. In one of his articles, he writes:

> I happened to discover Mr. Fan's name, which had then remained unknown outside his home village. Whenever people in China want to have a statue of Sun Yat-sen carved, they will always entrust the job to a famous sculptor or a foreign sculptor. Frankly speaking, as far as I know, none of their statues can excel the wooden images in the ancestral shrine of Qingyunpu Temple. And I believe that if people in Jiangxi Province suddenly want to put up a statue of Sun Yat-sen, they, too, will not ask Fan Zhenhua to carve it. Alas!

Chapter XXII

The year 1931 saw China in the midst of a grave national crisis.

The Japanese invaded in force the three northeastern provinces on September 18. Obeying the "absolute non-resistance" order issued by Chiang Kai-shek, the Northeastern Army, several hundred thousand strong, gave up the rich northeastern territory to the aggressor without firing a single shot, arousing nation-wide indignation. The weak-kneed Kuomintang government, knuckling under, frantically suppressed the people's democratic movement and threw the whole nation into an abyss of misery. Beihong was enraged by the tragedy of his country and people and the harsh social reality. No longer satisfied with the routine of teaching and painting, he decided to make charges and appeals on behalf of the people and the country. He thus began to work out the composition of the large oil of *Xi Wo Hou.*

The oil derives its theme from the ancient Chinese classic *The Book of History.* When Tang, founder of the Shang Dynasty, led a punitive expedition against the tyrant Jie of the Xia Dynasty, the calamity-ridden people eagerly looked forward to their emancipation by Tang's army and said one after another, *"Xi wo hou, hou lai qi su,"* meaning, "When our awaited sagacious leader comes, we shall be saved."

The picture portrays a group of destitute peasants raising their heads to look far into the distance; the earth is parched and the lean farm cattle are gnawing at the roots of trees. Their eyes burn with breathless expectation, as if looking to the sky for rain clouds in a time of severe drought. The picture measures 226.5 cm by 315.5 cm and contains altogether sixteen life-size figures.

In planning its composition, Beihong made several different draft sketches. In the one now housed in the Xu Beihong Memorial Hall of Beijing, there is a banner bearing the slogan of "Punish the tyrant and comfort the people."

While Beihong was devoting his time to this large oil, Zhang Daofan once more reached his dirty hand into Beihong's home. One night, upon Beihong's arrival home, Jiang Biwei said peevishly, "Every day you stay at Central University from morning till night under the pretext of making pictures, and I haven't been able to stop you from doing it. Now you've started painting the *Xi Wo Hou*. What do you mean by painting this oil? Who are you directing it against?" Before Beihong could answer, she demanded in anger, "Isn't it political?"

Beihong sensed that such remarks could not have come from Jiang without prompting. He asked in reply, "Did anybody call today?"

Jiang was speechless for a while, and a look of misgiving quickly flickered across her face. She said with great composure, "Yes, Zhang Daofan was here. He dropped in on his way to a meeting, and left quickly after a brief chat. He's very much concerned about you, and came to give you a piece of advice. He wonders why you should be painting such a picture at a time like this. He also says that you're not being sensible, and that's why you're running into trouble everywhere...." Her voice gradually softened.

With a sudden look of utter disgust on his face, Beihong raised his hand to stop her from talking any more.

Jiang, however, grew worked up and said, "O you! You never listen to me. You've fallen in love with another woman, and now you've started making this picture of *Xi Wo Hou*. You're gradually ruining yourself!"

"Biwei," Beihong bit his lip and said, "every time I come home feeling completely exhausted and hoping to get peace and quiet and warmth, all you do is shout at me, quarrel with me, suspect me and refuse to believe in me. You're interfering in my work, my painting, my daily life — whatever I do. Why are you getting such pleasure out of antagonizing me?"

"Me, antagonizing you! Then there's no need for you to come back! Go and see somebody who can give you happiness!" she started yelling

again, "Huh! What kind of a woman is Sun Duoci? A mere slut!"

"How can you use such insulting language against her? You're insulting my student, a well-behaved young girl! So far she hasn't yet said a word to me alone."

"Insulting? Don't you feel sorry for her? I'll not only use my tongue, but also get somebody to write my words and post them up in her classroom!"

"You're squabbling and cursing unreasonably. You've simply gone mad. How can I go on living and working here?"

"I told you long ago to resign and quit, so that we can both go to live in Paris again. You know I love Paris. And yet you're reluctant to leave. Isn't it because of her?"

"How can we abandon our country and go abroad to enjoy a leisurely and carefree life in a time of national calamity? If I do so, how can I face my students and my country any more?" Beihong could hardly suppress his anger.

"You're talking big, finding faults with me again. I'm no good, I'm a thorn in your flesh...." she howled, weeping.

Her fit continued into the dead of night. Beihong sat by his desk in silent distress, cupping his head in both hands. "What kind of life is this? What a terrible life this is!" he moaned.

The only thing that could give him peace and quiet was work — the enchanting work that was always beckoning to him. Every day he would hurry to his studio at the crack of dawn to begin a new day's work. The moment he stood before the large oil of *Xi Wo Hou*, all melancholy and pain vanished quickly. When he excitedly took up the palette and wielded his brush, he was completely immersed in the joy of painting. All personal vexations and misfortunes became as remote from him as clouds in the skies.

111

Chapter XXIII

In April 1932, Beihong took the students of the painting department to Beijing on a sight-seeing and life-drawing trip. On his way through Tianjin, he went on invitation to lecture at Nankai University. The university President Zhang Boling, upon hearing Beihong extolling in his lecture the richness of Chinese folk art, began to relate with wit the story of Clay Figurine Zhang. He concluded regretfully, "I saw Clay Figurine Zhang in my boyhood, but later I did not know where he had gone."

Beihong listened with gusto. He had long heard anecdotes about Clay Figurine Zhang. He had heard that the folk artist could mould lifelike figurines in his sleeves. But Beihong had always doubted the truth of the story because he had never seen the artist in person.

"Mr. President," Beihong requested with great interest, "could you arrange for me to see a couple of his figurines?"

President Zhang said after a little reflection, "That's easy. I know a certain Yan Fansun, whose father and uncle had each had a statuette of themselves moulded by Clay Figurine Zhang. Now, let's go and see Mr. Yan."

They went by car, and were warmly received by Yan, who immediately brought out the statuettes of his father and uncle. The two clay statuettes, about one foot eight inches tall and flanked by some wooden chairs, were each placed in a glass case. The statuette of Yan's bearded uncle, wearing a small round skullcap decorated with a precious stone and a black long gown and short jacket and resting his right hand on the desk, was vigorous and lifelike. Yan's father, bespectacled, beardless and dressed in a waistcoat, had a smile on his slightly drooping lips. Both statuettes were simply and elegantly coloured and marked by precise proportion, definite bodily forms and the subtlety of vivid

Xu Beihong in Nanjing in the early 1930s

Xu Beihong in Singapore in the
anti-Japanese war period

Xu Beihong in front of his traditional
Chinese painting *Jiufang Gao*

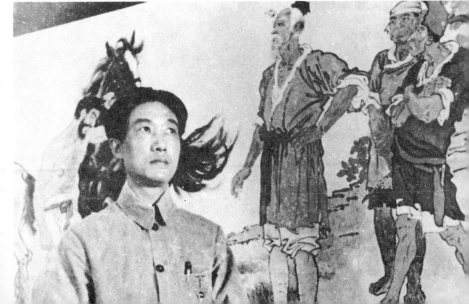

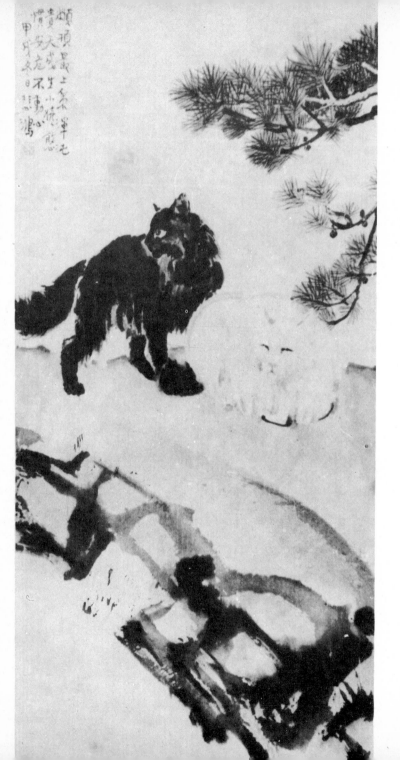

Temple at Cockcrow *Oil painting, 1934*

owsy Cat *Traditional Chinese painting; 1934*

Cock Crowing i
Wind and Rain
Traditional Chi
painting, 1937

Against the Wind *Traditional*
Chinese painting, 1936

Poor Woman of Sichuan *Tra-*
ditional Chinese painting, 1937

Sichuan Folk Drawing Water from the River *Traditional Chinese painting, 1937*

Sichuan Folk Drawing Water from the River (detail)

The Lijiang in the Spring Rain Traditional Chinese painting 1037

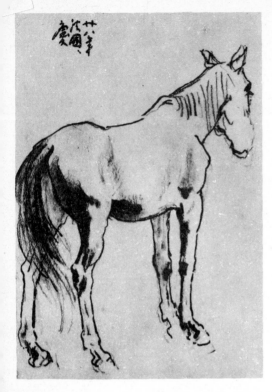

A Horse *Sketch, 1939*

Two Oxen *Sketch*

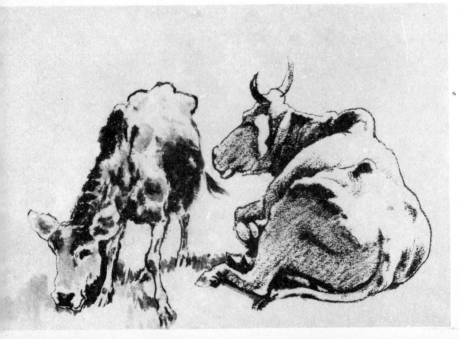

portrayal, seldom found in the clay sculpture of those days.

Yan said in recollection, "If Clay Figurine Zhang were still living, he would now be about one hundred years old. His descendants are also clay figurine makers by profession."

"Could you take me to their place so I can have a look at their works?" Beihong requested.

Yan nodded acquiescence, and took both Beihong and President Zhang on a visit to the shop that had originally been opened by Clay Figurine Zhang. As soon as they stepped into the narrow-fronted shop, they saw the interior packed with clay figurines of all descriptions, ranging from such ancient beauties as Xishi and Wang Zhaojun to modern fashionably dressed girls and young men in Western-style clothes. But Beihong was most interested in such common folk as watermelon pedlars, diviners and pot-bellied Buddhist monks — beautiful figurines in various postures and too numerous to be taken in. The shop proprietor said all these had been made by the fifth son of Clay Figurine Zhang.

"How fascinating, these unbelievable marvels!" Beihong said to himself in excitement as he lingered before the figurines, to appreciate them just as he had done before the famous sculptures by Auguste Rodin in Paris museums.

Before leaving the shop, Beihong picked out and bought a candy vendor, two cake vendors, one diviner and two fat Buddhist monks.

After he returned to Nanjing at the end of the trip, he still thought of the achievements of Clay Figurine Zhang and wrote an article entitled *Thoughts on Clay Figurine Zhang*, in which he warmly praised the extraordinary achievements of Clay Figurine Zhang and Fan Zhenhua, and also voiced grievances on their behalf. He says:

> The two cake vendors and candy vendor are realistic masterpieces. The one who made them can match his precise observation and excellent skill with those of the greatest sculptors in the world today Alas, the man endowed with such unique talent still remains unknown to the country! If we check the savings accounts in the Central Bank, we will see how people are unfairly paid for their labour and skill. Officials under presidential appointment and those acquiring ministerial posts by fawning on someone in authority need not fear the advent of national calamity and can remain unscathed even when the land sinks under them. The gap between the fates of the two different kinds of people is as wide as that between heaven and earth.

Chapter XXIV

Beihong's living quarters at Central University were small and had no studio. At the suggestion of Qian Changzhao and several other friends, money was pooled to build him a new house with a studio. When the building was completed in December 1932, Beihong and his family moved from Danfeng Street, Nanjing, to the new living quarters at No. 6 Fuhougang.

The well-constructed, two-storied house was complete with parlour, dining room, bedrooms, bathroom, toilet and studio, and had, in addition, a wide courtyard, in which stood two towering poplars with rustling leaves.

In spite of the cozy new living quarters, Beihong was heavy-hearted, seeing the troubled state of the country and the people and the growing national calamity following the Japanese invasion of Northeast China. He moved into the new house with a state of mind as agonized as that of the people throughout the country. He therefore named it "Precarious Nest."

Jiang Biwei, her gay face falling, became agitated. "How disappointing you are! See how I've exerted every ounce of energy in seeing to the building of this house! I'm the one that bought the land and the building materials, and supervised the construction. Now, we've moved in and have eventually a decent home of our own. But, of all names, you call it 'Precarious Nest!' Why don't you call it by a more auspicious name?"

Beihong said nothing but forced a sad smile. He had become accustomed to keeping silent before his wife to avert violent quarrels.

Why did he adopt the name "Precarious Nest?"

He says in his essay *My Precarious Nest:*

> The ancients say, "Think of danger when you enjoy a life of comfort." The reason I adopt the name of "Precarious Nest" is to prevent myself from forgetting the danger now confronting us at a time of calamity and turmoil and at a time of self-denial for the sake of national salvation.

In the same essay, he draws the following analogy:

A pine tree that grows on the precipitous cliff of Mount Huangshan, though under-nourished, has extremely great vitality. It braves wind and frost, and grows grotesque in shape. Then a busybody hires some stonemasons to dig it out of the cliff and transplant it in his own courtyard. He has it enclosed with a long wall and watered regularly. As time goes on, however, the pine tree becomes straight and fat instead of being gnarled and thin, and, like ordinary pine trees, loses all of its grotesqueness. Beihong, now having a new residence, should take warning from this story of the pine tree.

But Jiang Biwei did not heed this voice, nor was she willing to hear it.

Perfectly complacent, she was busy all day fixing up the new residence. She had the courtyard covered with mattress-like turf and planted with luxuriant flowers and trees, such as plums, peaches, bamboos and willows. When summer came, she put up on the lawn two large garden sunshades with round tables and cane chairs under them for the family to enjoy the cool and drink summer beverages. The interior of the house was laid out in French style. This was embarrassing and distressing to the patriotic-minded Beihong.

The divergence of thinking resulted in further divergence of their lives. They even disagreed with each other over trifling matters of daily life. Sometimes, when they went out on business and decided to dine out, Beihong would prefer to go to a local-flavoured small eatery or a stall where he could eat something cheap and delicious. This is not only because he liked the snacks they served, but because they brought back memories of the past — how tempting these small eateries and stalls had been to him during the old days when he and his father lived a vagrant life and when he was jobless in Shanghai! Besides, he liked to meet in these places good-natured and honest labourers and listen to their simple and straightforward talks.

But Jiang strongly objected to this. She called it degrading and beneath the dignity of the wife of a university professor and celebrated painter to eat in such humble places. To avoid unpleasant disputes, Beihong had to submit to her will with a dull pain.

It was only by throwing himself into work that he was able to forget his pain. He continued to work on the large oil of *Xi Wo Hou,* painting not only in colours, but also, as it were, in his own blood and tears. He felt as if he had placed himself in the midst of the common people in the

115

oil, eagerly awaiting their delivery from bondage by a saviour.

He went to Central University to give lectures as usual. The moment he entered the classroom, all sorrows and pains would evaporate away.

One day, Beihong received a letter enclosing a photo from a young stranger named Hua Tianyou, introducing himself as one who had learned carpentry since boyhood from his father, a poor carpenter by trade in Jiangsu Province, and saying that he was sending Beihong a photo of a carving of the head of his three-year-old son that he had done not long before to seek his opinion of it.

Beihong, much delighted by the vivid carving of the child's head, wrote Hua a letter of encouragement. After receiving the letter, Hua, then living in a remote place, felt inspired and came to Nanjing to request an interview with Beihong, bringing with him the wooden carving. He hoped to get an opportunity to learn sculpture with the help of Beihong.

Beihong tried to find Hua a job with an outlet for his talent. Soon, upon the recommendation of Beihong, Hua began as an assistant in the workroom of the well-known sculptor Jiang Xiaojian, who then happened to be working on a statue of Sun Yat-sen. That marked the first step he made in his career as a sculptor. Upon the completion of Sun Yat-sen's statue, Hua was invited to work in a big temple in Suzhou, where he repaired the clay image of a Buddhist monk allegedly made by Yang Huizi of the Tang Dynasty. Two years later, after he had succeeded in mastering numerous techniques of sculpture through study and practice, he decided to devote himself to sculpture.

Beihong was greatly pleased by the progress Hua had made and planned to find him an opportunity to further his studies. In 1933, when Beihong went to France to run an exhibition of Chinese paintings, he took Hua with him to Paris and paid for Hua's travelling expenses. Hua began his student life in Paris on a work-student programme. He shared a cheap, small room with the famous Chinese musician Xian Xinghai. Xian, who was also a poor student, would sometimes go out on the streets with an accordian on his back to sing for a living. When he came back utterly fatigued, he would always toss onto the table the few francs he had earned and say, "Tianyou, let's go halves!"

116

After many years of study in Paris, Hua also did carving for a living in France and eventually became a distinguished sculptor. He now holds professorship in the sculpture department of the Central Institute of Fine Arts in Beijing.

At that time, Jiang Zhaohe, of poor-peasant origin, was another young man whom Beihong held in very high regard. When Jiang went to call on Beihong out of admiration for the famous painter, Beihong discovered the young man's remarkable talent and let him live at his home to learn sketching. Jiang later became a painter renowned for his traditional-style Chinese paintings, especially his figure paintings. His works, possessing the good qualities of both traditional Chinese painting and Western-style painting, are rigorous in shapes and vivid in brushwork. His realistically painted figures, such as waifs and strays and Lu Xun's fictitious character of Ah Q make him a great master of our time.

Chapter XXV

The invasion of the Northeast by Japan left China's international status declining drastically, much to the bitter dismay of patriotic Chinese.

"How can China win universal recognition as a highly civilized country?" Beihong often asked himself, prompted by a sense of unshirkable responsibility. "How nice it will be to hold an exhibition of modern Chinese paintings abroad! That will win us world-wide understanding and sympathy, and raise China's international standing."

As it happened, the French State Gallery of Foreign Art invited Beihong by letter to exhibit Chinese paintings in Paris. Beihong busied himself making preparations right away, and set out for Paris in January 1933. He took along several hundred modern Chinese paintings, including his own works and works by other painters in his collection, as well as many well-known contemporary painters' works, either directly bought from them or borrowed from private art collectors.

This was Beihong's third trip to Europe and this time he went with Jiang Biwei and Hua Tianyou. They took a French liner captained by a Frenchman, who was very glad to see Beihong travelling on his ship and often invited him to his cabin to have coffee and snacks and enjoy chatting. Once, he asked Beihong, "An artist probably doesn't care for machines very much, does he?"

"Why not?" said Beihong. "I'm very much interested in machines because I like scientific knowledge."

"Then," asked the captain, "would you like to look around this ship?" "Certainly."

The captain began to show Beihong around the fourteen-thousand-ton ship. It was equipped with a network of pipes carrying salt, fresh,

cold and hot water. All electric installations, meteorological gauges and records of market conditions and current affairs, though complicated and compacted into a limited space, were functioning smoothly aboard the floating city.

When he went down with the captain to the engine room, he saw that most of the firemen were Chinese. Seeing the red fire casting its heat upon the sooted, gloomy faces of the firemen, Beihong felt as if he had run into an inferno. And long after his return to his own cabin, he still could not calm down. Later he wrote, "The moment I went down there, I was shocked by the terrible sight."

As the siren shrilled, the steamer nosed its way through the blue-green swells. Beihong again crossed the Pacific and the Atlantic as he had done fourteen years before. During the long voyage, he often stood facing the broad sea and recalled the fourteen eventful years. The calamity-ridden motherland, the miserable people, the disharmonious family — all these weighed on his mind like dark clouds.

In Paris, Beihong again lingered around the Louvre and below the Arc de Triomphe, this time nostalgically. His beloved teacher Dagnan-Boveret was no more. He tarried about in front of Dagnan-Boveret's studio, now occupied by a stranger.

Prior to the opening of the exhibition, in spite of work pressure, Beihong still remembered with concern Wang Linyi and Lu Sibai, who were then studying in France, and managed to find time to call on them. Beihong was a unique art educator as well as an ingenious artist. Not only had he a quick eye for talent, but he also offered those with it some financial aid.

He also strictly guided his students to take the right path and keep away from evil ways. This was diametrically opposed to the traditional idea: "While the teacher gives one only rudiments of knowledge, much should be left to one's self-cultivation;" as preached by feudal educators. When he visited Wang and Lu at the Ecole Nationale Superieure des Beaux-Arts and learned that both had been doing well in their studies and had distinguished themselves in the class, he was filled with unspeakable delight and hoped that they would soon finish their studies and return home to make contributions to the development of Chinese

art. On discovering among their exercises a fantastically shaped still life by Lu, Beihong at once criticized him severely for making such a picture. Although this kind of painting was then much in vogue in Paris, Beihong would never permit his students to pursue falsehood and affectation at the expense of truthfulness. He told Lu sincerely that to follow the fashion would do no good to the development of Chinese art, and that to become a real artist, one should always be determined to devote oneself to the cause of Chinese art.

On May 10, 1933, the exhibition of modern Chinese paintings formally opened in the Place de la Concorde in the centre of Paris. The opening ceremony was attended by more than three thousand people, including the French education minister, the French foreign minister and notables from various circles in France, who had come to see the exhibits and offer greetings.

In the course of the exhibition, the catalogues were twice reprinted, over two hundred laudatory comments were published in newspapers and periodicals, and the visitors totalled more than thirty thousand. Repercussions created by Chinese painting in Europe were so tremendous that articles on the exhibition also appeared in other countries —England, Spain and even distant America. All this brought great comfort to Beihong.

When the exhibition came to a close, the French government bought from it fifteen paintings in the traditional Chinese style, including those by Beihong himself, Qi Baishi, Zhang Daqian, Gao Qifeng, Wang Yiting, Jing Ziyuan, Chen Shuren, Wang Yachen, Lu Fengzi, Zhang Shuqi and Zheng Manqing, putting them on display in a special pavilion.

After that, Beihong went to Belgium on invitation to exhibit his own paintings. The Belgian people spoke highly of his works and the Belgian Queen viewed the exhibition with great interest.

Soon afterwards, at the invitation of Italy, Beihong also went to Milan with the exhibition of modern Chinese paintings. Newspapers and periodicals all over Italy unanimously praised the consummate skills and great achievements of Chinese painters. The exhibition was filmed and screened throughout the country. One Italian newspaper commented, "This marks another climax of Sino-Italian cultural

exchange since Marco Polo."

At the invitation of Berlin Art Association, Beihong also held an exhibition of his paintings in Germany. The association gave a banquet in his honour, and during the exhibition, special columns opened by some sixty Germany newspapers and magazines to introduce and comment on the exhibition all expressed high esteem for his works.

When he went to Frankfurt on invitation to hold an exhibition of his paintings, the president of Frankfurt University presided over the grand opening ceremony and the Frankfurt municipal authorities entertained him at a welcome banquet. When the two-week exhibition was drawing to a close, many visitors requested that it be prolonged, which was impracticable because Beihong had a fully packed programme, having also accepted invitations from many other countries. He decided to send his paintings to Rome to be exhibited around May 1.

It happened at that time that Britain and the Soviet Union simultaneously sent Beihong invitations to exhibit in their countries, both setting the date at around May 1. The Soviet invitation was especially urgent, asking Beihong to be present by all means around May 1 because at that time VIPs from various Soviet circles would have arrived in Moscow to take part in the spectacular May Day parade in Red Square.

After much consideration, Beihong decided to hold the exhibition in the Soviet Union instead of in Britain or Italy. Why did he change the original itinerary in favour of this new decision? In the article *Modern Chinese Painting*, written in 1946, he recalls:

> I then understood that the Soviet Union had been the first country to abolish the unequal treaties tsarist Russia had concluded with our country I had long been looking forward to visiting the Soviet Union to see its great efforts to reconstruct itself since the October Revolution. This was a very good opportunity.

The change of the itinerary, however, proved troublesome. Beihong had to go by train via Switzerland to Genoa, Italy, whence he was to take a seagoing vessel to the Soviet Union. But in Genoa he had to spend several days waiting for the arrival of his cases of paintings.

"Biwei," he said to his wife, "I feel like making use of these several days to visit Madrid. The museums in Madrid have a large collection of

famous paintings of the world. I don't want to miss this good opportunity. You remain here to wait for the cases of paintings, O.K.?"

"No! Absolutely not!" Jiang resolutely declined shaking her head.

Beihong looked at his gorgeously attired wife. When he was exhausting himself getting ready for opening the exhibition in Paris, she had stood by unconcerned with arms folded. She was fond only of visiting shops, buying cosmetics and ordering evening gowns or fashionable dresses. Beihong abandoned the plan of visiting Madrid to avoid getting into further trouble with her.

Several days later, when the cases of pictures arrived, Beihong and Jiang boarded an Italian liner to begin their eastward voyage.

When the ship called at Athens, Beihong went ashore to visit the Parthenon. Fourteen years before, he had been fascinated by some of its relics on display at the British Museum. Now, strolling among the rubble overgrown with weeds, he could not help thinking of ancient Greece and felt as if he had been transported back to the ancient world of Socrates, Plato, Aristotle, and Phidias.

Chapter XXVI

When the ship steamed into the Black Sea, the distant vast territory of the Soviet Union came in sight.

After Beihong landed at Odessa on the Black Sea, the Soviet Association for Cultural Relations with Foreign Countries sent special personnel to welcome and look after him, and accompany him on sightseeing trips to the local scenic spots and constructions.

Upon his arrival in Moscow, Beihong started making active preparations for the exhibition. Meanwhile, the Soviet Association also assigned special personnel to take full charge of preparing and arranging it. On May 1, 1934, when the exhibition of modern Chinese paintings was inaugurated at the History Museum in Red Square, the chairman of the Soviet Association gave a speech in which he reviewed the long history of friendship between the Chinese and Soviet peoples and expressed his hope for further mutual understanding in culture between the two peoples. Beihong in his reply speech expressed his thanks for the Soviet hospitality and his hope for the further development of Sino-Soviet cultural exchange.

The Moscow exhibition was an exceptional success. In *Propagating Chinese Art in Europe*, which he wrote after his return to China, Beihong recalled:

> The exhibition was more eagerly attended in Moscow than in any other European country. Sometimes the same visitors came to see it five or six times. Another noticeable fact is that while in other countries the visitors had been mostly intellectuals, in the Soviet Union they consisted more of workers and peasants than intellectuals. They would stand gazing fixedly at a painting and pondering and studying it, and would, on seeing me around, inquire of me about the content of each painting. They were greater art enthusiasts than Chinese workers or even the elite of any other foreign country They called this exhibition of foreign art the most spectacular one they had seen since the October Revolution.

While in Moscow, Beihong was repeatedly invited to deliver lectures at the Soviet Association of Art and various academies and universities of fine arts, and exchanged works with the noted Soviet painter Nesterov and the woodcut artist Krafchenka. He was especially happy about the friendship formed between himself and the noted Soviet sculptor Merkyloff.

Merkyloff, who was to die in 1952, was a thick-haired and bearded man of over fifty with black, flashing eyes. He warm-heartedly invited Beihong to be a guest at his home, which, situated in the suburbs of Moscow, had a big garden of over five hectares, decorated with huge granite stones and planted with thick-trunked white poplars. He was then engaged in making statues, a job entrusted to him by the Soviet government and not expected to be finished for more than ten years. In spring, Merkyloff would drill a small hole in the trunks of the white poplars and, after disinfecting it, let the tree milk drop into a bottle, which would fill by the end of the day. From each white poplar Merkyloff could get milk over a dozen times a year. He called the milk a life-prolonging tonic rich in various kinds of vitamins.

Merkyloff presented Beihong with two precious masks he had made, one of Lenin, and one of Tolstoy. The masks, though made of plaster, had been bronzed so that they looked like bronze sculptures. Beihong was deeply gratified.

When the Moscow exhibition came to a close, Beihong went to Leningrad on invitation to exhibit the modern Chinese paintings at the State Hermitage, the biggest art museum in the U.S.S.R. With a square in front capable of holding several hundred thousand people, the Hermitage had originally been the winter palace of the Russian tsar. To make an extensive introduction of splendid Chinese culture to the Soviet people, the museum attracted multitudes of spectators by putting on display at the same time the ancient Chinese bronzes, pottery, porcelain, jade carvings, ivories, sculptures and lacquerware in its collection.

In Leningrad, Beihong got acquainted with the famous Soviet sinologist Yaleseyev, who specialized in the study of ancient Chinese and had translated into Russian *The Book of Changes*, an ancient Chinese classic incomprehensible even to average Chinese. To the amusement of Beihong, the Soviet sinologist spoke to him all in classical

Chinese. Later, when Guo Moruo met Yaleseyev on a visit to the Soviet Union during the anti-Japanese war, the Russian still spoke classical Chinese and even used a classical Chinese expression to inquire after Beihong.

In Leningrad, Beihong also got acquainted with the old painter Liloff, whose landscape paintings Beihong was to mention admiringly several times even years later. Liloff invited Beihong to have a chat at his home, and took great pleasure in relating the following joke.

One year, when the Soviet government was collecting paintings showing the military exploits of the Red Army during the great revolution, Liloff was asked to contribute his works. But he said with a smile, "What I've painted are landscapes that certainly have got nothing to do with the great revolution. How can they be exhibited?" Someone, however, managed to obtain one of Liloff's landscapes and had it displayed at the exhibition. Some spectators, wondering what relationship there was between the landscape painting and the Red Army, asked the curator about it. The curator replied, "Don't you see the log cabin in the landscape painting? The Red Army is right behind it."

Of all the older Soviet painters, Nesterov was artistically the most outstanding. A devout Christian, he had painted most of the murals in Russian churches before the Revolution. When Beihong paid him a visit, he inquired of Beihong about his relations with French and German artists, showing particular interest in Beihong's relations with Dagnan-Boveret. Nesterov showed Beihong many portraits he had recently painted, all of which were masterly works of art. Beihong believed that few contemporary painters in the world could be put on a par with Nesterov. Nesterov, however, engrossed in painting, refused to pay attention to the affairs of the world or to put his works on display. The Soviet government tried to buy his paintings, but in vain. Later, when a younger painter contrived to have one of his portraits displayed at an exhibition and asked him to fix a price on it, he purposely named an exceedingly high price, more than ten times as much as the ordinary price. The Soviet government bought it nevertheless and had it exhibited at the art gallery. The next year, when the same painter had a self-portrait of Nesterov displayed at an exhibition, the Soviet government

not only again paid a high price for it, but also persuaded Nesterov to give an exhibition of his latest works. The government then bought the whole exhibit. Beihong was impressed. In the reminiscences he wrote in 1936, he says:

> To see the Soviet government uphold art without bearing grudges and take great pains to advocate real talent, one could not help being moved to tears.

It was early summer when the Leningrad exhibition of modern Chinese paintings was on. During this time, nights in Leningrad, known as "white nights," will remain bright for as long as a month without the necessity of putting on lights. In the never-ending evening twilight, Beihong would stroll along the bank of the Neva River, enjoying the soft breezes sweeping off the surface of the water. He passed his few pleasant days in Leningrad with a dream-like feeling. During the exhibition, besides making calls or trips, he would visit antique shops or art shops as soon as he had spare time. One day, upon seeing a beautifully carved figure priced at three thousand roubles, he was so fond of it that he decided then and there to buy it with the three thousand roubles he happened to have on him. He fished out the money and was about to pay it when Jiang, who had been standing beside him, snatched it out of his hand. She snapped with a fierce look on her face, "You kept the money without letting me know about it. I need it for shopping!"

Beihong smoldered over being thus embarrassed in public. He did not care to explain to her that the money had been given him as pocket money by Wu Nanru, Chinese charge d'affaires to Moscow. Wu, a native of Jiangsu Province and a next-door neighbour of Beihong in Fuhougang, had helped Beihong generously with the money when he learned that Beihong had been running the exhibition abroad without getting any government subsidies, and going about his work in a foreign country would certainly entail great expense.

What did Jiang need the money for? It turned out that she had taken a fancy to a Western silver dinner set plated with gold and modelled on the tsar's dinner set. The glittering, palace-style set, consisting of hundred and twenty pieces, was also priced at three thousand roubles. Now, with the money at her disposal, she of course did not hesitate to buy it. When she was gleefully packing it into her trunk, she did not know — and would never know — what pain she had

inflicted on her husband.

Upon the conclusion of the Leningrad exhibition, the city of Kiev also sent Beihong an invitation. But he had to decline because his students were expecting him to return to his teaching.

Before his departure, when the Soviet art circles expressed the hope that he would leave them with some Chinese paintings, Beihong let them choose what they liked. The State Hermitage picked twelve paintings, and Beihong gave the Moscow Gallery of Modern Art fifteen paintings by famous modern Chinese painters.

The Moscow People's Education Commission decided at a meeting to make Beihong a gift of thirteen books by some celebrated nineteenth century and modern Russian writers, which, however, did not materialize owing to obstruction by the Kuomintang government.

Chapter XXVII

Beihong took a Japanese passenger ship and arrived in Shanghai on August 17, 1934, via Vladivostok. His students held a grand welcome to celebrate his return. Aside from his highly prized sculptured faces of Lenin and Tolstoy, Beihong had also brought back replicas of works by Western realistic masters, including many copies of paintings by Repin and Surikov, masters of the Russian Peredvizhniki (Society of Wandering Exhibitions), such as *Ivan the Terrible's Murder of His Son, The Reply of the Cossacks to Sultan Mahmoud IV, The Morning of the Execution of the Streltsy* and *Boyarina Morozova.* He was the first Chinese to introduce the Russian Peredvizhniki to his own country.

In *Propagating Chinese Art in Europe,* written in 1936, he says,

> During this exhibition tour abroad, the Chinese paintings were seven times exhibited in France, Belgium, Germany, Italy and the Soviet Union, four "modern-Chinese-painting pavilions" were set up in various big museums and universities, and a total of two hundred million copies of articles and magazines extolling Chinese culture were published. In handling all affairs of the exhibition, both internal and external, I absolutely refrained from using the name of our government I should like to call the attention of our people to the fact that I did not get a single cent of financial aid from those special government offices which, as self-styled cultural foundations, had been annually wasting huge sums of public money The following is something most memorable. Soviet people would often ask me, "How many art galleries are there in your country? Yours is a country with an ancient civilization, so your art galleries must be better equipped than ours." Feeling much disconcerted, I would have to give a vague answer. As far as their grand structure and fine equipment are concerned, Soviet art galleries are indeed no inferior to, if not better than, those in Britain, France, Germany and Italy. Deplorably, our government has never cared to build art galleries to meet the pressing need of our people while it is wasting enormous funds every year in the name of cultural undertakings. To hell with it! We don't even have a single art gallery!

Prior to his departure from the Soviet Union, Beihong suggested

that Soviet artists should also come to China to give exhibitions, which helped to bring about the 1935 exhibition of Soviet woodcut prints in Nanjing and Shanghai. In his preface to the Soviet exhibition, he says:

> Art reflects the life of a nation and expresses and symbolizes the ideas of a nation.... The mutual respect and good-will among peoples of the world should begin with cultural exchanges.

In early 1935, soon after his return to China, a piece of bad news gave Beihong a terrible shock — his good friend Tian Han had suddenly been arrested by the Kuomintang government and sent to Nanjing under escort.

Beihong hurried to Tian Han's home. At the sight of Beihong, Tian Han's mother fell before him and cried bitterly. The old mother, from the time her husband died when she was still young, had quietly endured all kinds of hardships and difficulties in bringing up her three fatherless children. Now that her beloved son had been thrown into prison, though she had always been a woman of few tears, she was choked with sobs. Beihong helped her by the arm and tried patiently to console her. Tian Han's wife Lin Weizhong, suppressing her own sorrow, also tried to soothe her aged mother-in-law. She told Beihong tearfully how she had recently been to the prison to see her husband with her baby on her back and a mess tin in her hand. Lin had written Tian Han a letter of admiration after reading his works when she was still a young girl. Beihong pledged to do his best to rescue her husband.

Beihong busied himself to effect the rescue of Tian Han. On the pledge of Beihong and Zong Baihua, Tian Han was released on bail.

The steadfast Communist, however, did not keep quiet after his release from prison. With unwavering determination to devote himself to progressive drama, he started actively to organize a drama troupe and put on shows reflecting reality "for the sake of national independence and freedom." Tian Han exclaimed, "Some people say that since the popular drama movement has run into snags, the government should take it over. I think they are putting the cart before the horse. The people have always been the foundation of the state. The people do not always run into snags; the government will get nowhere if it goes it alone without popular support. The same is true of the drama movement as

well as of the national salvation movement."

In November of the same year, when the China Drama Association, under the charge of Tian Han, was inaugurated, many people from art and literary circles came to offer greetings, people such as Hong Shen, Zhang Shu, Ma Yanxiang, Bai Yang, Shu Xiuwen, Wei Heling, Wu Yin, and Wu Zuoren, The plays staged at the first performance were *The Feud* and *Song of New Spring*. Tian Han wrote the following lyrics of the theme song to *The Feud:*

> *Countrymen! Stop quickly the feud among ourselves,*
> *Let's fight the public enemy to the Chinese nation!*
> *Stop quickly the feud among ourselves!*
> *Let's fight the public enemy to the Chinese nation!...*

Meanwhile, Beihong wrote:

> Like a dying sick man still breathing strongly, this depressed nation of ours is giving forth Tian Han's violent and powerful voice, by which we know that both the sick man and this nation will undoubtedly survive.

The revolutionary cultural movement inspired Beihong's fighting will and influenced his thought. But just as the patriotic artist was plunging himself into the anti-Japanese, national-salvation cultural movement, a criminal hand was laying a dirty trap behind his back.

One day, Beihong came home earlier than usual because he planned to invite a friend to call on Tian Han with him. At the gate of his house, Beihong bumped into Zhang Daofan, who happened to be leaving the house. Zhang, who had often come for a rendezvous with Jiang Biwei during Beihong's absence was caught unawares. Embarrassed and flustered, he still behaved as if nothing wrong had happened.

"Er, er, Brother Beihong," said Zhang, "I just came to see you and you happened to be out. I've left behind some opinions for Sister Jiang to pass on to you." He turned his head to cast a smiling look at Jiang, who was standing behind him, and then turned around to address Beihong again, "Sorry, but I must be going because of another engagement." With a wave of the brand-new, broad-brimmed hat in his hand, he scurried off like a weasel.

Jiang accompanied Beihong into the room, a charming smile on her face and looking quite good-natured.

"Beihong," she said gently, "how could you refuse to paint a

portrait of Generalissimo Chiang Kai-shek? Vice-Minister Zhang told me just now that when he went to Central University to ask you to do it, you flatly refused and said you were not interested in the Generalissimo. Did you ever think of its consequences? I really can't understand why you've spurned exactly what others are dying for. Painting the portrait of the Generalissimo will mean a rapid rise in the world. So why not go ahead with it? Besides, in spite of your hard study in Paris, you've come back to be a mere professor while some of your former fellow students in Paris have joined the Kuomintang to become big officials. Even when President Dai Chuanxian and Minister Zhu Jiahua jointly recommended you to be a Kuomintang member, you also refused."

She heaved a sigh and, pointing her finger at the couplet "Hold your personal prejudice; cling to your willful behaviour" written in big characters and mounted on two yellow silk scrolls hanging on the wall, she continued, "Your couplet on the wall is such an eyesore to me. Why are you still hanging out with Communists like Tian Han? Since you came back from the Soviet Union, all you've been writing are articles propagating the Communist Party and praising the Soviet Union to the skies. Why don't you write about the poverty and miseries of the Soviet people? A great man knows how to ride the tide of his times. Why not look at the domestic trend, the current situation? You'd better hurry up and paint that oil portrait of the Generalissimo. That will do you some good, otherwise"

As Beihong listened to her endless self-seeking chatter, his thick, black eyebrows became more and more closely knitted, and the gloominess in his countenance gave place to anger.

"Will you please shut up!" Beihong interrupted her and raised one of his arms in annoyance. "Enough of your selfish talk!"

"That's really more than I can stand! The advice I've been giving you is all for your good," she said fuming. "Listen, we can dump this partnership and each go a different way. If you won't join the Kuomintang, I will! Don't think I'll yield to you!"

"And you're going to paint the portrait of Chiang Kai-shek as well?" Beihong retorted.

"Huh! You needn't satirize me. Perhaps I'm not as gifted as Sun Duoci. She alone is the great one. I never knew you to be such a person.

You've become so cruel" she howled.

One early morning, several days later, Beihong was about to go to the university to lecture when a boy student rushed in and panted out, "Professor, don't go to the university today!"

"Why?"

"Slogans against you are posted all over the classroom and even chalked all over the floor. They even mention the name of Sun Duoci."

Beihong's face turned dark as iron.

Jiang walked up with a smile, apparently not surprised by all that had occurred. There was behind her smile a clear evidence of inner gloating.

"Well," she addressed Beihong with mincing affectation, "I suppose you may as well go and ask Zhang Daofan to help you out of the predicament. He's very much concerned for us."

"I don't need anybody to help me out of the predicament!"

"Then go and see Sun Duoci!"

"I never think of seeing her!"

"You've already done quite a lot for her! And you want to send her abroad to study. And yet you think you've been doing everything without my knowledge!"

"I've never denied that I like her talent. I've fostered a great many talented boy students and helped them to go abroad to study. Why can't I foster a talented girl student?"

"I'll never let her have her own way! To tell you the truth, she's been cancelled as one qualified for going abroad to study!" Her eyes flashed with smug triumph.

You're going too far! You know she's been subjected to all kinds of humiliation, threat and attack. It's unfair." He tried hard to keep his senses.

"You're defending her again! Can't you stop being infatuated with her?" She yelled hysterically.

To put an end to the encounter, Beihong hurriedly walked out of his home. He lingered around the neighbourhood of his house all day. At nightfall, when he saw warm lights shining from inside the windows far and near, he visualized scenes of harmonious, happy families at table, and felt his stomach rumbling with hunger. Nevertheless, he remained

adamant and steered clear of his home, though for the moment he badly needed peace and quiet. He walked a long distance until he reached the home of his former fellow student in France Shen Yijia.

Shen, a chemist, had fallen in love with a certain Miss Zhang, who was the daughter of a senior Kuomintang member. The Zhangs strongly disapproved of the love affair between their daughter and Shen because the latter was a poor student. Miss Zhang, however, disregarded her parents' opposition and married Zhang in Paris. The newlyweds soon set out on their homebound voyage, but upon their arrival in Guangzhou, the Guangdong provincial governor, acting on a telegraphic message from the Zhang family, detained Shen and threw him into prison. The young wife nevertheless vowed to remain as faithful to her husband as ever. Later, they were reunited and had a child. Unfortunately, the child died of an illness, and husband and wife were very unhappy. They fought until they no longer loved each other, then agreed to a divorce. Miss Zhang was later remarried to the son of a revolutionary martyr, and Shen had since been living a bachelor's life.

Arriving at Shen's home, Beihong was given sympathy and solace by his former fellow student. That evening, Beihong felt unusually heavy-headed and weak, and he knew he was getting an illness. The next day, he went to see Wang Suyu, a doctor, he knew very well. After a careful check-up, Dr. Wang said, "Mr. Xu, your blood pressure is a little bit high. It's not serious now, but you may develop hypertension. You must be careful and relax. Besides, you have kidney trouble. That comes of overwork too, so you need a good rest." He wrote a prescription for Beihong.

But, where could he get a rest? Coming out of Dr. Wang's place, he again went to Shen's home.

Chapter XXVIII

A week passed. Beihong decided to leave Nanjing for Guilin, a city in Guangxi known for its unmatched scenic beauty, a place where he could paint in peace.

As soon as he got on the train, he felt as if a heavy load had been taken off his mind. Sitting close by the window, he watched the fast-retreating cottages and farms outside the train. The rumbling train left Nanjing far behind, and Beihong felt a thrill of relief. It seemed as if his endless worries and sufferings were being scattered over the long journey with the thick smoke of the locomotive.

Charmed by the paramount beauty of Guilin, Beihong was again immersed in his enthusiasm for painting. By making a vivid picture of the vast Lijiang River in misty rain, he introduced a novelty into the art of Chinese landscape painting.

When Beihong was thus absorbed in painting the landscape of Guilin, the anti-Japanese "June 1st Movement" broke out in Guangxi and Guangdong provinces. The circular telegram they published called on the Kuomintang government to comply with the popular wish and fight against Japan. Dozens of military leaders in Southwest China also issued an open telegram in response, saying that they wanted "to wipe out the repeated national humiliation, and struggle for the survival of the nation now being threatened." The June 1st Movement created a nation-wide repercussion and also inspired Beihong.

Consequently, Chiang Kai-shek mustered an army half a million strong, which began to march on Guangxi and was to besiege it along four routes. The exasperated Guangxi authorities expanded their fourteen regiments of provincial defence forces to forty-four regiments

in preparation for a decisive battle with Chiang's army.

The situation was explosive. While many people were fleeing from Guangxi in panic, Beihong insisted on staying behind to support the anti-Japanese demands of the Guangxi army and people. Inspired by the anti-Japanese and anti-Chiang slogans and unaware of the power struggle then going on among the ruling cliques, Beihong sought revitalization of the national spirit without heeding his own personal safety. The Guangxi military and government leaders, such as Li Zongren, Bai Chongxi and Huang Xuchu, had a high esteem for Beihong's attitude and treated him very courteously.

When she saw that war was imminent, Jiang Biwei decided to go to Guangxi, risking danger to try to persuade Beihong to return to Nanjing quickly. She took a ship in Shanghai for Hongkong, then a train in Hongkong for Guangzhou and there changed to another train for Sanshui, where she took a ship for Wuzhou. Finally she reached Nanning, the capital of Guangxi, on a small steamer from Wuzhou. It was hot summer.

Having been informed by cable of her visit to Nanning, Beihong went to the wharf to meet her with a feeling of great joy and gratitude. He seemed to have forgotten all the hapless squabbles and began to dream of having a happy family again.

But when they were left alone face to face, they were once again involved in a most unpleasant conversation. Jiang asked in a serious tone, "You know why I've come here?"

"No, I don't." Beihong again sensed the inharmonious atmosphere that had before enveloped them.

"I've come here to take you home!"

"Biwei," said Beihong cordially with a deep sigh, "it's only proper that I should go home with you since you've come to Nanning in spite of all kinds of hardships. But under the present circumstances, I can't leave this place. The strong demand of the Guangxi army and people for resistance to Japan should be given support by the whole nation, especially when Guangxi Province is now besieged by several hundred thousand troops of the Central Army. It would mean betrayal for me to leave here!"

135

"I know you never think of me. You don't want to betray anybody except me! Must I go home alone after coming here over such a long way?"

"Well, you don't mind staying here, do you?" Beihong asked hopefully.

"You're crazy! I hate Guangxi. Li Zongren, Bai Chongxi and others are a band of robbers. They're rebelling against the Central Government!"

Beihong's face fell and he kept silent, thinking it futile to carry on the discordant conversation.

In the following days, Beihong took Jiang to see the Lijiang River and visit Guilin and Yangshuo. But neither had much fun.

Soon after, Beihong saw Jiang off at the Nanning airfield. Then he again started his artistic creation and successively painted *Braving the Storm, Morning Song, Ancient Cypresses* and *Against the Wind* in the traditional Chinese style to express his deep concern for the destiny of the nation.

In *Morning Song,* many sparrows in a crisscross network of leafless tree branches are twittering in expectation of the advent of spring. Beihong put on the picture the inscription, "Spring is not coming, 1936."

The picture *Against the Wind,* in which sparrows are flapping their wings to fly against a violent windstorm, reflects the people's spirit of resistance and possesses a rich flavour of the time.

Ancient Cypresses is a picture of luxuriant, ancient cypresses with thick boughs and twisted branches as one often sees in Beijing. The man sitting under a cypress is the painter himself. Beihong inscribed the following poem:

> *Will there be an end to heaven and earth,*
> *Which have lasted so long since time immemorial?*
> *Endowed with a sensitive mind,*
> *I'm lost in musing.*

He sought refuge in Guangxi and went back to Guilin, where he passed his time on the Lijiang River.

The beautiful Lijiang was his companion, and also a place for him

136

to enjoy peace and quiet. He often went drifting around the river on a wooden boat and lived almost the same life as the boat people. The one who sailed the boat for him was a Guangxi boatman, whom he cordially called brother Zhou. Brother Zhou had an only son, aged twenty, who was a pedlar selling cigarettes and sundry other goods in town and often came to the boat with his mother. Beihong would chat with them and eat very simple meals with them — savoury rice or taros. He enjoyed the warmth of living with the boat family. The painter, who had never let his brush lie idle, did his painting *Boat Family* in the traditional Chinese style to mirror the life of those people.

One day, when Beihong left his boat and went ashore at Yangshuo, he saw in the small town a dilapidated cottage with two tall magnolias in full bloom. He liked the place so much that he could hardly tear himself away. He contemplated renting the cottage so that he could live there with the boatman Zhou and become one of the local common people. He also had a seal engraved with the inscription, "A common inhabitant of Yangshuo." Later, when Li Zongren heard of it, he bought the cottage and had it reconstructed before giving it to Beihong as a gift. Beihong was much indebted to Li Zongren for his kindness, but he felt lost as he stood before the rebuilt house with its whitewashed walls and vermilion windows. He had preferred the unadorned charm of the original small cottage.

Though the art students at Central University were longing for his return, the university president Luo Jialun had already decided to invite a certain Shanghai painter to replace Beihong, with the recommendation of Lin Sen, Chairman of the Kuomintang government. When the students learned of it, they immediately submitted a petition to President Luo to reject the incompetent Shanghai painter and demand that Beihong be asked to come back to teach them. President Luo said, "It is not that I refuse to invite him, but that he himself doesn't want to come back!"

One of the students, Feng Fasi thumped the table with his fist and questioned the president, "Why doesn't our university write to *ask* Professor Xu to come back?"

After receiving one letter after another from his students urging him to return, Beihong came back to Nanjing to resume his teaching.

137

On December 12 of the same year, the Xi'an Incident* occurred. Generals Zhang Xueliang and Yang Hucheng in Xi'an arrested Chiang Kai-shek out of patriotism and issued a call to the whole nation for cessation of the civil war and alliance with the Communist Party against Japan. This subsequently compelled Chiang Kai-shek to accept the alliance, making it possible to initiate the anti-Japanese national united front and providing favourable conditions for launching the nationwide anti-Japanese war.

On January 28, 1937, recalling the anti-Japanese hostilities of Shanghai, Beihong did the traditional Chinese painting of *In Remembrance of the Heroic Struggle*, on the upper right corner of which he wrote the following inscription:

> Five years have passed since the outbreak of the heroic national struggle on January 28, 1932. How I am overwhelmed with emotion in thinking of the past and the present!

In this picture he painted a crowing cock to symbolize the people's yearning for a bright future. Next he painted *A Cock Crowing in Wind and Rain*, signifying the call of the time and expressing the painter's yearning for the passing of the long night and the coming of dawn. During this period, Beihong was very prolific. In face of the national calamity and upheavals, he made increasing efforts to link up his artistic creation with the future of the nation.

In the spring of the year, Beihong went to Changsha, Guangzhou and Hongkong to hold exhibitions of his works.

When the exhibition was done, he decided to go to Guilin via

* In 1936 the Kuomintang's Northeastern Army headed by Zhang Xueliang and the Kuomintang's Northwestern Army headed by Yang Hucheng were stationed in and around Xi'an; they were charged with the task of attacking the Chinese Red Army which had arrived in northern Shaanxi. Influenced by the Chinese Red Army and the people's anti-Japanese movement, they agreed to the Anti-Japanese National United Front put forward by the Communist Party of China and demanded that Chiang Kai-shek unite with the Communist Party to resist Japan. Chiang Kai-shek turned down the demand, became even more active in his military preparations for the "suppression of the Communists" and massacred the anti-Japanese youth of Xi'an. Zhang Xueliang and Yang Hucheng took joint action and arrested Chiang Kai-shek. This was the famous Xi'an Incident of December 12, 1936. Chiang Kai-shek was forced to accept the terms of unity with the Communist Party and resistance to Japan and was then set free to return to Nanjing.

Hongkong. Passing through Guangzhou, he saw in town a notice for a woodcut exhibition. Being an enthusiast of China's developing woodcut, he tried to locate the place of the exhibition with the help of the address given in the notice although he was quite a stranger in the city. The woodcut exhibition, held on the upper floor of a photo studio, had been sponsored by three young men, namely, Lai Shaoqi, Pan Ye and Qin Zhonggang. The works on display all reflected the national salvation movement and strong grievances against the Kuomintang government. Beihong finally managed to find his way to the exhibition by making inquiries, and there he looked over the works of the three young people with great interest. His visit being unexpected, the three young people were quite unprepared to receive him. Beihong paid no attention, and encouraged them to make further efforts. He also had a group photo taken with them to mark his warm support for the new-born revolutionary art of woodcut.

Lai Shaoqi, then only nineteen, is now reputed for his unique style of calligraphy and traditional Chinese painting in addition to being an outstanding wood engraver.

Not long afterwards, Beihong revisited Guilin where he did the well-known traditional Chinese painting *The Lijiang in the Spring Rain*.

Chapter XXIX

On July 7, 1937, gunfire at Lugouqiao* kindled the flames of the Chinese people's all-out war of resistance to Japanese aggression. On August 13, Japanese troops attacked Shanghai in force before they marched on to Nanjing. Beihong, then in Guilin, hurried back to Nanjing in an attempt to remove his whole family to Guilin. Jiang Biwei, however, strongly objected to it.

"I'm disgusted with Guilin! It doesn't interest me at all!" she snapped in an extremely frigid manner.

Beihong was eager to effect a reconciliation with Jiang, not knowing that she had already become the mistress of Zhang Daofan. Jiang wanted to go to Chongqing, which the Kuomintang government had already chosen to be its war-time capital, and to which Zhang Daofan was also to go later. For the time being, however, she would rather remain in Nanjing because Zhang had not yet moved. Beihong could do nothing but leave her with a sum of money for travelling expenses before he himself hastily returned to Guilin.

Not long afterwards, Central University moved to Chongqing, and students requested Beihong to come back to teach there. Beihong came back to the university in October.

Upon its move to Chongqing, Central University was housed in poor school buildings and lacked studio facilities. Beihong made every effort to help the students overcome their difficulties. When some

* On July 7, 1937, the Japanese invading forces attacked the Chinese garrison at Lugouqiao, some ten kilometers southwest of Beijing. Under the influence of the nation-wide anti-Japanese movement, the Chinese troops put up resistance. This incident marked the beginning of the Chinese people's War of Resistance Against Japan, which lasted for eight years.

students became depressed, he would try his best to encourage them and buck them up. In addition to classroom exercises, he also taught them to paint picture posters so that they could play an active part in the anti-Japanese war.

What about his home? The home which Jiang had already set up in Chongqing was now always full of distinguished guests. Beihong found the heavily made up and gorgeously dressed woman talking volubly and treating him with supercilious disdain. While formerly she had still entertained a certain measure of wifely tenderness for her husband in spite of her quarrels with him, there was now none left and in its place were apathy and hatred. When they again fell out over some trifling matter, Beihong left home quietly, this time never to return.

He sent his student Yang Jianhou to fetch him his belongings from Jiang, but she gave him nothing but a few thin, old clothes, which she tied with a piece of string and let Yang carry away in his hand.

Beihong, who had taken up lodging at the bachelor quarters of Central University, now lived a solitary life. Teaching and painting were the only solace for his lonely unhappiness, and also the only thing that could afford him gratification. Little did he expect then that Jiang Biwei and Zhang Daofan had already made repeated vows of love to each other in Nanjing and that now in Chongqing, in one of her love letters to Zhang, she had written, "I belong to you both spiritually and physically."

Zhang Daofan, who had been a complete failure as a painter, was jealous of Beihong's talent and hated him for his refusal to serve the Kuomintang. So he made use of Jiang to carry out persecution and retaliation against Beihong.

On Chinese New Year's Eve in 1937, while people were setting off firecrackers, Beihong walked in solitude along the bank of the Jialing River. To him, the warmth of family life had become something of the remote past. On this evening, while every family was enjoying its reunion, he could not help reflecting on his boyhood, and his aged mother and brothers and sisters still living in the Japanese-occupied zone.

The night deepened. The lights on the opposite bank of the river were being extinguished one after another. On the silent deserted river

bank, there appeared a woman rag picker carrying on her back a bamboo basket and limping over towards Beihong. She was shabbily dressed and her starving eyes flashed with a fierce light. The unexpected sudden appearance of the woman anxiously collecting junk even on New Year's Eve filled Beihong with strong compassion. He quickly fished out what money he had in his pocket and thrust it into her hand. Holding the money in both hands, she was struck dumb with surprise and stood there staring at her generous benefactor. She made a deep bow to Beihong and, carrying the stick in her hand, walked away with a limp.

There flashed across his mind what had happened on that fearful, raw night of over twenty years ago by the Huangpu River. He seemed to hear again the moaning and sighing of river water. He was now more than forty years old, but nothing had changed.

Beihong quickly went back to his dormitory, and, getting ink and brushes, he began to paint from memory a picture of the woman by the chilly lamplight. On the upper right-hand corner of the picture, he affixed the following inscription:

A poor woman of Sichuan, portrayed on Chinese New Year's Eve, 1937.

Since the city of Chongqing is situated on a hillside, rows of houses stand tier upon tier and streets are slopes with rising stone stairs. In Shapingba, where Beihong lived, he often saw local people labouring up stonestairs over a thousand feet high carrying water from the river in two buckets suspended from a shoulder pole. After a long time of careful observation, he painted *Sichuan Folk Drawing Water from the River*, to describe the hard life of the working people. The picture is inscribed with the following poem:

I am often pained to see Sichuan folk carry water
Up a hill one thousand feet high.
Added to their hard toil on the farm
Is the torture of their routine.

Another traditional painting done then by the melancholy painter in Chongqing is named *Self-Portrayal*, which expresses his worry about the national crisis and longing for the bright future. In this painting, the painter himself stands below two giant ancient cypresses looking ahead into the distance while around his feet are jagged rocks, flowing water

and orchids. The upper left-hand corner of the picture is inscribed with the following poem:

Amidst a jumble of rocks skirted by flowing water
And the pervading fragrance of orchids,
I search for distant signs of action
And stand awaiting the rolling thunder.

Chapter XXX

The July 7th Lugouqiao Incident was followed by the fall of Beijing and Tianjin and the utter rout of the Kuomintang troops. After the Japanese occupied Shanghai and Nanjing in November and December of 1937 respectively, Wuhan was in imminent danger. People fled to the rear one after another to escape enemy rule, wandering about with their whole families as refugees. In order to raise funds to aid homeless refugees and to publicize the resistance movement among overseas Chinese, Beihong decided to go on an exhibition tour to Singapore.

To avoid the indiscriminate bombing by Japanese planes, Beihong had stored all his works in a cave on Qixingyan Mountain, Guilin. Now, in July 1938, he left Chongqing for Guilin, where he was to take out part of his works from the cave to be exhibited abroad. After that, he sailed eastward on the Xijiang River in Guangdong, planning to go to Singapore via Hongkong. But the subsequent fall of Guangzhou compelled him to drift about on the Xijiang River for over a month.

The boat reached Jiangmen, which lay close to a well-known small town named Sihui with a population of more than fifty thousand. There, a certain Mr. Chen, who was also a painter and had once taught at Guangzhou Art School, came to the boat to see Beihong after he heard of his passing through. He invited Beihong to have a meal and a talk at his uncle's home. After the meal, Chen produced a picture called *Nostalgia for the Xijiang River*. Beihong praised Chen for his skills, but he also saw at a glance a defect in the picture, asking humorously, "Can this picture also be named *Nostalgia for the Yangtse River* or *Nostalgia for the Yellow River*? It might even pass for *Nostalgia for the Heilong River*."

Chen asked, "Well, Mr. Xu, could you tell me how to make it worthy of the name of *Nostalgia for the Xijiang River*?" He eyed Beihong

uneasily.

Beihong said with a smile, "If it's a picture of the Xijiang River, it should possess such distinguishing marks as can tell of its locality and environment. For instance, if you paint in houses as a distinguishing mark, remember that houses in Guangdong Province are different in structure from those in other places. Take plants for example, if you paint in bamboos, remember that they are rare north of the Yangtse River, and even rarer north of the Yellow River. Bamboos in Guangdong and Guangxi provinces, though they grow thickly, mostly do not form groves such as we find in Zhejiang, Hunan, Hubei, Anhui, and Jiangxi provinces. And banyan trees in Fujian and Guangdong provinces are huge and their branches grow down towards the ground and take root while those in Hunan, Jiangxi and Sichuan provinces have big leaves, but their branches do not form new roots. That's something characteristic. As far as I know, Japanese banana trees in Guangdong yield clusters of fruit while those in Zhejiang and Sichuan seldom bear fruit, though they can blossom. Since Guangdong is subtropical and rich in tall palm trees, a number of towering palms and fruit-laden Japanese banana trees added to the picture will make it quite distinctive."

Chen understood and nodded agreement again and again, marvelling at the artist's rich knowledge of Chinese geography and flora.

Beihong arrived in Hongkong at the end of the year.

One day the previous year, he had, through the introduction of the Chinese writer Xu Dishan and his wife, called on a German woman to see her collection of Chinese calligraphy and paintings. The woman's father had for many decades held public office in China. Upon his death, she inherited from him four trunks of Chinese calligraphy and paintings. As she knew nothing about Chinese art, she wanted to sell them and hence asked Xu's wife to be on the lookout for a prospective buyer. Therefore, when Beihong called on her, the German woman personally opened the four trunks. Beihong looked into the first trunk, then the second trunk, from which he picked out two or three fine works he liked. When he looked into the third trunk, his eyes brightened because there appeared before him a very long scroll of figure painting. He was so

excited that, in unrolling the scroll, his fingers quivered and his heart beat violently with joy. He blurted out, "I'm not even going to look at the rest of the pictures! This is the very one I want!"

They immediately began to negotiate the price. Beihong then had on him less than ten thousand dollars in cash, so he suggested giving her in additon seven of his own paintings.

The woman, after pondering, agreed.

The scroll is a Tang painting named *Eighty-seven Immortals*. On dark brown silk, it is done by an unknown painter with the line-drawing method. The eighty-seven airy figures in it walking in procession have graceful shapes and animated postures, executed in vigorous and lively lines without colours. Beihong had a high opinion of the traditional Chinese line-drawing technique. He says, "Lines are at their best only when they exercise a whole gamut of artistic effects." This has been borne out by the picture scroll in question. He believed that it must have been the work of a Tang master-hand. He affixed to it the seal bearing the inscription, "I, Beihong, hold this picture as dear as my own life."

At that time, this was regarded as the only Tang figure-painting scroll extant until *Han Xizai's Night Banquet*, another figure painting of the Tang Dynasty, was purchased by Zhang Daqian. Beihong thought it the greatest pleasure in his life to have redeemed this national treasure from a foreigner so that it might remain in China.

After having it remounted and inscribed with some short comments, Beihong took the picture scroll with him to Hongkong, where he asked Zhonghua Book Company to prepare a photographic plate and make a de luxe printing. However, as he was in a hurry to depart for Singapore, he did not wait to see its publication.

To publicize the resistance movement and to acquaint more overseas Chinese with the real situation in the war-ravaged homeland, Beihong ungrudgingly gave great energy and time in associating with people of all circles in the overseas Chinese community in Singapore. Overseas Chinese in Singapore form the great majority of the local inhabitants. The tragic news of their country being trodden down under the heel of the Japanese invaders prompted them to give active support to Beihong in running the exhibition to raise relief funds for refugees at home.

On the opening day, the exhibition hall was crowded to capacity and the Governor of Singapore came in person to offer greetings. Except those not for sale, Beihong's works on display sold out quickly.

Beihong realized that many of the Chinese visitors had come not merely to buy the works of a celebrated artist, but also to offer their contributions to their motherland. He seemed to see again the poor riverside woman begging for alms on Chinese New Year's Eve and hear the gun shots at Lugouqiao. He felt deeply gratified with the fact that his art career had been linked up with the future of his own country and people.

When the exhibition ended, Beihong donated all the proceeds to aid refugees in China.

Chapter XXXI

In the spring of 1940, at the invitation of the great Indian poet Rabindranath Tagore, Beihong went to India to lecture at Visna-Bharati University.

Tagore, known as father of modern Indian literature and a patriot and democrat, was a revered friend of the Chinese people. When Beihong was in Santiniketan, where Visna-Bharati University was located, he passed many memorable days in company with Tagore.

Santiniketan, which means "the abode of peace," is a quiet place. The mango trees laden with clusters of fruit, the fiery silk-cotton flowers, the indefatigable, soft-voiced singing of birds, together with Tagore's refined speech and demeanour, were to live forever in Beihong's memory.

Beihong was fond of listening attentively to Tagore's sonorous recitation of his poems like the following:

....

The singing river water
Swiftly flows past
And sweeps away all dykes.
But the mountain peak remains behind,
Thinking
And full of longing.

....

While in India, Beihong made use of every opportunity, whether in his contacts with private individuals or in his public addresses, to publicize the anti-Japanese war and win the understanding and sympathy of the Indian people. Apart from teaching in the art department of Visna-Bharati University and social activities, he

148

continued to engage in artistic creation. He made sketches of many students of the university as well as some folk artists, such as *The Drummer* and *The Musicians*. He drew sketches, oils and traditional-style portraits of Tagore.

Tagore had consistently cherished a warm sympathy for China. He had a worried concern for China's War of Resistance, and repeatedly stressed to Beihong the lasting friendship between the peoples of China and India. On February 17, 1940, when the aged Indian sage Mohandas Gandhi visited Santiniketan, Tagore introduced Beihong to him and suggested holding an exhibition of Beihong's paintings to promote friendly relations between the two countries. Gandhi agreed. In a place thronged with people, Beihong took but a few minutes to finish a sketch of Gandhi, which the latter gladly autographed.

On the evening of the same day, Beihong attended the prayers conducted by Tagore and Gandhi in a square. The lofty sound of the chanting lingered under the watery moonlight. After the praying was over, Beihong walked through a forest of tall trees, treading on the speckled moonlight filtering down through the foliage, on his way to have supper at the home of Tagore's secretary, whose wife happened to be a well-known painter. The secretary and his wife were very hospitable, and Beihong had meals at their home every day.

Beihong soon finished preparations for the exhibition, which was held both in Santiniketan and Calcutta. In the introduction to the exhibition Tagore wrote:

>Beautiful speech is common to all mankind in spite of its diversified enunciation. By means of his rhythmic lines and colours, the Chinese art master Xu Beihong provides us with our forgotten scenes of antiquity without impairing the local flavour and peculiar style acquired through his own experience.
>
> I welcome this exhibition and I have fully enjoyed his paintings, from which I believe our art lovers will draw rich inspiration. Since the worth of superb works of art should be proved by themselves, too many words of recommendation on my part are superfluous. Let me, therefore, raise the curtain of talk to usher our visitors to a rare feast.

Again Beihong sent all the funds raised at the exhibition to China to help the refugees.

He then journeyed to Darjeeling, where he created *The Foolish Old Man Who Removed the Mountains,* a traditional-style painting he had long been considering. The theme of this painting is from a popular

149

Chinese fable,* with the moral that, so long as one perseveres and has great willpower, one can eventually overcome any difficulties. China's War of Resistance was passing just then through a most arduous stage, but Beihong firmly believed that if the Chinese people could carry on the struggle with the same tenacity as the Foolish Old Man, they would surely remove the two big mountains lying like a dead weight on them, i.e., feudalism and imperialism, and win final victory in the war. It was this conviction that spurred him on the paint *The Foolish Old Man Who Removed the Mountains.*

The painting, 424 cm in width and 143 cm in height, depicts the magnificent scene of mountain digging. Each figure in it was painted after a model and with an accurate draft sketch. The grey-haired and long-bearded Foolish Old Man stands holding a mattock while the beefy mountain diggers are wielding their tools.

From his lodging in Darjeeling, Beihong could feast his eyes on the incomparably majestic view of the distant Himalayas. With a great longing for his motherland on the other side of the mountains, he drew the traditional paintings *The Himalayas* and *Forest on the Himalayas,* as well as the oil painting *Morning Mist on the Himalayas.* While in India, he also visited many ancient temples, marvelling at the ancient Indian art.

Beihong also went galloping on horseback on the vast plain and reached places as far as Kashmir. He loved the graceful, sturdy steeds with long, steely-hoofed legs. He was spell-bound. He now came to know even better how docile, bold, loyal, tireless and patient these animals were. From then on, the horses he painted were characterized by greater vigour. With the technique of splash-ink or that of fine brushwork plus freehand strokes, he portrayed horses in a great variety

* It tells of an old man in ancient times known as the Foolish Old Man of North Mountain, who made up his mind to remove from his doorway two great peaks obstructing the way. Another greybeard known as the Wise Old Man, thinking he was attempting the impossible, derisively called him silly. The Foolish Old Man replied, "When I die, my sons will carry on; when they die, there will be my grandsons, and then their sons and grandsons, and so on to infinity. High as they are, the mountains cannot grow any higher and with every bit we dig, they will be that much lower. Eventually we shall clear them away." Later, when God heard of it, he sent down two angels, who carried the mountains away on their backs.

150

of postures, some standing erect and still, some turning back their heads and neighing, some prancing high up into the air, some trotting away.... He personified horses to express his own sorrow and care, or hope and joy.

In November 1940, Beihong wound up his tour of India. He returned to Santiniketan to say good-bye to Tagore, who, reclining on a couch with wavy long hair and silvery beard, happened to be recuperating from an illness.

The eighty-year-old Tagore had painted more than two thousand pieces since he started painting at the age of about sixty. The painting utensils he had used included Chinese and Japanese ink, and water-colours, gouache, pencils, crayons and oils such as those used in Western painting. His works, which enjoyed great popularity, had been exhibited in Paris, London and Moscow.

Now at Tagore's request Beihong, together with Nandalal-Bose, dean of the art department in Visna-Bharati University, spent two whole days examining Tagore's paintings. They picked out from them more than three hundred choice pieces, of which more than seventy of the best were to be published by the university.

Tagore was very pleased. A smile flickered in his limpid eyes, and a sadness over the separation crept across his sickly-looking face.

Beihong reluctantly bade farewell to the bed-ridden Tagore. Later, in Singapore, he was greatly grieved on hearing of Tagore's death and deeply cherished the memory of this old friend of the Chinese people.

Chapter XXXII

In November 1940, Beihong left India for his fourth visit to Singapore — a place which had left him with many delightful memories. The patriotic Chinese nationals all treated him with cordiality.

The Chinese in Kuala Lumpur, Pinang and Ipoh also came to invite Beihong to hold art exhibitions in the three cities to raise refugee relief funds for China; soon after his arrival in Singapore, he began to prepare for the three exhibitions.

The year 1940 was drawing to a close. While it was severe winter back in China, Singapore was in the depth of broiling summer days. Dripping with sweat, Beihong kept painting day and night to put out enough pieces for sale at the three exhibitions.

The round-the-clock toil brought on a sudden attack of illness. He felt an excruciating pain in his back; unable to bend or move, he had to be confined to his bed. But the very thought of his war-torn nation would conjure up the tragic vision of his compatriots being slaughtered by invaders and war refugees wandering about homeless. His peace was constantly disturbed. "I must hurry with the se exhibitions!" he kept urging himself. He tenaciously rose from his sickbed to pick up the brush again, ignoring the incompletely cured lumbago and the doctor's advice to the contrary. Unfortunately, like the intestinal spasm he had contracted in Paris due to hunger and cold, the lumbago became a lingering illness that kept tormenting him for the rest of his life.

In 1941, the fund-raising art exhibitions held successively in Kuala Lumpur, Pinang and Ipoh were exceptionally grand occasions warmly acclaimed by the local inhabitants and overseas Chinese. They all took it as an honour to buy Beihong's paintings. Whenever he appeared in the exhibition hall wearing a light-coloured Western suit and a black bow-tie, he would be completely surrounded by enthusiastic visitors,

each reaching out an album seeking his autograph. Beihong, in high spirits, would make use of the opportuniy to strike up a conversation with them and propagate the anti-Japanese war as best he could. Sometimes, when addressing a gathering in various places upon invitation, he would urgently call on overseas Chinese to do their best for the calamity-ridden motherland. Many of them, inspired by his patriotic spirit, became his good friends.

As eager supporters of the anti-Japanese war, overseas Chinese rushed to buy Beihong's paintings at each exhibition and took pride in doing so. Beihong donated all the enormous funds raised at the three exhibitions to the aid of China.

The American Aid to China Federation also extended an invitation to Beihong to hold an exhibition in the United States. Once more He returned to Singapore to make active preparations for it and began to paint tirelessly.

He was however, unexpectedly hard hit by a sudden change in the political situation. By the end of November 1941, all his picture albums, photos and exhibition materials had been sent to New York, and his paintings, having been packed, were ready to be consigned for shipment. But early on the morning of December 7, deafening explosions rocked Pearl Harbour. Japan had sneak-attacked Pearl Harbour and was also launching an attack on Singapore, which, taken by surprise, was thrown into terrible confusion.

That very night, Beihong hurriedly left Singapore for Burma by sea. Because travel then was difficult and he was pressed for time, Beihong, unable to take along all his works, left behind forty oil paintings — the best of his works and the fruit of decades of his painstaking labour — with a local primary school. When the Japanese troops began to round up and massacre patriotic overseas Chinese after occupying Singapore, the primary school authorities, afraid of getting involved with Beihong, who was known to all for the anti-Japanese propaganda he had actively engaged in, had to destroy all the forty oils by sinking them in a well.

About to cross the Sino-Burmese border into China's Yunnan Province, he felt a thrill of excitement, like a son returning from a far-away land to the side of his mother. Dead tired as he was after the nerve-

racking journey, harassed by Japanese airraids, the Kuomintang frontier guards insisted on checking his luggage as usual. Seeing them rummaging through his luggage and scattering everything around on the ground in a terrible mess, Beihong cast a worried look at the several bulky trunkfuls of his paintings, fearing that some mishap might befall them. He was left with no alternative but to fish out a visiting card and ask to see their officer. Minutes later, a middle-aged man in army uniform came out, and greeted Beihong smilingly, "Mr. Xu Beihong, I'm very glad to meet you. Please come in and take a seat!" Meanwhile, he also handed Beihong a visiting card of his own.

Looking at the visiting card, Beihong asked immediately, "Mr. Huang, may these trunks pass without being opened and examined? They contain nothing but my own paintings."

"Of course, of course," replied Huang warm-heartedly.

Beihong was easily moved by any act of kindness on the part of his countryman no matter how small it might be — so much so that when Huang asked for some of his paintings, he readily gave him two.

After crossing the border, Beihong went to Baoshan, an important frontier town in Yunnan. To save money, he went to eat sesame seed cakes at a small eatery instead of a full meal. The cake maker, hearing Beihong speak with a Jiangsu accent, beamed with joy and said, "We're from the same place!" The man, a former refugee who had fled to Yunnan to seek a livelihood after his hometown was occupied by the Japanese, was very homesick.

They had several chats together. One day, the cake maker asked, "Mr. Xu, could you take me along with you?"

"But I'm going back to Chongqing," replied Beihong apologetically.

"All right, take me along to Chongqing then!"

Eyeing with sympathy the middle-aged man who spoke with a heavy accent of his native place, Beihong readily promised to take him to Chongqing.

Soon afterwards, they arrived in Kunming accompanied by another person named General Liu, a refugee from Singapore. General Liu had come to know Beihong through the special introduction of some patriotic overseas Chinese when he visited the art exhibition Beihong

154

was holding in Singapore. Formerly secretary to the anti-Japanese general Ma Zhanshan, General Liu had later been imprisoned and brutally tortured by the Japanese following the occupation of Shanghai. He owed his narrow escape to the help of some patriots in the prison. In Singapore, he won the deep respect of many patriotic overseas Chinese and Beihong by telling of this episode in his past.

Beihong had a short rest in Kunming, where the weather is like spring all year round. During his brief sojourn in the city, however, he was always eager to do his bit for the anti-Japanese war. There he held an exhibition of all the paintings he had previously prepared to display in the United States. It was warmly received by people of all circles in Kunming. This time he devoted all the proceeds from the sale of the exhibits to the front-line soldiers as an expression of gratitude and appreciation.

In Kunming, as elsewhere, many serious young students of painting paid visits to Beihong. One day, a plainly dressed man in his twenties came to see Beihong with his paintings and sculptures. Beihong carefully examined his works and appreciated them very much for their rich flavour. Gazing at the youth, Beihong asked amiably, "What's your name? What's your present job?"

"My name is Yuan Xiaocen. I'm a student of Chinese at Yunnan University."

"Why not study painting instead of Chinese?"

This question evoked bitter memories for Yuan. He had been born in a small mountain village in Guizhou Province inhabited by the Miao and Han nationalities. Since he was a child, he had been fond of using charcoal to draw on the ground and walls the sheep and cattle in his care, and moulding clay images of pigs, chickens, dogs, rabbits and other small animals. Later, after he came across some printed copies of Ren Bonian's paintings in the county town where he was attending school, he began to do painting and sculpturing with greater dedication. However, the straitened circumstances of his family prevented him from getting any school training in painting. After being admitted to the Chinese department of Yunnan University, he had to pay his tuition fees with money earned by selling his clay images of animals. Now he was anxious to learn from Beihong and asked to be accepted as his student.

155

Beihong said encouragingly, "An artist should create works that appeal to the masses of the people, not anything decadent or moribund."

Beihong lent him his own sketch album and some sketches he had done from memory. Later, he took the young man to the suburbs of Daguanlou to paint from life and teach him how to draw buffalos by adding a few ink strokes to charcoal sketches, thus giving a feeling of space and solidity.

Once, when Beihong called at Yuan's house, he saw that in order to learn to paint peacocks, the young man was not only raising a peacock but also had a peacock tail feather hung on the wall so that he could practise close-detailed sketching. Beihong was pleased, saying, "Only by imitating nature can you bring forth new ideas and make progress. When I was learning to paint animals in Berlin, I did it every day by sketching real animals."

Beihong gave Yuan a pottery ink-slab as a gift and said, "Unlike a Duan ink-slab* which is impractical though famous and precious, a pottery ink-slab will serve a better purpose."

Thanks to Beihong's encouragement and guidance, Yuan became even more determined to be an artist. Later, after graduating from the university, he took up painting and carving as his speciality and eventually became a professional painter.

Beihong gradually recovered from the travel fatigue while working and preparing to go to Chongqing. But suddenly he received a near-fatal blow.

One day, when squadrons of Japanese bombers came over, the shrill air raid siren sounded long and loud. Beihong hurriedly left his upstairs room in a hostel at Yunnan University and, together with many other people, entered an air-raid shelter. When he returned to the hostel after the all-clear signal, he discovered that his door had been pried open and the *Eighty-seven Immortals* had been stolen along with more than thirty of his other paintings. His legs gave way and his eyes saw black, as if he had been violently punched in the chest. He put both hands on the table to prop up his body and tried to calm down, but his head was swimming.

* A kind of high-quality ink-slab made in Duanzhou (modern Zhaoqing), Guangdong Province. Its production originated during the Tang Dynasty.

Where was the *Eighty-seven Immortals* — a national treasure that he had been fortunate enough to redeem and a collected rare piece that he treasured as dearly as his own life? He kept calling out to himself, and immediately reported the case to the police so that they could investigate and recover the stolen paintings. Nothing came of it after the elapse of one day, two days, three days. He lost his appetite and sleep over it, and was down with extreme nervousness and anxiety. A medical check-up subsequently diagnosed his illness as hypertension.

Chapter XXXIII

In the summer of 1942, Beihong returned to Chongqing.

At the airfield, when he hurriedly walked down the gangway ladder wearing a white grass-linen long gown and a broad-brimmed hat and carrying under his arm a big roll of paintings, he was greeted not by any government officials, but by several of his students. While abroad, he had worked for the benefit of his own country without a single cent of government allowance and had made so many contributions to the War of Resistance; he was given no credit for it by the Kuomintang government.

He was back again in the misty mountain city of Chongqing, then the war-time provisional capital of the Kuomintang government. What a joy it was to him to be in the midst of his fellow countrymen and familiar students again and to find so many things waiting for him to do!

But fine crow's feet were beginning around the outer corners of his eyes. And his thick hair, once jet-black, was greying. He had been aging fast in the past three years. Though only forty-seven, he looked much older.

The moment he appeared at the art department of Central University, the students surged forward, vying with each other in greeting him. Beihong saw a hefty boy student holding aloft on a bamboo pole a long string of firecrackers spouting smoke and sparks.

He was surrounded by a throng of smiling faces. He tried to hunt out their individual names from the recess of his memory. Some came to his mind immediately, some were blurred, some were quite unfamiliar.

He entered his classroom surrounded by students. Ready on a makeshift table formed of crude school desks was a sumptuous dinner prepared by the students. After sitting down, the students each helped him to something with their chopsticks and put it before him. It was the

sole reception held in his honour after his arrival in Chongqing.

On the evening of the same day, he went to live as before in a dormitory at Central University where he had a small room with a bunk-bed. In the still of the night, he began to think of his lost home and two children, as well as Jiang Biwei. Although she had numerous defects and had had many differences and arguments with him, he was spurred by a sense of responsibility for his children and remembrance of the time he had first fallen in love with her. He could not refrain from going out quietly to the lost home.

He called on Jiang, but she was chilly and flatly refused to be reconciled. On hearing of Beihong's imminent return to China, Zhang Daofan had written her a letter in which he said, "You must reject any mediation and declare your permanent separation from him so that you can keep your personal freedom and forever remain my secret lover." Jiang immediately wrote him a reply reaffirming her determination to have no reconcilation with Beihong. She wrote, "A reluctant reunion would be a most unbearable and painful sacrifice on our part;" "I never doubt for a single moment your love for me;" "The sea may dry up and rocks may rot away, but my love for you will be everlasting." Little did Beihong then know that Jiang, who had repeatedly vowed to him that she would never remarry, should have degraded herself to such an extent as to become a paramour of a man already long married to a French woman. Zhang, then propaganda chief of the Kuomintang Party Central Committee, paid an unexpected visit to Beihong and said hypocritically, "Oh, none of that family trouble! Be reconciled quickly!" He winked his dull little eyes.

Beihong again applied all his energies to painting and teaching. To make up for lost time which ought to have been devoted to teaching, he came every day to the classroom early in the morning.

In 1942, at the national woodcut exhibition held in Chongqing, Beihong was exhilarated by the rich productions of woodcut artists in the Communist-led Liberated Areas. He particularly appreciated the richly poetic works of the woodcut artist Gu Yuan and lost no time in writing an article, which began with the following passage:

> I discovered at 3 p.m. on October 15, 1942, a brilliant genius in China's art field, namely, the great Communist artist Gu Yuan. Though I disqualify myself as a

159

parochial nationalist, I cannot refrain from rejoicing over the emergence of this giant master in China's woodcut circle, which has a history of less than two decades. As a qualified participant in future international contests, he will without doubt win honour for China....

Beihong's prophecy has come true. Gu Yuan later did become an outstanding wood engraver of international renown.

Because of the suppression of public opinion in the Kuomintang press, Beihong's article could only be published in the *Xin Min Bao* (*New People's Journal*), a privately owned Chongqing newspaper, and was later reprinted in the Yanan *Jiefang Ribao* (*Liberation Daily*). However, the publication of this article incurred the special "care" of the Kuomintang authorities.

One day, when Hua Lin, one of Beihong's former fellow students in Paris, met Beihong, Hua Lin pulled him to one side and whispered, "The article you wrote in praise of the Communist wood engraver has got you into trouble!"

"What trouble?" asked Beihong in reply.

"I hear that Zhang Daofan has asked somebody to write an article to attack you."

"O.K., let him attack! I won't budge!"

"Beihong, as I told you, or advised you, in Nanjing, you're an artist, not a politician. There's no need for you to get involved in politics. If you had taken my advice, you wouldn't have offended a man like Zhang Daofan."

"I think I should at any time say what I mean. It's my duty as an artist to publicize good works. If a Communist painter is good, why shouldn't I give him publicity? Many years ago, when I had a controversy with Xu Zhimo, I wrote, 'I value truth above anything else.' You know me well. I'll never give up truth and bow to power!"

"Oh, is it worthwhile? Is it worthwhile for you to do so?" Hua shook his head repeatedly.

Beihong felt very bad when he saw how Hua, who, as a courageous fighter of the Beijing cultural circles, had twenty years before condemned imperialism and feudalism both in speech and writing, had become such a coward.

Shortly after, Jiang Biwei's father Jiang Meisheng died. When

160

Beihong heard of it, he immediately rushed to the hospital mortuary. That evening, he, together with Jiang Biwei, sadly kept vigil beside the deceased.

In the dim, gloomy lamplight, as they both sat in silence beside the remains of the old man, Beihong remembered the day he had paid his first visit to the Jiang family. Jiang Meisheng, wearing a grey silk long gown and waving a folding fan, had come out to greet him, his face wreathed in smiles. As Beihong still remembered, the covering of the fan was then blank. Jiang Meisheng had purposely bought the fan with the blank covering so that Beihong might be asked to paint something on it. Beihong then and there had painted a cluster of bemboos with Chinese ink. Jiang Meisheng had appreciated it so greatly that he tapped his forefinger on the edge of the desk in excitement and repeatedly shouted, "Well done!" Later, at dinner time, Jiang Biwei walked down from upstairs, elaborately dressed for the occasion. She was wearing a brand-new pale purple short jacket and a dark blue silk skirt, her ebony hair hanging down over her forehead and her glittering, dark, big eyes resting with ease and grace on the newly arrived stranger....

From the other side of the old man's remains came the voice of Jiang Biwei; "How I wish to have father's portrait painted!"

Lifting his head to glance at her, Beihong stood up quietly, opened the handbag he had brought with him to take out paper and brush from it and then quickly sketched the portrait.

Dead silence reigned again. The night was long, and Beihong sank back into distant memories. He remembered how, when he and Jiang Biwei returned from Japan, Jiang Meisheng had received them without a word of reproach. Events of the past decades flitted across his mind one after another. He remembered everything that had taken place in the Jiang family.

The pale light of early dawn quietly peeped in through the window. Day was breaking. Beihong, mopping tears with his handkerchief, said, "Biwei, don't worry, I'll see to father's funeral arrangements."

He looked at Jiang, but she sat there without lifting up her head or saying a word, her face grief-stricken.

"Biwei," Beihong again spoke to her kindly, "It'll never do for us to go on like this! Let's make up for the sake of our children."

Jiang abruptly lifted up her head and said loudly, "Enough! We've already separated, so let it remain thus. Lots of people get divorced nowadays. It's nothing unusual. We're not suited for each other temperamentally!" She bit her lower lip hard to show her determination.

"You can remarry. I'll be damned if I'll interfere!" she added with curt finality.

Beihong was silent and said no more. Was there anything else he *could* still say?

Jiang was to write many years later, "Both before and after father's death, Daofan showed infinite love and concern for me During those days, though he held an important post in the Propaganda Department of the Kuomintang Party Centre and was busy from morning till night, he nevertheless tried to find time to meet me as best he could." She thought that Zhang had brought her tremendous honour and happiness because it was due to Zhang that after the death of her father, an ordinary university professor, Kuomintang Chairman Lin Sen and the Executive Yuan had issued a joint decree to commend him. Several hundred government officials, scholars and other celebrities had attended his funeral rites.

This time, though still unaware of the actual state of affairs, Beihong had firmly closed his heart to Jiang Biwei and resolved once for all never to meet her again.

Chapter XXXIV

In the autumn of 1942, Beihong began to prepare for the establishment of China Art Academy — a research-oriented art college. As there was a serious shortage of everything during the war, the academy had to make do with whatever was available. It was located in the ancestral temple of a Shi family in Shijia Garden, Panxi, opposite Shapingba. Beihong decided to go to Guilin to bring back his collected books from the cave of Qixinyan Mountain to be presented to the library of the academy.

In the winter of the same year, he boarded a long-distance bus for Guiyang, whence he was to go to Guilin. During his stop-over in Guiyang, he held an exhibition there and gave all the proceeds from the sale of the pictures to help finance the local middle schools.

Now he was to arrive in Guilin by bus. In spite of the transport inconveniences in those days, Guilin remained as attractive to him as a near relation. The beautiful memories of bygone days, the nearing Lijiang River, and his old friends Tian Han and Ouyang Yuqian then living in Guilin — all these made him forget the fatigue of his journey.

At last he was reunited with Tian Han and Ouyang Yuqian. The three pals of Nanguo Society had, since their last separation, each persisted in fighting on the art and literary front no matter what hardships and sufferings they met. Ouyang, then in charge of a theatrical society in Guilin, had been putting on many anti-Japanese plays. Tian Han, as head of the Art-and-Literature Section in the Third Bureau of the Political Department directed by Guo Moruo, had been doing the extremely heavy work of anti-Japanese propaganda and directing the anti-Japanese theatrical troupes. The three friends met like battle-tempered soldiers. Though in their forties, all three had greying hair. Both Tian and Ouyang were wearing thick spectacles while Beihong still had good eyesight. They could not help thinking of those days in the past when they had been colleagues in Nanguo Art Academy and fought side

by side. All that had been fifteen years before!

"Beihong, you've been single for six years. You've got to have a home!" Tian and Ouyang advised almost simultaneously.

Beihong kept quiet. He still had a fresh memory of the terrible sufferings given him by his former wife. Could a new wife give him happiness? He did not dare to imagine.

During his stay in Guilin, Beihong paid a special visit to Li Jishen, a general of the Guangxi group, who had taken part in leading the Northern Expedition and had later been imprisoned in Tangshan by Chiang Kai-shek. While in Nanjing, Li had often sent Beihong loquats to eat, knowing his particular liking for them. Beihong later painted a traditional painting of *Loquats,* on which he inscribed, "This nice fruit always reminds me of the return of the season and my dear old friend Li."

Li and his wife also felt sorry for Beihong being homeless and showed sympathy for him. Madame Li even attempted to introduce Beihong to a well-educated girl from a rich family, but Beihong politely declined.

Part Two

Chapter I

The landscape of Guilin is unequalled in the world. Through all ages, painters have used colourful strokes to depict its beauty, and writers have written splendid passages to sing its praises.

I feel an even more profound love and longing for this city because this is where I first met Beihong. It was then that the boat of my life took leave of the quiet riverside and began to enter a stormy sea, sail hoisted. My simple and serene life, once opened to the panorama of the world, began to be troubled by diverse cares and complexities.

I see myself tearing through the crowded streets of Guilin on my way to a big downtown theatre. The art troupe to which I belonged as a chorus singer was giving its second anti-Japanese benefit performance of the day. It was already time for the performance to start.

It was morning, the end of 1942. A cutting wind blowing in my face rudely stirred my blue long gown and bobbed hair. The sky was overcast and I felt a few tiny rain-drops falling on my hair. By the time I reached the theatre gasping for breath, I was already fifteen minutes late.

I hastily went backstage, heart thumping hard and cheeks flushed with shame. I was waiting to be greeted with anger and reproaches by the husky, stern troupe director. Just then, however, the curtain happened to be falling on a big chorus — the first item on the programme. Amidst the thunderous applause of the audience, I heard the troupe director barking angrily, "Liao Jingwen still isn't here yet! Who is to take her place in the next item?" No sooner had he finished than I appeared before him. His anger melted instantly, and, without having time to say a word of reproach, he pushed me onto the stage. I was to sing mezzo-soprano in a chorus of eight.

The performance, having gone through a four-month rehearsal, now apparently turned out to be such a hit that many public

organizations and individuals came to present us with bouquets and baskets of flowers. The troupe director smiled until his eyes were mere narrowed slits, and everybody was bouncing around with joy. The street-side dormitory where we were living had always been cheerless and desolate, but now it was a scene of lively mirth, like a dried-up river suddenly flooded with gurgling waters. While everybody else was talking cheerfully about the free performances they would soon give in other localities, I alone kept quiet for I had inwardedly decided to quit the troupe.

A week earlier, while in the reading room, I had by chance read in the newspaper that the preparatory office of the China Art Academy in Chongqing was going to recruit a librarian by examination in Guilin. I was strongly attracted by the advertisement, and quickly jotted down the place and date for signing up for the examination.

The day for the written examination happened to be my day off. Coming out of a colleague's home where I had been invited to dinner, I found by my watch that there was little time left for me to fetch the stationery from the dormitory. So I had to return to my colleague to borrow a writing brush and an ink box from her, and made for the examination hall in a hurry.

The examination hall was thronged with people both inside and out. When I stopped at the steps leading to the hall, I found standing beside me two girl students with the badge of Guangxi University on their chests, chatting loudly and merrily. They were fashionably dressed and had a graceful carriage. One of them had her face evenly rouged and powdered, her lips lightly painted, and her fluffy curly hair flowing gracefully over her forehead and shoulders. She was clearly aware of her beauty. She cast a sidelong glance at me with cold conceit and disdain. As I looked about me and saw so many applicants chatting away and apparently full of self-confidence, I was seized with a sense of inferiority and lost courage to sit for the examination. I was about to leave when the bell started ringing, but I walked into the examination hall with the throng.

A grey-haired, grave-looking elder wearing a dark-blue cotton-padded long gown entered the hall and went straight to the blackboard

to chalk the examination questions on it. It was not until later that I learned he was Xu Beihong.

Being too preoccupied to notice other people around me, I at once took up the brush and, with my head lowered, began to write my answers. I used up several sheets of paper in one breath. After handing in my examination paper, I hurried back to the troupe and immediately began to busy myself in writing articles for the troupe wall newspaper, of which I was the editor. I soon forgot all about the examination.

Not long afterwards, I received a letter in unfamiliar hand-writing. I hastily opened it and found it was from China Art Academy, notifying me to take the oral examination. To my great surprise, I had passed.

The day for the oral examination also happened to be the day for the troupe to give its second public performance. Because of the conflict between the two events, I hesitated to take the oral examination. After some careful calculation of time, however, I decided in favour of going.

Three applicants had been asked to take the oral examination. I was the first one to be summoned into a very plainly furnished office room, where Xu Beihong, the chief examiner, was sitting calmly at a desk by the window. Though only in his forties, he had already developed grey hair at the temples. He was wearing the same dark-blue cotton-padded long gown as before. His face was gracefully outlined and had very soft and gentle lines. Under thick eyebrows, there glittered a pair of beautiful but pensive eyes, with fine wrinkles radiating from their outer corners. He looked a little pale. Before him lay a thick pile of examination papers.

"Please sit down," said Xu pointing to a chair across the desk as soon as he saw me enter the room.

I sat down ill at ease. As his eye fell on the papers and then moved towards my face, he announced in a mild voice, "You came out first in the written examination."

I raised my head slightly and, glancing at the pile of papers, saw my own paper lying on top of them with its upper right-hand corner marked with "a hundred points."

My face burning, I sat before the world-famous painter like a bashful primary school child.

He immediately questioned me like a strict school teacher, "What's your hobby?"

"I love reading," I answered timidly.

"What books have you read?"

I tried to think up a laconic reply, but in vain. After a little hesitation, I said falteringly, "I've read the works of some modern writers, such as Ba Jin's *Family, Spring* and *New Life,* Mao Dun's *Midnight,* and Lu Xun's *Wandering* and *Call to Arms."* I stopped short at hearing my voice quivering with nervousness.

"Anything else?" he stared hard at me with near-stern eyes.

"Also some translated foreign novels. I particularly like some famous Russian novelists of the nineteenth century, like Tolstoy, Turgenev, Dostoevski" I stammered out some of my favourite books and writers.

"What else have you read besides these foreign novels?"

I replied after some pondering, "Classical Chinese novels like *Journey to the West, Romance of the Three Kingdoms, A Dream of Red Mansions."* Seeing that he was still staring at me and waiting for me to go ahead, I resumed in a low voice, "I'm very fond of Chinese classics, especially classical poems."

"Who are your favourite poets?"

"I like Du Fu, Li Bai, Bai Juyi," I made a short pause to catch my breath and then continued more fluently, "and also Wang Wei, Meng Haoran, Gao Shi, Cen Shen, Lu You"

He cut in with the question, "Which poems by Lu You do you like best? Can you repeat them from memory?"

For the moment, I was hard put to give an answer. I had to dig it carefully out of my memory. After a little calm reflection, I carefully recited two of Lu You's poems as follows:

(1)

Living alone in a desolate village without self-pity,
I still think of going to the frontier to defend our country.
Hearing wind and rain in bed late at night,
I began to dream of war horses galloping across frozen rivers.

(2)

Though I know all will be empty after one's death,
I still lament the loss of our national territory.

170

The day when our troops recover the Central Plains,
Don't forget to report the news to me at family sacrifices.

Xu Beihong nodded and asked, "Why do you like these two poems?"

"Because I've been greatly inspired by the poet's true patriotic sentiments."

"Can you recite any other poems by Lu You?"

After a little hesitation and consideration, I recited another two poems by the same poet. Then I told him how I had been touched by the poet's tragic love affair and his eternal love for the woman of his heart.

He nodded again but kept silent, evidently waiting for me to continue.

"Sir," I said respectfully, afraid of being too casual, "not long ago, I read in the *Xin Min Bao* your article in praise of the Yan'an woodcut artist Gu Yuan."

"Then, you also like to read articles on art? You're also an art lover?" a faint smile played on his thin, pallid face, his eyes softening gradually.

"Yes, sir. I've also read the article you wrote when you had a controversy with Xu Zhimo." I was on the point of telling him how I admired him for his courage to defend truth, but didn't checked myself because I was by nature disinclined towards complimenting other people to their faces.

"I suppose you must have a strong liking for knowledge. You're very diligent, aren't you?" His voice sounded not only soft but also amiable, which much encouraged me to keep talking.

"No, sir, I like to play. When I was a student, I used to be on the school volleyball and athletic teams." I grew more and more unreserved.

I saw a faint smile.

Then he seemed to be reminded of something he had forgotten and asked, "Well, please tell me why you want to quit the art troupe. I saw your performance yesterday."

"Sir," I blurted out straightforwardly, "it's because I don't like some of the people in the troupe. And, besides, I want to go to Chongqing to study at one of the many universities there. Without a

171

professional skill, one can never make contributions to the country." No sooner had I let out this secret wish than I regretted having done so, for I thought no one would care to employ a person who could not keep her mind on her work.

To my great surprise, Xu Beihong nodded his approval and said affably and encouragingly, "Very good, one should always think of making more contributions to the country, and should have lofty ideals and aspirations." After a moment's pondering, he said in an extremely earnest tone, "We've decided to employ you because you came out best in the examination. Think it over. If you're willing, you may start working right away. We're going soon to Qinxingyan Mountain to sort out the books stored in the cave and then take some of them to Chongqing. If not, please let us know by tomorrow, so that we can choose one from the next two candidates."

Looking up, I saw the wall clock pointing to 8:20, only ten minutes before the art troupe began its performance. I rose to my feet abruptly, pushed aside the chair and, with a laconic "Thank you," flew out of the room.

Chapter II

I lay tossing about uneasily in bed that night, unable to sleep. I had been longing to quit and go to Chongqing. But now the opportunity had come, I became reluctant to part from the art troupe and the chorus. The boys and girls of the troupe all hailed from diverse parts of the country, and many who came from enemy-occupied zones had drifted from place to place without a home. For four months, we had been close companions, sharing our lives, and I had developed a strong attachment for them.

Six months before, I had left an out-of-the-way village in Hunan Province, where I had suffered all kinds of persecutions, and arrived in Guilin after passing through many different places, with the hope of going to school or getting a job there. Being a stranger in a strange city, I had to temporarily stay in the dormitory of Wang Yingxian, who had studied in the same junior middle school with me. I soon ran out of what little money I had brought with me, and was faced with financial difficulties. Fortunately I was employed by the art troupe, after passing an examination. When I first came joyfully to the troupe carrying a small canvas suitcase and a bedding roll, I had been warmly greeted by smiling faces, which made me happy.

Now, after being with the troupe four months, I had come to regard it as home. Everything I saw around me had become so endearing. I made up my mind to go and tell Xu Beihong first thing the next morning that I was not going to Chongqing.

But there also appeared before my eyes several abhorrent faces moving around like so many demons. They were boot-lickers and back-biters, and I had been keeping them at arm's length. I understood that it was due to their intrigue that several troupe members had not long before been sacked. Many troupe members then had requested the

troupe director to countermand the order, and I had also demanded, "If people must be discharged because the troupe is overstaffed, then let me be laid off instead. I can still go back to my home in Hunan, while those to be discharged haven't got a home at all." However, all of our requests came to naught.

The wind was going down; it was late. In the dark sky outside the window, the clouds were dispersing slowly and the moon was hanging high above like a bright lantern. The limpid moonlight filtering in through the window fell on the side of my pillow. I was gradually falling asleep when suddenly I was awakened by a big noise. Listening attentively, I found that it was the crash of the table and chairs in the rear courtyard. Thump! Something fell onto the floor, and then a woman started weeping and screaming. Our director was having a row with his wife. Abusive language from the mouth of our gentlemanly director echoed in the night. The noise gradually died down and silence returned. I had hardly shut my sleepy eyes when I heard the mournful sobbing of a young girl. I recognized it to be from Jin Zi, the orphan girl who had been taken in by the director to serve as his maidservant. Worn to a mere shadow by heavy household drudgery, she now looked as feeble as a storm-tossed bamboo. My heart began to pound and an irrepressible disgust filled me. All that once again resolved me to quit.

Early the next morning, I calmly walked into the dining room as usual, bringing my hurriedly written resignation. After finishing my breakfast, I handed the resignation to the director. He read it in astonishment and then said with a smiling face, "Why do you want to quit? No, you can't! If you've any difficulties, just let us know, and we'll do our best to help you out."

"Director, I've no difficulties. My only demand is that I be allowed to quit."

"I won't agree!" he said loudly and obstinately, knitting his brows in irritation, then stalked off with heavy steps, his leather shoes clicking on the floor.

After two public performances in close succession, the director announced a three-day rest for all and meanwhile told everybody to pack things for a journey to Guangdong Province to hold free performances for the army.

174

In the washroom, water flowed noisily and the water trough foamed with white spray and soap bubbles. While many were washing clothes, shoes and socks, and making preparations for the journey, I availed myself of the three-day holiday to begin my new job.

I went daily to Qixingyan Mountain early in the morning to help Xu Beihong sort out more than forty wooden cases of his collected books and paintings in the cave. He was to take some of the books to Chongqing to be used by the preparatory office of China Art Academy.

The kilometre-long cave was an indestructible natural air-raid shelter as well as a wonderful scenic spot in Guilin. Part of the cave, already fitted with floorboards and electric lights, now served as a warehouse, in which Xu's books and paintings were stored. I and his student Zhang Anzhi helped him in moving the heavy wooden cases around, dusting them, removing the rusty iron sheets and nails and carefully prying open the lids. Xu removed the picture scrolls and books with great delight and closely examined them to see if they were damaged, mildewed, moistened or worm-eaten. He handled them with care and caution as if meeting relatives after a long separation.

I had never before seen such a huge collection of books and paintings. They unfolded before me for the first time in my life a varied, colourful, broad artistic world. Like the ordinary girl in fairy tales, I found myself transported into a wonderland where I visited a splendid palace and was dazzled by an endless display of novel, beautiful works of art. I was so fascinated by the works of such masters as Michelangelo, Raphael, da Vinci, Rembrandt and Rodin that a new spiritual world seemed to appear suddenly before my eyes and my heart was filled with longing for bright prospects and a happy life. It seemed as if a soft and invigorating breeze had blown into my simple heart to make me realize how lovely the world was and how lofty human wisdom could be.

I carefully took the books and paintings from Xu's hands and rearranged them neatly in the wooden cases. When I saw the flyleaves of some books inscribed with "I bought this book in Europe when I was most hard up," and "This much coveted book was bought with borrowed money," I came to understand how the owner had obtained these books — with great difficulty. I saw his eyes glittering and his face

175

beaming with a soft smile as he held these books. He would fix his eyes on a page and be lost in thought and recollection. Most of the time he would look at a book with a self-satisfied smile. He would sometimes bend over, sometimes stand erect, sometimes squat before a wooden case, all the time checking, leafing and fondling his books. He was like a millionaire reviewing his spiritual riches — those precious legacies of human wisdom — page by page, copy by copy, case by case.

On the evening of the third day, while walking back to the art troupe from Qixingyan Mountain at sunset, I happened to see in the distance the director wearing a Western suit and a broad-brimmed hat. When he came face to face with me, he greeted me cheerfully and asked with concern, "Tomorrow we'll be going to Shaoguan in Guangdong. Have you finished packing up?"

I shook my head.

"All right, I'll tell my Jin Zi to come and help you!"

"No, it's not necessary," I declined politely.

In the still of the night, as the cold moon shed its tender light on the dormitory window, I softly moved around in packing my things so as not to wake up my room-mates and be detained by them, and then departed reluctantly, leaving behind an open letter to the troupe. On the way out, I could not help turning my head to get as many last looks as possible at the dormitory where I had lived and the upstairs hall in the opposite building where we had often had rehearsals. I would never forget those young men and women whom I had met by accident and among whom I had lived for more than a hundred days.

After leaving the troupe, I went again to stay temporarily with Wang Yingxian in her dormitory. Wang was a quiet but jolly girl then working in the local tax bureau. When I first came to Guilin, she had been my only acquaintance in the city and the only person who could sometimes look after me. Sharing the room with us was another girl. One day, when we three were chatting together, we all regretted not having visited Yangshuo, a neighbouring town said to outshine Guilin in natural beauty. We thought that it would be a great loss to fail to see Yangshuo during our stay in Guilin. But how could we get there lacking transportation? In order to repay my former schoolmate Wang's

kindness to me, I decided to wait for a chance to ask Xu Beihong to help us hire a small boat for a trip to Yangshuo.

On the last day, when we had finished sorting out the books and paintings, Xu Beihong, Zhang Anzhi and I all walked out of the cave and brushed the dust off our clothes, feeling gratified and relaxed. Since we were all hungry, Xu treated us to a meal at a nearby eatery, which was so small that it had space enough for three tables only. The tables and chairs were all very simple and unvarnished. We also found that the place was frequented mostly by labourers. When the few simple dishes Xu had ordered were about to be served, there were still some remains of a meal on the table not yet cleared away. Xu stood up to find a rag and wiped the table clean with it instead of asking the waiter to do it. Trivial as it was, the whole thing left a deep impression on me. I found that Xu was not only amiable, but also very modest and unassuming.

At table, while I was listening to Xu talking with Zhang, suddenly I discovered that Xu had left on the table a complete, intact fish skeleton after he finished eating the small crucian carp. As I looked at him in amazement, he said smilingly, "As I was born in a place close to Lake Tai, I've been fond of eating fish since very young. And I've also learned the knack of eating a fish."

He was apparently in a good mood, so I took the opportunity to make known my desire to visit Yangshuo.

"Mr. Xu, why don't you take a rest for a couple of days?"

"Take a rest?" he said with a hearty voice. "Painting is my rest."

"But," I continued haltingly, "could you help us hire a small boat so that we can travel to Yangshuo?"

At the mention of Yangshuo, he seemed stirred. After a moment's meditation, he said firmly, "All right, I'll go with you."

Chapter III

As it would take a day and a half in those days to go from Guilin to Yangshuo by boat, we all took along with us our bedding rolls. The small wooden boat was an old-fashioned one with an awning. The middle-aged boatman and his wife, who both spoke the local dialect, were happy to take us.

The leaden sky was overspread with clouds and a fine drizzle was falling. As soon as the boatman pushed his long bamboo pole against the river bed, the boat began nosing its way slowly towards the middle of the Lijiang River. Both banks of the river were veiled in a misty curtain of rain, through which I could see steep mountains rising from the plain one after another like countless graceful fairies in green raiment standing by the riverside. In various postures and casting their reflections into the mirror-clear river, they created an idyllic scene.

After musing upon the mountains and waters for a while, Xu sat down under the awning, opened his painting folder, took out a figure painting which he had sketched with a charcoal pencil and started pondering. It was the rough sketch for his unfinished *Martyrs to the National Cause,* the picture of a funeral procession — a group of people carrying the remains of some soldiers who had died in combat. As he was preoccupied with thoughts of the picture and looked very serious, I chose not to disturb him. My friends and I devoted ourselves instead to enjoying the picturesque scene around us. All was quiet and serene except for the rhythmic sound of the oar-stirred water.

When the rain stopped and the dark clouds overhead had dispersed and vanished, the warm sun shone delightfully on our boat. Xu put down his sketch and walked with us to the bow. The beautiful Lijiang River, stretching endlessly ahead, flowed quietly. The ripples on the limpid water kept spreading away one after another. The splendid

sunlight had dyed the steep mountains a fresh green. In the distance, peasants could be seen working in twos and threes in the fields with hoes in their hands.

I drew a deep breath of the fresh, damp air and tentatively inquired in a low voice, "Mr. Xu, is this your first visit to Yangshuo?"

"Oh, I've been there I don't know how many times." There was a flash of recollection in his furrowed eyes.

"When did you go there first?" I asked out of curiosity. My former schoolmate Wang chuckled, probably remembering how I had been fond of asking questions in the classroom when I was in middle school.

"That was in 1936, during China's darkest period. I was then forced to leave Nanjing for Guilin" He gave a brief account of that part of his personal history and also mentioned his past dream of becoming "a common inhabitant of Yangshuo" and his favourite small cottage with the magnolias.

High up in the sky, a flock of wild geese were flying towards the broad horizon in formation.

"What happened later, sir?" I again asked curiously.

"After the outbreak of the anti-Japanese war, I returned to Central University at the request of my students."

"Is the small cottage still there?"

"Well, I don't know. I haven't been to Yangshuo for many years."

Wisps of kitchen smoke were curling up from distant house-tops. The sun sank behind the steep mountains, and the transparent sky glowed with golden sunset clouds. Our small boat, now moving quietly ashore, was to stop at Xingping, a beautiful town with many houses.

Greatly inspired by the beautiful scenery, my former schoolmate Wang broke into singing Robert Schumann's *Traumerei,* and I joined her. The river water seemed to be moved by our song to a more tranquil and gentle flow; Xu Beihong also listened attentively, strong emotions on his thoughtful face.

The boatman and his wife brought us a meal consisting of sweet-smelling taro soup and green vegetables, which, though simple and crude, had a typical rural flavour. Chatting and smiling at table, we enjoyed eating very much. After finishing the meal, we went ashore to take a stroll and experienced a spiritual uplift while stepping on the

179

spongy, rain-wetted earth and smelling the faint scent of trees and plants.

When night was falling, there was around us a pervading chilly vapour over the river, so we all went to sleep early. All was quiet on this winter night except for the low murmuring of river waters and the soughing of trees.

Early the next morning, when I woke to hear the twittering of sparrows and see the milky morning mist drifting slowly over the river like thin smoke, our boat was again pushing its way through the water.

Xu Beihong stood at the bow with open arms embracing the unrivalled beauty of dawn. He was doing deep breathing slowly, his cumbersome cotton-padded long gown swaying slightly to the heaving of his chest.

The river was murmuring and numberless steep mountains, revelling in the warm sunlight and retreating quickly, appeared even more beautiful than in twilight. My friends and I seemed to be roaming in a dreamland.

Xu's face also brightened up. He ran his eyes far and wide as if trying to paint the beautiful scenery in his mind. He soon retired to the cabin and again began musing over the rough sketch of *Martyrs to the National Cause*.

Wang suddenly fished out a small autograph album and, handing it to Xu, asked him to draw a picture in it as a memento. He took the album and, after some pondering, sketched my portrait with flowing, soft lines. I was amazed to see myself portrayed for the first time in my life. I was also amazed to see how my eyes sparkled in the portrait.

Surrounded by mountains and rivers, the simple, peaceful town of Yangshuo was so picturesque that it resembled a natural painting scroll. Xu, while looking around, went hurriedly towards a group of nearby houses. We all followed him closely.

Finally he stopped at a house with a newly painted green door and tapped at it twice. A tall, fat servant opened the door and asked, "Whom do you want to see, mister?"

"I'm not here to see anybody. I only want to take a look at the house," answered Xu eyeing the neatly dressed servant.

"We permit no visitors in the house."

"Why?"

"My master's moving in soon."

"Oh, I see. Who's your master?"

"The Shaanxi provincial governor's wife," answered the servant with a touch of superciliousness.

"But I lived here six years ago. Now I've come from a distant place only to take a look at the two magnolias in the courtyard."

The servant shook his head, his corpulent body blocking the doorway like a wall.

Xu, however, patiently explained, "Strictly speaking, I'm the owner of the house. It still belongs to me even now."

"Who are you?" asked the servant with the same superciliousness.

However, when he learned that the man standing before him was Xu Beihong, he made a deep bow, his face wreathed in an ingratiating smile. Then he pressed his fat body closely to the wall to make way for Xu to enter the house.

The two tall magnolias greeted us as if they had long been expecting their old acquaintances. Plain, stout and hardy, they resembled a scroll done with splashed ink by a great master, their tall, straight branches shooting skyward like iron arms and their crisscross twigs set off by the clear, blue sky. Xu fondled the rough boughs with a kind and happy expression on his face, as if conversing with an old friend after a long separation.

Looking over the whitewashed, high enclosing wall and the newly repaired and painted doors and windows, he said both to himself and to us, "Everything's changed beyond recognition except these two magnolias."

At a gust of cold wind, the twigs of the magnolias quivered and moaned, as if they had some inner sorrows to impart to us.

We visited the downtown area of Yangshuo with its narrow streets, where the pedestrians were few and the shops seemed to be dozing off due to bad business. It was a desolate and forlorn scene.

Chapter IV

Several days later, Xu Beihong and I started out on our journey to Chongqing, carrying with us a heavy load of books.

As the Guangxi-Guizhou special express in which we were travelling was about to pull out of the Guilin railway station, we waved good-bye to friends who had come to see us off. I saw Xu standing for quite a while at the coach door to catch a last fond glimpse of Guilin. I don't know what was then in his mind, but I can still remember clearly how his eyes showed great reluctance to leave the place. He loved Guilin, and I was to know later how deeply attached he was to it. As he bade farewell to Guilin, little did he expect that he was bidding it farewell for the last time in his life.

While the train rumbled along shrieking and steaming, Guilin was left farther and farther behind. There was on either side a boundless stretch of farmland and mountain ranges. The sky was clear and bright and the sun seemed to be shining with greater warmth. Mother earth was already giving indications of the coming spring.

After looking out of the window for a while, Xu took out a thick book in French from his brown handbag and began to read. Leaning his back against the seat by the window and holding the heavy volume in both hands, he looked so much absorbed in reading that he seemed to be sitting quietly in a library or at his own desk at home.

I, however, enjoyed no tranquility. My mind had been accompanying the speeding train. Out of the window, station after station receded, kitchen smoke was curling up from solitary farmhouses, paddy fields and ponds were glistening in the sun like so many mirrors, peasants were toiling in the fields with their farm cattle. Suddenly, the train dashed into a tunnel, with a violent quiver and deafening rumble, siren shrieking. Soon it emerged like a giant dragon and sped along

belching smoke, flanked by endless mountains.

Leaning on the window to gaze into the distance, I gradually became drowsy. To get rid of my somnolence, I started humming a tune in a low voice, which was a habit I had acquired in the art troupe. Unexpectedly, my singing disturbed Xu. He gently closed his book and rested his tired eyes on me.

"Sir, you like music too?" I stopped singing.

"Oh, very much," he said. "During the time when I was most hard up in Paris, I would rather go hungry than miss a concert."

"Sing again!" he urged. "Come on, go on with your singing."

I felt embarrassed. Thinking that he must have heard the singing of many famous vocalists, I lost nerve to sing again before him. I blushed.

"Sir," I changed the topic of conversation, "you must love painting better than music?"

"Of course," he replied readily.

"Then, how did you fall in love with painting?"

"Well, that would indeed be a long story." He seemed to be trying to evade answering my question.

"Sir, then tell me something about your life!" I importuned with childish sincerity. "Your past experience may be inspiring to young people like me!"

Reflecting for a while with a serious countenance, he began to narrate his past as if he were opening a book at the first page.

"I was born into a poor family," he said.

"In a city?" No sooner had I asked than I was embarrassed by my own impatience, for I saw Xu slightly knitting his thick, dark eyebrows as if he had been irritated by my interruption.

"No, in the countryside," he nevertheless replied affably. "In Jitingqiao Village, Yixing County, Jiangsu Province...."

His narration brought me to the charming regions of rivers and lakes in Jiangnan. There appeared before my mind's eye his kindly father, industrious mother, those simple and honest rural folks in the village. I could visualize his miserable boyhood.

He also related his wandering life in Shanghai: unemployment, hunger, poverty. I seemed to hear the roaring waters of the Huangpu River and, through the howling storm in the river, see the ruthless

183

struggle between life and death and hear his firm voice, "It takes a courageous man to be able to hold out against overwhelming adversity!"

At this point, Xu paused with a gloomy look on his face. When I looked out of the window, I saw the sun hidden by a thick layer of rolling, dark clouds. The train was rumbling along swiftly and the endless mountains were flashing back one after another.

This was perhaps the most stirring story I had ever heard. I was so touched that tears stole from my eyes. I stood up and turned around to wipe them away. Then I poured out a cup of hot water from the thermos flask and presented it to Xu.

"Sir, have some water please," I said in a low voice.

Holding the cup in both hands he took a sip of the water and then remarked, "Life is always so severe. If you don't get the better of difficulties, difficulties will devour you."

I was eager to hear him out, but he stopped. He seemed again to be lingering about in those sorrowful days and reviewing his past sufferings and miseries.

The train shook violently and gave a piercing, long shriek as it entered another long tunnel. It was late in the afternoon and dusk was falling slowly.

Xu looked somewhat tired or perhaps he was still immersed in thoughts of the past. He kept quiet and talked no more.

"Sir, thank you for telling me your story. But you haven't finished yet!" I looked up at his melancholy face in eager expectation of continued talk.

"As long as you stay with us, you'll get many chances to know more about me. Besides, there really isn't anything else worth telling," he said amiably and modestly.

"Sir, is your wife also a painter?" I asked, as if anxious to know more about the life and fate of the leading character of an interesting novel just finished. But, to my great astonishment, his face twitched with pain, as if he had been touched to the bone by my dagger-like question. I stared at him with wide eyes.

"I've no home. My wife and I separated seven years ago." The two sentences eventually escaped his tightly closed lips.

184

"Sir, why? Why did you abandon her?" I insensitively picked on the word "abandon." As an inexperienced young girl, I blamed all unhappy marriages on men.

"Abandon?" he repeated my word. "No, nothing of the kind!"

"Then what is it?"

"I can't answer your question in a few words. In the final analysis, it's due to our utterly different attitudes towards life. Our pursuits in life were not in the least alike. And she doesn't like art at all."

"Why didn't you help her?"

"I did everything that could possibly be done and with the greatest patience, but she chose to go a different way and called herself happy in doing so."

"You mean she wanted to break with you?"

"Yes, that's right."

"Have you got any children?"

"A son and a daughter, both living with her."

"So for seven years you've been living alone?"

Xu nodded in silence.

The earth was enveloped in darkness. Outside the window, the night was jet-black, chilly and boundless. As I lay in my shaky coach considering what he had told me, the broad picture of strenuous life began to unfold before me. Was everyone destined to undergo this rigorous test of life? What would the future have in store for me? ...

The faint, first rays of dawn peeped into the coach. There was no dazzling sunshine, no rosy morning clouds. The sky was cold and sombre as a leaden curtain. Xu Beihong was again engrossed in reading the thick French book held in both hands, and seemed not in a mood to carry on any conversation with me. I cast a solitary look at him and also a look outside the window, not daring to disturb him.

The steam whistle hooted as the train approached its destination — Duyun, and gradually slowed, puffing and sizzling. Duyun, a remote station in Guizhou Province, was a scene of hustle and bustle. Vendors were hawking their wares at the top of their lungs, children were crying by the sides of their mothers, passengers with luggage were talking loudly to each other.

185

I hustled back and forth in the crowd to accomplish my tasks. Xu's books turned out to be most burdensome and we had much bother in getting them tied up with ropes, and loaded onto the bus top like captured wild animals. Then the bus to Guiyang started bumping along on the rough highway.

Chapter V

When we arrived in Guiyang, it was drizzling and the streets were muddy. In checking the luggage, I found that Beihong's handbag and the basket of oranges which Li Jishen had given him were missing. Both had been left in my care by Xu and the handbag had contained some of his rough sketches. I felt uneasy and worried, but Xu did not say a word of reproach to me, nor did he look annoyed.

Guiyang at that time was still a wretched little town with narrow streets, tumble-down houses and bumpy roads which would be covered all over with mire after a rain. Another thing which struck me was that, like other cities in China, it was then full of shabby, unkempt poor people. There was certainly a grain of truth in the saying that in Guiyang "the weather is never fine for three consecutive days, the ground is never smooth for three consecutive li and the people never each own three *fen**of silver." But since the outbreak of the anti-Japanese war, the inaccessible mountain region had been opened up as a gateway to Southwest China and enlivened by some newly opened shops and hotels as well as the privately run Daxia University, which had moved there from Shanghai, and Guiyang Teachers College.

Probably due to the size of Guiyang, I successively met in the few narrow streets of the city several of my former middle school fellow students. I felt an unspeakable joy in running into these old friends in a distant land. I also met my elder sister, then studying at Guiyang teachers College. My sudden appearance was an enormous pleasant surprise to her. After supper, when my former fellow students and I were strolling the street before the gate of Daxia University, they happened to mention how the art exhibition held by Xu Beihong in Guiyang not long

* 1 *fen* = 1/2 gram.

before had created a furore in the city. They said that they had not known until they saw the exhibition that Xu, noted for his horse paintings, was equally adept at painting figures, landscapes, flowers and birds and other beasts. They had also learned that he was politically progressive and had been living apart from his wife. They seemed to know more about him than I did.

My former fellow student Xiao Zhou suddenly pointed to a gorgeous woman and said, "Look, she used to be our campus queen, and is now a social butterfly."

I raised my head and caught sight of a tall, slim young woman with a gentle face and wavy, long hair hung about her shoulders walking past gracefully. Her black velvet overcoat, tight-waisted and wide-hemmed, set off her fair complexion and thickly rouged lips nicely. The blue jade rings dangling from her ears quivered silightly with her lithe steps. Xiao Zhou added, "I hear that somebody introduced her to Xu Beihong. But he didn't take to her though she admired him."

The topic was followed up by a lively discussion. Some wondered why Xu, an artist, should have taken no interest at all in the young lady, who was virtually an object of art much admired and pursued by a great many young men. Some remarked that physical beauty did not necessarily mean spiritual beauty and Xu was probably looking for something lofty. Some commented that beauty should be natural and unembellished and should be spiritual as well as physical. The girls started arguing vehemently, as in their school days. Xiao Zhou, discovering that I had remained quiet, noticed abruptly, "Hey, why doesn't Liao Jingwen speak up?" She probably still remembered that I had never kept silent in school whenever there was an argument over some question.

I didn't speak. I was thinking about what Xu had told me and trying to figure out whether or not his former wife was the same type of woman as this social butterfly. I earnestly hoped she wasn't.

In Guiyang, I stayed with my elder sister at Guiyang Teachers College while Xu lived in a hostel. His none too large room was always crowded with visitors, some of whom were professors and poets; some were newspapermen and art lovers. Ready to fulfil their requests for his paintings, he used his small desk as a makeshift painting table and had it

covered all over with paper, brushes, ink, colour mixing trays, brush washers, etc. He always did his painting conscientiously and meticulously. He would pick up the brush, stand facing the paper on the desk and, after some reflection, start painting with great adroitness. He particularly excelled in varying the wetness, thickness and density of ink to show distinct gradations and convey a sense of volume and space; he subtly applied his remarkable sketching skill to traditional painting. His exact perspective, rigorous composition and precise but terse contouring and colouring all contributed to the liveliness of his works. Galloping horses, tall and straight bamboos, clusters of fragrant orchids — all these would miraculously appear in an instant from his hand, to the great admiration of the onlookers. Then, after affixing the names of the beneficiaries to their respective paintings, he would personally deliver them to their hands. Every day he was thus surrounded by art lovers and never got enough rest. But he was very happy, as if he could never tire himself out with painting.

A few days later, we resumed our journey to Chongqing by bus. Cases and bundles of Xu's books again became our major worry, and it was not until after repeated negotiations with the bus station that they were allowed to be piled up on the bus top in little mounds, all fastened with a network of ropes.

Because of the war-time shortage of oil, the long-distance bus in which we were travelling had to burn charcoal. Belching thick, dark smoke it barely managed to labour up high mountains. Outside the window, I saw the highway zigzagging and twining around one high mountain after another like an endless ribbon. Looking down the mountains, I was terrified by steep cliffs. They reminded me of Li Bai's poem:

> The road to Shu* is hard, harder than climbing to the heavens;
> Just hearing these words turns one's cheeks pale.
> Li Bai was not exaggerating.

Sometimes, when the bus broke down deep in the mountains, we had to go hungry and didn't even have water to drink. While most

* Modern Sichuan Province.

travellers were sighing with annoyance, Xu took things calmly. He even made use of the opportunity to enjoy viewing trees and plants and the surrounding scenery. Like a botanist, he could tell the names of many trees and shrubs one by one. I asked in surprise, "How do you come to know so much about trees and plants? Have you studied botany?"

Xu gave a hearty laugh. He laughed loudly as an elder would do at hearing the naive question of a small child. Then he said amiably, "As a painter, I keep my eyes observing the surrounding world all the time. Suppose I knew nothing about trees and plants and couldn't distinguish their twigs, stems, leaves and flowers, how then would I be able to paint them?"

"Sir, do all painters have observing eyes?"

He laughed again. "How can I answer this question of yours?" he said. "All painters are supposed to be observant, but there are some who work behind closed doors. They paint trees without seeing real trees, they paint mountains without studying real mountains. They do nothing but imitate model paintings. Consequently, they can't even paint a tree or a stone from life. They have no sense of reality, much less originality. Some painters do nothing but copy the works of ancient artists, like Dong Qichang and other Ming Dynasty painters who did decadent *wen ren hua* or 'scholar painting' in pursuit of quick, personal profit."

"Sir, do you mean experiencing reality by the 'sense of reality?'"

"Yes, only by a careful observation of real objects and sketching from life can you acquire the sense of the real. It's the source of all art."

"Then you mean that painting and any other forms of art should come of observing the surrounding world and observing life. Right?"

"Yes, but many painters don't act accordingly."

When the engine of the bus started roaring again, refreshed by the intermission, the travellers hastened to get onto it and Xu and I also stopped talking. We resumed our journey on the steep, narrow highway, flanked by high mountains.

At night, all the bus travellers went to stay at a small inn hung with the notice, "Check in before dark, wait for dawn after cockcrow." We all sat warming ourselves around a wood fire which, crackling and sending out bluish smoke, illuminated the gloomy, weary face of each traveller. We all sat hanging our heads, speechless with exhaustion. I

began to think of my hometown. Was my aged grandma now also sitting by a fire? Through the leaping flames before me, I seemed to see the smoked walls of my home and grandma stitching the soles of cloth shoes by firelight. While her wrinkled hand was moving up and down, the thread and needle quivered weirdly in the light. The other travellers must be homesick too. Many of them had probably lost their homes during the war.

The dismal atmosphere was oppressive. Xu sat quietly by the fire, a faint light flickering on his face. He popped up his head all of a sudden as if shaking off some sorrow and began to crack jokes with the other travellers, though they were perfect strangers to him. Simple and humorous language flowed ceaselessly from his mouth like a stream of clear spring water, moistening their dried up minds and brightening their gloomy faces. He also seemed to glow with delight.

"Hello, fellow townsman, one more joke please!" shouted a middle-aged worker in a Jiangsu accent, waving to Xu. He had judged the joker to be his fellow townsman by his accent though he did not know him to be Xu Beihong. Both had been compelled by the war to go into exile in the hinterland.

Xu started telling another joke, "Once upon a time, there was a high official going to town in a sedan chair. But, since night had fallen, the gate of the city wall was shut tight. His servant stood below the wall and shouted arrogantly, 'His Excellency Wang is here. Open up quick!' The soldiers on guard at the gate replied, 'Show us his *pianzi* (meaning his 'visiting card')!' Official Wang was mad at the soldiers for their impudence to demand his visiting card. So he yelled from inside the sedan chair, 'The *pianzi* is me, and I'm the *pianzi*.* My name is Wang, *wang ba dan!***' Ironically, in cursing the soldiers, he actually cursed himself instead."

The listeners burst out laughing uproariously. The hearty, merry laughter filled the small inn, and drifted over the remote mountain gorges.

* *Pianzi* also means "swindler" in Chinese.

** *Wang ba dan* means "son of a bitch" in Chinese.

Chapter VI

After a four-day bumpy bus ride, we finally arrived in Chongqing. Long famous as a mountain town, it now came into sight with tier upon tier of houses standing on the slopes. As the war-time capital of the Kuomintang government, it had big thoroughfares and numerous government office buildings in the downtown area. However, what distinguished it from other Chinese cities was its terraced streets formed of flights of stone stairs rising one above another in lieu of flat road surfaces. At street corners, there were often litter carriers soliciting customers. Litters in Chongqing were a sort of uncovered sedan chair for carrying people up and down the stone stairs.

China Art Academy was situated at Panxi on the northern bank of the Jialing River in the outer suburbs of Chongqing, easily accessible by land or water. But we still had quite a lot of bother in getting Xu's heavy trunks of books transported. By the time we reached Panxi, I was already dead tired.

The academy had the Shi family ancestral temple in Shijia Garden, Panxi, as the temporary site of its preparatory office. The temple was a two-storied building on a hillside. Rooms on the ground floor were all built with stones, and, going upstairs, one saw a spacious courtyard with a pavilion in its centre housing the Shi family's ancestral tablets. On either side of the pavilion was a small two-storied building. The two small buildings, facing each other, were rough wooden structures without glass windows. But, in war-time Chongqing, even a place like this was far from easy to come by. In its favour, it was a very quiet compound with green pines and cypresses as plums and bamboos.

Right outside the gate was a flagged path leading several hundred metres to a steep flight of several hundred stone stairs on the hillside,

leading down directly to the Jialing River bank. Midway on the slope, streams of clear spring water gushing from among a jumble of rocks converged into a huge waterfall. The gurgling water added to the subtle charm of the quiet garden. Halfway up the mountain, there stood a large rock chiseled into the shape of a tiger which anyone who happened to pass by for the first time would be startled to see. One day, when a former schoolmate of mine came from another town to visit me at dusk, she was terribly frightened by the stone tiger and at once took shelter under a tree, keeping still with bated breath. A villager happened to come by and she quickly tugged at his clothes and warned him in a whisper that there was a tiger ahead. The villager said laughingly, "That's a stone tiger."

The preparatory office of China Art Academy had only a small staff. Since Xu was planning to turn the academy into a research institute, he invited some research fellows and associate research fellows to be its staff members. Among those successively invited were Zhang Daqian, Wu Zuoren, Li Ruinian, Shen Yiqian, Feng Fasi, Zhang Qianying, Zhang Anzhi, Chen Xiaonan, Fei Chengwu, Sun Zongwei, and Zong Qixiang. Associate Research Fellow Zhang Qianying, the first staff member I met there, was a graduate of the art department of Central University in Nanjing, where she had studied under Xu. Mature and over thirty, she, though a little bit full, impressed one as being buxom and pleasant-looking and spoke the charmingly soft dialect of the Shanghai-Suzhou area. She was good at oil painting and could write a regular script in beautiful small characters. She shared a room with me while Xu lived in an upstairs room of the opposite building.

Besides making a card catalogue of the books Xu had brought to Chongqing, I went during my spare time to watch him paint or sometimes help him with such chores as rubbing the ink stick on the inkslab, or spreading the paper. He was then making preparations for an art exhibition to be held in Chongqing. In addition to painting, he was busy with odd jobs, such as mounting traditional Chinese paintings, framing oil paintings, and having the exhibits catalogued and labelled. I also did my best to help him with these things.

Sometimes, during his spare time he would also give me some rudimentary knowledge of painting and calligraphy. Thanks to his

193

earnest instruction, I began to live a more varied and fuller life.

Xu went daily to teach as usual. Early in the morning, he would walk to the Jialing River bank to eat a couple of baked sweet potatoes bought from a vendor's stand, cross the river by ferry, and then walk to Shapingba to give lessons at Central University until he returned at noon. He never took a nap after lunch. He said, "Noon is the best time of a day. It would be a pity to waste it in sleeping." So he always devoted the after-lunch time to painting. In the evening, he would continue to paint by the dim light of a kerosene lamp.

The longer I worked with Xu, the more I respected him. Sometimes, when I saw him washing his own clothes or sewing on a button that had come off, I would be touched with sympathy and pity for him. On a warm evening of the early spring, when other people were fast asleep, I heard him alone taking a walk downstairs. Through the faint starlight, I saw his slightly bent figure pacing up and down with a very miserable and prematurely old appearance. I began to realize that he had a very heavy, afflicted heart. I involuntarily threw on some clothing, walked downstairs quietly and approached him from behind.

"Sir," I said, "it's late. You should go to bed."

He looked back with a start, "Oh, little devil, what did you get up for?" He sounded a bit reproachful.

"Sir, you may catch cold in the chilly night air, and besides you must teach tomorrow morning." I spoke in real earnest.

He gazed at me fixedly. In spite of the prevailing darkness, I could still see sadness in his face.

"Sir, you should get enough sleep," I added concernedly.

He turned to face me, "Anything else you want to say?"

"No, sir," I replied. But, instead of going, I continued to stand before him. It seemed that my legs could no longer do my bidding.

"Sir, you seem to be afflicted with pain. I feel sorry for you."

He heaved a sigh so slight that it was almost imperceptible to me.

"You're still too young to know the complexities of life. Don't worry about me!" he said staring at me.

"But, sir, I think you ought to have a warm home. Why don't you make it up with your wife?"

194

"Make it up? That's impossible. And besides, she refuses to make up. She's right when she says that we have different dispositions...."

"Then why don't you accommodate yourself to her?"

"There's something on which I just can't give in to her. Being an artist, can I stop loving art?" He was a bit agitated and huddled himself up against the chilly air. I draped my jacket over his shoulders, but he stood there unfeelingly. Evidently he was again immersed in thoughts of the past.

Only a few pallid stars were twinkling in the black sky. As the night grew later, the air became even chillier. My hair was wet with dew, and I suddenly shivered with cold and sneezed.

As if suddenly aroused, he cast a look at me and urged, "Go back and sleep!"

"Well, sir, you too."

He nodded.

We each went to our own rooms.

But I turned around in bed and could not fall asleep. It was my first sleepless night in Chongqing. My mind was busy trying to think out a solution for Xu. How I wished to go and try to persuade his wife to come back to his side and be of help to him in his art career! I earnestly hoped that she would be moved by my great sincerity.

The next morning, however, when I mentioned my wish to a girl student of Xu's, she shook her head and said with finality, "That's out of the question."

I added persistingly, "They are both over forty and have two kids, so they ought to make up."

"Who says they oughtn't?" She was several years older than I and knew that things were not so simple as I thought. "Many friends have made efforts to reconcile them, but in vain...." She left off talking.

Probably because of my previous night's sleeplessness and exposure to the cold, I developed a fever after seeing the girl student, feeling very weak and heavy-headed. I lay in bed shivering with cold though covered with a cotton-padded quilt, and did not appear at noon for lunch at the canteen.

Everyone came to see me on hearing of my illness. But Xu was the only person who knew how I had caught cold. Sitting in a chair by my

bed, he watched me take the medicine and then again and again laid his big palm on my forehead to see if my temperature had come down.

"Little devil," he addressed me affectionately, "you're so kind-hearted. Why do you bother about me? After all, I've been alone for seven years already."

"But, sir," I looked up in his mild eyes and said, "you shouldn't live such a lonely life. Last night I discovered that you're suffering."

"It doesn't matter. When I work, I completely forget about the miseries and sufferings of my personal life," he continued in a low voice as if he were talking to himself. "Of course, I'm also eager to have a partner who can share my aspiration and purpose. But the past always rankles my mind. It's very difficult to find a highly satisfactory partner. I'm already forty-eight and I don't want to run into any more family troubles again."

"Sir, I remember that Tolstoy says, 'Happy families have much in common while unhappy families differ in their misfortunes.'"

He nodded, "But it's by no means easy in my case to have a happy family again."

"Sir," I said looking at my watch, "you'd better be going now. A lot of work still needs to be done for the forthcoming art exhibition."

He rested his palm on my forehead again, but this time he blurted out with fright, "What a burning fever! I must go and fetch the doctor." He as good as dashed out of the room.

I began to feel dizzy, my body ached all over and everything went dark. Later, I seemed to see many figures flashing about before me. While in a coma, I seemed to hear Xu calling me. I moved my lips but was unable to speak.

Later I was to learn that I had suffered from not only a cold, but also malaria. The doctor gave me injections of atropine. Xu kept watch by my bedside all the time.

My illness lasted a fortnight. I became pale and weak. I had lost my mother when I was a child, so whenever I was ill, it had always been my grandma that kept me company and looked after me. Now she was very old and feeble. How I longed to see her!

To lessen my loneliness, Xu frequently took time to visit me at my bedside and entertain me with various stories and accounts of his

personal experiences. He had a rich and profound knowledge of history and geography and could speak with absorbing interest, so that I felt less painful during my illness. Thus, every day I would unconsciously wait for him to turn up, and my heart would leap with joy at hearing his hasty footsteps on the stairs. I was profoundly grateful to him. Later, whenever he failed to show up at an expected time, I would feel disappointed and upset. One day, it was already getting dark when he hurriedly came up to my bedside upon his return from Central University. He found my eyes brimming with tears.

"Little devil, why are you crying? Homesick again?"

"No," I murmured.

"Then what?"

"I thought you were not coming today."

"Is that what made you cry? Oh, you're such a child!" he said with fond compassion. "At Central University, in addition to giving lessons, I have other matters to attend to. As a teacher, I must care for every student. From now on, whenever I'm late in coming, don't cry, but wait patiently. Understand?" His eyes sparkling with delight, he hastened to take my temperature, count my pulse and check if I had taken my medicine or not.

Looking at the thermometer, he said cheerfully, "Your fever's down. Your temperature has returned to normal!" Then he sat down and started telling me interesting stories again.

I was recovering from my illness and could gradually take a walk outdoors. One evening, after supper, Xu accompanied me in walking down the steep stone stairs to the bank of the Jialing River. Rosy sunset clouds were lighting up the sky like fire and the river waters were pulsating with dazzling golden light.

"What a beautiful picture!" Xu exclaimed joyously.

"Sir," I said, "how can I express my gratitude to you for your care and concern? I'll forever respect you as your student."

A faint smile passed across his face. "Don't say gratitude to me. If you must say gratitude, it's I that owe you a debt of gratitude," he said with great modesty. "You've done a lot of things for me."

"Well, sir, they're just my obligations. As a matter of fact, I've done

too little for you, and I don't know how to repay you for the many kindnesses I've received from you."

Looking at me with gentle eyes, he said, "I've been very moved by your kind heart and your simple honest feelings."

"I'll do whatever I can for you as long as I'm at your side," I replied.

"Jing," he affectionately addressed me, using my given name for the first time, "these days I've had the strange feeling that you've been sent here by some divine force to keep me company. I've grown so attached to you that you seem to have become part of my life." He grasped my hand in his big clammy palm.

"Sir," I said in a flurry, "I've also grown irresistibly attached to you. You've opened up a new emotional world for me, but, but…." I faltered without finishing the sentence.

The sunset glow had faded out. Night was coming on and the moon was rising behind the mountains.

"But, Jing, you haven't finished yet, have you?"

I had no courage to continue to speak. I kept quiet lest he should be hurt.

He let my hand go. "Jing, let me finish your sentence, 'But I can't love you to become your wife.' Is that what you want to say?" He said with a tremulous voice, riveting his melancholy eyes on me.

"Yes, sir, please forgive me," I replied, casting down my eyes.

"Why say forgive? You're beyond reproach. I've repeatedly thought the matter over. I'm forty-eight, and twenty-eight years older than you, so I shouldn't have made the request of you. But love is something which often comes about unexpectedly. I've been suppressing my feelings of love for many years, but now I've unexpectedly poured them out before you. You've brought me great happiness because your presence by my side seems to have healed my pain. The presence of a simple and honest girl like you has re-kindled my longing for love and a home." He bit his lip hard as if trying to swallow back what he was about to say.

Tears filled my eyes and trickled down my cheeks.

"Jing," he said in a tender, low voice, "don't feel sorry for me. The age gap can never change. I'll never force my will on you. You can do what you want!" In the moonlight, his face appeared exceedingly gentle

and soft. There was only a trace of regret hidden in his eyes.

Cupid had been hovering around us without our knowledge. But instead of happiness and joy, he had brought me limitless anxiety, hesitation and pain. I knew that both of us were having violent inner conflicts. While working by his side as usual and doing my best to offer him help, I enjoyed no peace of mind and was often lost in silent meditation.

He was also obviously trying hard to control himself. Early every morning he would go as usual to teach at Central University and spend all his spare time in painting after he came back. We seldom talked to each other and no longer went together for walks along the Jialing River.

At that time, he often did traditional painting, and so continued to work on the composition of *Martyrs to the National Cause*. With several students of the art department serving as his models, carrying rectangular wooden boxes as coffins, he would draw many rough sketches with charcoal pencils on large sheets of tough paper. Sometimes, to vent his feelings, he also painted galloping horses, flying eagles, buffalos, and lazy cats. He was thoroughly engrossed in creative work.

One day, while I was silently rubbing the ink stick after clearing the painting desk, he suddenly addressed me with a sigh, "Jing, how nice it would be if I were ten years younger and you ten years older!"

Noticing the suppressed feelings and pain in his subdued voice, I sobbed inaudibly with tears in my eyes.

He hastened to stroke my hair tenderly with his big palm, took out his handkerchief to wipe away my tears softly, and said like an elder comforting a child, "Don't cry. From now on I'll mention this no more. Let's go back to the small boat to Yangshuo and treat each other as new acquaintances."

"Thank you, sir," said I. "If there's anything beautiful and memorable in my prosaic life, it all began with the small boat to Yangshuo."

Chapter VII

As the opening day of the art exhibition drew near, Xu Beihong was fully occupied with his work, and we again became cheerful and happy as if nothing unusual had happened between us.

When the exhibition was formally inaugurated in late spring, 1943, visitors, numbering over ten thousand a day, poured in to see it. This was the richest and most colourful exhibition I had ever seen. His huge oils *Tian Heng and His Five Hundred Followers* and *Xi Wo Hou,* as well as his traditional paintings *The Foolish Old Man Who Removed the Mountains, Jiufang Gao* and *Sichuan Folk Drawing Water from the River,* all fascinated me with their lifelike figures. All these paintings, with their lively images and profound morality, served to educate and encourage the people to seek brightness and have confidence in winning victory in the anti-Japanese war.

I availed myself of this opportunity to share as much of Xu's delight as possible by standing among throngs of visitors to listen to their words of praise.

The most unforgettable occurrence of the exhibition was the appearance of Jiang Biwei, who came as a visitor. It was the first time I had seen her. Aged forty-four, she was chubby and full and wearing a close-fitting dark-coloured long gown. Her face was so thickly rouged and powdered that she looked like an actress who had just stepped down from the stage without removing her stage makeup and costume. The glossy dark hair thickly covered her forehead like that of a child, and on either temple her hair was done in a bun hanging over the ear. I had not yet seen, until then, any grown-up woman wearing her hair in this style, so I gazed at her in amazement.

She shook hands with Xu like a friend, and then said loudly, "Father enjoyed the highest posthumous honours, thanks to the great

efforts made by Daofan." Her smiling face showed evident smugness. Then she took out from her fashionable handbag a packet of American cigarettes and had one lit up and dangling from her lips. She threw a searching look at me.

Later I learned that, shortly before she visited the exhibition, she had attended her father Jiang Meisheng's memorial service, held a hundred days after his death. Among those present were Wu Zhihui, Ye Chucang, Chen Lifu, Zhang Daofan and Pan Gongzhan, high officials of the Kuomintang government.

Jiang Meisheng had died as a professor of Sichuan Social Education College. In an article Jiang Biwei had written in remembrance of the grand occasion when her father and mother Dai Qingbo had married, she said, "The Jiangs' residence was then the largest building in Yixing.... The uniting of the Jiang and Dai families by marriage was in those days a grand affair in Yixing. Mother was given a dowry consisting of clothes numerous enough to last her all her life and gold so heavy it could only be weighed with a steelyard." But, after her father's death, she wrote, "Father willingly lived a simple life without worldly desires. He owned no house or land. His personal savings of some ten thousand yuan plus the pensions given by the Education Department of Sichuan Province and the Executive Yuan was barely enough to meet the expenses of his funeral rites and burial."

Both before and after the opening of the exhibition, many of Xu's students came to the hall to help. I can never forget the harmonious relations between teacher and students. Often, early in the morning or in the evening, when no visitors were admitted, he would take time to explain to his students the techniques and characteristics of his works and tell them how he had created them, for he knew they had had no opportunity to see such a large collection of his works in other circumstances. He was using the exhibition hall as a classroom.

Most of the paintings on display this time were not for sale. The purpose of this exhibition was not to raise money, but to offer the people of Chongqing an opportunity to appreciate art and be morally encouraged.

One of the paintings not for sale was *Vultures*, done in the

traditional style with precise modelling and powerful brushwork. The two large vultures perching on a precipice owe their vigour to the skillful disposition of light and shade as well as terse, smooth outlining. The claws, eyes and beaks in particular, all depicted with vivid, minute touches, reveal the fierce nature of the two birds of prey. The contrast they form with the light-blue distant mountains and splash-inked rocks is one between exquisiteness and robustness, which subtly oppose and complement each other.

A high-ranking American army officer, then acting as aide to the Kuomintang government, took a fancy to this painting and could not get it off his mind. Later, when he was leaving for home in glory at the end of the war, Chiang Kai-shek decided to give him a precious gift in gratitude for the meritorious service he had rendered to the Kuomintang government. However, when asked what he would like to be given, he said that he liked nothing better than Xu Beihong's *Vultures*.

Xu flatly refused to sell it when the Kuomintang officials approached him. Anxious to fulfill their mission, they repeatedly came to see him with the same request and, thinking that money could change his mind, declared that they would pay any price for it. Nevertheless, he still rejected the offer, and the painting is now stored in the Xu Beihong Memorial Hall in Beijing.

Xu also raised a large sum of money from the sale of some of the works, but again he gave it out to aid some needy friends and students or spent it buying books and paintings. He gave money generously to many who came to borrow from him. The sufferings of his early days had engendered in him a sympathy for anyone in distress.

Jiang Biwei of course seized the chance to send Lu Sibai to collect money from Xu for the children's living expenses. Lu, who had been working at Xu's side since he returned from abroad, was now dean of the art department at Central University. He had married, thanks to Jiang Biwei acting as the match-maker, Ma Guangxuan, also a professor at Central University and niece of the senior Kuomintang member Wu Zhihui. It was always through Lu that Jiang had obtained money or paintings from Xu. This time, almost half of the proceeds from the sale were passed on to Jiang by Lu in the name of the children's living expenses. It was quite a substantial sum.

Xu had always lived an austere life. At the China Art Academy, he had ordinary meals in the canteen together with other people. He often ate mildewed rice, drank water taken from the fields, and used a Kerosene lamp. He had only a small bedroom-cum-studio with a few pieces of unpainted furniture — a desk used as a painting table, a wooden bed, a wooden cabinet and two wicker chairs. He always wore a blue cotton-padded cloth long gown in winter and a white linen-cloth jacket in summer. He never wore garments of silk. He wore Western-style clothes only when he attended social functions.

After the exhibition ended, the tension of work relaxed. We resumed our after-supper strolls by the Jialing River and feelings of tenderness again came into our hearts bit by bit. At dusk, as breezes swept over the broad river surface, heavily-loaded cargo boats were swiftly carried forward by turbulent waters. The bare-backed, sun-burned boatmen, sculling hard, sang their work song with a loud and sonorous voice.

As the sun sank beyond the horizon, the sky and water turned from lead-gray to pitch-black and lights on the opposite bank flickered. We sat down on a stone by the river; Xu, who had been impressed by the toiling boatmen, mentioned the nineteenth-century Russian master Repin's oil *The Volga Haulers,* calling it a realistic, vivid and moving depiction of the Volga boatmen. He also mentioned Repin's other outstanding painting *Unexpected Arrival,* calling it a work of the highest perfection in art history. Another great Russian painter whom he then mentioned was Surikov, whose masterpieces *The Morning of the Execution of the Streltsy* and *Boyarina Morozova* he thought were among the most solemn and stirring works in existence.

With a sense of responsibility for his country and people, he regarded it as his own duty to rejuvenate Chinese painting. He said, "By the rejuvenation of Chinese art, I mean to study nature and follow universal laws, to use man as the main theme and, above all, to regard the people's activities as the nucleus of art. That's what I've mentioned in one of my articles."

"You mean painters ought to learn from nature, to start from the objective world and life and reflect them truthfully?"

"Yes, the moment a painter refuses to depict objects truthfully, he's

guilty of the same crime as a liar," he added. "Of course, many people object to this idea of mine."

"Sir," I said, "I've often come across articles in small newspapers attacking and vilifying you."

"Is there anything strange about that? I've lots of enemies. I strongly condemn both formalistic painting of every description and the traditional Chinese painting that simply imitates ancient artists without any sense of realism. Many present-day painters belong to either of these two categories."

"But, sir, one shouldn't make too many enemies!" I remembered how badly I had felt when I first read those tabloid sheets.

"For my own comfort, I could have chosen a smooth, broad way. But I've got to keep in mind the future of our country," said he. "In 1934, upon my return from the Soviet Union, some people ganged up to attack me violently because I had praised the works of some Soviet realistic painters. Ever since I started my art career, I've been abused and attacked I don't know how many times." He spoke calmly without a trace of agitation.

"Sir, I've been impressed with the way you distinguish between your loves and hates. I've read an article about you written by Huang Miaozi. He says that once when he called on you in Nanjing, he was startled to see hanging on your studio wall a couplet written in large characters and mounted on two yellow silk scrolls. The first line of the couplet reads, 'Hold your personal prejudice,' and the second, 'Cling to your willful behaviour.' Is that true?"

He nodded in silence.

"Sir, both your idea and action are for the good of the people. Then why do you call them 'personal prejudice' and 'willful behaviour'?"

"That simply means my refusal to go along with those in power in the Nanjing Kuomintang government in their evil ways."

"Huang Miaozi writes very moving and interesting articles in a flowing style. Is he of Miao nationality as his name indicates?"

Xu smiled, "No, he isn't. Miaozi is but his personal name. You'll some day have a chance to meet him."

We would thus spend our after-supper hours in walking, chatting, listening to the moaning of the river water and facing the warm evening

204

breezes. It was his only respite from a day's hard work. He would also talk often of current events, the war and his worries about the future of China. Despite the active U.S. participation in the Pacific war, the Kuomintang troops were still losing front-line positions from day to day. He would often think of his aged mother, he said, about whom he had heard no news whatsoever except that she had died after the Japanese occupied his hometown. He also talked sometimes about his hard student days and the sufferings of his poverty-stricken life in the past.

"Sir, you have amazing willpower." I called to mind the days when, as a wanderer in Shanghai, he had painted on an empty stomach, and when, suffering from both poverty and sickness, he had persisted in painting in Paris, even with excruciating stomach pain.

"One will get nowhere without strong determination and willpower," he said. "Genius must go with diligence." He paused and then continued humorously, "Laziness is a costly luxury. When the time comes for you to clear up your account, you'll go broke."

Sometimes he would also talk about his unfortunate home and love.

"Sir," I said frankly, "if you and Jiang Biwei can never agree, then why did you fall in love with each other in the first place?"

"She wasn't like this in the beginning. At that time, she was soft and gentle. I was then only twenty-three, and she only nineteen, so we both knew very little about love, marriage and life." He raised his head to stare at the unfathomable night sky with its dim starlight as if trying to retrieve long faded memories from a remote region.

"She opposed the marriage arranged by her parents and eloped with me. That was considered progressive at the time and could not have been done without great courage and determination. Her devotion then to me was something I always cherished. Later, when we were poor students in Paris, she stood by, sharing both joys and sorrows with me all the time. That was something I appreciated too. In Paris, since I was too much occupied with my studies to mind her, she gradually fell into the habit of going to cafés and dances, and making social contacts. After our return to China, she started interfering in my daily activities. At first, she would complain whenever I bought books or paintings. Later, she even

interfered in my work, my painting and my thought...." He painfully recounted the past troubles one by one.

"But I put up with all that patiently to avoid having quarrels with her. Later, an unfortunate event happened in connection with Sun Duoci, a most talented girl student of mine." He narrated the whole story in detail as I have recounted earlier.

I listened quietly without saying a word to interrupt him. I was tracing the image of Sun Duoci in my mind.

"The whole incident lasted a year, during which time I was never once left alone with Sun Duoci. The terrific persecution, slanders and rumours directed against her were more than she could endure. She's quiet by nature, but one day a year later she broke her silence and tearfully told me her grievances. She said she wanted to quit her studies and go back to her hometown. I tried to persuade her to keep on studying, to develop her artistic talent and become fully accomplished, for I placed high hopes on her, as I would on any promising student. She accepted my advice patiently. But she was getting still heavier blows. A painting she had done and left in the classroom was stabbed with a knife and scribbled with the threatening words, 'We shall treat you in the same way as we did this picture.' The more she was persecuted, the more sympathetic I became for her and the more my heart was forced to be inclined to her. However, I still didn't think of divorcing Jiang Biwei, though we'd been having frequent terrible quarrels for many years. But she flatly refused to reconcile with me. In 1936, I was forced to leave home for Guilin, and later I lived by myself in a dormitory at Central University. That's how I became homeless. In 1938, when I went to Guilin to take some of my books and paintings from the cave on Qixingyan Mountain to show in Southeast Asia, I met Sun Duoci and her parents, who also happened to arrive there. I was then already homeless. But since I was busy preparing the overseas exhibition, and she was to accompany her parents to Zhejiang Province, we parted soon after the chance meeting." He seemed a bit tired and paused.

"And then, sir?" I asked.

"Later, when I was in Hongkong, she wrote me a letter from Zhejiang to inform me that she was teaching at a school there. She also enclosed in the letter a poem she had written. The poem showed her to be

very sad. So I wrote back to cheer her up and encourage her to strive to make progress, develop her talent and do her best for the anti-Japanese war.

"Still later, after I arrived in Singapore, I received from her another poem which again revealed her sorrowful state of mind. But since I was then busy with one art exhibition after another and too much concerned about the war-time sufferings of our countrymen to care for trifling matters, I didn't write her a reply and gradually lost all contact with her."

"Sir, I feel sorry for her. You could have been very happy with her living with you."

"Let bygones be bygones! Jing, now I'm only eager to have you at my side. When you're with me, I feel real warmth in my life and I can work more energetically."

"Sir, I feel the same way. I'm very, very much attached to you."

"Then, let's get married right away, Jing." Although the night was dark, I could see, by the light of the moon, his deep, clear eyes flashing with excitement and tears. He continued in a subdued voice, "Jing, are you really willing to marry a man twenty-eight years older than you?" In his voice, I sensed anxiety and uneasiness as well as joy and excitement.

"Yes, I am. I've overcome step by step the obstacle of age difference and come bravely before you, willing to devote my whole life to you and your work." I nestled my head closely against his firm, steady shoulder.

It was a warm night in spring. The moon was pale and the breeze was refreshing. The quiet waters of the Jialing River were twinkling merrily. Mother nature was all tenderness.

"Jing, let's go back," he said softly.

We walked up the steep stone stairs hand in hand in the glassy moonlight, soft breezes whispering sweetly at out side. We said good night to each other and retired to our respective rooms.

Chapter VIII

I was about to go to bed when I discovered to my surprise two letters lying beside my pillow. Hastily opening them, I found that one was from my father and the other from my elder sister, then studying at Guiyang Teachers College. Both of them reproved me in their letters for my relationship with Mr. Xu. It turned out that Jiang Biwei had written each of them a letter, in which she claimed that she was still Xu's lawful wife and charged me with acts of estranging Xu from her. Blaming me for his grief, my father even quoted in his letter the old saying, "If one cannot leave behind a lasting good reputation, one should at least refrain from leaving behind a lasting bad reputation." My sister, too, advised me to break with Xu immediately. Angered by the unfair treatment, I lay still on my bed like one thunderstruck and spent the whole night feeling terrible anguish.

What Jiang Biwei had done was incomprehensible to an unsophisticated young girl like me. After pondering over the matter repeatedly, I made up my mind that since Jiang was perhaps willing to be reconciled with Xu, I should leave the next day. So I rose from my bed to write my farewell letter to Xu by the dim light of a kerosene lamp.

I tried hard to choke back my tears when I wrote as follows:

Dear Sir:
 Pray pardon me for leaving you without saying good-bye. I just cannot stay here any longer even though I am more than willing to keep on working at your side. I shall always respect you, understand you and sympathize with you; and I am always grateful for the great loving care you have shown me. In the long years to come, I shall forever bear in mind the instruction and encouragement you have given me.
 It is my sincere hope that you will continue to seek possibilities of reconciliation with Madame Jiang Biwei, for I think she may now come round.

I have left on your desk the paintings you have given me and the portrait you have painted for me, for though I like them very much, I have no right to own them. I should not, nor dare I, take away from you these works of yours. However, in a place unbeknownst to you, I shall always keep them alive in my heart, for I have looked at them hundreds and thousands of times already.

Take good care of yourself and forget about me.

I was anxiously awaiting daybreak, but the night seemed to be as long as a year to me. At the thought that I was soon to leave the place and part from my beloved Xu once for all, I felt extremely distressed; the pillowcase was wet with my tears.

The mists of dawn were rising and the pale first rays of the morning sun were peeping into my window. I got up quickly to pack my luggage, which consisted of only a small canvas suitcase.

From the opposite building came Xu's footfall on the wooden stairs. Looking out of the window, I saw him making for my room instead of going straight out of the gate as he had often done. I hurriedly flung myself onto the bed and covered myself with a quilt. I heard his hasty footfall as he was ascending the staircase — a footfall which now brought me overwhelming sorrow instead of glee as it had used to do. He approached my room and gave two light raps on my door. Hearing no answer, he stood below my window to call in a low voice, "Jing!" and take a peep into my room. I kept still, feigning sleep. I was determined not to see him or make any noise; I felt a lump in my throat. I knew the moment I set my eye on him again, I would lose all courage to leave him.

Xu walked downstairs quietly and then his footfall died away in the distance. After going out of the gate, he would as usual walk to the riverside where, after buying from the food stall there a couple of baked sweet potatoes for breakfast, he would take a ferryboat to cross the river on his way to Central University.

After he was gone, I hurried from my bed to wash and dress. Looking into the mirror, I discovered that my face had lost its usual freshness overnight and looked deadly pale; my eyes had become red and swollen with crying.

Zhang Qianying, who had become my next-door neighbour since the big room which we had shared was divided into two with a partition, had also got up because she happened to be in a hurry to go out. She left wearing an elegantly designed and coloured long gown and carrying a

209

parasol.

With my suitcase in hand, I went straight to Xu's upstairs room in the opposite building to leave my letter to him and the paintings he had given me. Then I set about working for him for the last time, straightening up the paintings and rough sketches lying about in disorder. The sun slanting in through the window was no longer delightful; everything around me was dismal and dreary. I gently touched every piece of furniture in the room, simple and crude as it was; and after taking a last look, I walked out dragging my weary feet, leaving behind the happiness I had once found there.

I walked down the staircase and when I was out of the gate, I looked back repeatedly with tears trickling down my cheeks. Moving along on the familiar flagged path, I suddenly remembered the pleasure of my first visit to this place together with Xu. On both sides of the path, grass, flowers and tall, gnarled trees all seemed to be staring at me sympathetically. How dreamlike were the months of life I had passed here! A thrush, perching on a tree branch, seemed to know my mind and twittered to me a sorrowful note. My heart ached and bled, and my hand carrying the suitcase shivered. Leaning myself against a big tree, how I wished I might hear Xu calling me lovingly again! One more such call, and I would go right back to him and tell him I would forever stay with him regardless of any censure.

I walked down the steep stone steps one by one and reached the riverside where, at the crowded wharf, I bought a steamer ticket for Chongqing from the narrow wicket of the booking office. As the next steamer was scheduled to arrive an hour later, all I could do was sit on a bench and wait. I sat there unfeelingly, without seeing or hearing anything. At the shrill sound of a distant steam whistle, the passengers stood up and moved forward. The steamer drew alongside amidst the shouting of sailors and the clanking of the anchor. Aroused by passengers embarking or disembarking, talking or yelling, brushing past me or rudely bumping against me, I hastily picked up the canvas suitcase and went ahead.

I was about to step onto the gangway, which would decide my future destiny, when a heavy hand landed on my shoulder. I quickly turned round to find Xu standing behind me panting hard. He seized my

arm and said intensely, "Jing, you can't go! How can you go off in such haste?"

While my mind was adamant, my legs were too soft to make a move, as if something were tugging hard at them. "Please go back!" I said tearfully.

"Jing, don't do this! You have been upset, haven't you? Cool down so you can tell me what happened."

He made me sit down with him on a bench and told me the following: Since hearing no answer to his call in the morning, he had been worried that I was laid up with a cold, and after finishing two periods of lecturing he had come back quickly to find my letter on the desk. He had run to the wharf.

"Jing, Heaven's been kind and generous to me. One minute late, and I would have missed you forever. I ought to be thankful to Heaven." His eyes were glittering with nervous joy, and his forehead dripped with sweat.

"Jing, how can I make it up with Jiang Biwei? You're too naive. Besides, it's she who flatly rejected reconciliation, and we've been separated for seven years. You're in no way to blame."

"Maybe she's willing to be reconciled now," said I, showing him the letters from my father and sister.

He shook his head in anguish and said indignantly, "No, that's not what she wants. She's trying to ruin me, that's all! I still remember clearly what she told me when she kept vigil beside her father's remains."

Meditating in silence, I suddenly remembered what a girl student of his had once told me, "Jiang Biwei says that while she absolutely refuses to make up with Xu Beihong, she also absolutely refuses to let him have happiness." At that time, I was unaware that Jiang had already become Zhang Daofan's mistress and that it was Zhang that had been instigating her to inflict this cruel torture on Xu Beihong.

Xu continued, "I've asked quite a few friends to talk her into going through divorce formalities, but she rejects both reconciliation and divorce. Later, when I went to seek advice from lawyers, they all said that since we had not completed marriage formalities in the beginning, we were regarded as cohabitants only and that if the cohabitation ceases, neither side is legally bound."

Several days later, Xu took me to see the lawyers. They all said the same thing was stipulated by the law of those days.

I wrote to inform my father and sister of the real state of affairs, but they chose to believe Jiang's words rather than my explanations, and continued to write me one letter after another, reproving me and urging me to quickly sign up for a college entrance examination. I did not dare to let Xu know about that for fear that it should add to his displeasure and anxiety. Though working at his side as usual, I was filled with vexation and inner conflicts. We no longer went out to walk together or mentioned the question of marriage.

Spring was gone, and each day was getting warmer and warmer. I began reviewing my lessons in preparation for taking a college entrance examination, and often sat up late into the night. But as soon as I lay in bed, my mind would be vexed by the recurring thought of parting from Xu. Sometimes, in my nightmares, I would see him suddenly become old and infirm and hobble along towards me until I woke up weeping and wailing in grief.

One depressing, sultry night, I went outdoors alone in an agitated mood. Walking past Xu's building, through the open window upstairs, I saw him stand bending over his desk in his white grass-linen jacket and trousers, and painting by the dim light of a kerosene lamp. How I wished I could enter his room and say, "It's so hot, you should take a rest! Let's go to the riverside for a walk." He would no doubt gladly put down his brush, wipe away the beads of perspiration on his forehead and accompany me to the riverside, because, as he had told me, he thought it a wonderful luxury in his over-strenuous life to go out with me for an after-meal walk.

After standing mutely below his building for a while, I walked away quietly by myself. I had resolved to suppress my feelings as best I could and reduce my contact with him so that we might be less anguished at the time of our parting in the future. It was a pitch-dark night, without stars and moon. Murky clouds hung heavy in the black skies and frogs were croaking in the fields. I groped my way along the straight flagged path until I reached the far end of it, and then walked down the steep stone steps to the riverside. I sat on the same rock we had sat on before and began to ruminate over the many things that we had talked about while

sitting here.

I felt extremely pained at the thought of my imminent departure, after which I could no longer hear his kind words of counsel and he would again lead a solitary life. How I hoped that someone else would show him as much love, respect and solicitude as I did! As for me, because of the strong objection on the part of my father and sister, I would have to leave him and go my own way.

I sat by the river lost in reflection, totally oblivious of the whistling wind and distant thunder. Suddenly, a blue flash of lightning streaked across the dark river and was followed by a peal of roaring thunder. A few drops fell on my head and soon it started raining in torrents. While running against the storm on my way back, I slipped and fell down the muddy stone steps. Feeling pain, I struggled to my feet, but fell again.... Right at this moment, I heard a distant voice calling in the storm, "Jing! Where are you? Jing! Jing! Where are you?..."

It was Xu's voice — a voice fraught with fear, anxiety and love, and a voice which was to ring clearly in my ears throughout the rest of my life.

When he carried me indoors in his arms, my face, hair and clothes were all dripping with rainwater. Outside, it was still pouring hard and the violent wind was whining plaintively against the tree branches.

Grasping my cold fingers, he said, "Jing, I understand your anxiety and sorrow. Never mind about me, and do whatever you want to do! Besides, I've been thinking these days that you're so young, too young for me to love you. I fear, I fear very much that I may not give you happiness."

Evidently he had plucked up great courage to utter the last few words, which seemed to have been lying on his mind like a dead weight.

After that stormy night, we would meet every day and talk to each other as usual. I could still see the same expression of concern and love in his eyes, but I sensed even more strongly that he was suppressing his feelings in painful silence.

Chapter IX

Summer vacation was drawing near. Having finished the term's lectures at Central University, Xu decided to take the students of the preparatory office of China Art Academy to Guanxian and Qingcheng Mountain to do sketching and painting, leaving behind a male clerk and a male janitor to look after the office.

At first, I insisted on staying behind in Chongqing to get ready for local university entrance. But Xu and other members of the office tried to persuade me to go with them, saying that I might as well sign up for university entrance in Chengdu; it would be very inconvenient for me to stay behind without a female companion. I still hesitated, so it was not until after a long deliberation that I finally decided to go with them.

I had not expected that Jiang Biwei would also suddenly decide to have her son and daughter go on vacation with Xu. When she sent the message through Lu Sibai, Xu agreed.

On the day we started the journey, Jiang turned up to see off her children. This was my second meeting with her. She was wearing a long gown, simple and graceful in colours and designs, thick rouge and powder on her face and the same big round girlish buns on her temples. We looked at each other without speaking. Nor did she speak to Xu. But she was smiling all the time and looked quite pleased with herself.

Xu's son Boyang and daughter Lili were then both junior-middle-school students. Ever since their parents had separated, they had not been living with their father. Lili had dislocated her hipbone at the age of nine when she took a fall. She cried in pain, but her mother was too busy to take care of her or send her to hospital. Later, the pain stopped, but she walked more or less with a limp. She was lively and cheerful by nature, full of self-confidence and diligent in her study. Boyang was reticent and lacked the liveliness and cheerfulness befitting a junior-

middle-school boy. The parents' separation, I think, had inflicted a trauma on both children. My sympathies were with them.

We travelled straight to Chengdu by bus. The city was clean and tidy, but no less hot than Chongqing. I arrived just in time for the university entrance examinations. I signed up for the exam in the journalism department of Yanjing University and the chemistry department of Jinling Women's College of Arts and Science (also called Jinling Women's University) respectively. The entrance examinations of the two universities, each lasting two days, were held in different places on different dates and gave different test questions. Xu was greatly concerned about me and purposely stayed in Chengdu for several days so that he could better look after me.

For the Chinese examination, Yanjing University required that each applicant write a composition under the given title of *After Reading Generalissimo Chiang Kai-shek's "China's Destiny."* Since I had not even read Chiang Kai-shek's book, I knew nothing about its contents and was of course unable to write a composition on it. Having thus flunked in the Yanjing University entrance examination, I had to put my hopes in Jinling Women's University.

After the ordeal of several days of examinations, I accompanied Xu to Guanxian. The group, in addition to members of the preparatory office, consisted of Yu Feng, Kang Shoushan, Boyang and Lili.

In Guanxian, which is situated in the middle reaches of the Mingjiang River, we were very much struck by the Dujiangyan water conservancy project, constructed more than two thousand years ago by labourers led by the Shu (Sichuan) prefectural magistrate Li Bing and his son. The turbulent currents presented a magnificent sight. Standing before Erwangmiao (The Temple of Two Sages), built in A.D. 494 in commemoration of Li Bing and his son, we were seized with a feeling of respect and admiration for the two ancients when we recalled how they had tunneled through mountains and built dikes to turn a flooded area into fertile farmland. Inscribed in the temple was a six-character formula for harnessing rivers, meaning "Deepen watercourses by dredging and control water by building dikes." Two posts in the main hall were inscribed with the following couplet in praise of Li Bing's exploits in preventing floods by water control:

> To this gentleman we owe the ever-true six characters and the
> livelihood of people in fourteen counties;
> By this magistrate we are given a settled life on the river and eight
> hundred li of mountains and fertile land.

The temple, however, was in a state of disrepair. Out of respect and admiration for Li Bing and his son, Xu donated then and there twenty thousand yuan for its maintenance expenses.

Within a stone's throw of the temple, there was a rope-and-plank bridge, which would sway gently when people walked on it. As soon as I stepped onto it, my legs felt like jelly and I had to retrace my steps. Later, we took instead a bamboo raft to cross the turbulent waters. While we were being tossed about on the surging river, our clothes were soaked by the whitewater foam of breaking waves.

Next we visited Qingcheng Mountain, where, among peaks rising one above another, ancient trees stood sky-high and all was quiet and tranquil except for the singing of birds and insects. We put up at a temple named Tianshidong — a place where, according to legend, Zhang Tianshi had stayed to attain perfection in Taoism. It had a magnificent hall and rooms to lodge travellers.

Xu had a room all to himself in the temple. There he successively painted illustrations for the ancient Chinese poet Qu Yuan's *Nine Songs*, such as *Martyrs to the National Cause, Mountain Spirit, God Xiang*, and *Goddess Xiang*. He also had the first two enlarged in the traditional Chinese style. *Martyrs to the National Cause* is in praise of soldiers who had laid down their lives for the nation while *Mountain Spirit*, depicting a beautiful female mountain spirit languishing for a young man, is symbolic of the poet's own love for his motherland.

I was relaxing after sitting for university entrance. Xu helped me practise calligraphy after a model of the famous ancient calligrapher Wang Xizhi. He was very fond of Chinese calligraphy and had a rich collection of rubbings from stone tablets or bronze vessels. He had devoted a great deal of energy to learning calligraphy and had copied many famous stone rubbings. He liked, in particular, rubbings from stone inscriptions of the Northern Wei Dynasty for their forcefulness, boldness, solemnity and reserve. He also liked figure carvings done by ordinary craftsmen for their simple modelling, and unconventionality.

216

His own calligraphy shares in the Northern Wei style.

The other colleagues who had come with us were also painting in earnest. Some were sketching in Qingcheng Mountain, and some went to fairs near Guanxian to paint minority peoples and colourful, busy market scenes.

Every day, over meals at a round dining table big enough for more than ten at a time, we would exchange information about what we had seen and heard. After supper, everyone would go for a walk. Xu and I would often saunter along a quiet brook until we reached a small wooden bridge and sat down there to listen to the murmuring of the spring water flowing down the ravine. As the dusk deepened, fire-flies glimmering with a bluish light started flying over our heads, the cool evening breeze wafted the aroma of the trees to us, and from time to time woodpeckers were heard tapping from afar. A beautiful, tranquil, enchanting evening! The quiet trees also seemed to enjoy the pleasure of watching us in the gathering darkness.

One evening, however, tears again glistened in my eyes and then rolled down my cheeks.

"Jing, why are you crying again?" he asked in a gentle voice.

"Sir, I'll not be able to work at your side," I replied sadly. "The summer vacation will soon be over, and I must be going to the university." I had already received an admission notice from Jinling Women's University.

"Jing, I'm glad you've been admitted. Never mind about me, but study hard to make yourself useful to this disaster-ridden country. Of course I'll miss you when you're gone, but at a time of national calamity when Chinese are being humiliated and slaughtered by foreign aggressors, one's personal sufferings are hardly worth mentioning."

I was touched and invigorated by his encouraging words.

We walked back along the same whispering brook. The summer evening was pervaded with a coolish mountain air. At our touch, dew fell off branches of the wayside trees in large drops.

Not long afterwards, all of us went to spend a few days visiting Shanqinggong, which was also a Taoist temple. Among the fellow travellers, the one who had the most contact with me was Kang Shoushan, who, a graduate and then an assistant of the art department

of Central University, had been a student of Xu's. Since Liberation, she has been an associate professor at the architecture department of Qinghua University, teaching sketching and watercolour painting. She often distinguishes herself by painting buildings and landscapes in the traditional style. Then aged twenty-seven, she was my senior and a fellow provincial from Hunan, so we often had chats together. A portrait she had done of me won Xu Beihong's high praise.

Yu Feng, who had also studied under Xu at the art department of Central University, is the noted writer Yu Dafu's niece. Of a lively disposition, she is a good writer as well as a painter. She taught us to dance and play games, and we all had great fun together.

Tianshidong was the habitation of a group of rigidly stratified Taoist monks who, led by a head monk, had to observe many taboos and commandments. A middle-aged monk often came reverently to present Xu with a trayful of freshly picked walnuts, and the elderly head monk often came to pay him regards. The cook, having learned of Xu's liking for tomatoes, went out of his way every morning to prepare him a bowl of tomato egg soup. All of them had the common wish of being offered a painting by Xu.

More than a month later, as we were leaving Qingcheng Mountain, Xu gave seven of the monks each a picture he had painted. When the seven monks were crowding together to view the pictures to be distributed to them, Xu proposed the condition that the cook should be the first to make the choice. But the cook shook his head repeatedly, his discomfitted eyes falling first on the head monk and then on Xu. His bright eyes seemed to inform Xu that though he was much obliged, he could not, in front of the head monk, do what he had been told to. Xu understood what he meant and personally picked out the best picture and gave it to him.

Later I was to learn that the middle-aged monk, who had often given Xu walnuts, had had the horse painting given him by Xu inscribed in stone so as to sell its rubbings to tourists.

Chapter X

After coming down from summer at Qingcheng Mountain, we stayed a day at Guanxian and then returned to Chengdu by bus. Xu stayed in the home of his old friend Chen Li while I went to register with Jinling Women's University. Like a bird soaring to the heavens, I had summoned my greatest courage and willpower to fly away from Xu, but I kept looking back fondly at my old nest.

At night, as I lay in bed in the university dormitory and looked at the ivy and glassy moonlight on the window, tender thoughts began to crowd into my mind. I wondered how Xu was getting along, whether he had gone to bed or not. I could never forget our conversation at parting.

"Good-bye!" he said on the day of my departure, "I'm very glad that you've achieved what you've been wishing. I hope you'll study hard to become a chemist. Our country is in great need of scientists."

I could only nod my head.

He continued, "Jinling is a very strict university run by Americans. Its graduates speak fluent English and are more cultured and refined. Some of them marry high Kuomintang officials after graduation."

"Sir," I cut in hastily, "that's not what I'm going to do."

"Jing, I hope that you will remember our national crisis and the sufferings of our people," he went on thoughtfully. "Do make up your mind to serve our country and society."

"Thank you, sir. Wherever I go, I'll bear in mind what you've told me."

I dozed off in the midst of these memories. Next dawn, I was roused by the sound of the waking bell and rose immediately to wash and dress. Then followed exercises, breakfast, and classes.

I was thinking of Xu all the time. He was busy preparing an art exhibition to be held in Chengdu and yet I was unable to lend him a

helping hand. Never had I been so anxiously looking forward to Sunday, for it was only on Sunday that I could see him.

The early morning of the first Sunday arrived to my great delight. What a beautiful, light-hearted and happy morning! Out of the university gate, I walked along at a brisk pace feeling unspeakably joyous and excited. Even the rising sun seemed to be smiling sweetly on me.

Again I met him; again I saw his kind beaming face, again I heard his gentle voice, "Jing, I'm so happy that you're not far off from me."

He had obviously become thinner. His cheeks, formerly full, were sunken and he looked weary from head to foot. I busied myself for a whole day in rubbing the ink stick, spreading sheets of paper, and cataloguing the exhibits, as I had done for him before.

After supper, he walked me to the university. Because of the week-long separation, I had put high hope on our momentary reunion. Only after tasting the bitter fruit of separation, did I realize that I could never retrieve my heart. In the moonlit night, the stars also seemed to be whispering with joy.

"Jing, don't think of me too much, but study hard. I don't like people who are not diligent," he whispered softly.

"Sir, I just can't help thinking of you, but I'm doing quite well in all my studies. It worries me to see you getting thinner. I think ..." I stopped short and choked back the words about to rise to my lips.

"What are you thinking?"

I kept quiet.

"Jing, what's on your mind? Tell me."

I hesitated.

"Jing, speak up, what are you thinking about?"

"I think you shouldn't always remain single, with no one at your side to look after you. You'd better quickly find a suitable partner," I answered with great sincerity though not without heartache.

"Jing, love is something so miraculous. Sometimes, when I am tired with painting and stop to get a rest, I seem to hear your university bell ringing at the end of class. I would go there to see you right away if it were not for the fear that I should disturb you."

"Sir, you still haven't answered my suggestion yet. You shouldn't

always keep your feelings suppressed. You've got to have somebody to look after you," I repeated.

"Jing, with your image in my heart, how can I love anybody else? Besides, your love is so deep, so true, so pure. It's something I've never experienced before, something seldom found on earth. I'm willing to wait for you until you graduate from the university four years from now. If by that time you should have fallen in love with somebody else, I won't say a word of complaint at all."

"Sir, you're already forty-eight. Four more years, and you'll be over fifty. You shouldn't wait for me! Once you've got a sweetheart, I'll leave you right away and she can take my place," I said feeling miserable.

"Jing, love is valuable just because it's irreplaceable. Even an angel from heaven with all the beauty, virtue and wisdom of this world combined in her would never give me as much happiness as you can. Do you understand, Jing?"

I wept in silence.

It was not until he had accompanied me as far as the university gate that he left me reluctantly and went back alone. I can still clearly visualize the reluctance on his weary face and his receding figure clad in the white linen long gown.

When the second Sunday came round, we met happily again. Seeing that I had become a university student, father no longer wrote me letters of reproach.

Shortly after, Xu's art exhibition opened in Chengdu to the excitement of the local people. I again went among crowds of spectators to hear their words of praise and share Xu's joy. His oil *Tian Heng and His Five Hundred Followers* and his traditional paintings *The Foolish Old Man Who Removed the Mountains, Jiufang Gao, Sichuan Folk Drawing Water from the River, A Poor Woman of Sichuan, A Cock Crowing in Wind and Rain,* and *The Lijian in the Spring Rain* had a strong appeal to the visitors. The exhibition had a great impact upon artistic circles in Chengdu, and many paintings were sold.

As soon as the exhibition ended, however, Xu received a letter from Lu Sibai transmitting Jiang Biwei's demand for more money to support

221

their children. Consequently, almost half of the proceeds from the exhibition, a large sum, again went to Jiang's hands through Lu Sibai. Part of the remaining money was donated by Xu to aid writers and artists who were poor and sick.

Autumn in Chengdu was beautiful and bounteous. Bathed in autumn sun, the forests and farmland in the suburbs looked bright and splendid, and the air was heavy with the aroma of ripening rice.

One Sunday, Xu and I went to Xindu County to visit Guifu (Osmanthus Residence), in which there were more than a hundred and eighty osmanthus tress, then in full blossom, planted by Yang Shengan of the Ming Dynasty. The covered horse-drawn carriage in which we were travelling sped ahead on the Chengdu-Xindu highway.

It afforded him spiritual enjoyment to see the horse tearing ahead against the wind and hear the clip-clop of its hooves. He felt as if his heart were galloping together with the animal.

The carriage driver was a kindly old man with a sun-burned, wrinkled face. Wearing a patched, coarse-cloth jacket, he sat arching his back in the front box. He was whistling, and before he raised his whip the old chestnut mare had lifted her hooves to increase speed. While the roadside trees and houses were flashing past, the quick, rhythmic hoofbeat sounded like a summer-night shower pelting down against windows. The mare gradually began to steam and, with her glossy skin exposed to the scorching sun, heaved wearily, her mouth gaping and her nostrils flaring. The old carriage driver was understanding enough to hastily rein her in; the mare slowed down and ambled like a soldier on a slow march. But soon she started trotting again.

The old driver shook his grey head and turned to address us with a broad smile, "She's old, but like a human being, she's eager to do well!"

Xu followed up by remarking cheerfully, "Uncle, you've done quite well in training this horse!"

"You've got to be a horse-lover if you raise a horse," said the driver complacently. "Don't think that she's only a beast. As a matter of fact, she understands everything, and is sometimes even more intelligent than man. Today, for example, she's happier than I am because I'm doing good business having you two as my fares. I depend on this old horse for a living, and she depends on me for a living, too. We can't get along

without each other. See, I've sold everything except this horse. Sometimes, even when I myself have got nothing to eat, I still don't forget to feed her. When I'm cold, I still manage to keep her warm. When her head is bending low, I won't give her any work to do for I know she's in a bad mood. I'll then work all by myself instead...." The old man talked away without stopping.

"Uncle, you're right," Xu cut in with excitement on his face. "I like people like you who're good to horses. Horses are both hardworking and loyal."

Having been encouraged, the driver became even more garrulous. He went on like a chatterbox, about his family, the war disaster, the rising commodity prices, the hard life. The mare, trotting along, kept her pointed ears erect as if she were listening with rapt attention to her master's complaints.

The breeze was wafting to us the faint fragrance of the osmanthus blossoms, a fragrance that was becoming heavier as we went along. When I looked into the distance, Xindu County was already in sight. Unfolding before us in the bright autumn sun was the graceful scene of numerous osmanthus trees holding aloft a screen of thick green foliage. Our carriage, after quickly finishing a journey of several dozen kilometres, came to a halt with a jerk.

We alighted in high spirits. After paying the fare, Xu held out his hand to lovingly stroke the sleek back of the mare and said amiably, "Thank you." The docile mare pawed gently and shook her graceful neck with delight.

The driver was busy getting water and feed for the horse. "Hey, here's something for you," Xu suddenly said to the driver, producing from his leather handbag the rolled picture of a galloping horse, which he had painted the previous night and had intended to have mounted at a picture-mounting shop on the way back.

The driver raised his wrinkly brow to squint at Xu in bewilderment.

"Uncle," I put in a word of explanation, "it's a picture given to you as a gift."

The driver's clouded eyes brightened up and his furrowed face beamed. Taking over the picture with both hands, he said repeatedly, "Oh, oh, thank you, sir.... thank you, sir."

"Uncle," I added, "this picture's worth even more than the fare we've given you. Don't give it away casually! Understand?"

The driver nodded repeatedly, saying, "Yes, I see. Yes, I see. I'm fortunate enough to have run into you two good people. Early this morning, when I saw a magpie coming down to my window, I wondered what good luck it might bring to a poor old man like me. Now, it has really come true" The garrulous old man used his right hand to hold up the cuff of his left-hand sleeve to wipe away the tears on his cheeks.

Xu shook the stone-rough hand of the driver repeatedly and said, "Good-bye!" Then we went towards Guifu.

"Sir, why did you suddenly give the painting to a carriage driver who is a stranger to you? He doesn't even know who you are. Aren't you a bit too generous?" I asked in surprise.

He answered in a soft voice, "I love horses, so I also love those who treat horses well. You see he not only drives the horse skillfully, but also treats it as a member of his family. His love for this animal has touched me. And, besides, he's so poor!"

Hearing his words, I also felt touched.

We sauntered slowly before the osmanthus trees. The strong scent of their flowers was mentally refreshing and intoxicatingly sweet. With trunks so big that one could just get one's arms around, these ancient trees stood there like weather-beaten, aged people. Though they bore scars of the past long years, the fluid of life was still coursing through their bodies. In spite of the fury of the elements to which they had been subjected for several centuries, they were still putting forth blossoms. Their dark green twigs and leaves were lavishly decorated with small golden or white blossoms, whose petals came floating down on our heads and bodies and the ground in a slight breeze. The sunlight filtering through the foliage cast dark shadows of the trees. As we aimlessly trod in the beautiful shadows, a feeling for the frailty of life came over me. Many centuries had gone by and generation after generation had been laid to rest underground, but the trees continued to live on tenaciously, standing erect to brave the elements. When I imparted my thought to Xu, he nodded silently and then said, "Life is short. But it still continues when the body is buried. Whatever one does for the good of one's family, one's cause, and one's country will forever survive in the hearts of later

generations. In this sense, the prominent ones among us will never stop scattering among the living people their beautiful blossoms. They will live even longer than trees, for trees are bound to die eventually."

However, his words of encouragement did not stop me from being sentimental. I thought of my mother who had died sadly at thirty-nine and my elder sister who had died at eleven. Both events had deeply affected me as a child.

On another Sunday, Xu and I went on a sight-seeing trip to Du Fu's thatched cottage in Chengdu. It is a Chinese-style structure where Du Fu had once lived when he came to the city in A.D. 759. Inside the cottage there is a lovely courtyard with green bamboos and a brook spanned by a small bridge. Xu was very fond of Du Fu's poems and had done quite a few traditional paintings entitled *After One of Du Fu's Poems*. Like the poet himself, who lived a life of frustrations, the thatched cottage had also passed through many vicissitudes. It had been renovated many times after falling into ruin, for the people had always cherished the memory of the great poet. Standing in front of the cottage, Xu said, "The poems left behind by Du Fu are among the immortal works handed down from ancient times. They are the ever-fragrant beautiful flowers scattered by him among the living." He still had in mind what we had talked about in Guifu, and then continued thoughtfully after a pause, "Before one dies, one ought to leave behind for the coming generations something lofty and valuable."

If ever we had moments of real joy and happiness during those days, they came on those brief Sundays.

Chapter XI

The happy days were short-lived.

Xu and I were soon to part, due to his return to Chongqing. He was busy packing his things, including paintings not for sale. Meanwhile, he had to dash off some paintings to satisfy the request of some friends in Chengdu.

He grew ill through overwork. At first he felt chilled and dizzy, then he had a fever and his blood pressure went up. The doctor blamed it on overwork. Xu lay in bed without any kinsfolk to look after him, so I was given a leave of absence and kept watch by his bedside. After treatment, the fever gradually went down, but he was not yet recovered. He looked pale and emaciated and suffered from intestinal spasm, an additional illness. Pain caused beads of sweat to ooze from his brow. But he refrained from uttering a single groan, biting his lip until it turned white.

He was anxious to return to work in Chongqing, even though he had not yet fully recovered from his illness.

His old friend Chen Li advised me earnestly, "Mr. Xu's been living all by himself for seven years! I know what it's like! Why must you attend college? You can learn a lot as well if you stay with him! You ought to make a little sacrifice to enable him to make more contributions to our country."

I fell silent, torn by conflicting thoughts. I was eager to look after Xu, but I did not want to give up my studies at the university. I was greatly tormented with the question of what to do.

"Jing," Xu, reading my mind, said with consideration, "don't bother yourself about me. Go on with your studies!"

"But I can't help thinking of your health. I'll be worried if you go back to Chongqing alone without any relative to look after you."

"Jing, why do you worry? Haven't I been alone for seven years already? Another four years, and it will add up to eleven. Now more than half of the eleven has already passed," he said smiling in an attempt to amuse me, but I wept in silence.

Back at the university, when I opened my book, I could not see words on the page; when I sat in the classroom, I could not hear the teacher's lecture; when I was in the laboratory, I knocked over the oxygen cylinder and dropped a test tube on the floor. At the sound of the class-dismissal bell, I knew Xu must be sitting on the lawn before my dormitory waiting for me to come back, for he was leaving for Chongqing in two days. I had yet to finish the experiment as well as a report on it before I could leave the laboratory. But my heart had already left.

Though Xu had repeatedly encouraged me to study hard, my emotions refused to heed the call of reason, especially when I recalled the doctor's advice, "He's in poor health and his blood pressure's a little high, so he ought to pay particular attention to his diet and everyday life." But who was to look after him and take care of his diet and daily life? At night, I tossed about in bed and could not sleep.

On the day before his departure, I went to call on him in emotional turmoil. Chen Li, however, came up to me with a broad smile on his face, and informed me that he had bought us two plane tickets to Chongqing. Thrusting the tickets into my hand, he addressed me in his inveterate Sichuan accent, "You shouldn't think of yourself only!"

We stared blankly.

Xu hastened to say repeatedly, "That won't do. No, that certainly won't do. Jingwen can't go with me. She mustn't give up her studies on my account."

My heart was beating double-time. My respect, love and sympathy for him, my concern over his health, my sorrow for our imminent parting — all these surged up within me with the vehemence of an irresistible flood. They swept away all my misgivings and anxieties and instantly brought me to the long-pending decision to accompany him to Chongqing and marry him as soon as possible so that he could have the warm home denied him for many years.

His attempt at dissuading me from going no longer worked

although he kept on saying, "Be cool-headed, otherwise you'll have regrets."

"I'll never regret this!"

"But I still hope you'll remain here to continue your studies. That's more important than anything else!"

"Sir, you're always thinking of others, but not of yourself."

"Jing," he said with a melancholy look on his face, "I still think you're too young. I've been wrong to love you. You'd better remain here to attend college! Maybe later you can gradually forget me and find someone more suitable."

"No, nobody else in this world can ever take your place in my heart."

Chen Li stood by with a complacent smile. I had never expected that the general, who had been following a military career for half a lifetime, could be so sincere and thoughtful.

Ten years later, when I met him in Beijing, he had been transferred to be Vice-Minister of Agriculture and Forestry of the Central People's Government.

Born into a poor family and brought up by his widowed mother, Chen had risen from the ranks. One day, when I asked him about his life experience, he said that when his younger brother died, his mother had wrapped up his dead body in a broken mat and buried it in a pit she had dug, but that the next day when she went there to take a look, she had found a pack of hungry dogs gnawing at the skeleton. Although several decades had passed, his eyes glistened with tears as he told the gruesome story. He was politically enlightened and for many years supported the Chinese Red Army by sending them money and munitions. Later, shortly before Liberation, he led an armed insurrection against the Kuomintang in Southwest China at the risk of his personal safety.

At last I took off with Xu at the Chengdu airport. It was a fine, sunny day. Our plane flew steadily over fertile land and hills and the Bashan Mountains were dimly visible. Then, when the ever-flowing Yangtse and Jialing rivers came into sight, we knew we were over Chongqing. The magnificent town appeared so foggy. What a memorable and bewildering place it was to me!

Again I was back in Panxi where everything — whether a brick, a stone, a blade of grass or a tree — was so familiar to me. Everything remained the same except the pavilion beside a building which had been demolished by a Japanese air raid during our absence; the clerk and the janitor, however, were both unscathed.

That I had discontinued my studies and returned to Chongqing with Xu soon caught the attention of Jiang Biwei. She again wrote father a letter to stir up trouble. And again father and sister interfered. I decided to go to Guiyang to talk things over with them directly and seek their understanding so I could get married as soon as possible. Xu bought me a bus ticket for Guiyang and saw me off at the bus station. Once again I had an exhausting, bumpy ride on the Sichuan-Guizhou plateau.

After I arrived in Guiyang, I rented a small house next to Guiyang Teachers College where my elder sister was studying, so that she could easily come to see me. Through many conversations between us, she gradually understood that Xu and I did love each other deeply and truly and that reconciliation between Xu and Jiang Biwei was absolutely impossible. However, she insisted on having a talk with Xu before she could say yes or no to our marriage. Father had opposed the marriage because of Jiang Biwei's declaration that she and Xu had not been divorced and her refusal to go through the legal formalities of a divorce.

Meanwhile, Xu went early every morning as usual to teach at Central University, and he had to wait until the winter vacation began before he could come to Guiyang. His letters to me were full of longing, and I anxiously looked forward to our early meeting.

Winter in Guiyang is cold. The weather is gloomy, and the heavy dark clouds hang like sludge in the sky. It rained almost every day and the air was irritably damp. Near the end of the year, I received, to my great delight, a letter from Xu telling me that he would be leaving for Guiyang to meet me on Chinese New Year's Eve.

Time crawls when one waits in eager expectation. Only joyous time speeds. Every day I waited in growing anxiety, but Xu still did not arrive. It was already the last day of the twelfth month of the lunar year. Rain had been falling since early morning. Time and again I went to the front gate to see if he was coming. "He'll be here today anyway!" I told myself

229

in agitation, the thrill of excitement and joy over the imminent rendezvous suffusing my cheeks with blushes. But, after the morning was gone, he still did not turn up. I grew fidgety and lost appetite for lunch, going repeatedly to the front gate to look out. One o'clock, two o'clock, three o'clock Time was passing second after second to the beating of my heart, and the bleak evening twilight of winter came.

Then came night. New Year's Eve is the time for family reunion, but Xu still did not arrive. Looking into the mirror, I discovered that my face had lost colour and looked wan and sallow. My sister and I sat around a fire listening in silence to the popping of firecrackers set off by thousands upon thousands of families. The clock struck ten, then eleven, and in the intermittent cold rain outside, the streets were bare of pedestrians. People kept indoors to enjoy their family reunions.

"He won't be coming," said my sister. "Don't be silly. You're too naive and simple!"

"Oh, he'll certainly come," I said with finality, though I could hear the quivering of my own voice.

"How stupid! Can he still come when it's already so late? If he had wanted to come, he would have been here much earlier!" said my sister in a huff.

I began sadly to recall many events of the past. I remembered how, when I helped my former fellow student Yang Degong to resist the marriage that her elder brother had arranged for her, I had been consequently subjected to all kinds of persecution in Liling County, Hunan Province, where her brother was teaching. Fortunately, Degong and I managed to leave the county and hurried to Hunan's war-time provincial capital Laiyang to sign up for college entrance. But, since all colleges and universities had already finished giving their entrance examinations except the National College of Commerce, we signed up for its entrance examination and were both admitted. However, I did not enroll as Degong did because I was not interested in the study of commerce. When I learned that Guangxi University was going to enroll new students, I immediately took a train for Guilin. In route, the train was repeatedly held up by Japanese air raids, and I arrived in Guilin only to find that the deadline for signing up had passed. All I could do was find a job in Guilin. Who would have expected that I should come to

know Xu Beihong in Guilin?...

My reverie was interrupted by a knocking at the door. I jumped to my feet abruptly. Surely, that was Xu! Only he would have knocked in this way. I ran out to open the door; it was midnight. Xu appeared before me, his blue, cotton-padded, cloth long gown spattered all over with mud.

He stood by the stove to warm his frostbitten fingers over the fire again and again.

"Jing," he said, "I left Chongqing in a mail car which broke down halfway, deep in the mountains. I had to change to a long-distance bus, which also broke down. So I again changed to an open truck, which also broke down twenty kilometres from Guiyang. What could I do? And this is New Year's Eve! I had to meet you by any means! So at last I covered the rest of the journey on foot."

"You walked twenty kilometres alone in the dark night through mud and rain?"

He nodded.

"Why did you do that?" I complained. "You ought to have put up at a hotel when the car broke down. I don't like to see you torturing yourself like this!"

"Jing, tonight is New Year's Eve. I knew you were waiting for me and I didn't want to let you have a lonely time on this night. Besides, I've been thinking all the time that if I could make it to Guiyang tonight to see you, our marriage will surely succeed, otherwise it will fail. I call it an omen."

"Hm!" I sighed a deep sigh and quickly took off his wet gown. As there were no men's clothes for him in my place, he had to sit wrapped in a quilt while I was drying his gown by the fire. We both sat up until daybreak. My sister was also touched.

The next day, Xu moved to a hotel. The Guiyang press immediately reported his arrival in the city, and his friends and students, newspapermen and many art lovers all came to see him one after another. His room was packed from morning till night.

231

Chapter XII

At last Xu and I held our engagement ceremony in Guiyang. Many of his friends came to offer us congratulations, and, in accordance with the custom of the time, we published in the newspapers an announcement as follows:

> Friends and relatives are hereby notified that Xu Beihong and Liao Jingwen are now engaged in Guiyang.

Three days prior to this, Xu had also published in the papers a formal announcement as follows:

> I, Xu Beihong, and Miss Jiang Biwei have severed relations of cohabitation for eight years due to incompatibility of temperament. In view of the fact that Miss Jiang has been persisting in her own way despite mediation by friends and relatives, it is no longer possible to re-establish our former relations. Therefore, from now on I shall not be in any respect concerned with Miss Jiang. This announcement is hereby proclaimed for the benefit of those not yet informed.

We were both very happy. Xu said lovingly, "Jing, from now on, don't call me sir. You should call me by my personal name."

"Beihong!" I responded in high glee. "Without your permission, I wouldn't have dared!"

He gave a hearty laugh.

Then we went to the suburbs of Guiyang to visit a farm set up by one of Beihong's former fellow students in France, to whom Beihong had once offered some financial aid. He gave us a warm welcome and treated us to some tasty fresh vegetables grown on the farm. After the meal, we went sight-seeing on sturdy horses kept by the farm. This was my first experience on horseback; I moved along slowly with the help of a groom holding the reins for me. Beihong climbed into the saddle nimbly; as soon as he spurred it, the horse galloped off briskly to vanish in the distance, leaving behind a rising cloud of dust.

In winter, Guiyang presents no desolate scenes as one sees in North China. The open country remains a vast expanse of fresh green and now and then one can still hear the sweet songs of little birds.

Beihong, however, was soon going back to Chongqing. He decided that he would come back to Guiyang to get married and settle down in its suburbs to paint as soon as he was through with some important matters at Central University. He loved the tranquil and simple surroundings on the outskirts of Guiyang. The simple, honest peasants, the exotically clothed minority people, and the Miao people with their moon dance and reed pipes were all so picturesque to him. I, too, found Guiyang less jaded than Chongqing, where war profiteers were putting on a false show of peace and prosperity and people liked to fawn on the powerful. I longed to go to the countryside because I had often found its simple, quiet life so alluring.

Beihong again travelled by a charcoal-burning long-distance bus on the Sichuan-Guizhou highway flanked by high mountains, but he was feeling light-hearted. On the way, he stopped at every fair, where he squeezed his way into milling throngs to search carefully for things he could buy his fiancee. His seat-side was stuffed with a rising pile of such gifts as blue-and-white homespun batik, bracelets hand-carved by minority people, and valuable furs. He bought so many things that by the time he reached Chongqing he did not have a cent on him to pay his fares.

I waited longingly for him to come back and live with me in a small cottage in the suburbs of Guiyang where I would watch him paint and take care of his life. And I was sure that he was going to produce many works here. I was indulging in sweet illusions and dreams. But day after day passed without his scheduled arrival. He did not even write me a single letter.

After the severe winter was gone, spring came round with flowers. I grew apprehensive and kept writing to him, but without getting a single reply. I was thrown into an abyss of perplexity and agony. I also began to feel annoyed by his long silence. Nevertheless, there was no doubting the truthfulness of his love. What had happened to him? I was seized with the fear that he might have fallen ill, with no one to look after him. So, after sending him a telegram, I set out for Chongqing.

It was early summer. Leaving behind my winter clothes in Guiyang, I started the arduous journey by mail car on the rugged road between Guizhou and Sichuan provinces. In passing through the places where Beihong and I had formerly had a stopover, I was filled with nostalgia. How I wished I could have a bird's wings to fly to Beihong in no time! The four days on the journey seemed even longer than the two months I had previously spent waiting.

At last I was again in the misty town of Chongqing. After I crossed the Jialing River by ferryboat and walked up the familiar stone steps, my heart started pounding violently at the sight of the distant preparatory office of China Art Academy.

I dashed upstairs and knoked hard at Beihong's door, but there was no answer. When I made enquiries of people at the preparatory office, they all told me he had gone downtown two days earlier. So I had no choice but to wait patiently. The next day, however, he came back with a gloomy look. My sudden appearance gave him a great pleasant surprise. It turned out that he had been downtown to ask some of his friends at Zhong Hua Book Company to make enquiries about me, both of us having failed to receive from each other letters and telegrams sent during the previous two months. We soon learned that all our letters and telegrams had been intercepted. They even took my letters to Chinese Art Association, which was under the charge of Zhang Daofan, to read them out for the amusement of their boss.

Having found out the real cause, Beihong was furious. Nevertheless, we were fortunate enough to have finally connected and even to have found out the despicable conduct of those acting on ulterior motives.

While Beihong and I were getting ready for our marriage, Jiang Biwei demanded that the divorce procedure be completed and that Beihong give her an alimony of one million yuan in cash plus forty paintings by ancient artists and a hundred paintings by Beihong himself, as well as half of his monthly income as living expenses for the children.

The lawyer repeatedly advised that Beihong bear the children's living expenses but ignore the rest of her demand. Some people, however, came to speak on her behalf, trying to talk Beihong into meeting as much of her demand as possible. Since Beihong had always

shown tolerance towards her out of consideration for her early love for him and the hardships she had shared with him in Paris, he decided to satisfy her demand as best he could.

He kept painting day and night. In addition to the hundred traditional paintings to be given to Jiang, he had to make some other paintings for raising the one-million-yuan fund. Meanwhile, he continued his daily teaching at Central University indefatigably.

He asked Lu Sibai to pass on to Jiang fifty traditional paintings he had just finished as the first instalment of the total of a hundred. Besides, he also sent her by Lu forty ancient paintings in his collection, including Ren Bonian's masterpiece *The Nine Elders,* and two hundred thousand yuan in cash.

At that time, the anti-Japanese war was still in a difficult and precarious stage. My hometown Changsha had fallen and newspapers reported that Hengyang was in emergency. Guilin, having a direct railway connection with Hengyang, was therefore also in imminent danger of being occupied by the Japanese. Feeling great anxiety about all the things he had stored in Qixingyan Mountain,Guilin, Beihong remitted ten thousand yuan, which was all the money he had with him, to Zhang Anzhi, who was then teaching in Guilin. He asked Zhang quickly to transport all his things out of Guilin, and, in case the money remitted was not enough for the freight, to look up Shen Yijia, who was then running a factory in Guilin. After several exchanges of correspondence between Beihong and Zhang, Hengyang fell and people in Guilin were terribly alarmed. It was even difficult to obtain a rail ticket, let alone to check in luggage. Zhang could do nothing but have eight cases of Beihong's paintings and books picked out and sent to Pingle County, leaving the rest in the cave.

Then Beihong sent an urgent telegram to Huang Yanghui, urging him to go to Guilin quickly to move out the cases still stored there. Huang, whose watercolours and bamboo paintings had won Beihong's high praise, had been a diligent and remarkable student of Beihong's at Central University, Nanjing. He was then working on the Guizhou-Guangxi railway and had done a rich array of watercolours depicting the railway projects. Beihong also asked Huang to take along as his helper the cake maker, a fellow provincial whom Beihong had met in

Baoshan and brought to Chongqing and who was later employed by a middle school canteen in Guiyang through the recommendation of Beihong. Huang and the cake maker immediately set out for Guilin; the train they took was terribly crowded, with refugees even sitting on top of the coaches. Huang, not having enough money on him to pay the freight, went with a letter from Beihong to call on Li Jishen, who generously allocated him twenty thousand yuan of public money. So the several dozen cases of Beihong's books and paintings originally stored in the cave of Qixingyan Mountain, Guilin, were at long last transported to Guiyang.

Just at this time, Beihong was shocked by a piece of unexpected news.

Lu Yinhuan, a student of the Central University art department, wrote Beihong a letter from Chengdu, saying that, through the introduction of a friend of her husband's, she had visited a stranger at his home, where she saw an ancient figure painting exactly the same as Beihong's lost painting of *Eighty-seven Immortals,* with which she was quite familiar because Beihong had taken an enlarged photograph of the painting to the Central University classroom for students of the art department to copy.

His heart aflame with the news, Beihong paced up and down the room with great agitation.

"Jing, I must leave for Chengdu right away." His voice gave away both delight and apprehension.

"Well, I'll go with you," said I.

We were both thrilled with excitement.

"But," he continued after some reflection, "I'm afraid that the collector of the painting might be alarmed at the news of my presence in Chengdu and then destroy the stolen piece as incriminating evidence."

After long deliberation, Beihong decided to look up General Liu, a very capable man from Singapore, and ask him to go to Chengdu to try first to get acquainted with the collector and make friends with him so that he could have a chance to look at the painting before consulting with Beihong as to what measures to take. Beihong gave General Liu some money to cover the expenses and told him again and again, "The

most important thing is not to alarm the collector lest he should destroy the painting. I'm even ready to buy it back!"

General Liu set out immediately for Chengdu. He presently got acquainted with the collector and saw the painting, which he identified as that of *Eighty-seven Immortals,* the one he had seen before. He wrote to tell Beihong that a large sum of money was needed to effect the safe return of the painting.

In order to raise the money, Beihong was again painting day and night. He first remitted General Liu two hundred thousand yuan in cash, and then sent him paintings again and again, totalling several dozen pieces. At long last, General Liu proved himself worthy of the mission and brought back the painting to its rightful owner.

Beihong held in both hands the national treasure, the picture he held as dear as his own life, and, with his face flushing and his fingers shivering, he unrolled the scroll. The eighty-seven immortals appeared safe and sound before his eyes, looking as serene, solemn and graceful as ever, as if nothing untoward had happened to them. However, both the affixed seal bearing the inscription "I, Beihong, hold this picture as dear as my own life" and his inscribed comments on it had been removed. Beihong gleefully improvised the following poem:

> *I'm happy to meet the immortals again*
> *And to view them heartily with my wife.*
> *The sweet ever goes with the bitter in life;*
> *The return of the divine pill comforts my mortal bones.*

When I saw the broad-shouldered, pot-bellied General Liu wearing a small moustache and looking extravagant in a suit of brand-new clothes, I could not help doubting whether all the money and paintings sent by Beihong had been received by the collector.

When I let on my doubt to Beihong, he just dismissed it with a smile and said with equanimity, "Why bother about the money? He's done us an amazing turn by bringing back the stolen painting."

From then on, General Liu often came to ask Beihong for his paintings, and was sometimes given five or six pieces on a single visit. Beihong never let him down, being always grateful to him for the good deed he had done.

Later, I learned as I had expected that all the money and paintings sent by Beihong had gone to the hands of the general instead of being given to the collector. After the victory of the anti-Japanese war, we further learned in Beijing that Liu, who had fabricated his heroic past record, was only a self-proclaimed general.

In 1948, when the painting of *Eighty-seven Immortals* was re-framed, Zhang Daqian and Xie Zhiliu each inscribed a postscript on it at the request of Beihong.

Soon it was full summer again.

People who have ever been to Chongqing all know that the city is like a huge stove in summer. Dripping with sweat, Beihong kept on working until the summer vacation, then went to Liangfengya in the outer suburbs of the city to stay in his friend Yang Dechun's home, which was a quiet villa surrounded by trees.

It was his habit to stand while painting so that he could wield his brush more freely and concentrate on the brush tip the strength of his wrist, elbow and whole body. He painted with powerful and vigorous strokes.

There he again painted *After One of Du Fu's Poems,* the Chinese ink and wash picture of a beautiful woman. Executed with the traditional Chinese method of outlining and the Western technique of chiaroscuro, it displays smooth brushwork and graceful colours.

I would help him with rubbing the ink stick against the inkstone, spreading sheets of paper on the table or affixing his seals to the paintings, and sometimes also with some minor colouring, which also gradually developed in me a love for painting.

The paintings he did at that time were mailed to Kunming to be bought by a certain merchant there. In raising the million yuan demanded by Jiang Biwei, Beihong exhausted himself by overwork.

Ever since we came to Liangfengya, Beihong had been too busy with painting to take a walk with me out of doors. When he took off his slippers and put on his leather shoes, I discovered to my astonishment that his ankles and legs were swollen.

I accompanied him outdoors with a heavy heart. The tender moon was staring down and the breeze was whispering in the thick foliage.

238

Though the earth was still giving off heat, the serenity of the moonlit night did give us some comfort. We trod on our own shadows while strolling along the mountain path bathed in moonlight.

"Jing," said he suddenly, "maybe I've been working too much, too hard, and too hastily."

"Yes, Beihong, you've overworked yourself," I said looking at his weary face. "Even a young man could not endure working round the clock as you do!"

"But I must let Jiang Biwei have my money and paintings as soon as possible so as to lift the painful, heavy load on my mind once for all," he said in dejection. The gloomy look on his face was plainly visible in the moonlight.

"Oh, Beihong," I implored, "tomorrow you should see a doctor for a health checkup. You mustn't work any more like this without a rest."

He hung his head in silence.

"Beihong," I said with great tenderness, "it's your health that can guarantee our happiness as well as your work. So you ought to pay good attention to it!"

"I think the dropsy in my legs is due to the long hours I've spent standing to do my painting," he consoled me in a gentle voice.

"What if it isn't?" I said, feeling depressed. "Better see a doctor for a careful checkup."

Beihong accepted my advice. Early the next morning, we walked down the winding, rugged mountain path to a clinic at the foot of the mountain run privately by a doctor, who was a retired student from Germany.

The doctor listened to Beihong's heartbeat with a stethoscope and exclaimed after taking his blood pressure, "Mr. Xu, you must entirely stop painting and go into hospital right away. Your blood pressure's as high as two hundred mm."

The doctor, who had two false legs, looked at us seriously. His words, though well-meaning, had given us a terrific shock.

The doctor was a man who got excited easily. When he was a student in Germany, he had been rescued by a hospital in Berlin after trying to commit suicide by lying on a railway track because he had been disappointed in a love affair. Then, when he woke up to find his two legs

amputated, he again attempted suicide by cutting the artery in his wrist. This time he was saved by a young German nurse, who asked him tearfully, "Why did you treat yourself so cruelly?" She did her best to comfort and encourage him. Gradually they fell in love with each other, married and came to live in China.

Acting on the doctor's advice, I immediately took Beihong to Central Hospital in Chongqing. The head of the internal medicine department, after making an overall physical examination, took me to another room and said.

"His blood pressure's very high. We call it a 'terminal case' in hospital terms. He's in danger of having cerebral haemorrhage at any moment."

My heart thumping hard, I trembled all over and staggered. The term "terminal case" had cut me to the heart. Did it mean that the illness might suddenly deprive him of his life? I simply could not bring myself to believe it.

While Beihong was lying in the hospital bed, his face became a bit swollen too. In addition to hypertension, he was also suffering from nephritis. He told the doctor that, back in 1942, after his picture scroll *Eighty-seven Immortals* was stolen, he had lost both appetite and sleep for three days and nights, and that the heavy blow had since brought on hypertension, which he at that time overlooked. As to nephritis, he said that back in the 1930s, when he was in Nanjing, a doctor named Wang Suyu had found him suffering from kidney trouble which he also overlooked because of his unsettled busy life. When he was in Singapore he had also suffered from serious lumbago and occasional intestinal spasm. Had he taken good care of himself, his health would not have continued to decline. But long years of strenuous work had overtaxed his constitution.

I kept watch by his sickbed day and night. Probably to lessen my anxiety, he would chat away merrily as if there were nothing wrong with him. "If I'm called on right now to get up and run ten kilometres, I know I can do it," he said in high spirits. He never conceded defeat.

It was the height of summer. The glaring, hot sun was beating down on him through the ward window, which had a western exposure. The war-time hospital was ill furnished, without even a curtain, so Beihong

240

had to cover his eyes with a handkerchief to keep off sunlight. I sat by his bedside to read newspapers to him aloud. He followed the war situation closely. Although the U.S. participation in the Second World War had pinned down and worn down part of the forces of the German-Japanese fascists, Japanese troops continued to push into China's hinterland. Millions of Chinese people were still groaning under the enemy heel.

The other patient in the small ward was a rich industrialist more than sixty years old, who had cardiovascular trouble. The old man, a widower, had a beautiful daughter, who looked after him in hospital. Whenever he complained about his daughter being fond of play and often making herself scarce when she was needed, I would volunteer to care for him.

Lights in the wards went out early at night in accordance with the hospital regulation. The old man's daughter and I would sleep on the floor. The young girl would often sneak outside in the night to have a chat and walk with a young doctor with whom she had just got acquainted. She would fall asleep as soon as she lay down on returning, while I would lie awake in bed thinking all the time of what the doctor had called a "terminal case." Death had cast its grim shadow on my mind for the first time.

At the time Beihong first entered the hospital, he was required to pay in advance one month's charges for ward, food and medicine, which we barely managed by pooling what money we each had on us. He had always been generous with money. Often, as soon as he got money, he would spend it in buying books, calligraphy and paintings or in helping needy students and friends. The two hundred thousand yuan he had earned of late by selling his paintings had all been spent in redeeming the *Eighty-seven Immortals*.

I did not let him know that I was penniless lest he should be worried, nor was I willing to borrow money from other people. The doctor put him on a saltless, low-fat diet. Because of poor appetite, he often left some food uneaten, which I would collect into another bowl and stand eating to allay my hunger in the corridor outside. I would reappear before his bedside with a forced smile. When he inquired what I had eaten for my meal, I would have to invent some lies like having eaten a bowl of noodles or some glutinous rice cakes at a restaurant opposite the

hospital gate.

Since Beihong was hospitalized, he had received no salary from Central University. As I learned later, Lu Sibai, head of the art department, had handed Beihong's monthly salary to Jiang Biwei after drawing it from the university. The aura she had gathered around her through her shady relations with the Kuomintang propaganda chief Zhang Daofan had drawn some sycophants to her side. Lu Sibai's moral character, formerly honest and pure, had become gradually tarnished by the rust of the old society.

The old man in the same ward would often get impatient and now and then rise from his bed. He would sometimes look for something like a necktie, or rearrange the food cans in the bedside cupboard, or complain against his daughter and talk with a deep sigh about his wife who had died not long before. Late one night, he stopped breathing and was carried to the mortuary. His lively daughter flew away as briskly as a swallow.

I was thus left sleeping alone on the hard floor. When I gazed at the old man's now empty bed, I seemed to hear his footfalls and muttering, which sent chills down my spine. Seized with terror, I quickly rose to my feet and went up to Beihong's bedside. But I could not find it in my heart to wake him up. Seeing him breathing evenly and having a sound sleep, I kept watch by his bedside with renewed hope and courage.

Chapter XIII

The sanguine-natured Beihong finally got the better of his illness. His blood pressure went down and his dropsy disappeared.

A month later, he was given permission to leave hospital by the doctor. We returned to Liangfengya to stay with Yang Dechun. Once every week we invited the same doctor from the privately run clinic to come uphill to do a checkup. The doctor forbade Beihong to resume work, saying that his blood pressure was still unsteady and he had not yet recovered from nephritis. But, as the saying goes, "Illness is the sole bitter enemy to a hero." Beihong grew impatient at being confined to bed and refused to stay idle. Since he could not paint, he wanted me to read newspapers and magazines aloud to him every day. My only wish then was to do everything possible to reduce his boredom so that he could better recuperate and recover his health as early as possible.

One day, he complained of a pain in the neck and felt very thirsty towards evening. I went downhill to invite the same doctor again, but he sent a nurse instead to give Beihong an injection of glucose. After the nurse was gone, Beihong shivered all over with a sudden spell of chills; then he ran a high fever and had a weak pulse.

On that day, Yang Dechun and his wife happened to have gone downhill to the urban district of Chongqing where he owned a factory, leaving only a servant at home. I left Beihong in the care of the servant and hurried out to fetch the doctor. In the darkness outside, a fine rain was drizzling and a chilly wind reminded me autumn was coming. I groped my way down the rugged mountain path and, after crossing a muddy country track, came to the clinic. I knocked quickly at the door and was answered by a fair-complexioned, plump nurse, the one who had administered the glucose injection to Beihong. When she took me to the doctor, I hurriedly informed him of Beihong's condition and asked

243

him to make an emergency house call.

The doctor said loudly, "It's nothing but a reaction to the glucose injection!"

"But, doctor," said I pleadingly, "Beihong's terribly weak, his pulse is very weak, almost impalpable."

He shook his head resolutely, "It's too dark and the weather's bad. I can't go out until early tomorrow morning."

He gave me a bottle of liquid medication to be taken by Beihong. Again I tore along in the darkness. How helpless and wretched I felt! To get Beihong the medicine quickly, I dashed nonstop on the rough mountain path. The sky as well as the earth was a vast expanse of utter darkness. Now and then I heard wild beasts howling in the nearby mountain valley.

When I returned to Beihong's bedside, he had a blazing fever and panted feebly. After taking the medication, he kept quiet with eyes closed, his wan face looking deathly pale and painful. I sat by his bedside in eager expectation of daybreak. All was quiet about us except for the ticking of his pocket watch which he had kept for well over twenty years.

Beihong had endured the sufferings of the long night with stamina. With the light of the early dawn falling on the window and the trees in front of it, birds outside began to chirp merrily and the splendid sun was slowly rising from beyond the mountain. At last I heard the voices of people talking downstairs, among them the deep, raucous voice of the doctor. I hurried downstairs to find his sedan chair by the gate and, together with the sedan chair bearer, helped him to come upstairs on his artificial legs.

The doctor, bending over, examined Beihong's heart with the stethoscope and then measured his blood pressure. I watched his countenance with anxiety only to find the sudden disappearance of composure from his chubby face and his bright eyes looking flurried. It was not until I and the sedan bearer had helped him into the next room that he said in a grave voice, "His systolic pressure is close to zero. His heart's no good. He may die at any moment."

"Doctor," I pleaded in a tearful voice, "please save him by any means."

"Hm, it's very difficult," he sighed.

244

"Doctor," I said, "it's all due to the glucose injection. I wouldn't have agreed to the shot if I'd known that it could bring on such a strong reaction."

"No reaction will happen under ordinary conditions. Even if it does, it'll do no harm to a healthy heart."

"Then why didn't you think of the other possibility? Aren't you responsible for it?"

The doctor was speechless.

"The most important thing now is to rescue the patient," I urged him.

He resumed in a flurry, "I happen to have several German-made cardiotonic injections for my mother. They are not available on the market. You can have one from me first, and then look around for some more."

He immediately sent for the injection. After Beihong was given the shot, his blood pressure began to rise and his heart rate increased. Then the doctor left in the sedan chair.

I asked Beihong's students to visit local pharmacies separately to ask for the German cardiotonic injections. But, due to the acute shortage of medicine in war-time Chongqing, they were nowhere to be found. General Liu, who had helped Beihong recover his stolen painting, did succeed in buying, through some unknown channels, ten ampoules of the medicine in a box. I was grateful when he appeared before me with the box. But the medicine went unused because, after his heart condition improved, Beihong was sent to Central Hospital in no time, where he was treated with another drug. The hospital put him in a private room.

The doctor told Beihong to lie still and forbade him to move; every day I spoon-fed him at meal time as he lay in bed.

Beihong was unaware that since he was hospitalized, Lu Sibai, who drew Beihong's monthly salary, had handed it to Jiang Biwei, and that consequently I had been compelled to borrow money from Yang Dechun's wife. Again, to allay my hunger, I would stand in the corridor outside the ward eating Beihong's leftovers.

One day, Mrs. Yang hastened to me nervously with the news that Jiang Biwei was going to take away all of Beihong's paintings and the

245

works of art he had collected. She urged me to go home quickly to salvage some important paintings.

"No," said I, "I can't go away from Beihong. He's still dangerously ill."

"Well!" Mrs. Yang sighed. "You ought to think of yourself too. What if Mr. Xu should...."

"I'm very grateful to you. Thank you for your kindness," I said in agony. "If Beihong dies, I won't take his paintings. If he survives, Jiang Biwei will still have to return to him what she's taken away."

A month passed, but Beihong was still confined to bed. And the time came again for Beihong to pay the next month's hospital charges in advance, but I was penniless. Although the batch of paintings mailed to Kunming had all been sold, the man who had handled the transaction, hearing of Beihong's serious illness and dazzled by the aura surrounding Jiang Biwei and Zhang Daofan, adopted a wait-and-see attitude and refused to send Beihong the money immediately.

Several old friends of Beihong's, learning of his distress, extended a helping hand. Wu Yunrui often sent Beihong better food to eat. Once head of the physical culture department of Central University, he became president of East China Physical Culture Institute after Liberation. He was upright and warm-hearted. Thanks to Beihong's influence, he also developed a fervent love for art, and became an amateur painter. Later, after the death of his wife, he married Wu Qingxia, a famous woman painter in Shanghai.

Long afterwards, I was to learn that Beihong's upright old friends and students had stopped Jiang Biwei from taking away his paintings and collections during the illness.

At one point, Zhang Daofan's associates came to me and tried to convince me to forget Beihong.

"Well," one of them said, feigning great sincerity, "we all sympathize with you. It's really unfortunate for a young girl like you to wait on a patient all day. Why not renounce your engagement? You ought to have a long-range view...."

These people left no stone unturned in trying to persuade me to leave Beihong. If I had been persuaded, the heavy blow would have been the last straw for the bed-ridden Beihong. I saw through their vicious

intent and categorically rejected their so-called "concern" and "advice."

But advice out of real concern also came from friends. Two resident physicians in Central Hospital named Zhang Jingyi and Chen Li, who had been several classes ahead of me in my middle school and later graduated from Xiangya Medical College in Changsha, gave me the following well-intentioned advice when I met them in the hospital, "High blood pressure is a very troublesome illness. Even if he's out of danger for the time being, the illness will linger on for the rest of his life and he may have a sudden cerebral haemorrhage at any moment. You're still young, so you ought to take your own future into account. How can you have happiness with such a patient?"

"Well, you don't understand. I'm willing to sacrifice anything for him, including my own life," I answered with tears in my eyes. "Besides, what love would there be if I should consider my own interests at a time when he's in great trouble?"

"But you're far too young. There's such a big gap between your ages that we have to worry about your future happiness. You should give the matter careful consideration when he gets better. Anyway, you must think twice!"

"I've thought it over thousands of times. My heart is firmly attached to him. I'll never leave him." Then I told them that when I was seventeen years old I had read a Chinese translation of *Jane Eyre* borrowed from my former schoolmate Yang Degong, who had received the book by mail from a friend far away. The novel tells how the heroine Jane Eyre, a pure, good-natured orphan, finally returns, after all kinds of hardships and sufferings, to Mr. Rochester, who loves her truly. By that time, Rochester has gone blind and is no longer a rich man, but young Jane Eyre nevertheless marries him without hesitation.

Little had I expected then that I, too, would in future undergo all kinds of frustrations, misfortunes and sufferings in my love affair. But I was now enjoying true love, which not all people could be fortunate enough to have. Moreover, he had made such marvellous contributions to Chinese art, and he was so ill-fated in his life. I would not regret it at all, I told them, if I could live with him for only a short time or even if he should die the next day.

Winter brought its chill to the hospital, where there was no central

247

heating or fire and I still had to sleep on the floor. Cold wind continuously squeezed into the room from under the door and its chinks, and I did not even have a cotton-padded dress because I had left all my winter clothes in Guiyang at the time of my hasty departure from the city. Throughout the severe winter, I wore instead a flannelette-lined silk long gown which Mrs. Yang had lent me when I first accompanied Beihong to the hospital.

Though in sickbed, Beihong kept worrying about national affairs and I continued to read the daily papers to him aloud. The Japanese troops pushing ahead along the Guizhou-Guangxi Railway were menacing Beihong's books and paintings stored in Guiyang again. I purposely tore off reports of the current war situation from the daily papers I had bought for fear that the anxiety they brought him would deteriorate his illness.

Seeing the torn paper I had brought into the ward, he inquired what was the matter with it. .

"Oh," I answered nervously, "that's because the newsboy is too young to take good care of his papers."

For days on end, the newspaper always had a hole in it. Beihong, however, never uttered a word of complaint because of his compassion for the newsboy. The disfigurement of the daily paper lasted until the Japanese troops were forced to pull out of the Guizhou-Guangxi line in retreat.

There were frequent air raids by Japanese planes. Whenever the siren started wailing, all patients in the hospital would be carried to a dugout on stretchers. Down in the dark, mouldy air-raid shelter, all of us would feel terrified, fearing again that many people would be killed or rendered homeless by the Japanese aircraft, and that even we ourselves might perhaps die underground. I remembered how thousands of people had once died of suffocation inside a big dugout in Chongqing when its roof fell in during a large-scale Japanese bombing raid.

A storm lamp on the damp wall of the dugout seeped a dim, flickering light. Beihong lay on the stretcher, his swollen face appearing even more pale in the dim light. But his eyes shone with unswerving determination and his raven black eyebrows were closely knit.

"Beihong, are you feeling all right?" I asked cautiously.

"Yes, I am. I only feel badly that I have to be laid up when our country is in deep trouble and urgently needs my service!" He heaved a long sigh.

Three months elapsed. He was mending nicely, and could get up and sit on a recliner. Sometimes, I would help him out of the ward into the courtyard where he could walk slowly for a short while. Since he entered hospital, he had not had a haircut or a shave, so that, with a dark, bushy beard under his chin, he looked like a very old man.

At last, Beihong was given permission by the doctor to leave hospital and recuperate at home. I went happily about getting him ready to leave; I bought some medicine from the hospital for him to take at home and sent for a barber to give him a haircut and shave. I was hopeful and buoyant, suddenly forgetting all the torments I had suffered during the past few months.

We returned to Panxi with a feeling of renewed happiness, and took up quarters again in the two-storied building inside the Shi family ancestral temple.

It was winter, 1944. The weather was biting cold; the north wind was whistling around the house, and freezing air squeezed its way into the house through chinks in the wooden walls. Our hands and feet ached with cold. We had to warm ourselves with a charcoal brazier.

Beihong was still very weak. He had to lie in bed or recline in a sling chair. He still could not resume his work. I continued to read him papers and magazines and give him medicine at fixed intervals.

In carrying on a tenacious struggle against illness, Beihong had endured his sufferings with amazing willpower and had never uttered a groan. Now he had come back and was gradually regaining his health. But he often looked sad and his eyes reflected the hidden anguish in the depth of his heart.

"Beihong, what are you thinking about?"

"I've been thinking how nice it would be if I could be quickly restored to health by a sure cure. I'm so anxious to work."

"What else are you thinking about?"

He kept silent.

"Beihong, there must be something else on your mind."

With his countenance abruptly turning grave, he said, "Jing, it's

249

true that I need you badly and even sometimes fear that you might leave me suddenly. But I still can't help thinking that you're so young while I'm so weak and that I shouldn't be an encumbrance to you...." Because of the conflicts in his mind, he choked with anguish and had to stop short.

"Beihong," I said with redoubled tenderness, "we're engaged. I'm your future wife. I'll never leave you."

"But an engagement can still be cancelled when conditions change. When we got engaged, I was healthy, but now I'm very, very weak. So you ought to reconsider the whole thing." Though he was an emotionally strong man, his voice was unusually sad.

"It's just because you're very, very weak that I won't leave you, for I believe nobody else could look after you as loyally as I do."

"Then, Jing, you're willing to long endure my weakness?"

"A hundred times willing! Not to endure, but to enjoy happiness as long as I'm with you and can do my best to look after you."

"My dear Jing!" his eyes sparkled with joy. "I hope, and I believe, I can regain my health, not only for the sake of my work, but also for your sake."

It was not until he left hospital that I told him since he fell ill, we had been living by borrowing because all his monthly salaries had been taken away by Jiang Biwei. Thereupon, Beihong asked Lu Sibai to return him his private seal which had long been left in Lu's keeping.

Lu brought the seal to Beihong. But the next day, Beihong's daughter Lili also came to see her father.

"Father, I need your seal to draw your pay."

"Then, what am I going to live on?" Beihong asked his daughter.

"You can sell your paintings."

"I can't paint now that I'm sick. What can I do?"

Lili gave no answer.

"Besides, you're only a child and don't need so much money. How much do you need every month for board expenses and pocket money?" asked Beihong very mildly.

Lili was then a boarding student at the middle school attached to Central University. She told her father truthfully how much she would spend on meals and how much pocket money her mother would give her.

"Then, I'll give you double. All right?"

Lili agreed.

I went to a restaurant to buy two dishes of food so that Lili could stay for lunch. After eating the lunch, she went back happily.

Early the next morning, as I was preparing medicine for Beihong, I heard hasty, loud footfalls on the stairs approaching from below. I rose to my feet quickly. Lili came again, this time followed by a maidservant carrying a parcel.

Lili went straight up to her father and said, "Dad, mother says she can't support me with what little money you've promised me, so she told me to come here to live with you."

The maidservant kept rattling away on one side. I stopped her from talking any more, and then turned to Lili, "Your father's been very ill. You're welcome to come here to live with us and help me take care of your father. But I hope you haven't come here out of spite."

The simple, naive girl said nothing in reply. She was dressed in a blue-cloth long gown and was already fifteen years old. During her stay with us, she was touched when she saw with her own eyes how I looked after her father and what an austere life we lived.

When she saw the thin, flannelette-lined long gown on me, she asked naively, "Why don't you wear a cotton-padded long gown?"

"My cotton-padded clothes have all been left in Guiyang. I haven't brought any."

"Why don't you buy a new long gown?"

"Your father's ill, so we've got to spend money mostly on him. The medical expenses alone cost quite a lot of money."

Lili also boarded at the canteen of the preparatory office as we did. After she and I finished eating at the canteen, we would bring back Beihong's meal for him to eat in the bedroom.

One day, Lili told me in a complaining tone, "Mother lives a much better life than you. For breakfast alone, she has American coffee, milk, fried eggs ... She smokes American cigarettes and has a maidservant to wait on her, all at father's expense."

251

Chapter XIV

The spring of 1945 arrived late, the weather still being quite chilly. Beihong's hypertension and nephritis lingered on.

The political atmosphere then was chilly and stifling as well. The arduous anti-Japanese war continued. While people in enemy-occupied zones were in misery, a state of utter confusion prevailed in the vast rear area where corrupt officials ran wild, profiteers engaged in hoarding and speculation, commodity prices rocketed, refugees wandered about and people smoldered with discontent.

On the morning of February 5, Guo Moruo came from the urban district of Chongqing to visit Beihong. Guo, wearing a dark-blue cotton-padded long gown, appeared with a gentle smile and bright eyes. He was older than Beihong, but in good health. He brought Beihong some red dates and millet from Yan'an.

"Beihong, these have been brought from Yan'an by Zhou Enlai, who asked me to pass them on to you together with his regards. He's very sorry that he's too busy to come to see you," he said genially while handing me two paper-wrapped parcels he had produced from his handbag.

I opened the parcels. Beihong's pale face brightened up at once when he saw the scarlet dates and golden millet. He stretched out his hand to fiddle with them gently, and lovingly caressed one of the red dates in his palm.

"Please convey my thanks to Zhou Enlai. And I'm also much obliged to you for bringing them to me over such a long way," said Beihong in deep gratitude.

Beihong had come to know Guo Moruo in Shanghai back in 1925 and they had both been living in Chongqing since the outbreak of the anti-Japanese war. But they seldom saw each other because Guo was

living in the city proper while Beihong was in the outer suburbs. Now they sat around the small charcoal brazier; Guo warmed his cold fingers over the fire and sipped hot tea. Then they started an animated talk, about illness, the situation of the art and literary circles, and current events. Their copious talk was punctuated with gleeful laughter. Beihong talked with growing excitement as though his illness had suddenly passed away. The topics of their conversation ranged from artistic creations to the abstractionist school and the doctrine of "back to the ancients" in the field of fine arts, which Beihong strongly condemned. Guo fully agreed with Beihong. Beihong then spoke highly of the art of woodcut in the Liberated Areas. As to the current situation, he expressed great discontent with the Kuomintang government and concern over the destiny China. But both of them were optmistic about the future. When they agreed on the urgent need for a democratic coalition government joined by the Communist Party as an aid to the anti-Japanese war, Guo pulled out from his pocket a written declaration entitled *Opinions of the Chongqing Cultural Circles on the Current Situation.* As Guo spread it, Beihong saw at once that it was a declaration drafted and copied out with a brush by Guo himself. Beihong's eyes glittered with excitement, for every line and every word in it was the common voice of the people! Beihong immediately picked up a brush to sign his name on the declaration. Guo told me that if I agreed, I could also add my signature, which I did without hesitation because the declaration spoke the voice of our inner hearts. My own signature was quite insignificant in view of the fact that I was only a young girl doing some auxiliary work with Beihong.

Outside the window, the trees kept swaying in the wind. A ray of faint sunlight slanting through fog cast the shadows of the tree branches on the papered window, and the freezing air continued to penetrate into the room through chinks in the wooden wall. I poked the charcoal in the brazier to make it burn better and give more warmth.

I ran downhill to buy a bottle of Luzhou Daqu liquor plus several dishes to go with it. We had Guo stay for lunch with us. Because of his illness, Beihong did not drink at table.

Guo was very excited and talked cheerfully while finishing cup after cup of the aromatic liquor. His broad forehead was beaded with

perspiration.

To keep Guo company, I also had cup after cup of the liquor. Feeling relaxed and warm, I was no longer conscious of the severe winter.

Beihong smilingly looked at us drinking to each other. He expressed his high respect for Guo in issuing the militant statement in the white-terror-ridden Kuomintang heartland regardless of his own personal safety. Guo beamed with great modesty. Both of them quite understood that they were running great risks in affixing their signatures to the declaration.

Guo then composed the following poem impromptu:

> *A man of valour does not refuse a thousand cups of wine;*
> *Alone on horseback he charges a forbidding mountain pass.*
> *Someone seems to be striking a zhu* for him;*
> *And Panxi of today is cold like the Yishui River of yore.***

Beihong, rubbing his palms together, said with a smile, "How my hand itches to have a try! Were it not for my weakened wrist, I would paint a picture to commemorate our meeting today."

At parting, Guo exhorted Beihong again and again to take good care of his health. Beihong, being too weak to see him off, asked me to accompany Guo downhill to the Jialing ferry. I did not turn back until Guo had boarded a boat.

Ten days later, on February 22, 1945, when the Chongqing *Xinhua Daily* published the full text of *Opinions of the Chongqing Cultural Circles on the Current Situation* with the signatures of three hundred and twelve persons, it shocked all the cultural circles and the whole

* *Zhu* is a lute-like ancient Chinese musical instrument with thirteen strings, struck with a bamboo ruler.

** The Yishui River is in Yixian County, Hebei Province. In 227 B.C., when Jing Ke, a brave man of the Warring States Period (475-221 B.C.), set out for the State of Qin to assassinate its aggressive king, people, in giving him a farewell dinner by the Yishui River, sang to the accompaniment of the *zhu* music the poetic lines, "The wind sighs and the Yishui River is cold; the hero will be gone forever." Guo Moruo here compared Panxi in Chongqing to the Yishui River to show the then political atmosphere.

nation as well as the Kuomintang government. Chiang Kai-shek was exasperated. He sent for Zhang Daofan, who was then director of the Cultural Movement Commission of the Kuomintang Centre as well as chief of the Kuomintang special agents, and gave him quite a dressing down, demanding to know why all the notables in the cultural circles had been dragged in by the Communist Party. Zhang answered with trepidation that the *Xinhua Daily* had usurped their names and that he would be publishing another declaration after conducting a thorough investigation into the matter.

Like a cur having been flogged by its master, Zhang at once took out his fierce anger on a clerk at China Art Association, who happened to have signed his name on the declaration, cursing away while thumping desks, kicking chairs and crashing teacups and teapots to the floor. The genteel-looking clerk, who was slender and wore a small moustache, was struck dumb with fear. Lest he should lose his job at China Art Association, the clerk had to sign an announcement drafted by Zhang and splashed in the Kuomintang *Central Daily* against his will. The announcement said that the Communists had usurped his name because instead of *Opinions of the Chongqing Cultural Circles on the Current Situation,* the document he had signed was on how to provide relief for the needy in the cultural circles. The announcement was intended to mean that he had been duped by the Communists.

One afternoon, Beihong and I were reading the *Xinhua Daily* when we heard footfalls on the stairs. A man in his early twenties entered our room with a newspaper under his armpit.

"Mr. Xu," he made a deep bow, "Generalissimo Chiang Kai-shek has been very angry about *Opinions of the Chongqing Cultural Circles on the Current Situation* published in the *Xinhua Daily.* It's a very, very serious matter. Now here's an announcement in the *Central Daily* written by somebody to show up the fact that his signature on the declaration had been usurped. Director Zhang asked me specially to bring you this newspaper. Please have a look." He presented the paper to Beihong with both hands as sanctimoniously as if he were holding an imperial edict.

Taking over the paper, Beihong gave it a hasty glance, casually threw it into a chair beside him and then asked coldly, "What does

255

Zhang Daofan mean by sending you here?"

The visitor answered with another deep bow, "What Director Zhang means is this: you must know how serious the matter is. If somebody else's been fooled into giving his signature, so must you have been. Director Zhang would like you to publish the same announcement in the paper."

Beihong fixed the visitor with a stony stare and said in a stern tone, "I haven't been fooled. I bear full responsibility for my signature!"

The visitor, after a little hesitation, said in an empty, near-supplicant voice, "Director Zhang says it's the Generalissimo's idea that you should publish the announcement, for otherwise things would be very bad indeed for you, very bad indeed …." He said "very bad indeed" repeatedly as if the three words were weighty enough to crush Beihong and bring him to his knees.

Beihong's eyes burned with anger. The intimidation, instead of shaking his unyielding character, his patriotism and his sense of justice, had aroused his righteous indignation. He said resolutely and calmly, "No matter whose idea it is, I'll never withdraw my signature!"

I also put in with rage, "The declaration published in the *Xinhua Daily* is exactly the same as the one we signed."

The crestfallen visitor slipped out with the newspaper under his arm.

"Jing, early tomorrow morning you go downtown to tell Guo Moruo all that has happened here so that he can rest assured that we'll never waver."

"Go downtown? How can I help worrying about you to leave you way behind at home?"

"But you must go. Jing, we must inform Guo Moruo and the *Xinhua Daily* of Zhang's dirty tricks."

I complied with his wish. Early the next morning, after he finished the breakfast I had prepared and was given the day's doses of medicine, I hurriedly descended the mountain to board a steamer on my way to the city proper to see Guo Moruo.

Guo and his wife Yu Liqun received me warmly. They had already been fully informed of what had taken place and held Beihong in high esteem for having flatly refused to withdraw the signature.

Xu Beihong in Chongqing

Xu Beihong with
Li Jishen

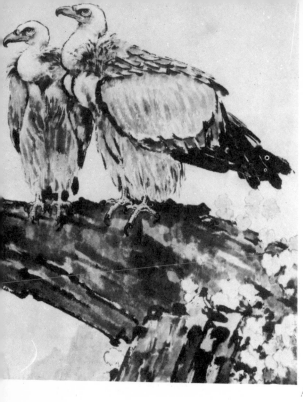

Vultures *Traditional Chinese
painting, 1941*

A Cowherd *Traditional Chinese
painting, 1941*

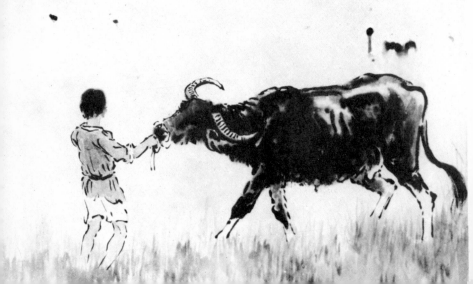

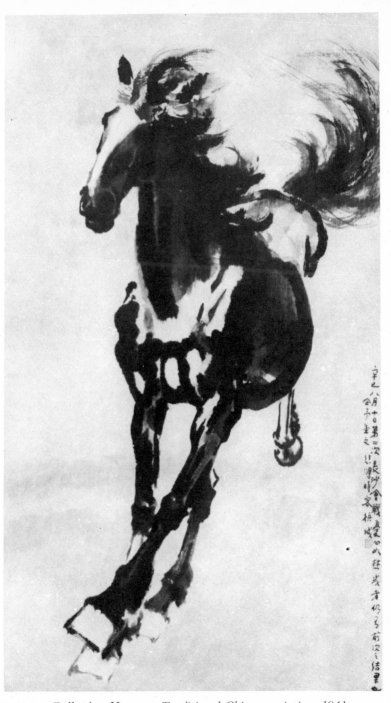

Galloping Horse *Traditional Chinese painting, 1941*

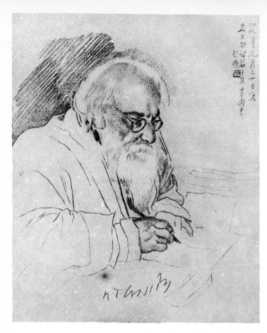

R. Tagore at Work
Sketch, 1940

A funeral attendant (draft)
in *Martyrs to the National
Cause Traditional Chinese
painting, 1943*

Liao Jingwen *Sketch, 1943*

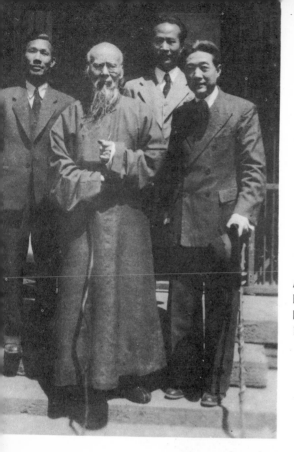

From left to right: Li Hua, Qi Baishi, Wu Zuoren and Xu Beihong in Qi Baishi's home, 1948

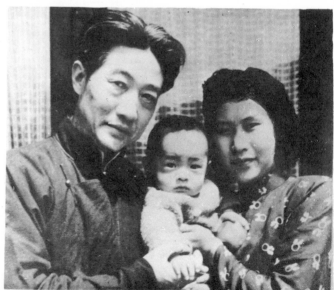

Xu Beihong with the author and their baby in Beijing, 1947

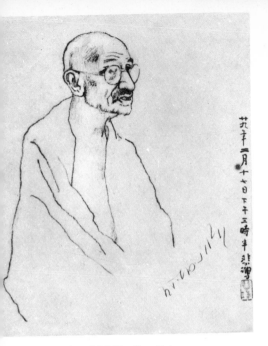

A Singaporean Boatman
Sketch, 1941

A portrait of M.K. Gandhi
Sketch, 1940

Two Musicians *Sketch, 1939*

Eighty-seven Immortals (detail)　　A scroll painting in Xu Beihong's collection

I said, "Beihong calls it his duty to do so. He'll never waver or surrender."

Guo smiled gleefully. Yu pressed me to stay for lunch, which I did, thinking it ungracious to decline her hospitality.

After lunch, I left in haste for the ferry by bus. In the crowded, noisy steamer, while I stood leaning against its railing and looking at the turbid, rolling waters of the Jialing, I called to mind the recent happenings and worried about Beihong's illness. Thoughts of the national calamity as well as Beihong's illness made me heavy-hearted and depressed. Welling up like the rolling waves was the furious indignation stirred up in me by the Kuomintang reactionaries' dirty tricks in deceiving and blackmailing people.

The steamer drew alongside. When I finally reached the familiar mountain path, both the sky and the river were shrouded in the evening twilight. Then I saw Beihong waving to me from afar; I quickly ran up to him. Standing in the chilly wind, he asked with anxiety, "Did you see Guo Moruo?"

"Yes, I did. I've told him everything. He had me stay for lunch too."

He said with happy excitement, "You're back so late. I feared that Guo Moruo might have met with some misfortune." He drew a deep breath.

I helped him to go home. At the touch of his icy fingers, I shivered involuntarily with cold. It gave me a pang of pain to see him walking with such difficulty. But this was the first time he had walked outside the gate since he fell ill!

One evening several days later, as dusk was falling, someone was suddenly heard pounding up the wooden stairs in haste. Then a middle-aged man with a triangular face entered our room. Forcing a hypocritical smile, he took off his hat and said, "Mr. Xu, Generalissimo Chiang, Director Zhang and many others are waiting for you to withdraw your signature...."

Beihong interrupted him in a loud and clear voice, "No, certainly not!"

The smile vanished instantly from the triangular face. Bending forward, he continued in a low voice as if he were whispering in

257

Beihong's ear, "Mr. Xu, if you persist in refusing to withdraw the signature, you'll take the chances of losing everything you have. I've been ordered to notify you...."

Beihong abruptly rose to his feet and declared with finality, "I'll always hold myself responsible for my signature!"

Beihong's mild eyes now glared like lightning, and his hand holding the back of the chair quivered slightly. The triangular face stared at Beihong dumbfoundedly and the man slunk away like an injured dog with its tail between its legs.

I eyed Beihong in great agitation and went up to help him lie down. Before my very eyes, the honest, generous, gentle and modest Beihong had become an even more lofty and awe-inspiring figure. The respect I had held for him was not only the respect entertained for my loved one, but also the respect entertained by an ordinary Chinese for an upright artist.

Not long afterwards, a so-called declaration of the cultural circles drafted by the Kuomintang came out with of course a content diametrically opposite to that of the previous declaration drafted by Guo Moruo. When they brought it before Beihong and demanded that he sign his name to it, he sternly refused to do their bidding. Letters came in one after another, some telling him to behave wisely in a delicate situation, some intimidating and blackmailing him, some insulting and reviling him. He tore them into small pieces and threw them out of the window to be blown to the four winds.

After nightfall, Beihong and I sat in the dim light of an oil lamp while the cold wind was whistling against our papered window. I took fright at hearing some small noise which seemed to be coming from below the window outside. Beihong, however, remained calm.

He said with composure, "Don't be afraid. Our deeds are just and ethical. It's they who ought to be afraid!"

His powerful words gave me great encouragement. Fear gave way to strong indignation when I realized that we as Chinese were not guaranteed even the rudimentary rights of existence.

Chapter XV

The warm breezes of spring came. They awakened the slumbering earth and gently pushed open our window. The resuscitated trees swayed their boughs and twigs in the breeze. The waters of the Jialing flowed even more swiftly, carrying away with them the endless boats on the river.

Beihong, recovering gradually, began to move around outdoors. While we walked slowly in the greening fields, flowers greeted us with smiles, birds on the branches sang us songs, the sun bathed us. Mother earth seemed to be celebrating and rejoicing over our happiness.

Soon, Beihong resumed teaching at the art department of Central University. But he now went there only two or three times a week instead of every day. He had not yet fully recovered from hypertension and nephritis. Besides teaching, he also did some painting.

One day, Zhao Shaoang, a celebrated painter then still in his prime, came to Panxi to visit Beihong. Having been a student of Gao Jianfu and Gao Qifeng, Zhao excels in painting birds and flowers, landscapes and grass and insects. His works possess not only the strong characteristics of the Lingnan school, but also a unique style of his own. He has outdone his teachers.

Zhao has also experienced hardships. He lost his father when he was still a child and learned painting with the money his mother earned as a servant. He treated his mother with filial devotion. Later, deeply grieved over her death, he named his home "A House in Memory of Mother" and had it inscribed on a horizontal wooden tablet in Beihong's handwriting. On one side of it were some small characters also inscribed by Beihong, meaning "This inscription is to express Shaoang's deep affection for his mother." The wooden tablet is said to be still hanging in his drawing room.

Chang Shuhong, who was an oil painter returned from France, also came to see Beihong. When Chang held an exhibition of his works in Chongqing, Beihong had written a preface to praise his superb paintings of figures, landscapes and still-lifes. As director of the Research Institute of Dunhuang Art, he had brought to Chongqing with him for public exhibition copies of frescoes from Dunhuang to acquaint the public with the magnificent achievements of Dunhuang art made during the various ages since the Northern Wei Dynasty.

Among those who came to look Beihong up were also the noted art historian Chang Renxia, the talented young sculptor Fu Tianchou and many other friends in the art circles. Fu had also been a student of Beihong's. In the spring of 1946, when his works, including those done by copying ancient sculptures in Dazu, Sichuan Province, were put on exhibition, they were warmly received by the public. Beihong greatly appreciated Fu's works, such as *Wrath of a Bumper Harvest, Wangfu Stone, Qingming Festival* and *Heavy Load,* which, characterized by stress on implied modelling and assimilation of traditional Chinese technique to Western sculptural art, are full of deep sympathy for the unfortunates.

Meanwhile, Beihong also had more than forty cases of his books and paintings sent to Panxi from Guiyang.

Soon the summer vacation came round again. Beihong was greatly delighted to see a number of students about to graduate from the university. He exhorted them to strive to create, through tempering themselves in society, works reflecting the spirit of the age and possessing individual style.

He told them to carry sketchpads with them so that they could draw at any moment whatever persons and objects they found interesting in their day-to-day life, for the constant practice of sketching would not only enable them to express their thoughts and feelings, but also help them develop technique and collect materials for future creations. He said, "All large paintings are made up of small sketches, so you must persist in doing constant sketching."

It happened about that time that Zhang Daofan called on Beihong. He came wearing a suit of well-pressed, light-coloured Western-style clothes made of quality woolen fabric. As the weather was hot, he was in

his shirt, holding the jacket on his arm. His thick hair was well trimmed. He swaggered into our room looking very much pleased with himself.

"Brother Beihong, I ought to have called on you earlier," he said with a grin.

Beihong, reclining on the sling chair, did not rise to greet him.

"Not yet recovered? You still look pale," after taking a close look at Beihong, he sank into a wicker chair and continued. "Well, I've been up to my neck in work. That's why I didn't have time to look you up during your long illness. I was invited to make a speech today at National Art College, and happened to pass by here on my way back. So I thought I would drop in to see you. My car is parked on the highway down below."

Raising his eyes to find Beihong still quiet, he went on unhurriedly, "Brother Beihong, as a great painter of world-wide fame, why should you be living such an austere life?" Then, running his eyes over our humble room with its simple and crude furniture, he added, "During the days when I was in Nanjing, I saw hanging on the wall of your studio a pair of scrolls inscribed in big characters with the couplet, 'Hold your personal prejudice; cling to your willful behaviour.' Now the scrolls are no longer on your wall, but you're still your same old self the way you get along with people. Isn't it terrible to be always so hostile?" He drawled to affect mildness of tone.

Beihong's thick eyebrows were closely knit.

"Take *Opinions of the Chongqing Cultural Circles on the Current Situation,* for example. Why must you be so stubborn? It's very dangerous for you to go on like this." Zhang had finally divulged the real purpose of his visit.

Casting a disgusted look at Zhang with glassy eyes, Beihong said calmly, "One should have one's own principles and ideals. I know how to distinguish between what I should do and what I shouldn't do. I'll do what I should even at the expense of my own life. Anyway, one ought to make a clear distinction between right and wrong and uphold truth. Life is precious, but many people in history have sacrificed their lives in safeguarding truth. I've high respect for their moral character. But people like you are bent on deceiving...."

Zhang hastened to interrupt Beihong.

"Brother, you're still the same as when you were in Paris. You were excusable at that time because of your youth. But now, shouldn't you know better after more than twenty years? To tell you frankly, you're a pedant! All the time, you're embracing 'truth' and 'truth' only! How much is your 'truth' worth? Brother, you should be more practical. 'A great man knows how to ride the tide of his times.' That's the way to avoid banging your head against a brick wall...."

Seeing that Beihong's face was turning grim with an obvious look of annoyance, Zhang stopped short and cleverly changed the topic of conversation.

"Well, we'll talk no more about this, no more about this. Let's go on to something more pleasant! Last night, the singing star Ziluolan came to perform at my department. Some say that she kept looking at me while she was on stage." Exultant over his luck with women, he added in French, *"Ma femme francaise est aussi charmante."**

Eyeing Zhang coldly, Beihong said with scorn, "That means all you think of are your personal gains and pleasures, but never the future of our country!"

The muscles on Zhang's triangular face twitched slightly, but he pretended to be calm, "Brother Beihong, you're going too far. Everybody knows I'm exerting myself to the utmost to serve the Kuomintang and our country!"

Beihong only gave him a scornful glance.

Zhang felt somewhat embarrassed by Beihong's silence. He fished out of his pocket a snow-white linen handkerchief, spread it with a flick, and carefully cleaned his pointed thin fingers with it. Then, after folding it up and thrusting it into his pocket again, he stood up blinking his dull eyes listlessly.

"I must be going now. They're waiting for me to hold a meeting in my department!" said he reaching out his hand to shake Beihong's hand.

Beihong, still reclining on the sling chair, did not rise to see him off.

I saw him downstairs. On a landing of the staircase, he halted to address me ingratiatingly, "You're really worthy of your name

* My French wife is also very charming.

Wenjing.* We often hold a dance at our place. Come and join us! You'll be more than welcome." He raised his eyes to stare at me with concealed wickedness.

"Thank you, but I haven't got time because I have to look after Beihong." I continued to walk him downstairs.

"Please don't bother to come any further."

"No," said I, "I'm not seeing you out, but going to shut the gate." The smile vanished from his face when he heard the taunt.

No sooner had he stepped out of the gate than I banged it shut and hurried back to Beihong's side.

"He's a perfect clown," I said to Beihong.

Beihong only gave a faint smile.

* The two Chinese characters *wen* and *jing*, which form the author's personal name, mean "gentle" and "quiet" respectively.

Chapter XVI

On August 14, 1945, news reached us that Japan had surrendered. The anti-Japanese war had won victory! People were wild with joy.

They cheered, jumped and lost no time in telling each other the good news. Firecrackers started popping all around us. All personnel of the preparatory office rushed outdoors and met in excitement; then we ran indoors again to seek food and drink. How we wanted to spend our time in drinking and reveling to our hearts' content!

Beihong, also thrilled with excitement, came among us as if he had completely got over his illness. His pale face showed a healthy flush and beamed with an immeasurable joy, like a clear sky decorated with fleecy clouds in the wake of a storm. He had suddenly put on a strong and energetic appearance. However, if one looked closely, one would find that his forehead was deeply wrinkled, the hair at his temples was greying, and his back was slightly bent forward under the weight of long years of sufferings. Though only fifty-one years old, he was aging fast.

How slowly the war years had dragged! Children had grown up, middle-aged people had become old, innumerable innocent, honest people had lost their lives, beautiful homesteads had been reduced to ruins, thousands upon thousands of wives had lost their husbands, mothers had lost their sons and daughters. The nightmarish days had finally come to an end. During our memorable moment of joy, all people had this common desire and conviction: never let any war of aggression scourge China again!

In spite of his ill health, Beihong continued to teach at Central University and at the same time did some traditional ink-and-wash painting.

At the war's end, many Kuomintang officials flew to Nanjing and Shanghai to take over enemy-occupied cities and property. While the

currency of the Wang Jingwei puppet regime in the Japanese-occupied areas was fast depreciating, the Kuomintang currency had become strong. So Jiang Biwei again demanded that the divorce formalities should be performed and that, since all the two hundred thousand yuan previously given her by Beihong had been spent, Beihong should give her another million yuan plus a hundred paintings (though she had already been previously given fifty paintings). She also demanded twenty thousand yuan per month as living expenses for each of the two children. Beihong's monthly pay was no more than twenty thousand yuan, though he was then a professor of the highest grade.

I went downtown to consult with Guo Moruo and his wife. Guo recommended that I see the lawyer Shen Junru, and Mrs. Guo walked me to Shen's legal office.

Shen, a progressive elder, stood high in public esteem, having formerly been jailed by the Kuomintang government for patriotic activities. He had great sympathy for Beihong and readily promised to attend to his case. He said that, though generally speaking two cohabitants seeking divorce were not required to go through any legal formalities, Beihong was urged to sign a written agreement with Jiang Biwei so as to anticipate any further disputes she might cause. I accepted the lawyer's advice. Meanwhile, I also received a remittance from Kunming in return for Beihong's paintings already sold there.

In spite of the great efforts made by Shen to negotiate a proper settlement, Jiang insisted on her harsh terms. Finally Beihong had to sign off, conceding to the above-mentioned demands of hers. Since their son Boyang had joined up to fight the Japanese, Beihong was to postpone paying his monthly expenses of twenty thousand yuan until he returned home from the army.

The divorce was signed by both parties in the presence of the lawyer Shen Junru acting as witness. Beihong brought Jiang not only the million yuan and hundred traditional Chinese paintings, but also an oil depicting her learning to play the violin in Paris. He brought it to her because he knew this was a favourite of hers. He still remembered the old days even at the time of their final separation. The curtain thus dropped on the concluding scene of the family tragedy.

Later that day, Jiang, armed with the money and paintings, went to

visit Zhang Daofan's China Art Association, where she spent a whole night playing mahjong, probably out of high elation over her new acquisitions.

Not long afterwards, our wedding ceremony took place at the Sino-Soviet Cultural Association in Chongqing with Guo Moruo and Shen Junru acting as chief witnesses.

Many friends and students of Beihong's attended our wedding. Since we had asked beforehand not to receive any gifts, the students brought with them baskets of fresh flowers instead, which lent much colour and grandeur to the scene. Guo composed a poem to congratulate us:

> The Jialing River is greener than tea;
> The green bamboos are prettier than flowers.
> O what a wonderful scene!
> Panxi graced by the new home of our artist.

From then on, Beihong had a real home. But it was a very humble home. We had not bought any new articles for daily use when we got married. Our furniture consisted of the same old unvarnished wooden bed, an unvarnished desk, a wooden cabinet, two cane chairs and a sling chair. We still lived in the Shi family's ancestral temple, ate the same simple food with our colleagues, burned the same oil-lamp. We were extremely joyous and happy nevertheless.

We were filled with unusually fresh feelings — soft, gentle, and happy feelings. Beihong said repeatedly, "I've found my real sweetheart! Nobody except you can treat me with such true, steadfast, pure and selfless affection. How can I repay you?"

"Why say repay?" I said bashfully. "I only mean to make you happy."

"I'm really happy! Jing, I've always thought that since you've made so many sacrifices for me and I owe you such a debt of gratitude, I ought to give you what I treasure most."

"No, I don't want anything." My face was burning with shyness.

"Jing," he insisted, "as a painter, I dearly love my own favourite works. But I'm going to give all of them to you and put your name on

them."

In spite of my protests, he inscribed many of his paintings with "Dedicated to my dear wife Jingwen." (These paintings are now housed in the Xu Beihong Memorial Hall, Beijing.)

Every day I would rub the ink stick and spread sheets of paper for him or watch him paint. I also did such household chores as washing his clothes and cleaning our rooms. He had his teaching hours at Central University gradually increased, and would lecture for hours on end in the classroom though he had not yet fully recovered from his hypertension. He seemed to be more high-spirited than ever in the past.

We would again go on walks together after supper. Dusk in spring was so warm and pleasant. Huge patches of rosy sunset clouds decorated the clear sky like pieces of coloured silk flying high above. The fields and trees, all fresh green, seemed to be smiling quietly in the evening glow. The Jialing, flowing freely and merrily, was gradually dissoving in the thick evening mist. The drowsy round moon was rising and stars were twinkling elusively. What an enchanting evening! Having experienced the agonies of despair, I was now drinking heartily the sweet nectar of happiness. I walked beside Beihong through the evening breezes. I asked him again and again, "Is all this true? Why do I feel as if I were in a dream?"

He answered again and again, "It's true, Jing, it's all true. It's a compensation given us by life after we've suffered all our miseries."

Chapter XVII

While the whole nation was jubilant over the victory of the anti-Japanese war, heavy black clouds again appeared in the clear sky above China. In order to eliminate the Chinese Communist Party, which had fought heroically during the war, the Kuomintang government was speeding up the deployment of its troops in preparation for a large-scale civil war. The people saw the impending storm. Revolutionary students were the first to pour into the streets to hold demonstrations and raise the call: "For democracy! For peace!"

Progressive students of the Central University art department also flung themselves into this mighty current of revolution. They organized a Mustang Society to draw cartoons as weapons for exposing the Kuomintang reactionaries' evil war preparations under the guise of peace. These cartoons played a tremendous role in educating and arousing the masses.

The Kuomintang authorities were so alarmed by the students' revolutionary activities that they hurriedly assigned a group of Three-People's-Principle Youth Leaguers* among the students to start an anti-Communist parade in an attempt to put down the revolutionary call for "Oppose dictatorship, struggle for democracy; oppose the civil war, struggle for peace." The masses of the people, however, were yearning for peace in the post-war years.

In early March, 1946, when Beihong went to teach at Central University art department, he was met in the administrative office by several students of Mustang Society who showed him a picture album they had painted and edited. He carefully looked over every page of it.

* A reactionary body organized by the Kuomintang for roping in young people on anti-Communist, anti-popular activities.

When he saw the page entitled "All political parties and groups, unite to build a New China," he nodded approvingly and excitedly, his face showing intense eagerness and his eyes fixed on the page for a long while. Then, when he came to the page urging the safeguarding of the people's rights, a student next to him said indignantly, "Mr. Xu, not long ago, the Three-People's-Principle Youth League sent a blackmail letter to our Mustang Society. They wanted us to stop publication immediately. And our wall newspaper was also torn off by some thugs."

A very serious look came over Beihong's face. Raising his head to look towards the direction the student was pointing out with his finger, he could still see remaining traces of the wall newspaper outside the window.

At once he told the students to fetch him his brush, inkstone and paper. He quickly painted the picture of a galloping wild horse and inscribed it with the following:

> Specially painted for Mustang Society in early spring, 1946, to express the belief that there will be an end both to this long night on earth and to the boundless wilderness before us.

Chongqing became even more bustling. The streets were full of stalls spreading goods on the ground for sale; many people were auctioning off their own clothes to get ready to return home.

Officials of the Kuomintang government had already left batch after batch by plane. Many of them had gone to the former enemy-occupied zones to enrich themselves by hook or by crook. As some government offices also began to move, people started leaving the city in numbers. Passenger boats sailed up and down the Yangtse River between Chongqing and Nanjing, carrying with them people anxious to go home. As a result of the eight-year anti-Japanese war, many a family had remained disunited and many a mother had been looking forward to the return of her sons. It was therefore very difficult to book a passage to Nanjing or Shanghai.

I often accompanied Beihong into Chongqing to see art exhibitions or call on friends. We met Tian Han several times; a bosom friend of Beihong's he was a writer I held in esteem. Though a few years younger than Beihong, he was more grey-haired, which probably

accounted for the fact that he wore his hair cropped. Tall of stature and bespectacled, he spoke mandarin with a strong Hunan accent.

One day, Beihong and I went downtown to invite him to eat with us at a restaurant. He was accompanied, to my surprise, by a group of friends. Beihong told me that it was Tian's habit always to be accompanied by many friends wherever he went. Another thing Beihong told me: one day in Nanjing, when Beihong went to a restaurant at Tian's invitation, Tian had also brought in at the last moment a group of friends from the art and literary circles. After the meal was over, Tian found all his pockets empty of money, so Beihong had to foot the bill. Everybody laughed uproariously.

Beihong and Tian treated each other as affectionately as brothers. Tian was very much pleased to learn that I was also Hunanese. When I said that I was very fond of his plays and my former schoolmates had staged his *The Tiger-hunting Night* and *Return to the South,* he smiled modestly and said, "It's a great honour for us Hunanese to have Beihong as a son-in-law of Hunan Province." He added, "Jiang Biwei forced Beihong to quit Nanguo Art Academy and cut off relations with me. But Beihong and I have always remained good friends while she herself has broken off with Beihong. That shows how hard it is to bridge over differences in thought."

"Yes," I added, "it's a tragedy. It brought Beihong many years of mental suffering."

"That's why Balzac says: Love is the most difficult school in life," he said wittily. "Now, Beihong has graduated from this school with honours."

Beihong, however, remained unusually silent, probably thinking back to the Nanguo days. The faint memories of the past had returned to him.

One day, Tian invited Beihong and me to attend the report-back performance given by the Fourth Anti-Japanese Drama Troupe. Beihong was deeply impressed with a rich variety of anti-Japanese skits, songs, folk dances and exhibited paintings and reference materials. In *The New-type National Art of the Fourth Anti-Japanese Drama Troupe,* he says as follows: The fact that the drama troupe had "put on so many performances in so many places to affect so many audiences over as long

270

a period as eight years" was itself a "great, heroic epic." "Every member of the troupe has engaged in the epic creation with high devotion, wisdom and will They have tempered themselves into brilliant pure steel by long years of struggle against hardships and difficulties."

The oil painter Feng Fasi, a member of the troupe, had been a student of Beihong's. As early as when he was in Guangxi, Beihong had already seen the sketches and paintings that Feng had done at the front, in the rear or on the march with the drama troupe. The sun-tanned oil painter had stood before his teacher in excitement, telling of his life in the drama troupe. Beihong had carefully looked over Feng's paintings one by one, while listening to him talk about his tense, militant life.

"In our troupe, every painter has to be a player and singer at the same time. He has to paint stage sets, make stages and assemble or disassemble them. In addition, he has to make use of his breaks and after-work hours to paint wall pictures, write slogans, and edit wall newspapers. He has to go here and there writing or painting with a paint pail in his hand. He seldom has spare time," Feng had told him with ardour. "For the sake of the anti-Japanese war, we exposed ourselves to wind and rain, endured hunger and cold, walked hundreds of kilometres from town to countryside or over endless mountain ranges. We lived in leaky houses, ate the same simple food together, and our monthly pay was hardly enough to meet the minimum requirements of life...."

"I've decided to engage you as an associate research fellow of China Art Academy," Beihong had declared to the weather-beaten oil painter before him. "But I don't want you to do your painting in our academy; I want you to stay on with the troupe and do your painting in the midst of fighting."

Feng listened respectfully to his teacher's instruction, his eyes sparkling with unswerving determination. He understood that his teacher's purpose was to keep him at the front or in the rear to contact more soldiers and working people. He wanted realistic works capable of reflecting the stormy age.

Now, Feng accompanied us in viewing the paintings and reference materials on display, including many of his own works. On one side of his oil *Papayas* was inscribed the following poem by Tian Han:

There still is life among the debris;

271

Of what avail are rains of bombs?
Papayas in the city of Longzhou
This year grow huge and tall like giants.

Beihong also appreciated his charcoal drawings *Transporting Steel Sheet Piles on the Guizhou-Guangxi Railway* and *Iron Works,* his frontline sketches *Smouldering Embers* and *Huilong Mountain,* and his oil *Catching Lice,* which, adroitly executed, all reflected life both on the front and in the rear.

In his article *The New-type National Art of the Fourth Anti-Japanese Drama Troupe,* Beihong spoke highly of paintings by the troupe members, calling them "valuable achievements of the anti-Japanese war, distinguished by originality in the choice of subject and depth in the method of execution." He said that their songs "have vigorous tones and sharp words and therefore a strong appeal to the audience," and that their stage shows "are most brilliant, ingenious and thrilling." He warmly praised the troupe members for their superb technique, which "can never be acquired by a few years of schooling at home or abroad." While extolling their "lofty ideals," he hoped that the troupe members would "strive to help bring about solidarity, unification and democracy."

He concluded his article with "As one can easily see, the achievements of the drama troupe are but a logical development. However, what surprises us is that the remarkable drama troupe should have been affiliated to the Kuomintang political department which is completely ignorant of culture." Again he denounced the rotten Kuomintang government.

Beihong was unaware that the drama troupe was a revolutionary art group led by the Communist Party. Beihong long remembered the arduous efforts and outstanding contributions they had made during the war.

Chapter XVIII

In midsummer, 1946, Beihong and I went downtown to call on Li Jishen. Li had allocated a fund for moving Beihong's books, paintings and art collection from Guilin shortly before its fall to prevent their destruction by gunfire. We were very grateful to him for having helped to salvage these national treasures.

Li, medium-statured and dressed in a greyish silk long gown, wore a smile on his full, broad face.

After exchanging a few words of greeting, he told us that he was leaving for Nanjing the next day on the S.S. Minlian of the Minsheng Steamship Company, and that he had two surplus cheap steamer tickets, one for a steerage passenger, the other for a passenger without a berth. He said that he would give us the tickets free if we wanted to leave on the ship with him the next day.

We understood that it was extremely difficult to get a steamboat ticket at that time and that some people, anxious to return home after the eight-year disruption, had drowned when the junks they had decided to take were capsized by the rolling waves of the Yangtse. Thinking it an opportunity not to be missed, we decided to leave Chongqing the next day on the S.S. Minlian.

Beihong and I hurried back to Panxi to pack. We had been living a very simple life and had nothing to dispose of or sell except Beihong's more than forty cases of books and paintings. He picked out the most important contents and packed them in a three-metre-long iron case and several camphorwood trunks, leaving the remaining cases to the temporary care of our colleagues at the preparatory office pending their later shipment to Nanjing.

That night, all personnel of the preparatory office sat on the broad, flat ground in front of the buildings to have a final chat before our

departure. This was where we had long come to enjoy the evening cool in summer. On those moonlit nights, while sitting there among his colleagues, Beihong would talk about the current situation, art and literature, and his own personal experiences, but mostly about painting. The subjects of his talk would range from Egyptian and Greek painting and sculpture to various schools of art in the nineteenth century. He would dwell on Realism, Romanticism and Impressionism, as well as the fashionable formalistic neo-artists of the West he opposed. He could give the names of several hundred artists and talk about their representative works, styles, characteristics as well as the historical anecdotes about them. His brain was a treasure house of world art. He could also talk distinctly about all famous Chinese painters through the ages and their works. His speech was lively, witty and humorous. We would often sit under the moonlit, starry sky chatting away without noticing the lateness of the night, our shadows on the ground gradually merging into one.

Qi Zhenqi, a painter working at the preparatory office, had jotted down Beihong's nocturnal talks in the diary he was keeping and intended to publish them under the title of *Moonlight Chats*. Unfortunately, Qi later died and the whereabouts of his diary was unknown.

Early the next morning, Beihong and I bade good-bye to Panxi with reluctance. People of the preparatory office saw us to the Jialing riverside. On the way, Beihong and I repeatedly turned round to look at the distant Shi family ancestral temple. The two simple, crude wooden buildings stood towering on the slope as usual and their open windows, like wide-open eyes, stared at us silently.

Beihong and I boarded the S.S. Minlian, the most crowded vessel I had ever seen in my life, with even its decks swarming with passengers planning to sleep on them.

The congested mountain town of Chongqing was baking in the fiery sun of July. Though we had elbowed our way onto the steamer perspiring all over, Beihong's cases of paintings were prohibited from being shipped because the steamer was said to be already overloaded. Later we were to learn that it carried not only an excess number of passengers, but also a huge quantity of rice to be sold in Nanjing for

staggering profits.

Beihong was terribly worried and told me repeatedly, "If they refuse to load my cases, I won't be taking this ship."

These cases contained not only his own important paintings, but also his collected art treasures, including the scroll *Eighty-seven Immortals*.

We patiently took up the matter with the ship authorities and Li Jishen also put in a word for us, but to no purpose. It seemed that we were left with no alternative but to go ashore. But good luck often comes out of the depth of despair. We were just about to disembark when we came face to face with one of the men in charge of the steamer. He happened to know Beihong.

"Hello, Mr. Xu!" he greeted us enthusiastically, his sweaty face beaming.

When informed of our problem, he said without hesitation, "That's easy. It doesn't matter at all to take on a little more cargo like this."

In the midst of the clanking of the anchor, the droning of the engine and the hubbub of the people, the S.S. Minlian began to shake and move slowly towards the middle of the river, its steam whistle shrieking. Beihong and I pushed our way to the railing and stood waving farewell to our friends.

The figures on the bank grew smaller and dimmer. Chongqing, like an ink-and-wash landscape painting, was fading out behind the grey mists.

The passengers walked back to their seats one after another. But Beihong continued to stand leaning against the railing, as if still gazing at the invisible town of Chongqing in the distance. Looking deep in thought, he was completely impervious to the wind sweeping from the river surface to lift chest-high the lower hem of his white linen-cloth long gown. He had spent so many memorable days in the misty town of Chongqing during eight difficult year!

The wind was becoming stronger and dark rolling clouds were gathering in the sky. Sailors hurriedly put up tarpaulins beside the railings to guard against the coming storm. Beihong also returned to our own place in a corner of the deck which, covered with our bedclothes,

275

was just big enough for us to lie down. We had given up the steerage accommodation and chosen to sleep on the deck instead.

We were surrounded on all sides by passengers. Because of the limited space, some even had to lie curling up on the deck. Among the passengers were scholars, scientists, writers, artists....those who enjoyed no political status in the old society in spite of their contributions to the people. All first-class cabin berths had been taken up by high Kuomintang officials and their children.

Having learned that there were aboard the ship many scholars and well-known personages, the passengers invited some of them to deliver speeches at meetings they organized during the long voyage. Beihong was among those invited. They also published a mimeographed tabloid called *The S.S. Minlian*.

At night, after the hubbub of voices died down, we were still kept awake by children wailing, mothers scolding and people talking in their sleep. And I even feared that people might inadvertently tread on my belly in striding over me; I was already six months with child.

The lovely, spectacular Yangtse, however, brought me great joy and consolation. With the swift river shining red under the rosy clouds of dawn and the sun-baked steamer cleaving through the waves, my heart, too, seemed to be bathed in the sun like the steamer, feeling warm, joyous and carefree.

While the green fields and mountain ranges were receding slowly on both banks, the grand, precipitous Three Gorges loomed into sight. Then, Kuimen, also known as Qutang Gorge, the gateway to the Three Gorges, suddenly appeared before us, and we were invited by the captain of the ship to go to the bow to get a full view of the scene. The sheer precipices and overhanging rocks seemed to have been hewn out with supernatural skill. The waters were rushing past swiftly with the momentum of an avalanche.

Chapter XIX

The ever-flowing Yangtse, after cutting through Sichuan, Hubei, Hunan, Jiangxi, and Anhui provinces, finally brought us to Nanjing. When the ship came alongside the Pukou wharf, we went ashore with throngs of passengers and our luggage was unloaded by the dockers. Again we were faced with the problem of transporting Beihong's heavy cases. Leaving Beihong behind to watch over the cases, I went to look for some sort of vehicle and was lucky enough to hire a two-wheeled horse-drawn carriage. After the cases were laboriously lifted into the carriage by the drivers, Beihong and I sat in the back seat, and the horse started down the broad street, its hoofs kicking up clouds of dust.

Summer in Nanjing is also very hot. The earth had parched up under the scorching sun, and people were dripping with perspiration and panting hard. Although the Kuomintang government had moved back to Nanjing, the city looked cheerless and the streets were desolate, with traces of war ravages still remaining.

Soon after our arrival, Beihong and I toured Xuanwu Lake and Linggu Temple, and paid our respects to the Sun Yat-sen Mausoleum. Beihong told me that in the autumn of 1934 he had painted an oil portrait of Dr. Sun Yat-sen to be hung in the auditorium of the Ministry of Communications in Nanjing and that its whereabouts was now unknown.

We also happened to walk past the front gate of Beihong's former residence, "Precarious Nest." Through the neat fence were visible the luxuriant growth of flowers and trees in the courtyard and the newly repaired columns and windows at the verandah.

Beihong walked away hurriedly after a casual glance at "Precarious Nest," perhaps due to his unwillingness to be reminded of his former family.

Although it was not stated in the divorce agreement that this house was to belong to Jiang Biwei, Beihong had never cared to haggle with her about its ownership. Later we were to learn that Jiang had already rented the house to the French Information Service at a high rate after having it repaired on her hasty return from Chongqing. But on an empty plot within the compound she had another house built for herself with a bright, spacious studio in it. All the rooms were decorated with different flowers, which the florist in town came to replace with new ones every day. This was the resort Jiang had specially fixed up for Zhang Daofan with the money she had obtained from Beihong. It was a place where Zhang could come in or go out at will. It had in fact become his second home — or a rendezvous for his mistress. In this studio, specially fixed up for him by Jiang Biwei, there was not a single painting by the Director, who had formerly studied painting in England and France.

We stayed in Nanjing for one month, during which we called on some old friends. Since Beihong had accepted the invitation to be president of Beiping Art College, we set out for North China in a hurry.

We left Nanjing for Shanghai, whence we were to leave again for Beijing (then called Beiping).

Travelling on the same train with us was Xu Ziming, a fellow townsman and old friend of Beihong's who had in 1915 called Beihong to Shanghai. Although Beihong's senior by many years, Xu Ziming was hale and hearty and spoke mandarin with a heavy Yixing accent. Throughout the journey, he kept telling me stories from over thirty years before. He had witnessed Beihong's miseries when he was wandering about destitute in Shanghai at age twenty. Full of friendship and respect for Beihong, he spoke of Jiang Biwei with reproach and indignation. Beihong, however, sat listening quietly, never saying a word against her.

Arriving in Shanghai, we met Wang Yachen and his wife, whom we had not seen for many years. Wang, a noted painter and founder of Xinhua Art College in Shanghai, had made indelible contributions to China's art education, having trained a large number of young artists. He had been actively assisted by his wife Rong Junli in his career as an artist. But Xinhua Art College, which had closed during the Japanese occupation of Shanghai, now stood little chance of being reopened. We stayed with the Wangs at their invitation and had a very pleasant time

together.

One of the many old friends whom Beihong met in Shanghai was Wu Zhongxiong, whose step-grandmother, named Ren Yuhua, was a daughter of Ren Bonian. Wu, then working in financial circles, was also good at painting. He had given Beihong many unfinished paintings by Ren Bonian, which Beihong completed one by one. Another two old friends whom Beihong met were Bai Jiao and Deng Shanmu, whose calligraphy he greatly admired. Still another was the former Commercial Press salesclerk whom Beihong had come to know when he was wandering about destitute in Shanghai. The salesclerk, later promoted to be head of the public relations department of Commercial Press, had made the acquaintance of a great many people in various circles. He was very warm-hearted and always ready to help others. But since some of his acquaintances were Communists, he had been arrested by the Japanese puppet regime after the fall of Shanghai. He had suffered brutal torture in jail. Later, after his release, he was unemployed and lost his former graceful, capable self to the serious mental and physical injury he had sustained. When we met him, we found him completely down and out. Beihong had great sympathy for him, and, for old time's sake, tried to find him a job in Shanghai, but in vain. So Beihong took him to Beiping with us, and managed to have him employed as a clerk in the office of the dean of students at Beiping Art College, where he did such routine work as taking charge of the students' stipends.

Beihong and I went together for a walk along the bank of the Huangpu River. When he stood pensively by the riverside to give me a detailed account of his wandering life in Shanghai over thirty years before, his face was shaded with melancholy and he once again visualized his former self—a twenty-year-old man who would have been drowned in the river had he taken but one more step forward. During the more than thirty years since then, that sorrowful event had again and again risen in his mind.

The turbulent Huangpu, having witnessed the miseries of countless people, was rushing moodily on as usual. Looking around, Beihong saw new additions to the skyscrapers on the Bund looking down upon the pedestrians with a cold, stern stare. Beggars in rags, wild-haired and

279

dirty-faced, were everywhere. How many talented young people were suffering the same fate Beihong had suffered before! Many new Kuomintang VIPs, who had been hiding in the vast hinterland to wallow in vice and luxury, were now making fabulous fortunes as post-war recovery officials and setting up private residences to house their mistresses. Dance halls and restaurants were still reverberating with lewd music and songs.

We went to call on Guo Moruo, who, still going strong, received us warmly. His wife Yu Liqun greeted us with the same amiable, sweet smile. But, as we were in a hurry to attend a dinner party given by a friend, we took leave of them after having only a brief chat together.

We were about to walk out of the drawing room when Zhou Enlai unexpectedly came in. He stepped forward to reach out a strong, warm palm and give us his firm handshake. Hearing that Beihong was leaving for Beiping, he immediately said in great delight, "Good! You should go there."

Since the peace talks between the Communist Party and the Kuomintang were on the verge of breaking down, many of Beihong's friends, thinking North China unsafe, were trying to dissuade him from going there. Many thought that, as a famous painter, Beihong should stay on in Nanjing, which was the capital of the Kuomintang government and a political and cultural centre of the country. Zhou Enlai, however, encouraged Beihong to go to Beiping and said to him, "I hope Beiping Art College under your management will train talented artists for the people."

He incidentally mentioned that he was thinking fondly of Beiping. When he stood before us, he impressed us with the image of a lofty, profound man, his limpid eyes shining bright. While talking affably, he had his head slightly raised with a thoughtful and considerate look on his face. His words, though brief, gave us great encouragement.

Soon afterwards, Beihong and I left Shanghai by sea for Qinhuangdao, where we were to change to a train for Beiping.

Chapter XX

Beihong and I arrived in Beiping on August 31, 1946.

This was my first visit to the ancient capital. The solemn, magnificent Tian An Men, the splendid Imperial Palace, the ancient city walls, the tree-shaded broad streets, the atmosphere pervading the city — all attracted me on my first visit. But, on the other hand, traces of war ravages still remained, business was languid, people were poverty-stricken and unemployment was mounting.

Beiping Art College was situated at No. 10 East Zongbu Hutong, a narrow but simple and quiet compound with grey brick buildings. Beihong's arrival immediately enlived the college premises. The students were seething with excitement. The walls were posted over with slogans welcoming President Xu Beihong and the classrooms were ringing with laughter and song.

Before coming to Beiping, he had decided to invite Wu Zuoren to be dean of studies at the college. He said in a letter to Wu, "I am planning to run a Leftist school.... None but you can qualify as our dean of studies."

Beihong invited the underground Communist Feng Fasi to be professor at the oil painting department. He also told Feng, "I am planning to run a Leftist school."

The other painters whom he invited to teach at the college were all both artistically accomplished and ideologically progressive, such as Li Hua, Ye Qianyu, Li Ruinian, Ai Zhongxin, Li Keran, Li Kuchan, Li Hu, Zhou Lingzhao, Dong Xiwen, Wang Linyi, Hua Tianyou, Dai Ze, Wei Qimei, and Liang Yulong.

He also invited two eminent artists of advanced age, Qi Baishi and Huang Binhong, to be professors at the college.

Li Kuchan, a student of Beihong's in the 1920s when the latter was a

teacher of the Painting Research Society in Beijing University, had later also learned painting under Qi Baishi. His free-style paintings of flowers and plants, fowls and birds, and fishes are marked by bold and smooth strokes and a pleasing vitality. In the 1930s, when he held an exhibition in Shanghai, Beihong had bought his painting *Happy Fish,* which is now housed in the Xu Beihong Memorial Hall in Beijing.

Ye Qianyu has long been known for his cartoons. In 1944, when he gave an exhibition of his works in Chongqing, Beihong spoke highly of his traditional Chinese paintings. His vivid paintings of Indian women dancers with their graceful shapes and lines show development beyond traditional Chinese painting and the creation of a new style. Beihong had bought two of his Chinese-style paintings at the exhibition, and now invited him to be head of the department of traditional Chinese painting.

Li Hua is a famous progressive artist who has made remarkable contributions and achievements in the field of woodcut. But he is also skilled in painting. His ink-and-wash paintings on Xuan paper* depicting the landscape and people's life in Hunan Province and his later paintings of figures in Tianqiao, Beiping, all possess a pleasing novelty. Now Beihong invited him to be head of the woodcut department.

Ai Zhongxin, who had been an excellent student in Beihong's class at Central University during the anti-Japanese war, was then an outstanding young painter with unrivalled imagination and consummate skill. The oils *Snow Scene at Hademen* and *Yonghe Lamasery,* which he had painted in Beiping, were warmly praised by Beihong.

Li Keran, who had developed a new method of his own, creatively showed his unique style with charming brushwork. His landscapes, done with layer after layer of overlapping faint ink washes, give a sense of depth and vastness.

Dong Xiwen, who was good at oil painting and had once copied murals at Dunhuang with extreme care and precision, was a painter of remarkable skill.

Zhou Lingzhao, Dai Ze, Wei Qimei and Liang Yulong were all

* A high-quality paper made in Xuancheng, Anhui Province, especially good for traditional Chinese painting and calligraphy.

artists of unsurpassed talent with valuable works of their own.

In short, Beihong had made every effort to recruit first-rate artists as teachers. He regarded their recruitment as essential to the successful running of Beiping Art College.

Soon after he came to the college, Beihong called a meeting of student representatives, at which he made inquiries about the original teachers' work and the students' life and study, and listened amiably and patiently to their opinions about teachers they liked or disliked and why. He acted like a father who had just returned from a far-away place and was anxious to know about his children. In the beginning, the young people, feeling ill at ease, stared at each other in embarrassment and were very guarded in their speech. However, as a highly experienced educator, Beihong knew how to encourage them to unbosom themselves. Soon, they all started talking freely. Obviously they had keenly sensed that the newly arrived president was not only a famous painter, but also a sincere, honest teacher capable of giving them real guidance. One of them first broke the silence by declaring that one of their professors, who had studied in France, could do painting no better than a first-year student at the college.

Another student at once added, "Yes, it's true. Once a sketch I had done was completely spoiled by a few alterations he made, so I had to do it all over again. I showed both sketches to my class and they all said the altered one was just no good."

"Though he himself doesn't know how to sketch, yet he's here to teach us. And he's a senior faculty member, a professor. He's one of the two full professors in our department," said a good-looking boy student.

Beihong had long been aware that the professor was a poor painter for he had happened to study in France at the same time as Beihong.

"Did you ever submit your opinions to the college authorities?" asked Beihong.

"Yes, we did. But it's no use. We hear that he has powerful backing and nobody can lay a finger on him," said an older student in a subdued voice.

The students also mentioned irrational and backward teaching methods and certain college practices aimed at hampering their freedom

283

of thought.

After the students left, Beihong started pacing up and down the room impatiently, as he had seldom done except when most irritated.

"Beihong, what's the matter?" I asked.

He halted and raised his head to stare at me, saying, "Things here in this college are rather complicated, and I've decided to discharge the incompetent professor. It looks as if we're in for another contest."

He had once told me, "As teachers, we should not blush with shame when we meet our students again after not seeing each other for a number of years." He meant to say that students should graduate armed with the skills needed for doing their work competently, otherwise their teachers should feel conscience-stricken and ashamed for having failed to acquit themselves well.

However, since he had not yet fully recovered from his illnesses, Beihong was very much in need of peace and quiet. Before we came to Beiping, I had hoped that the surroundings here would enable him to live a more tranquil life and help him regain good health. Now, such hope would probably turn out again to be a fond dream.

Upon his arrival in Beiping, Beihong had been given a warm welcome at a meeting held by Beiping Art Association. The association, which was led by the Kuomintang Central Cultural Movement Commission, and of which the incompetent professor was a council member, was trying to ingratiate itself with Beihong and pull him in. In a welcoming speech, the professor couched his high esteem for Beihong in terms bordering on flattery. Beihong resolutely joined instead Beiping Association of Art Workers, organized by some local progressive artists, and became its honorary chairman. And soon after the meeting of student representatives, Beihong declared the discharge of the professor.

One afternoon, a tall, gloomy-looking man walked into our drawing room with a bulging black briefcase under his arm. The visiting card he handed to me indicated that he was a Kuomintang department head stationed in Beiping, that is, a Kuomintang special agent chief. Then he fished out of his briefcase the professor's written complaint and, after just showing it, quickly put it back into the briefcase again and declared in a very stern tone, "The professor's our underground agent. He set up a secret radio station in his home during the anti-Japanese war.

We ought to give him preferential treatment in consideration of the contribution he's made."

Beihong replied seriously, "As president of Beiping Art College, I must hold myself responsible to my students. I can't give your man preferential treatment at the expense of the students' future."

"You mean the professor must be discharged?" asked the man with a steely look in his eyes.

"Certainly! Nobody can reverse my decision!"

A violent dispute ensued. The man blustered, "You say he's not qualified to teach because he's a poor painter, but we call him a good painter!"

Beihong retorted with anger, "It's up to the public, not me alone, to judge how he paints. If you people call him a good painter, you go ahead and employ him. But in this college, under my charge, we'll employ no incompetent man as a professor."

The man was rendered speechless by Beihong's resistance. The atmosphere in the room turned extremely chilly. A few minutes later, the man picked up his bulging briefcase and stamped out of the room in a rage. He turned round at the gate to shout loudly at Beihong, "I'm going to report you to the Central Organization Department and the Ministry of Education!"

Not long afterwards, the Central Organization Department head Chen Lifu and the Education Minister Zhu Jiahua each wrote Beihong a letter to dissuade him from discharging the professor. But they also met with his firm rejection. An "anti-Xu Beihong scheme" started brewing on the sly.

When the anti-civil war, anti-starvation student movement broke out, progressive teachers and students poured into the streets to hold mammoth parades. Afterwards, the Kuomintang Education Ministry insisted on discharging Feng Fasi, Gao Zhuang and Li Zongjing, the three professors who had taken part in the demonstrations, but Beihong held out against the order and still issued them letters of appointment.

Meanwhile, on hearing that the Beiping Garrison Headquarters was going to arrest students who had participated in the parades, Beihong informed them straight away to leave the city as quickly as

possible.

In order to protect Li Hanxiang, a student who had also joined the parades, Beihong renamed him Li Hanqiang and wrote to Hangzhou Art College to seek his transfer to that college. He did not want such a studious and bright student to discontinue his studies. But all his efforts turned out fruitless. Li was finally compelled to go to Hongkong where he went in for acting and directing instead of painting.

Today, thanks to his efforts and talent, Li has won fame as a film director in Hongkong. I think that he also owes his present successes to his former training in painting. It is a pity that Beihong died too early to see Li's achievements.

While he was a staunch, righteous fighter in the progressive mass movement, Beihong was also a strict art educator advocating constant reform.

As he had always done, Beihong attached great importance to strict training in basic skills, stipulating that a two-year course in sketching should be required of all majors, including students of the departments of traditional Chinese painting and pattern drawing. He had learned through his own experience in painting and teaching that only by a two-year strict training in sketching could students acquire a preliminary ability to paint from life. He had always valued painting from life, but opposed the exclusive practice of copying models of painting, which he regarded as only one of the means of learning the techniques of our predecessors. He spared no pains in advocating the innovation of traditional Chinese painting, stressing that traditional Chinese painting should also be used to reflect the people's life.

He would personally give lectures in the departments of oil painting and traditional Chinese painting and often go to various departments to supervise and improve classroom teaching. He would call a meeting of art teachers every fortnight so they could listen to opinions and exchange experiences.

Beihong's progressive activities and measures soon incurred the displeasure of the Kuomintang government. Attacks both overt and covert were directed against him. Just as he had expected and as I had feared, a bitter campaign broke out.

In October 1947, soon after the autumn term began, the

286

Kuomintang Central Cultural Movement Commission in Nanjing sent a cultural agent to start and direct the "anti-Xu Beihong scheme." To begin with, Beiping Art Association, which was led by the Kuomintang Central Cultural Movement Commission, distributed leaflets making attacks on Beihong to stigmatize him as a criminal of the art circles."

Meanwhile, three part-time teachers at Beiping Art College declared a strike and the Kuomintang newspapers supported them by publishing attacks against Beihong in sensational terms, calling him an enemy to traditional Chinese painting.

Presently, Beiping Art Association declared at a press conference held in Zhongshan Park that they were "fighting for personal art, for 'art for art's sake' and for ancient artists," and that traditional Chinese painting should "transcend reality." They condemned Beihong for organizing Beiping Association of Art Workers to "split the art circles in Beiping." The three teachers also declared, "Xu Beihong is plotting to destroy traditional Chinese painting and Chinese art."

Beihong fought back resolutely. He held a press conference on October 15, 1947, at which a student representative who spoke first explained that Beiping Art College was teaching traditional Chinese painting and carrying out theoretical reforms with the aim of integrating traditional Chinese painting with life and abolishing the unrealistic contents of some traditional Chinese paintings. He added that the college was carrying out technical innovations on the basis of sketching to abolish the bad practice of doing nothing but copy model paintings.

Beihong issued a written statement at the press conference to present briefly his own viewpoints and to cite indisputable facts to refute the lies spread by Beiping Art Association. In their leaflet they wrote that the department of traditional Chinese painting at Beiping Art College had this term enrolled only five students and had made sketching a three-year course. The written statement runs in part as follows:

This time the department of traditional Chinese painting has enrolled thirteen students, more than twice as many as the leaflet declares. They have been enrolled not to fill the planned enrollment quota, but on the strength of their good results at the entrance examination, without which none would have been admitted....Last year, our college adopted the five-year education system, according to which all

students, whether they major in traditional Chinese painting, Western painting, sculpture or pattern drawing, are required to devote the first two years to learning sketching as a group before they are allowed to begin the study of their fields of concentration in different departments. All that has been reported to the Ministry of Education for the record. The three-year course as alleged by the leaflet is evidently untrue. The two figures as mentioned above are both groundless charges.... In this ancient capital of Beijing, many independent-minded artists have often given private lessons in painting to many students, which serves as a supplement to college education. Traditional Chinese painting is but one of the fields of concentration offered by our college. Because of the need of our country and their own wish, all students want to paint pictures reflecting the people's life and none want to limit their study to the slavish imitation of ancient artists only. It would be a great mistake indeed not to make the best use of the five-year study to achieve this end. Two years of strict training in sketching will enable students to observe and picture still objects at most. It will take an even longer time of hard study to learn to picture moving objects. During the remaining three years devoted to their fields of concentration, students are required to learn to paint ten kinds of animals, ten kinds of flowers and grasses, ten kinds of birds, ten kinds of trees as well as *jie* painting, so that a diligent student of medium or high natural gift will, upon graduation, know where to direct his own efforts, and, being well armed with fundamental skills, will be able to paint figures, animals and buildings of all descriptions with facility. Artists of new-type traditional Chinese painting should at least know how to paint figures which are vivid and life-like and landscapes which show regional characteristics The object of new-style traditional Chinese painting is not to make reforms or combine Western and Chinese techniques, but to imitate nature directly.

Such imitation cannot be carried out by mere empty talk, and it would be parroting the prejudice of our ancients to say that laying stress on sketching will result in works similar to those by Giuseppe Castiglione* or Japanese painters. A mere examination of works by such rising artists as Jiang Zhaohe, Ye Qianyu, Zong Qixiang and me will prove the mistake of such a prejudice and show that the new-type traditional Chinese painting is full of potentialities waiting to be given full play by men of courage It is probably essential for an artist to be well-read and widely-travelled. While it is acceptable to honour the spirit of our nation, it is unnecessary to seek help from the skeletons of our ancestors.

Kuomintang newspapers, instead of publishing its full text, garbled

* Giuseppe Castiglione (1688-1766), Italian Catholic, painter and architect, was appointed an imperial painter by the Qing Dynasty after he came to Beijing to do missionary work. He was adept in painting portraits, flowers, birds, beasts and, in particular, horses. However, his works, with their detailed execution, bear formal resemblance only.

Beihong's written statement to confuse public opinion and even engaged in personal attacks.

Beihong did not retreat in face of the fierce attacks. With all students, workers and staff members rallying closely around him, teaching on the campus went on normally without any disturbance or confusion. Much to the delight of the students, Beihong himself took over the classes for the three teachers who had been on strike.

Thanks to the support of his colleagues, the so-called "controversy between old and new types of traditional Chinese painting" (in fact, part of the "anti-Xu Beihong scheme") ended in the failure of the Kuomintang campaign.

The struggle, however, did not end. The Kuomintang agents continued to report Beihong to the Kuomintang government in Nanjing, and even secretly informed the Education Ministry in Nanjing and the Beiping Garrison Headquarters that Beihong was harbouring Communists and members of the China Democratic League. They also met regularly to continue plotting the "anti-Xu Beihong scheme."

We enjoyed no peace or quiet in our daily life and often received threatening or abusive letters. One day, I received a letter in unfamiliar handwriting. After opening it, I found that the letter, signed "Beiping League of Veteran Painters," was obscenely worded and extremely dirty in content.

"Beihong, let's go away! Let's leave this place!"

Beihong, however, said calmly, "To go away means to compromise. Besides, there will be struggles wherever we go. For the sake of developing Chinese painting, I must take this difficult path."

I hung my head to wipe away my tears, feeling shame and remorse for my weakness. Beihong came to sit tenderly by my side, and said to me in a very soft voice, "Jing, how difficult it is to be my wife! Like me, you must undergo all kinds of sufferings, slanders, attacks and struggles. I know you're young and have never experienced such a complicated life. But I've been fighting for more than twenty years."

Chapter XXI

When we first came to Beiping, we lived in two rented wing-rooms, facing east and west respectively, in No. 22 East Biaobei Hutong. The landlord and his family lived in the main room, with a southern exposure. They sometimes invited people to their room to play mahjong until late into the night. When the guests were leaving in the dead of night, there was always such a noise that we could not sleep. As I was then still pregnant with my first child, I had to go out every day to hunt for a more quiet lodging. After the agent had taken me here and there, I would come back completely exhausted without having found a suitable dwelling.

One day, a clerk of the general affairs section in Beiping Art College called on us with the news that there was for rent a quiet house not far from Dongsi. He said he had been there to take a look and thought it suitable for us to live in.

Beihong and I went with the clerk to take a look. Like many ornate residences in Beiping, the house looked very imposing, its gate having two vermilion door leaves and a stone lion with its upraised head on either side. After the clerk gave several raps on the door, there appeared before us a gorgeously dressed, aging foreign lady. We learned that, now a widow, she was a Frenchwoman formerly married to a wealthy Chinese and that the house was a legacy left behind by her deceased husband. She was living in the front compound and intended to rent us the rear.

With great delight, she took us to the rear compound through a corridor. The house, which was spacious and neat and had recently been given a face-lift, looked magnificent with its painted rafters and carved beams. The courtyard, planted with flowers and trees, was very quiet. The main room, with a southern exposure, was big and bright and had a

complete set of furniture, including a carved redwood desk inlaid with marble, on which Beihong could do his painting, a high-class Simmons spring bed, stylish sofas, gracefully coloured carpets, and long velvet curtains. Hearing that Beihong was a returned student from France and a famous artist, the French lady said she would like to let him have the house at a very low rent, her eyes sparkling with ebullience and her wrinkled face beaming with joy. However, the smile on her face disappeared when Beihong took leave of her after exchanging a few words in French with her.

"Beihong, what did you tell her?" I asked anxiously.

"I declined her offer."

"Declined her offer? You don't even care for a good house like this?" I stared at him in astonishment.

"Jing, not because it's no good, but because it's too good, too magnificent. It doesn't fit a man of status. We ought to preserve our true qualities as intellectuals," he replied pensively.

His reply took me quite by surprise. But in view of the fact that Chinese intellectuals at large were then still living in poverty, Beihong's way of thinking was comprehensible.

On September 28 of the year, because of the exhaustion I had suffered in going about to look for a suitable house, I gave birth prematurely to my baby boy Xiao Hong.

After coming out of hospital with the baby, I returned to live in the same house in East Biaobei Hutong until the end of the year, when we moved to an ordinary compound at No.9 Xiaochunshu Hutong. The compound was old and had a smallish yard with a small solitary locust tree. We lived there for about a year until we moved to No.16 East Shoulu Street after the wall enclosing our yard suddenly collapsed one day and we had to look for a new place to live.

Beihong bought the house on East Shoulu Street with money he had earned by selling his paintings. The house was not too big, but there was a wide open space within the compound. A huge locust tree about a hundred years old with luxuriant foliage stood in the west yard while in the east yard stood a giant Chinese toon several dozen feet tall. Like a big umbrella, it provided us cool shade and breezes on hot summer days. However, when we first moved in, the compound was lying waste. We

weeded the yards and planted a great many fruit trees. In the west yard, where we planted vegetables, tomatoes, cucumbers, reddish-purple amaranth and perilla not only embellished our compound, but also provided delicacies for our table. Beihong often worked with me in the yards during his spare time. Together we gave water and fertilizer to the fruit tree saplings and vegetables, and shared the joy of bumper harvests.

What delighted Beihong more than anything else was the unexpected, speedy growth of hollyhocks at the foot of the enclosing wall and on other empty plots, which presented a dazzling galaxy of crimson, snow-white, purplish and pink flowers, and among which our seven or eight cats frolicked. Beihong named our new dwelling "Hollyhock Residence" and "Residence of Tranquility." He even composed poems to sing the praises of these hollyhocks, and painted pictures of them in the traditional Chinese style.

In November 1947, I had a second child, this time a girl whom Beihong named Fang Fang.

The two children Xiao Hong and Fang Fang added great bliss to our family. On Xiao Hong's first birthday, Beihong wrote the following in the autograph album I had prepared for the child:

> Though born in a troubled time, you have nevertheless been a pleasure to me and your mother for a year now. I hope you will always bring us pleasure, but never any vexation.

As far as the country was concerned, it was indeed a troubled time. The Kuomintang, acting in defiance of the popular wish for peace, had flagrantly launched a full-scale civil war, plunging the people into another war catastrophe after the terrible ordeal of the eight-year war of resistance to Japan. They tried to justify their act with the deceitful name of "suppressing the rebellion," and convinced a handful of public figures to be members of their newly established "Committee for the Suppression of Rebellion and National Reconstruction." They did not want to leave out Beihong, but met with his flat refusal. Later, in order to make use of his international prestige, they invited him to be a member of the Chinese delegation to the "Pan-Asian Conference" held in India. They sent him many letters and telegrams to urge him to set out for India as soon as possible and even had news of his departure for participation in the conference published in advance in the newspapers.

292

Nevertheless, again they met with his flat refusal.

The Kuomintang, while clamouring for "suppressing the rebellion," held the "National Assembly" in Nanjing, which occasioned a great many scandals. Jiang Biwei, invited to be a delegate to the assembly in her capacity as one of the "social elite," attended the first session. Gorgeously dressed and heavily made up, she was called by tabloid sheets a "bewitching woman of the assembly." She even claimed blood ties with Chiang Kai-shek, saying that the Jiangs of Yixing and the Chiangs of Fenghua (Chiang Kai-shek's hometown) shared the same ancestry.

That same year, Beihong's eldest son Boyang, having been released by the army in Northeast China, came to Beiping to stay with us for a few days until he went to Nanjing to see his mother Jiang Biwei. In accordance with the divorce agreement, Boyang and Lili ought to have stayed with their mother. However, shortly after he went to Nanjing, Boyang informed Beihong by letter that he did not wish to stay on with his mother and wanted to come to Beiping. Beihong agreed and immediately sent him traveling expenses. Beihong earnestly instructed him to be industrious and live simply and study hard so that he could be useful to the country. Boyang made up the senior middle school lessons he had missed, and entered the painting department of Beiping Art College after passing its entrance examination. A year later, he was transferred to the department of music composition at Central Conservatory of Music. From then on, he had no more contact with his mother.

Lili was then still a senior middle school student in Nanjing. She also often wrote to tell her father that she was eager to stay with him and planned to go to university in Beiping after finishing her middle school education so that she could be near him. I found from her letters that she had become quite understanding and considerate and even politically progressive. Her letters also revealed, between the lines, much dissatisfaction with her mother.

Chapter XXII

Beihong had great respect for Qi Baishi; his affection for Qi was sincere and profound. He often thought of this great master of traditional painting, whom he had not seen since they parted in 1929. Soon after his arrival in Beiping, Beihong went to call on Qi.

When Beihong held exhibitions in Southeast Asia to raise relief funds for war refugees in China, he had written Qi letters to inquire after him. As Qi was then too old to leave the enemy-occupied city of Beiping, Beihong composed many poems in his memory. After the victory of the anti-Japanese war, Beihong wrote to Qi again and soon received a reply to the effect that he had been reconciled to a life of poverty and was still going strong. Qi also wrote, "It is my parents that begot me; it is you that know me."

Now the two friends met. It was in the same old simple studio with iron railings in Kuache Hutong, Xidan. His long silver beard flowing down over his chest, Qi was a joy to behold. Reaching with tremulous fingers for the bunch of keys tied to his waistband, Qi opened three locks on a big wooden cabinet and took out many cakes to entertain us. The cakes had become as hard as rocks from long storage. Thinking it ungracious not to eat them, we each picked up a cake and started munching it slowly as if it were a rare delicacy.

As soon as Beihong took up his post as president of Beiping Art College, he invited Qi to be an honorary professor. Beihong went presently to Qi's home to fetch him, not in the horse-drawn carriage of seventeen years ago, but in a speedy sedan.

But Beihong was no longer elegant and strong; he was grey-haired and ill. During the seventeen years, he had travelled all over his motherland, and to various Asian and European countries as well, always making long, difficult journeys. For the sake of his calamity-

ridden motherland, he had fought tenaciously to advocate the realistic art movement. He indefatigably continued to create art and train young talent, thus winning for himself the reputation of having students throughout the land. Now, instead of working in isolation, he had invited many outstanding artists to teach at Beiping Art College, including Qi Baishi.

Beihong and Qi began to have close contact. They often called on each other and even painted together. When Beihong painted a rooster, Qi would complement it with a rock; when Qi painted a dragonfly, Beihong would complement it with some flowers and grass. Qi would often come to enjoy the cool of a summer evening with us in our spacious turfed courtyard planted with fruit trees, flowers and plants. Whenever Qi had troubles on his mind, he would come to talk them over with Beihong. Sometimes, when he had trouble in calculating the amount of money earned from selling his paintings, he would come to ask Beihong to help him with his accounts. He had full trust in Beihong.

We also met Beihong's respected old friend Zhang Daqian, a painter of high accomplishment. I saw him for the first time when he called at our home on East Shoulu Street and had a most friendly chat with Beihong. Zhang, about the same age as Beihong, looked very refined and easygoing with a beautiful, long beard flowing down his chest. I had once greatly admired his paintings at a show in Chongqing.

In the preface to *Collected Works of Zhang Daqian* published by Zhong Hua Book Company in Shanghai in 1936, Beihong wrote as follows:

Daqian, the gifted painter, has visited all famous mountains and big rivers in China. Woodcutters and hermits, tall pines and ancient cypresses, bamboo fences and thatched huts, tall buildings and pavilions — all these invariably engage his meticulous attention and go into his heart, be the weather rainy or sunny, gloomy or bright.... In his home are placed strange plants and flowers, exotic birds and beasts and ancient rarities of the Xia, Shang, Zhou, Western Han, Eastern Han, Wei, Jin, Sui, Tang, Northern Song, Southern Song, Yuan and Ming dynasties, among which he indulges himself and lives a completely easygoing life.... What he paints at ease combines the old and new, imaginary and real, good and evil, and is clear and refined and bright and pure. Those who say that Daqian is good at nothing but imitating the ancients have certainly underestimated him.... In 1932-1933, at the invitation of some West European countries, I went there to give an exhibition of Chinese paintings, including Daqian's landscapes, which fascinated the Europeans with their graceful brushwork. Consequently, his paintings of

lotuses and *Jiangnan* landscape are now respectively stored in Paris and a Moscow state museum, adding splendour to modern painting....

On the day Zhang paid us a visit, he painted two pictures of lotuses right in our home. Beihong had invited the mounting craftsman Liu Jintao to come to our home to prepare a bowl of ink for Zhang to use in painting. Zhang wielded the brush freely with a smile on his face and finished the two pictures in no time. The lotuses were done with splashes of ink and the white lotus flowers with contour delineation. The contrast between the heavy and the light and between the abstract and the concrete was just right, and the brushwork was concisely executed. He gave one picture to me, and the other to Li Zongren and his wife.

Born in the countryside of Hebei Province, Liu Jintao had come to Beiping on foot to learn a trade when he was a boy and apprenticed himself to a picture-mounting shop. After he was through with his apprenticeship, being eager to have a business of his own, he rented a small house in Liulichang. But, because of slack business, he could hardly make ends meet. Beihong, seeing that Liu was highly skilled and was hardworking and honest, tried to help him out. Besides giving Liu several pictures done by himself, Beihong also asked some well-known painters to make pictures for him, so that, finally enabled to formally open his business, he put up the signboard "Jintao Mounting Shop" in Beihong's handwriting and became a good friend to all the painters. He gradually attained higher skills in his craftsmanship, and became one of the rare mounting masters of the time.

At that time, the facility of Beiping Art College was very small, and Beihong had requested Li Zongren, then head of the Kuomintang field headquarters in Beiping, to appropriate another bigger building for the college. So, in addition to the picture of lotuses he had asked Zhang to paint for Li, Beihong also painted for him a galloping horse. Li later did allocate to the college a very big schoolhouse in a place where the present Central Institute of Fine Arts is located. Beihong had a great deal of trouble in getting the schoolhouse vacated by the Kuomintang soldiers stationed there, even after going to the trouble to paint pictures for some of them.

While in Beiping, Beihong also came to know Yu Fei'an and Tian Shiguang, two *gonbi*[*] painters. Yu was then enjoying the reputation of a

great painter while Tian was still a young man. Beihong struck up an acquaintance with Tian after attending an exhibition of his paintings. While *gonbi* paintings generally tend to be dull and stiff, Tian's works are vivid and lively. Under his colourful brush, the delicately and neatly executed flowers and plants are full of charm and interest. Beihong spent a long while viewing the exhibits without meeting the painter himself, whom he had not yet come to know. So Beihong left behind a note asking for the painter's address so that he might visit him.

Tian was then very poor and lived in close quarters. Thinking his lodging too shabby a place for the great master Xu Beihong to visit, Tian immediately went to call on Beihong instead. Beihong had a high opinion of him and invited him to teach flower-and-bird painting at Beiping Art College. Teachers in those days were underpaid. One day in winter, when Beihong saw Tian clad in thin clothes, he immediately took off the woollen sweater he was wearing and put it on Tian. Tian declined again and again, but Beihong insisted and did not feel comfortable until Tian finally accepted it.

Having himself lived a poverty-stricken life in his youth, Beihong showed particular concern for promising young artists.

* Traditional Chinese realistic painting characterized by fine brushwork and close attention to detail.

Chapter XXIII

Beihong was the early riser in our family. He would be up and about when the first faint rays of the morning peeped in. The first thing he would handle every morning was to write replies to letters he had received the previous day, letters from all over the country, some from his friends, some from his former students, but mostly from young art enthusiasts, who, though strangers to Beihong, had written to seek his advice.

Beihong would write back conscientiously to offer them solutions to their problems. Sometimes, he would personally correct the paintings they had sent and point out their merits and demerits before mailing them back to the senders. He would do this all by himself and never make other people do the work lest they should be so careless as to bungle it. When, seeing that he was already busy enough with his administrative and teaching job and that he was in poor health, I tried to dissuade him from answering all the correspondence himself, and to ask his secretary to do it, he declined.

"Jing," said he earnestly, "you don't know young people's minds. The letters I write them in reply, no matter how brief, will give them great encouragement. Young people need our encouragement. And I'm even more duty-bound to take care of those who are talented but still unable to go to art college."

In 1947, Liu Boshu, a fourth-year pupil of Shiyan Primary School in Nanchang, Jiangxi Province, wrote Beihong a letter saying that he was interested in painting horses, and mailed Beihong several pictures of galloping horses he had copied from Beihong's published collection. This was something daring for a ten-year-old primary school student to do. Beihong's reply reads in part as follows:

Little Brother Boshu,

I have been impressed with your letter and paintings. I have many students, and now I am particularly happy to be the teacher of a bright schoolboy several thousand li away. Since students of painting are advised to study nature, painters of horses must study horses and painters of roosters must study roosters. They must carefully observe the appearances, movements and bearing of these animals and grasp their main features rather than their minor details (such as meticulous depiction of the plumage). The simplest method of study is to make a lifelike self-portrait in pencil or charcoal by looking at yourself in a mirror, or a portrait of your parents, brothers, sisters or friends. Portraiture is most difficult and must be learned in childhood by instinct so that all other problems can be solved readily. I am sending you herewith several photos for your reference. You need not imitate my paintings, for real horses are more worthy of study than those painted by me.

I love to paint animals, and have spent a very long time studying each real animal. Take horse painting for example. I have made no fewer than a thousand sketches of them You must make up your mind to be a preeminent painter in the world, and not to be complacent with small achievements. After you finish the junior middle school studies, you can take the entrance examination for an art school, and, when the time comes, I will be more than willing to give you necessary guidance. For the time being, you must study diligently such common subjects as Chinese, history, biology, arithmetic, physics and chemistry, for none can afford to neglect such essential general knowledge.

Boshu's father was a primary school teacher and his mother a hardworking housewife. In this impoverished family, both parents did not know how to foster a boy with an early inclination towards painting. Beihong continued his correspondence with Boshu to give him guidance and encouragement. Later, Boshu entered the Central Institute of Fine Arts and became an outstanding painter. He is now teaching at the same institute.

Luo Shuzi, a young man in Dalian, mailed Beihong a sketch he had done to ask for his advice. From then on, Beihong wrote again and again to give guidance to the young stranger and also sent him two sketches by himself to serve as examples. One of Beihong's letters to Luo reads:

Brother Shuzi,
　　My last letter to you must have been received. Pictures drawn with a lead pencil are less satisfactory than those drawn with a charcoal pencil, or even than those drawn with charcoal plus some adhesive (rosin oil). Strokes should vary in strength so as to avoid monotony. Large Soviet sketches are good, but they are

classical in style and close to the *guange* type.* Students of them, if not careful enough, are apt to make disgusting sketches as dull and flat as

* A type of traditional Chinese painting characterized by a lifeless, stereotyped style.

guange-type paintings....

The postscript he added in small characters says, "Make sketches with exact delineations."

While giving warm and sincere guidance to these unfamiliar young people, Beihong also occasionally got unfair treatment in response. Once a young self-styled calligrapher in Tianjin sent Beihong a de luxe fan covering bearing his own inscription, ostensibly to seek his advice, but actually to fish for compliments. Beihong wrote back to point out some defects in his calligraphy, saying that his characters were "big like Emperor Qian Long's handwriting." The young man immediately sent an extremely abusive reply and demanded the return of the fan covering. What was even worse, he purposely addressed the envelope as: Xu Beihong, student of Central Institute of Fine Arts. Beihong, however, just dismissed it with a smile, and continued to write letters in reply to unfamiliar young people.

Busy as he was, Beihong still managed to take time to receive numerous unfamiliar visitors, most of them young art enthusiasts.

In 1946, a young man named Wei Jiangfan trudged from Northwest China to Beiping almost like a beggar to seek an interview with Beihong. When he stood before Beihong grasping a roll of sketches in his hand, he was penniless, with practically nothing to live on. The sight of the shabbily dressed, sun-burned young man with his hungry big eyes flashing with a warm love for art touched Beihong to the heart. Beihong immediately arranged a temporary job for him to cut stencils in Beiping Art College and provided lodging for him in the college dormitory. Soon afterwards, Wei was admitted by the college after passing its entrance examination, and Beihong helped him to acquire a grant-in-aid.

Chapter XXIV

Nineteen forty-eight was an exciting year, with news of military victory for the Communist-led People's Liberation Army (PLA) pouring in again and again. One afternoon in late autumn, Beihong and several artist friends sat in our parlour talking about the current situation, exchanging news that could not be found in Kuomintang newspapers and rejoicing over the victory of the War of Liberation in Northeast China. Suddenly a deafening explosion set the whole house shaking and window panes crashing down. We rushed out of the house in panic to see in the distance a huge dark column of smoke boiling up into the sky, expanding like a mushroom. Later, we were to learn that a Kuomintang ammunition dump at Nanyuan Airfield had blown up. It seemed to have heralded the liberation war in the Beiping-Tianjin area.

Kuomintang officials were fleeing pell-mell from Beiping and the whole city was in a state of panic and confusion. The Kuomintang Education Ministry in Nanjing sent an urgent telegram to all colleges and universities in Beiping ordering them to move to the south. Beiping Art College also received the same telegram, but Beihong refused to obey the order, for he had beforehand decided through consultation with the key faculty members of the college, such as Wu Zuoren, Li Hua, Wang Linyi, Feng Fasi and Ai Zhongxin, that they would under no circumstances leave Beiping and that the college would never move to the south.

At that time, the underground Communist Party secretary of Beiping Art College was a student in the oil department named Hou Yimin. He was a slender, handsome young man with calm, intelligent eyes. The excellent results he had achieved in painting were much appreciated by Beihong. But none had expected that this active and diligent young man was then in charge of the underground Party branch

in the college. He had learned of Beihong's thought and decision not only through personal contact but also through Professor Feng Fasi of the oil department, who was Beihong's former student and also an underground Communist.

Beihong, who spoke first in his capacity as president of the college, put forward the idea of not moving the college, for which he had already obtained in advance the approval of many faculty members. Beihong's stand immediately won the warm support of Wu Zuoren, Li Hua, Ye Qianyu, Wang Linyi, Feng Fasi, the English teacher Fan Zhichao and the student representative Li Tianxiang. Only a very small minority objected. When it was finally put to a vote, those in favour of staying in Beiping constituted the overwhelming majority. So it was formally passed at the administrative meeting to keep the college where it was.

Presently, the Kuomintang Education Ministry remitted to the college an emergency fund to be used, as its telegram indicated, for moving the college to the south. Beihong suggested that the fund be distributed to all teachers, workers, staff members and the student union to buy grain for emergency use, so that they could stand by the college and wait for liberation. The proposal gained the instant support of the Communist underground and was formally adopted at a meeting of college representatives summoned by Beihong. Teachers, workers and staff members were each allocated a sum of money, and the remaining fund was all given to the student union to buy a large quantity of millet.

The situation became increasingly tense. Commodity prices were rising many times a day; grain prices, in particular, were skyrocketing; streets were swarming with people buying and selling silver coins. All people hastened to exchange fast-depreciating Kuomintang banknotes for silver dollars.

The cultural and educational circles in Beiping were also in a state of tension and confusion. Hu Shi, president of Beijing University, was the first to leave for Nanjing by plane.

Beihong had come to know Hu Shi back in the 1920s, but had since had little contact with him because they did not know each other well enough.

We met Hu again shortly before Liberation, and when we talked about the current situation and inquired whether he was planning to

leave Beiping, he answered in the negative. Several days later, however, he left by plane from Nanyuan Airtield. Soon after Nanyuan Airfield was blockaded by PLA artillery fire so that the special plane sent by the Kuomintang Education Ministry to evacuate well-known figures could not land and had to return to Nanjing without fulfilling its mission. Unwilling to leave behind experts to serve the Communists, the Kuomintang rushed to build airstrips in Tiantan and Dongdan squares respectively by felling a large number of trees there. The next plane from Nanjing did manage to land. Those who left Beiping on this plane included President of Qinghua University Mei Yiqi, President of Beiping Teachers University Yuan Dunli, President of Beiping Research Institute Li Shuhua and their families.

Though also listed among those to be evacuated, Beihong categorically refused to leave for Nanjing. He soon had frequent visitors who tried to talk him around and even to frighten him into leaving with numerous rumours they had invented. When threats failed to achieve their purpose, they tried inducements, saying that if he went to Nanjing he would be given a substantial sum of foreign money to hold an art exhibition abroad. As far back as 1946, Indian Ambassador to China Panikkar had, on behalf of Indian Prime Minister Jawaharlal Nehru, earnestly requested Beihong to visit India again to give another exhibition of his works. Now, though still very anxious to go to India to pay homage to its splendid ancient cultural relics, he did not think it the right time to do so. He felt the Chinese people then most urgently required him to remain in Beiping.

It was getting colder and colder. The lake in Beihai Park was covered with a thick layer of ice. The roadside trees had been stripped of their leaves, leaving their bare branches and twigs trembling in the cold wind.

Beiping, besieged by the powerful PLA forces, had its city gates closely shut and could get no supplies of grain, vegetables, fish or meat from outside. We all ate the pickled turnips we had prepared long beforehand and sometimes ate soya bean sprouts prepared at home.

Now and then the PLA artillery fire was heard booming. Inside the city, there were still an enormous number of Kuomintang troops, who,

though bottled up like turtles in a jar, could still bring to the people a tremendous loss of life and property if they should put up a desperate struggle. They were faced with an urgent dilemma. General Fu Zuoyi, then in command of the troops, had no alternative but to invite some local scholars and celebrities for consultation, Beihong among them.

The meeting took place in Zhongnanhai amidst an extremely tense atmosphere. General Fu, in his brief address, expressed his desire to listen modestly to everybody's opinions. But a long silence followed as the clock on the wall kept ticking away. They looked at each other in speechless apprehension, thinking it too dangerous for them to voice any demand for the peaceful liberation of Beiping.

At long last, Beihong stood up and said in a firm, strong voice, "Beiping is a world-famous ancient city of culture, and also a rarity in the world of architectural art. In order to save our outstanding ancient civilization from destruction and the local people's life and property from loss, I hope that General Fu will take the interests of the whole into account and comply with the popular will so that Beiping can be safe from gunfire"

The silence was thus broken. Everybody put on a smiling face and the whole meeting was astir. Professor Yang Renbian, the celebrated historian, rose to his feet and said, "I fully agree with Mr. Xu Beihong. If General Fu could do something to save Beiping from gunfire, I, as a historian, will never forget to record his contributions in the history book I'm going to write."

Many others, including the noted biologist Hu Xiansu and the curator of the Palace Museum Ma Heng, also spoke up one after another to express their ardent hope that the general would put the local people's safety and the protection of the local cultural relics first, and therefore do his best to bring about the early peaceful liberation of Beiping.

The general, who had been listening with patience and attention, finally stood up to express his gratitude for everybody's frank opinion.

After the meeting, people lost no time in telling each other the news, feeling more and more hopeful of the peaceful liberation of the city as if it were close at hand.

Late that night, when all was quiet, the telephone in my home

suddenly started ringing. I threw on some clothing and got out of bed. From the telephone came an unfamiliar gruff male voice, "Call Xu Beihong to the phone!"

I answered, "He's sleeping. You can leave your message with me."

He asked in reply, "Who's speaking?" But, before I had time to answer, he said ferociously, "Tell Xu Beihong to mind his head!"

Obviously, Beihong, like many other people, was in great danger. As a precaution against mishaps, we had already had the wall surrounding our residence thickly covered with caltrops. Nevertheless, many students and friends still worried about our safety and paid us frequent visits during those extraordinary days.

One day prior to this, Feng Fasi had called at our home to inform Beihong that Tian Han, who had secretly come back to Beiping bringing news from the Liberated Areas, wanted us to arrange a rendezvous with him.

The next evening, the long-separated Tian arrived in the car Beihong had sent to bring him. As he appeared wearing a cumbersome, cotton-padded, blue long gown, with a big gauze mask over his nose and mouth, a large, thick scarf round his neck and a hat lowered over his brow, we could hardly recognize him.

Beihong rushed ahead to greet him in excitement. Their hands locked in a firm grip.

I left the chauffeur with our son Xiao Hong, telling him to guard the gate and not to let anyone in while taking care of the child.

Tian, taking off his hat, gauze mask and scarf, stood before us with the same smiling face as always. Behind his glasses, his myopic eyes flashed with irrepressible joy. It was the heart-felt joy of a real Communist. The new China for which he had suffered and struggled would soon be born. It was no longer a distant dream, but an imminent reality. The two bosom friends smiled all the time with excitement and happiness in enjoying their reunion after the long separation.

That night, owing to power failure, I had to light a candle in our drawing room while Beihong, Wu Zuoren, Feng Fasi and I sat around the travel-stained Tian Han to listen to him whispering excitedly

about the situation in the Liberated Areas. The news he had brought us was thrilling, especially the instructions to Beihong from Mao Zedong and Zhou Enlai. Tian said cheerfully, "I met Chairman Mao and Comrade Zhou Enlai before I set out for Beiping. They hope that Beihong will in no circumstances leave Beiping, but do as much work for the local cultural circles as possible."

We were very much moved to hear that while busy directing the nationwide people's liberation war, Mao and Zhou still thought about Beihong and the artists and intellectuals in Beiping. Their kind words, like brilliant sunrays filtering through dark clouds, had brought us a pleasant surprise and excitement.

While the cold wind outside howled, our windows kept rattling. From afar came the shrieking of a police van. We knew the Kuomintang was making large-scale arrests and had already thrown a great number of people into prison.

Suddenly, Xiao Hong was heard crying loudly. I rushed to the gate to find two Kuomintang soldiers wrangling with the gate keeper with rifles in their hands. They demanded to come inside to check on household occupants and pointed their bayonet-fixed rifles at me.

Picking up the frightened child, I ushered them into Beihong's studio and purposely raised my voice in asking for tea and cigarettes to be served. Then I showed them the residence booklet.

One of the two soldiers took a glance at it with his head tilted to one side and asked, "That's all the people you have here?" Before I had time to answer, he asked staring at me with a fierce look in his eyes, "Any guests from other localities?"

My heart thumped violently. But I feigned composure and replied, "No!"

They looked around with prying eyes, and one of them unceremoniously picked up from the table a pack of "Three Castles" cigarettes and thrust it into his pocket. Then they walked out carrying their rifles and started knocking irritably at the gate of our next-door neighbour.

It was a silent, cold winter night. At Beihong's bidding, I went to the entrance of the alley to look about carefully. Making sure there were no suspicious persons around, I returned home to arrange for

Tian Han to leave in our car immediately.

Overexcited, Beihong and I did not sleep until very late that night. Tian's happy smile and the great good news he had brought us all kept us from calming down. Beihong was muttering to himself the instructions of Mao Zedong and Zhou Enlai passed on to him by Tian, "In no circumstances leave Beiping, but do as much work for the local cultural circles as possible."

The next day, Beihong and I went again to see Qi Baishi. This time we entered the quiet compound only to find him sitting in his studio looking extremely worried. The moment he saw us, he began to rise tottering to his feet, his old face no longer lit up by his usual tranquil smile. We learned that he too had been intimidated. Some people had lied to him, saying the Communists had blacklisted all the moneyed people, including Qi himself, to be killed as soon as they occupied the city. Seized with worry and fear, Qi was preparing to leave Beiping soon with all his family members. Just as we were talking, the telephone on the desk started ringing. After answering the phone, Qi's nurse Xia Wenzhu said that the civil aviation company had called to discuss Qi's flight to Hongkong.

Thereupon, Beihong and I tried to tell him not to believe rumours.

"Mr. Beihong, you're really not leaving?" Qi asked incredulously.

"Of course not. My whole family will stay here, so will Beiping Art College. Everybody will stay in Beiping."

"Then, will the Communists kill me?"

"Certainly not. The Communists respect those who have made contributions to culture. How can they kill you?"

"Mr. Beihong, can I still sell my paintings when they're here?"

"Of course you can. I guarantee that you can continue to sell your paintings.

Sincerity was written large on Beihong's face. Then he said that Beiping would most probably be liberated peacefully, and that in case of any emergency in town, Qi could join us to take refuge at Beiping Art College, where the students had already been organized to protect the campus.

Qi, nearing ninety, was hard of hearing; to make himself

understood, Beihong had to shout into his ear word by word and sentence by sentence.

Qi, who had always placed great trust in Beihong, now resolutely cancelled his flight to Hongkong. His eyes, no longer shadowed by doubts and misgivings, gradually regained their lustre, and his worried face began to smile. He hospitably had us stay to eat a Hunan-style lunch with him. After lunch, when we were leaving, he saw us to the gate with his walking stick in hand, the gay smile on his face again reflecting his usual cheerfulness and calm.

Chapter XXV

The long, dark night was over. Over the Tian An Men gatetower came the first light of dawn. Beiping was peacefully liberated!

On January 31, 1949, when a mammoth city-wide parade took place in celebration of the event, I marched among the contingent of Beiping Art College, raising my arm and shouting cheerful slogans together with the other paraders. Though a howling wind from the north was blowing hard, people were warm at heart.

Beihong also began to bustle about. A new page had begun in his vicissitudinous life. Ever since childhood, he had been grieved by the long-standing national humiliation and the poverty and sufferings of the people. How he had been longing for the birth of a rich, powerful new China, which would put an end to all oppression, foreign aggression and national poverty! It was with this longing that he now hailed the liberation of Beiping.

At a grand banquet in Beijing Hotel, Zhou Enlai, his face radiant with well-being, threaded his way through the crowd to Beihong and shook hands with him, saying, "Now we meet again!"

Zhou laughed heartily. Then, pulling up a chair, he sat down beside Beihong and, like an old friend, inquired about Beihong's health and the conditions of the art circles.

Zhou was five years younger than Beihong. On that day, he wore a dark-coloured tunic suit. His thick black eyebrows glistened in the lamplight and his bright, piercing eyes radiated unforgettable warmth and hope.

While listening to their conversation and looking at Zhou, I could not refrain from thinking that before me was a great man of indomitable spirit, who had performed brilliant feats at the risk of his life for the cause of the Chinese people's liberation. Yet he was so gentle, so amiable

and approachable. After hearing Beihong's brief account, Zhou said pensively, "The task before us is still very arduous. Nanjing, Shanghai and many other places in China are still awaiting liberation. You've great influence in the art circles, so I hope you'll continue to do more work." As he stood up, he said almost tenderly, "You still have to take good care of your health though!"

Severe winter was gone. The spring of 1949 had now alighted gracefully and merrily upon our beautiful courtyard. The fruit trees that Beihong had planted were sending forth buds. The grass had also started emerging from the ground.

Beihong's friends arriving in Beiping from all over the country were given accommodations at Beijing Hotel. Beihong and I often went to visit them, and they also often came to call at our house. Among them were noted personages like Guo Moruo, Shen Yanbing (Mao Dun), Li Jishen, Shen Junru, Liu Yazi, Zheng Zhenduo, Jian Bozan, Tian Han and Hong Shen. They had a get-together every two or three days. Sometimes, they also came to watch Beihong paint. Once, in great excitement, Beihong painted a very large picture of a horse holding up its head at full gallop. On this picture, he inscribed the following to express his joy:

> *The century-long illness is cured;*
> *Looking ahead, one sees the light.*

Gone were the days when the Chinese people could be bullied and oppressed by the imperialists! Beihong was elated at the bright future of our country.

Another time, after painting a horse galloping at full speed with four legs raised in the air, he inscribed on it the following lines:

> *Democracy triumphs after a hundred battles across the land;*
> *The path is broad and smooth after all obstacles are removed.*

Occasionally, some friends did calligraphy or composed poems in our home. The poet Liu Yazi wrote a poem specially dedicated to us.

Hanging on the wall of our parlour was an ink-and-wash painting of bamboos by the Qing Dynasty painter-writer Zheng Banqiao, inscribed with the following poem by the painter himself:

I lie in my yamen bedroom and hear bamboos rustling
Like common people groaning and moaning.
Though petty county officials we are,
We do care for even a twig or a leaf.

When Shen Junru saw the painting, he took a liking to the poem and carefully copied it down with a writing brush in my autograph album. The poet Ai Qing also used a brush to autograph my album with "Everything for the people" in graceful, big characters. When I asked Hong Shen, the open-minded, humorous playwright, for his autograph, he jokingly wrote in my album this one single sentence, "If one is too lazy even to do good, how can he be willing to do evil?" When Mao Dun, who was standing next to Hong Shen, was asked to write, the contemporary literary giant also did jokingly by copying what Hong Shen had just written and adding a note to it in smaller characters which reads, "A verbatim transcription of Brother Shallow's sentence." It set everybody laughing uproariously.

Just then, Tian Han came up to pick up a brush and write in my album the following poem he had composed impromptu:

If one is too lazy even to do good, how can he be willing to do evil?
If one does not even fear death, how can he be afraid to live?
Ignoring both life and death, and both good and evil,
Let's seek peace for common people.

We all applauded him and the whole parlour rang with merry laughter.

These art-friends seemed never to tire of chatting together. They talked about anything, big or small. Though Nanjing, Shanghai and many other cities had not yet been liberated, they all had full confidence in the victory of the liberation war. In addition to the current situation, they talked most about the host of duties they each were going to perform in future. Having experienced so many vicissitudes in the old days, they now felt as happy as those who had climbed to the summit of a high mountain. After labouring up a thorny, narrow path and now enjoying a bird's-eye view of China under red flags, they laughed as heartily as children.

The People's Liberation Army, after scoring a brilliant victory on the battlefields of Northeast and North China, now won another decisive battle in the Xuzhou-Bengbu region and was heading straight for the northern bank of the Yangtse River in force, posing a direct threat to Nanjing and Shanghai. The Kuomintang government officials were thrown into panic.

At Zhang Daofan's bidding, Jiang Biwei went with her daughter Lili to Shanghai, from whence she was to go to Taiwan. But Lili suddenly disappeared in Shanghai. Where had she gone?

Jiang, very much worried, started looking for Lili here and there, and had someone write to inquire of Beihong whether her daughter was in Beiping or not. But Lili wasn't there either.

Beihong, hearing that Lili was missing, was also very worried.

"Beihong," I said, "I think Lili must have gone to the Liberated Areas."

"How do you know?"

"I've learned from her letters that she's becoming progressive. She's also revealed between the lines her dissatisfaction with the old society and the Kuomintang. And she's always been eager to live with her father...."

Beihong nodded in silence, a smile appearing on his worried face.

Not long afterwards, we received a letter from Lili in a Liberated Area in southern Anhui Province, saying that she had been very excited to see her father's name in newspapers, and that since relations between her and her mother had reached the breaking point, she had, without Jiang's knowledge, contacted the Communist underground and gone to the Liberated Area to join in the revolution. She added that while she hated her mother, she also pitied her sad plight — being willingly led by the nose by the political swindler Zhang Daofan.

It gave Beihong great delight and solace to learn that Lili had gone to a Liberated Area to join in the revolution. We went over her letter again and again.

Later we were to learn what a hard time Lili had had in Nanjing, how she had longed to leave Nanjing and go to live with her father, and how she had also longed to go to university in Beiping. However, she was compelled to stay in Nanjing because, after graduating from middle

school, she was admitted by Jinling Women's University. At the university, because of her contact with progressive students, she had grown more mature and more politically conscious. There was born in her a strong antipathy towards Zhang Daofan and a hatred towards the Kuomintang.

One day, Zhang Daofan bought her a bed. But she blocked the door with her body to prevent the bed from being carried into her room.

When she was a freshman at Jinling Women's University, I learned years later, the naive but fair-minded Lili wrote an article to expose Zhang Daofan's wicked acts as a Kuomintang secret agent and had it published in the wall newspaper on the campus. Being then a boarding student, she would go home each weekend. After the paper was posted, she came home on a Saturday afternoon and saw her mother burning with irrepressible rage.

"Mum," Lili asked, "why are you so unhappy?"

"Why? You're asking me!" Jiang thundered and violently threw a wad of paper at her.

Lili bent down to pick up the paper ball that had landed by her feet. Opening it hurriedly, she found that it contained nothing but her article which someone had copied from the wall newspaper. She knew that this must have been done by Zhang Daofan's underlings. She clenched her teeth and did not say a word.

Jiang, however, yelled hysterically. She scolded Lili like some virago shouting abuse in the street, calling her ungrateful. The more she yelled, the more uncontrollably furious she became, as though she were about to devour her daughter.

Lili tottered under the terrific mental shock she had received. She mindlessly stretched out her hand to pick up a bottle of poisonous lotion left on the table by her mother, uncorked it and emptied it at one gulp.

She fell onto her bed, conscious of nothing except a severe pain in her stomach that kept her groaning and tossing on the bed. Her mother just looked on with cold indifference. The housemaid, however, could not bear to stand by idly and hurriedly hired a pedicab to take Lili to a hospital.

Lili was eventually saved. While lying in her hospital bed, she asked herself sadly if she could go back to such a home again. How she wished

313

she could have wings to fly to the side of her father. She had lived with her father so seldom; she had been forced to live apart from him ever since childhood. She still remembered that one day in Chongqing, when she learned that her father was coming back from Southeast Asia, she was too excited to go to sleep and stole out of her bed in the night to reread the letter from her father. The letter which she had gone over many times reads as follows:

Dear Daughter Lili,

Your letter is well written, but I am sorry to learn that you have to repeat a grade. It would be all right to see you continue to stay down in primary school if you could stop growing any taller, for otherwise a big girl reluctant to leave primary school would be an affront to other people. From now on, don't fail to get promoted to the next grade unless you have been ill or for some other special reasons, for otherwise you will have no right to enjoy higher education.

The piece of handwork you have done is very interesting. Thank you for this lovely gift to me. For the time being, I can give you nothing to play with. But if you study diligently, some day you will surely have lots of things to amuse yourself.

I often remember how you would make a nuisance of yourself by crying "O Mama...." when you were still a little baby. Who would have expected that that crying of yours would ever bring me a feeling of infinite sadness for the past?

In time of national calamity, everyone should do his bit for this country. I don't think that we will be less happy than other people after the calamity is over.

Dad

Enclosed in the letter was a Dutch stamp Beihong gave to Lili. One postscript to the letter, written in bigger characters, says, "Dutch stamps must not be soaked in water." The other postscript, written in smaller characters and addressed to Boyang, says, "The enclosed stamp this time is for Lili. All my future letters will have stamps enclosed so that you two can get an equal share of them."

Lili remembered clearly that ever since she received this letter from her father, she had become a diligent student. She not merely went up to the next grade, but also received high grades in every subject. She had studied hard just to please her father. Later, her mother gradually prevented her from writing to her father.

She could never forget that, when her father returned from abroad, her mother had stubbornly refused to be reconciled with him and stopped him from coming home. As a result, Lili could seldom see her father, as if they had been cut off from each other by a high mountain.

314

How she envied her schoolmates who, unlike herself, could live with affectionate parents!

She greatly sympathized with her father for the single life he had long been living. Later, she was pleased to hear of the engagement between her father and stepmother. But her mother compelled her to write to reproach her father. As a matter of fact, the letter had been drafted by Jiang Biwei herself and then copied out by Lili. Beihong, instead of being offended, immediately sent someone to pass on words of comfort to Lili.

The numerous past events flowed through her mind one after another,leaving her with fits of cutting pain. Should she write her father of all that had happened? She kept wondering while lying in the hospital bed. How she wished she could immediately write to him — she was so eager for his affection, comfort, support and protection! But she knew she could not do so because she would rather quietly swallow her sorrows than subject her ailing father to such a blow.

A well-intentioned schoolmate took Lili out of the hospital and put her up in her own home, where she stayed for a week until she returned to Jinling Women's University. From then on, Lili suffered from chronic stomach trouble.

As the People's Liberation Army was winning one overwhelming victory after another, Jiang Biwei decided to take Lili to Taiwan with her. Lili was much distressed to hear of it and told herself resolutely then and there, "That's the limit!" She managed to get into touch with the Communist Party underground and left home without saying good-bye, going secretly to the Dabie Mountain guerrilla area to place herself at the service of the Chinese Communist Party.

After Nanjing was captured by the People's Liberation Army, the Party sent Lili there to take part in the work of taking over the city administration. One day, when she happened to pass by her home in Fuhougang, she merely cast a cold glance at its gate. Her mother had gone to Taiwan, leaving behind the two beautiful buildings and numerous pieces of exquisite, high-quality furniture. Nevertheless, she did not think the premises worth seeing at all, nor was she willing to recall the days she had formerly spent there. She was resolved to devote herself whole-heartedly to revolutionary work. Wearing a gray cloth

army uniform and a gray cloth army cap, she went about her work energetically as a woman soldier. She was living a life materially much poorer than before, but spiritually very rich. The thought that she, together with millions of her countrymen, was trying to bury an old society that had impoverished and tormented people, had brought her great joy. China was saved, the people were liberated. The misfortunes she had met in her personal life had by now become quite negligible to her, as if they had already vanished along with the smoke of battle in the liberation war.

When Wuhu was liberated, Lili was among those sent there to take over Anhui University. To show her break with the past, she renamed herself Xu Jingfei. When young students eyed her with respect, she was ill at ease, feeling as bashful as a new army recruit.

She wrote to tell Beihong her hope of being transferred to Beijing. She had long been dreaming of living near her father to hear his words of advice. Besides, Beijing was the political and cultural centre of the country and she was yearning to visit Tian An Men Square. Her ailing father Beihong, too, was eager to see her!

I finally decided by myself to report the situation to her Party organization, which immediately agreed to arrange her transfer to Beijing. I remitted her travelling expenses by telegram and urged her to start off for Beijing as soon as possible. Now her long wish of living near her father would soon come true. I delightedly looked forward to her arrival.

Soon, the news of her imminent departure for Beijing spread among the young students, many of whom came to plead with her:

"Comrade Xu Jingfei, please stay here!"

"Comrade Xu jingfei, we don't want you to leave us. There are still many things we haven't told you yet!"

What the young girls said gave her not only delight, but also much food for thought. "A revolutionary should be completely dedicated to work," she told herself in a disturbed mood. "So many martyrs have given their lives for the revolution. Why shouldn't I abandon the hope of living near my father?"

A full moon was hanging in the dark blue sky. Its soft light again plunged her into meditation. Her heart went out to her father.

Sparrows chirping on the tree branches before her window ushered in the dawn. Hearing the "thud-thud" of students running in the playground, she quickly got out of bed, put on her clothes, and joined the students at drill. Though she had not slept a wink during the night, she was nevertheless full of vigour.

She told the girl students in a low voice, "I've decided not to leave."

The young girls were agog and hastened to ask her:

"Really?"

"Is it true that you're not going to Beijing?"

"Is it decided?"

Lili answered calmly, "It's true I'm not going. I've decided to stay here."

Ever since then, Lili has been working in Anhui Province. She married Li Hongmo, head of the agronomy department at Anhui Agricultural College. She had a baby, and was later admitted to Anhui Agricultural College. She lived a simple, hardworking life. After finishing college, she was long engaged in the research and teaching of agricultural science. Although she had leg and stomach troubles, she persisted in going to work in the paddy fields and conducting scientific experiments in agriculture. She has written some high-level scientific theses on agriculture.

In 1951, when Beihong was seriously ill, Lili came to Beijing to visit her father. Beihong was very happy to see her, but they exchanged only a few words because the doctor did not allow him to talk too much. None had expected that it was to be her last meeting with her father.

Jiang Biwei, who had since cut off all connections with her daughter Lili, later openly lived with Zhang Daofan, only to be abandoned by him later. She died alone in Taiwan.

Chapter XXVI

In March 1949, Beihong was invited to be a delegate from new China to the World Peace Conference held in Paris. The delegation, headed by Guo Moruo, consisted of Beihong, writers Ding Ling, Ai Qing, Cao Yu, Tian Han, Hong Shen and Cao Jinghua; scholars Ma Yinchu, Zheng Zhenduo, Jian Bozan and Deng Chumin; well-known Beijing opera actor Cheng Yanqiu; dancer Dai Ailian; and painter Gu Yuan.

Zhou Enlai was very much concerned about the preparations being made for the delegation and personally inquired about its route of travel and outfit. Besides sending a doctor and a nurse to accompany the delegates, most of whom were advanced in age, Zhou had a fur coat specially made for each of them — one made of soft, warm racoon — to keep out the severe cold in Siberia. It was the first fur coat that Beihong had ever worn.

Before the delegation started out, I busied myself in packing for Beihong, stuffing all the medicines that he was to take on the way into his bag. I bought two equal shares of articles of daily use, one for Beihong, the other for Tian Han, who was then living alone in Beijing Hotel.

On March 29, we saw Beihong off at the railway station. Although he was to be away for only a short time, I felt anxious for him because he had not yet recovered from his hypertension and chronic nephritis. Since we had come to Beijing, this was the first time that Beihong was away from home.

The railway platform was thronged with people giving a warm send-off to the delegation. Besides the delegates' family members, relatives and friends, there were many simply interested in the delegations success.

Beihong was to tell me later that as soon as the train pulled through Shanhaiguan Pass, he felt a pleasant thrill of excitement to see lying before him the vast, fertile land of Northeast China, which, once occupied by Japanese troops, had now returned to the embrace of China. On April 3, when the train reached the border town of Manzhouli, a snowstorm was raging and it was extremely cold.

When the train arrived at Chita, the Soviet government received the delegation and arranged for them to have lunch at a big local restaurant. Because the clothes rack was near the fire, it was discovered after lunch that two fur coats had been scorched by the heat, coincidentally one of them being Beihong's.

Beihong wrote me about it with regret:

> Forty years ago, when the first silk jacket I wore was scorched by a cigarette, I swore to forgo the pleasure of wearing silks forever. As to a fur coat, I have never owned one in my life partly because I could not afford it. It is most deplorable that the fur coat given me by Comrade Zhou Enlai should have been unfortunately burnt and ruined....

Fifteen years earlier (in 1934), Beihong had been to Chita, then a desolate hamlet now turned into a busy town. The train passed by Lake Baikal with its broad, white frozen surface giving off a dazzling shimmer of reddish-orange in the early morning sun.

The Chinese delegation arrived in Moscow April 11. But the French government refused it entry because new China, which had not yet been officially founded, then had no diplomatic relations with France. Consequently, it was decided to hold the World Peace Conference in both Paris and Prague simultaneously.

After a two-day stopover in Moscow, the delegation left for Prague. In Czechoslovakia, as the train passed by the six-thousand-foot-high, snow-covered mountains, Beihong saw in the distance lofty, beautiful mountain ragnes covered with dense forests of firs and neat, green wheat fields in the valleys. He was deeply impressed with them and called them the "fruits of labour of the Czechoslovakian people."

On April 23, when the conference was still in session, came the announcement that the Chinese People's Liberation Army had liberated the Kuomintang capital Nanjing. All present rose to hail the happy news and applauded thunderously. Many left their seats and went to shake

hands with the Chinese delegates, embraced them and even lifted the younger ones among them high in the air. While the Chinese delegates sang *The Internationale* in unison, those from other countries chanted, "Mao—Ze—Dong" word by word to the accompaniment of their hand-clap. The whole hall was wild with joy.

Finally, Guo Moruo addressed the conference in gratitude. His declaration that "the victory of the Chinese PLA is a sure guarantee of world peace" again won a tremendous ovation.

In the evening, the people of Prague poured endlessly into the hotel where the Chinese delegates were accommodated to offer them congratulations and flowers. Beihong and other members of the delegation were kept awake all night receiving the visitors.

The last speakers at the conference included delegates from China, Spain and Romania, who all appealed for the defense of peace and opposed the intrigues of warmongers. The conference came to a close amidst cheers and singing.

Upon the conclusion of the conference, Beihong toured the city of Prague, which, like a beautiful garden, had neat, clean streets decorated with colourful flowers and many unique ancient buildings.

Beihong also visited the state museum and the state art gallery, where he enjoyed viewing masterpieces by such great painters as Rubens and Rembrandt. Visiting the Czechoslovakian Art School, he saw students in advanced classes doing huge paintings reflecting workers' life. He also called at the Eastern Academy and the School of Industrial Art. Students of the cloth-dying department were making a great variety of designs and he was told that those whose designs were adopted would then go to the factory to take part in the manufacturing process. He also saw the exquisite etched glassware at the industrial art school, produced in a similar way to Chinese jade carvings.

The Chinese delegation made a one-week stop in Moscow on its way back to China.

While wandering about Red Square, Beihong remembered his first trip there. Fourteen years earlier, eager to seek understanding and friendship, he had been cordially received by the Soviet people and had sown the seeds of friendship between the artists of the two countries. At that time, China had vast areas of its territory occupied by the Japanese

Xu Beihong in the early
post-Liberation period

Xu Beihong at home
in Beijing, 1953

Xu Beihong with his wife, Liao Jingwen, in Beijing, 1950

Zhou Enlai at an exhibition of Xu Beihong's paintings
in Beijing's Zhongshan Park, 1953

Xu Beihong at work in his home, 1951

An inscription, "Beihong's Former Residence," written by Zhou Enlai for the Xu Beihong Memorial Hall

The living room in Xu Beihong's home

Xu Beihong's former residence at 16 E. Shoulu Street, Beijing

Mother of the People's Army
Sketch, 1950

Model Worker *Sketch, 1951*

Model Worker *Sketch*

Combat Hero *Sketch, 1950*

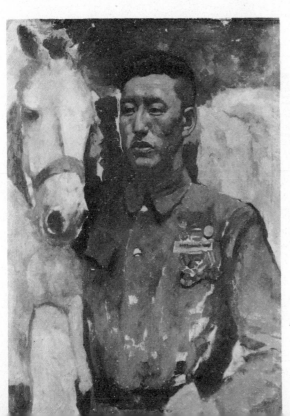

Tai Xide *Unfinished oil painting, 1950*

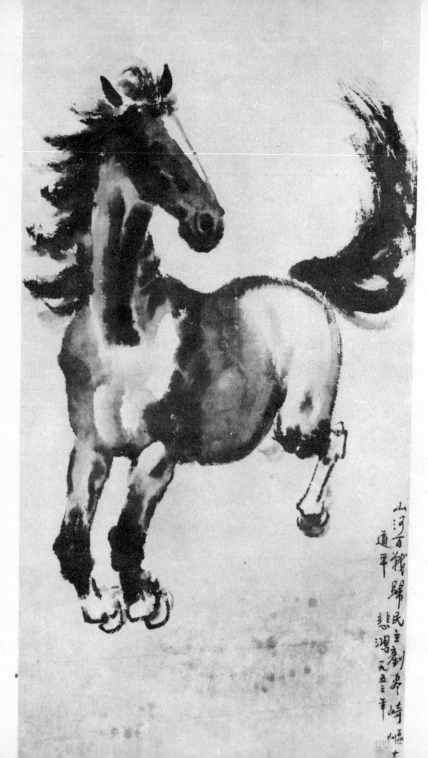

山河百戰歸民主劉岑崎

道平

悲鴻一九五三年

Galloping Horse *Traditional Chinese painting, 1953*

Portrait of Zhang Xiruo
Sketch, 1949

Portrait of Tian Han
Sketch, 1949

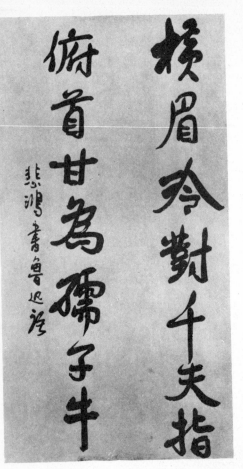

横眉冷對千夫指
俯首甘為孺子牛

悲鴻書魯迅句

A couplet from one of Lu Xun's poems, in Xu Beihong's calligraphy

我愛畫動物,皆對實物用過極長時間的功。即以馬論,速寫稿不下千幅,並學過馬的解剖,熟悉馬之骨架肌肉組織。夫然後,樂在筆先,揮毫立就,遂能有得也。所以,我愛畫動物,皆對實物用過極長時間的功。

Part of a letter written by Xu Beihong in 1947 in reply to Liu Boshu, a primary school pupil in Nanchang, Jiangxi Province

and the Chinese people were in the abyss of misery. Now, China had broken her shackles and stood up like a giant. She had pointed out the way forward for the oppressed peoples of the world and brought them hope. The Chinese delegation was accorded a riotous welcome wherever it went. This was something new to Beihong. On his previous trips to distant foreign countries, though he had been respected and welcomed as an artist, he had nevertheless been despised as a Chinese national. Now, what cheers, honour and pride the three characters "Zhong Guo Ren" (meaning "Chinese national") had won for the delegation!

He also recalled how Jiang Biwei had raised a quarrel with him in Leningrad fourteen years before. He learned from the interpreter that the antique shop they had visited was still there, but the carved figure he had liked had long been sold.

He discovered to his great excitement, when he called at the art gallery in Moscow, that the old formalistic paintings had long been cleared away. Now on display before him instead were revolutionary realistic works reflecting the life and struggle of the Soviet people, which he greatly admired.

On May 10, the Chinese delegation left Moscow for China by train. On the long homeward journey, while sitting in the rocking railway carriage, Beihong sketched portraits for Tian Han, Ding Ling, Zheng Zhenduo, Jian Bozan, Deng Chumin and others.

In passing through Shenyang, Beihong visited Lu Xun Art Academy, where he was very happy to meet the painters Hua Junwu and Shao Yu. He very much appreciated their works with revolutionary themes. He also met the director of Northeast Pictorial Press, Zhu Dan, who had been an underground Communist when he studied under Beihong in the 1930s. When Beihong suffered Kuomintang persecution, Zhu had rallied progressive students to defend him. Later Zhu went to the Liberated Areas to join in the fiery revolutionary struggle and lost all contact with Beihong. Beihong gave him a picture of a galloping horse he had painted specially with the following inscription:

Jubilantly painted by Beihong in 1949 to greet the liberation of Beijing.

On May 25, the delegation arrived in Beijing. When the train pulled into the station, I stood among the crowds of people to welcome

Beihong and the other delegates. Beihong alighted from the train with the other delegates, looking very cheerful.

When Zhou Enlai gave a dinner to welcome the delegation at Beijing Hotel, Beihong and I were seated at the same table with him. At that time, the PLA was making its southward advance with flying colours. Zhou talked cheerfully and humorously and an atmosphere of pride and joy prevailed among all those present. In the midst of the talk and laughter, somebody casually mentioned that according to the *Reference News,* Zhang Xueliang* had been executed. The news, though later proved to be untrue, then much disturbed Zhou Enlai. The brightness on his face suddenly gave way to apprehension and pain. After a moment's silence, he said heavy-heartedly, "We ought not to have let Zhang Qun** escape, for otherwise we could have held him hostage and exchanged him for Zhang Xueliang." (It was then reported by newspapers that Zhang Qun had fled on the last airplane.)

I was then strongly convinced that Zhou Enlai was a very tender-hearted and thoughtful man who would never forget anyone who had done the people a good turn.

The next day, Beihong went to the Central Institute of Fine Arts to talk glowingly about what he had seen and heard. He even went to the classrooms to distribute to students some small picture books he had brought back from abroad. He gave Li Tianxiang an album of Kotoff's paintings because he knew that Li's careful, neat approach to painting was similar to Kotoff's. He gave each student a different book of paintings befitting his or her style.

After finishing all that he had to attend to upon his return from abroad, Beihong lost no time in resuming artistic work. He quickly painted the stirring scene of wild excitement at the World Peace Conference over the news of Nanjing's liberation. It is a vertical scroll of colourful traditional painting, 360 cm by 70 cm, in which there are portraits of many actual persons.

* See Chapter XXVIII, Part One. Zhang Xueliang was put under house arrest by Chiang Kai-shek after he escorted Chiang to Nanjing upon the peaceful settlement of the Xi'an Incident. Later Chiang took him to Taiwan and placed him under surveillance there.

** A top-ranking Kuomintang official.

Due to stress and fatigue, he fell ill soon after finishing this painting. With his blood pressure running as high as two hundred and his limbs feeling like jelly, he showed indications of hemiplegia. On the doctor's advice, he temporarily stopped working. But, after lying in bed for a few days, he again began teaching.

Meanwhile, he also took part in designing the national flag, the national emblem and the national anthem of the People's Republic of China soon to be founded. The adoption of the national emblem went off without a hitch. But it was no easy job to make a proper choice of the national flag from among tens of thousands of designs submitted by contributors, especially when opinions differed so widely. Some designers put on the red flag not only a five-pointed star, but also a horizontal yellow band to symbolize the Yellow River, the cradle of the Chinese nation and its five-thousand-year-long civilization. Though many agreed that the yellow band was quite meaningful, it was considered improper to have the national flag divided in two by it. The deliberation dragged on until finally Tian Han picked up the five-starred red flag, already dismissed, and said, "This is a very good design even without the Yellow River!"

People came up and, after some discussion, agreed upon the design.

As to the national anthem, none of the thousands of contributions received was desirable. But the matter had to be settled because it had already been put on the agenda of the up-coming Chinese People's Political Consultative Conference to adopt the national flag, emblem and anthem. Chairman Mao, therefore, called a meeting of more than twenty people to settle the matter through consultation.

Before he went to the meeting, Beihong told me, "I'm going to suggest using *March of the Volunteers* as the national anthem."

"How can it work?" I said. "The words of the song say 'The Chinese nation faces its greatest danger.' Is that all right?"

"Why not? The French national anthem *La Marseillaise*, originally called *March of the Rhin Army*, is a solemn, stirring song. In 1792, the revolutionary workers from Marseille marched into Paris singing this song. Later it was officially adopted as the national anthem of France."

He read me the words of *La Marseillaise*. "You see, isn't it solemn and stirring? People who've won victory shouldn't forget the past

struggle. This song's capable of inspiring the French people to keep marching on in high spirits. The same with *March of the Volunteers,* which sings of the popular will and national confidence. It marks the victory of the struggle against the enemy. What's so bad about that?"

At the meeting called by Mao Zedong, when Beihong suggested using *March of the Volunteers* as a substitute for the national anthem, he was immediately supported by Zhou Enlai, who thought the song majestic, heroic, and full of revolutionary spirit. The architect Liang Sicheng cited a fact to illustrate the popularity of the song: One day when he was in the United States, he had heard someone whistling the tune behind him in the street, who turned out to be a young American on a bicycle. Other people also voiced their support for the proposal one after another. At last, Mao, in summing up all the opinions, expressed his approval for it.

Soon afterwards, the national anthem was formally adopted at the first session of the Chinese People's Political Consultative Conference.

October 1, 1949, saw the founding of the People's Republic of China. Beihong, together with many Party and government leaders, stood on the Tian An Men rostrum to listen to Mao's solemn declaration to the world, "The Chinese people have stood up!"

The band struck up the new national anthem. It flooded Beihong's mind with scenes of the Chinese people waging unyielding struggles and giving their lives to the cause of the revolution. The inspiring melody resounded through Tian An Men Square and would expand and resound throughout China.

Chapter XXVII

Upon the successful conclusion of the Chinese People's Political Consultative Conference, Premier Zhou Enlai personally appointed Beihong as President of the Cental institute of Fine Arts. Soon afterwards, at the First National Congress of Art and Literary Workers held in Beijing, he was again elected Chairman of the National Association of Painters. From then on, he was very busy with public activities as well as teaching.

One day, Qi Baishi came to see us with his son leading him by the hand, looking worried and tearful.

Since Qi's wife died when he was eighty-two years old, he had had his daily life taken care of by a nurse called Xia Wenzhu. Xia, a spinster aged more than fifty, after caring for Qi for seven years, had suddenly left angrily after a dispute with him over some trifle. Qi came to see Beihong. The old man told us sadly, "I can't even find it in my heart to part with an object after using it for seven years, let alone a person!"

He stared at Beihong blankly and appeared absent-minded. He was anxious that Beihong should do something to help him out.

Beihong tried to comfort him as best he could, saying, "Don't worry. I'll send Jingwen to persuade her to come back."

Xia was nowhere to be found. Qi would come to our home early every morning in the hope of meeting her. I grew annoyed with her and even hesitated to continue the search. Beihong, however, told me to stay calm and try to find Xia by every possible means and persuade her to return to Qi.

When I called on Hu Zhengzhi at his home to inquire about Xia's whereabouts, both Hu and his wife unexpectedly told me, "Wenzhu is to get married soon. She won't be able to serve the Qis again."

I insisted on speaking to her face to face. Through the good offices

of Hu and his wife, I did meet her. But all the efforts I made to persuade her to return to Qi were in vain, for she was already busy preparing her trousseau.

In order to console Qi, I had to look for a new nurse for him as soon as possible. But where could I find him a suitable one immediately? There was no alternative but to place a want-ad in newspapers. Beihong again put me in charge of the matter.

Qi later changed his nurse several times mainly because none of them cared to remain long on this job. This affected Qi's mood and made him very unhappy. Beihong was very concerned.

That year, the peach trees planted by Beihong bore abundant fruit. Beihong sent a car to bring Qi to our home to pick peaches in our yard to amuse himself. Since a heavy shower had left puddles of rain-water on the uneven road, we had to use a cane chair to carry Qi into our compound as soon as the car pulled up at our gate.

Qi was elated and all smiles. Standing beside the peach trees still dripping with rain-water, he slowly reached out his wrinkled hand towards the branches weighed down with clusters of fruit and carefully picked the attractive honey peaches one by one while I stood by carrying a bamboo basket. Beihong also stood nearby to help with the plucking.

Qi eyed the basketful of brightly coloured peaches admiringly as if they were rare treasures. After he had lunch with us, I escorted him home by car with the basket of peaches. As I helped him from the car at Kuache Hutong, he said, "Let the peaches go ahead of me." So he walked behind the peaches with his eyes fixed on them and entered his studio.

Like a child, the ninety-year-old artist had an ardent love for anything of beauty.

Beihong showed the utmost solicitude for young art workers as well as old painters. While the First National Congress of Art and Literary Workers was in session, there was held an exhibition of paintings from all over the country, of which a traditional painting from Northwest China name *Father Is Joining Up to Fight Chiang Kai-shek* attracted Beihong's attention. The picture, relatively small in size, depicts a gay, good-natured young peasant leaving for the front after joining up while his wife, a smiling young country woman with a baby in her arms,

is seeing off her husband reluctantly but cheerfully. The vivid, skillfully executed figures won Beihong's high praise. The painter's name was Huang Zhou. Beihong immediately started inquiring about him and hoped that he would send some more of his paintings.

The young man, a propagandist in an army unit in Northwest China, sent Beihong some traditional paintings portraying Uygur girls dancing, among which was one called *Apple Trees in Blossom*. Thanks to the vivid, smooth lines and the proper employment of deep and light colours, the gentle, graceful girls look real and full. Beihong was greatly delighted to see the embodiment of the Xinjiang minority people's day-to-day life in artistic works. He wrote a letter to leaders of the Ministry of Culture, in which he requested that Huang Zhou be transferred to the newly established Nationalities Art Research Institute because his unique style of painting, if fostered, would have a great future.

When the army leadership heard of this, Huang was transferred to Beijing by the Beijing Military Area Command. He met Beihong and received from him much encouragement and guidance. Since then, Huang's rich, varied works have gradually become known and widely admired.

In 1950, Yang Zhiguang, a nineteen-year-old painter, came from Shanghai to visit Beihong and expressed his wish to take the entrance examination for the graduate class at Central Institute of Fine Arts. He had brought with him his newly published collection. After opening the album to look over the landscapes Yang had painted in Taiwan, Beihong believed that the young man was highly gifted but needed further careful training. So he began with a few words of encouragement.

"Few of your age can publish a collection like this, and your pictures are well done." He continued, "I wonder if you're willing to take my advice."

"Of course I am. Please go ahead," the young man replied.

"Well, I would rather advise you not to join the graduate class, but to begin from the first year as an undergraduate so that you can start from the beginning, lay a good foundation and master the basic skills of modelling. All right?"

Yang nodded with conviction, "I'll do what you tell me."

So Yang became a first-year student of the institute and learned step by step to paint geometric forms, full-formed human heads, and human bodies. He did excellent sketching and got full marks for it in each examination.

One day, Beihong went to the classroom to watch the students sketching human bodies. Yang's sketch was complete in all respects except the knees, for which he had put down only a few squarish outlines. Beihong stood viewing the sketch for a while and then asked Yang, "Look, what's the best part of this sketch?"

Yang pondered without giving a hasty answer. He would have mentioned the head which he thought was flawless, but he hesitated to do so.

As Yang kept quiet, Beihong said, "The best part of this sketch is the knees because, being unfinished, they can still be done well while those already finished can no longer be done again."

Yang has now become an outstanding figure painter. He adroitly blends the techniques of Western and traditional Chinese painting, and can paint with ease lifelike pictures of all common working people we meet in our daily life as well as writers, artists, dancers, and performers.

Beihong often went to the classroom to check on the results of the students' study, and he paid particular attention to the first-year students, calling it "suckling the new-born baby." He always saw to it that the first-year students got the best-qualified teachers while he himself would often go to the classroom to guide the first-year students and repeatedly exhort them to paint honestly and not to pursue things with a surface gloss. He taught them the principle of "Better square than round, better clumsy than clever, better dirty than clean." He attached great importance to the constant practice of sketching from memory and later comparing it with a sketch from life.

While visiting a class which was soon to finish its first-year study, he found the students doing their last sketch — the plaster figure of a discus thrower. A student from Hunan Province named Zeng Shanqing attracted Beihong's attention. Zeng, then very thin, had never learned painting before he entered the institute and had never known charcoal technique. Beihong commented when he saw what Zeng had done in the entrance examination, "Evidently he's never learned painting before,

but he's got the feel for it and is therefore quite promising." So Zeng was admitted.

A year later, Zeng began to display his talent for sketching. He did the final sketch from a rather unfavourable position behind the plaster statue — the only place where he could still find enough room for his easel because all the front and side positions had been occupied by his classmates. It was not easy for him to make this sketch because of the poor light, yet it earned the high praise of Beihong and was given a special award at the institute-wide exhibition of students' works.

Beihong often told his students to do more practice in sketching human limbs. He said, "One who sketches a figure often has difficulty with its hands and feet. So additional practice is needed in sketching them."

The hardworking Zeng did accordingly. During holidays he sketched his own hands and feet with the help of a mirror. Consequently, he not only mastered the difficult art of drawing human hands and feet, but also found them to be as expressive as human faces.

Beihong taught the fourth-year students to paint figure oils from life. At first, he would always tell them to determine accurate colours for themselves as best they could. Some students would go to great lengths to seek colours from the model, such as purple, yellow, pink and green. Beihong, however, denied that they had found the right colours, saying, "By accurate colours, I don't mean to be bright with various colours. Colours must be in harmony with light," he exhorted. "Both the lightest and the darkest colours should be used with great discretion, for, like the deadliest weapons, they should be used only when they're indispensable for a certain purpose."

One day, after standing before Zeng's easel to look at it for a while, Beihong sat down, took over the palette from Zeng, and used the palette knife to scrape together all the dirty colours and mix them up. Then he melted a dried piece of lemon yellow with oil and added it to the mixed dirty colours. As soon as he applied the yellowish-grey colour to the shoulders of the figure on the canvas, a seeming miracle appeared, for the mixed colours instantly gave a beautiful grey. It not only fused itself into the whole, but added lustre to the nearby colours.

One day, hearing that Zeng could not attend the oil class because

his paints had been stolen, Beihong gave him many tubes of French oil colours, which were then very expensive and hard to come by. Beihong also knew Zeng was hard up for money, so one day, when he saw two watercolours by Zeng, *Courtyard in May* and *Dusk After a Rain*, Beihong said, "I'll buy these two pictures." He fished out money from his pocket and offered it to Zeng.

In his last year at the institute, Zeng suddenly contracted tuberculosis. What a heavy blow it was to such a young man! When Beihong heard of it, he tried to comfort him by saying, "When I first arrived in Beijing, the doctor discovered calcified spots on my lungs during a health checkup in hospital. I was much astonished to hear him say, 'You must have had a severe case of pulmonary TB when you were young.' I never knew it before. I was too poor to afford a health checkup then. . . . So don't worry, for it's surely a curable disease. . . . I should like you to eat more garlics from now on. . . ."

Since Zeng was cured of the TB, he has produced a large number of excellent works and has become known for not only his oils but also his traditional Chinese paintings. He has worked hard to apply the techniques of oil painting to traditional Chinese painting. He is now teaching at his Alma Mater — the Central Institute of Fine Arts.

Other students of Beihong's now on the teaching faculty of the institute are Dai Ze, Wei Qimei, Hou Yimin, Li Tianxiang, Jin Shangyi and Zhan Jianjun, who are all influential art educators and celebrated painters.

Chapter XXVIII

When Beihong first came to Beiping in pre-Liberation days, he often visited art shops in Liulichang to hunt out good calligraphy and paintings of both modern and ancient times. When he was too busy to make such visits, the art dealers would call on him with calligraphy and paintings. Whenever he saw a favourite piece, he would exclaim, "What a marvellous picture!" or "A rare work of art!" Words of praise would gush from his mouth until an art dealer demanded a much higher price than he had originally intended and refused to take anything less. Beihong, however, would be willing to pay any price for what had caught his fancy. Sometimes, for lack of enough cash at home, he would make up the balance with his own pictures.

"Beihong," I would sometimes counsel him, "why did you show so much eagerness for the painting you wanted to buy from the art dealer? You're always letting the dealer know that you intend to buy a painting from him anyhow so you pay much more for it than need be."

Beihong, nodding and smiling, would agree that there was much sense in what I had said. Nevertheless, the next time an art dealer came with a good painting, the same thing would happen all over, much to the benefit of the art dealer.

"Oh, you're just hopeless!" I complained.

"Jing," he said, "when a good picture suddenly appears before me, how can I pretend to be cool and apathetic? I can't help being excited at the sight of a really good picture!"

One late afternoon, Beihong came home looking dead tired after a meeting and was in need of a rest when something suddenly occurred to him. "Jing," he called to me, "I must go out right away."

"What's the matter? Why don't you go out after supper?"

"No. The monthly exhibition of calligraphy and paintings for sale

is now on at Mr. Fang's home. As today is the first day of the month, there must be some good paintings for sale. If I don't go there today, they may be bought up by other early visitors."

In the early post-Liberation days, the People's Government still allowed individuals to exhibit their private collections for sale. Fang, himself an art collector, would also put on display works collected by other people.

"Well, I'll go with you," I said.

Beihong was much pleased. So we went together to the Fangs in Chuilu Hutong. They lived in an ordinary compound having several rooms hung with calligraphy and paintings. Fang, who happened to be talking with a foreign ambassador to China, came out to greet us. The ambassador, who happened to have known Beihong and shown much friendship and admiration for him back in 1946, had remained in the same post since Liberation. Now he had settled on a scroll painting by Wang Zhenpeng of the Yuan Dynasty, named *Mei Fei the Imperial Concubine*, but, thinking the marked price too high, he was bargaining with Fang.

Taking a close look, Beihong found the picture scroll depicting a grand scene of life in the imperial palace, with splendid buildings and numerous figures. The most interesting part is a palace painter making a vivid portrait of Mei Fei, the favourite concubine of the Tang Emperor Ming Huang. To salvage the superb ancient picture from falling into foreign hands, Beihong told Fang without a moment's hesitation, "I'll buy this picture, at the marked price, not a single cent less."

Fang of course consented gladly. The ambassador looked very glum when he was told that Xu Beihong had bought the picture at the marked price.

Later Beihong inscribed the following postscript on the picture scroll he had bought:

> Judging from the way the figures, trees and stones were painted and the application of the *jie* painting technique, Qiu Shizhou must have been the painter of this picture scroll, for in the last five hundred years he was the only master skillful enough to do this. Although its white silk still looks new and clean due to careful preservation, we still do not think it less than five hundred years old. People with the habit of revering things old have hastily ascribed this picture to Wang Zhenpeng, alias Guyunchushi, which is utterly groundless. I have borrowed money

to buy this picture because a good ancient figure painting is hard to come by, much less a carefully and neatly done *jie* painting like this.

Among the many valuable ancient paintings Beihong bought in Beijing was a Northern Song figure painting named *Zhu Yun Breaking the Balusters* (by an anonymous painter).

It illustrates the following historical story. Zhu Yun, an official under the Han Emperor Cheng Di, resented a corrupt official, Zhang Yu, who had brought ruin to Western Han by using his powerful connections to set up a faction for selfish ends. Zhu went to the Emperor, saying, "High officials at court nowadays can neither correct the mistakes of Your Majesty nor do anything to benefit the common people. I, therefore, beg Your Majesty to grant me the imperial sword so that I can give them an object lesson by killing one corrupt official."

The Emperor asked, "Who's the corrupt official?"

Zhu answered, "Zhang Yu, the Duke of Anchang."

Exasperated by Zhu's suggestion to kill Zhang, who was his teacher and very much in his good graces, the Emperor ordered that Zhu be pushed out and beheaded by the guards. Zhu resisted so much that he broke some of the court balusters he was clinging to.

Just then, Xin Qingji, a high officer, implored the Emperor to pardon Zhu, saying, "Zhu is known for being blunt and outspoken. If what he says is correct, he shouldn't be killed. If what he says is wrong, he should be treated with leniency. I beg to defend him even at the expense of my own life."

The Emperor reconsidered and accepted Xin's opinion. He pardoned Zhu and gave orders that the court balusters should remain unrepaired as a lasting compliment to the faithful official who dared to speak bluntly.

Beihong inscribed the following on the side of the picture:

> This painting, mentioned in many books, is the work of Hua Gui of the Northern Song Dynasty, and is a wonder among Chinese works of art. The expression and posture of Zhu Yun in the act of struggling with the guards are so ingeniously portrayed that the picture is unrivalled by the works of any great master in Chinese history. It enjoys a high reputation not only because it has been mentioned by scholars. While my *Eighty-seven Immortals* shows the quality of harmony and solemnity, this picture expresses the atmosphere of resistance and tension. I consider myself very fortunate in having these two wonders in my

keeping to afford me spiritual consolation.

When Beihong collected art, he always took into consideration not the fame of the painters, but the artistic value of the pictures themselves. He once exchanged a huge landscape by Dong Yuan of the Northern Song Dynasty for *A Homebound Boat in the Storm* by Jin Dongxin of the Qing Dynasty, a picture of much lower cash value in the possession of Zhang Daqian. The inscription he put on the latter picture says:

> This is one of the great wonders of Chinese painting. As far as I know, like Fan Zhongzheng's *Travelling Along a Mountain Stream* and Zhou Dongcun's *The Northern Seas*, this painting should be considered one of the four best Chinese landscapes extant in the world It is the picture itself, rather than the name of the painter, that I value.

Beihong once bought a Ming painting *Wang Xizhi Putting His Handwriting on a Fan Cover*, which depicts the following story.

An old woman selling fans is worried over a lack of buyers when, as luck would have it, she happens to run into the great calligrapher Wang Xizi, who says, "Your fans may sell better with a bit of my handwriting on them." Thereupon, he takes over her fans and starts writing vigorously. The old woman, who does not know who he is, looks apprehensive, fearing that her fan covers may be spoiled and hence become even more difficult to sell. A Wang's page boy, however, delighted to see him giving help to the old woman, goes all out to prepare ink on the side. The figures in the picture are well-proportioned, vivid and lifelike.

Beihong wrote the following inscription on it:

> This is a rare gem in the treasure trove of traditional Chinese painting. The apprehension of the old woman and the conscientiousness of the page boy set off the lofty and casual air of Wang Xizi. The elegant, lovely picture is not necessarily the work of the Northern Song master Li Boshi The wilderness has been substituted for the market-place as its background to heighten the main figure's freedom from vulgarity. It is hard to imagine what the effect would be like if it had been done by one with freer brushwork.

Beihong also had unexpected strokes of luck. Once, in a small market, he discovered, in a pile of waste paper, a picture which few had noticed, and bought it almost for nothing. Mouldy and torn, it was the picture of a Buddhist disciple painted by an artist of the Northern Song

Dynasty. To my surprise and delight, as soon as Beihong had it re-mounted, the picture became dazzlingly brilliant.

Beihong worked indefatigably day after day to collect excellent ancient Chinese paintings to protect them and forestall their loss to foreign lands. At the same time he would buy all his shoes from a junk shop, being unwilling to spend more money on a pair of new ones.

Chapter XXIX

In 1950, when the national conference of combat heroes and model workers took place in Beijing, Beihong went with some teachers from the institute to paint the portraits of some outstanding figures. He sketched, or painted in oils, the portraits of many exemplary persons.

He also planned to paint an oil of The Meeting Between Lu Xun and Qu Qiubai.* He paid a visit to Qu Qiubai's widow Yang Zihua and Lu Xun's widow Xu Guangping to consult them about the composition of the painting. He also called on Lu Xun's brother Zhou Jianren to solicit information about the life, clothing and habits of Lu Xun. He made many rough sketches.

Meanwhile, he was attracted by a news story stating that in order to control floods in southern Shandong and northern Jiangsu provinces and to prevent one million hectares of fertile land from being inundated, the Yihe River in northern Jiangsu was to be extended another two hundred kilometres. The Shuhe River in Shandong was to have its course changed, to empty into the sea through the Shahe River in southern Shandong. The herculean water conservancy project was the first major attempt at changing nature made by new China. He decided to go to the construction site to observe and learn from real life so that he could create a huge oil reflecting new China under construction. Work on The Meeting Between Lu Xun and Qu Qiubai had to be discontinued temporarily.

I saw him off at the Beijing railway station with worries and misgivings. For the past few years, he had persisted in working in spite of

* Qu Qiubai (1899-1935) was a writer and a leader of the Chinese Communist Party in its earlier period.

his illness. I feared that his blood pressure, often as high as two hundred, might suddenly kill him. But he never gave a thought to it.

He stood by the door of the hard sleeper waving to me cheerfully. He was accompanied by some teachers of the institute, his student Liang Yulong and the security cadre Sun Hongxu. He had insisted on travelling in the same carriage with hard berths instead of one with cushioned berths. The train puffed out of the station slowly and then began to speed along until it went out of sight in the distance.

Beihong was inspired to see several hundred thousand labourers working on the construction site. He sketched their portraits and many scenes on the spot.

After his return to Beijing, he started planning a grand oil painting to depict the harnessing of the two rivers.

But just then, a much feared misfortune befell us. Beihong was stricken with a cerebral haemorrhage.

The stroke came on late at night without my knowledge, for I was then sleeping with the two little children in another room farthest from where he was sleeping so he would not be disturbed by them when they started crying at night. Early the next morning, after the children and I had got up, Beihong was still in bed. Ordinarily, he would have been up and working with the light on before daybreak. I guessed that he had been sleeping late, probably because of fatigue. But when he still did not get up at seven, nor at 7:30, nor at eight, I grew fidgety. I walked to his bedroom, pushed the door open lightly, and saw him lying in bed, mute, with his agonized eyes open and his body already half paralyzed. I whizzed out of his bedroom to call Dr. Zhong Huilan, then head of Central People's Hospital, whom Beihong had often consulted ever since we came to Beijing.

Dr. Zhong lost no time in hurrying to our home. He helped us carry Beihong into the car and escorted him to Central People's Hospital.

When Premier Zhou Enlai learned of Beihong's illness, he immediately gave instructions to save the patient by all means; Beihong received the best possible medical treatment and care.

At first, as he was completely unable to eat, a rubber tube was used to carry a liquid diet direct into his stomach. Four months later, he was able to sit up in bed.

Ever since he entered the hospital, I had kept watch by his bedside day and night. When I saw that he was on the mend, I began to see light and hope again for life. As I had done when he was laid up in the past, I read him newspapers, magazines and articles that were not likely to excite him.

Every month, he asked me to go to the admission office to inquire about the total expenses he had incurred in hospital. I told him not to worry about the money because, in contrast to those days in Chongqing, he would not only get his monthly salary as usual but also have all his medical costs reimbursed by the government.

"Jing," he said very gently, "I understand that. But I must find out how much the government is paying for me. I don't want to forget it."

So, at his bidding, I had to find out from the admission office the total hospitalization expenses and then inform Beihong of it. I did that every month.

After four months, Beihong's medical costs added up to more than forty million yuan (every ten thousand yuan of those days is equal to one yuan of today). This made him very uncomfortable. Remorse and shame shone in his mild eyes.

"Jing," he said almost in agony, "our country's still very poor. Because of my illness, our country has expended an enormous sum of money. I must do my best to repay it; after I've recovered, I'll work doubly hard to pay back my debt of gratitude."

As soon as he got better, he insisted on leaving the hospital. The doctor agreed and prescribed him some internal medicine and injections for home treatment.

In November of the year, we returned to our pleasant abode in East Shoulu Street. Everything at home made us feel warm. Close at our knees were not only our lovely son and daughter, but also our eight differently coloured Persian cats. Beihong liked cats and also liked to paint them. He kept so many cats at home to permit constant observation. Overjoyed at the safe return of their master, they mewed and jumped fondly into his arms.

Still ailing, Beihong had to be confined to bed. Every day I would rub Chinese ilex oil on the paralyzed side of his body and limbs and massage him. Li Huiwen of the institute clinic would come every day to

give him injections. But Li was pregnant and had difficulty in coming by bicycle, so I also learned to do it myself. I would continue daily to read him newspapers, periodicals and fiction. I finished reading him such favourite novels of mine as Leo Tolstoy's *War and Peace* and Romain Rolland's *Jean-Christophe,* which he also liked very much.

In the spring of 1952, Beihong was still bedridden. He felt sorry for having passed his prime in old China. One day, he told me with regret, "If only I had been born ten years later!"

How he wished he could still be energetic enough to serve new China! But, instead of being pessimistic and despondent, he was full of confidence and still yearned for work. While confined to bed, he planned a set of picture posters showing China's historical relics, ranging from the painted pottery of Yangshao Culture to the jade carvings, bronze ware, porcelain, famous paintings, and buildings of past ages, which were to be hung up in schools, colleges, universities and other public places to develop people's patriotism as well as to enlarge their knowledge.

The year 1953 came bringing hope with it. In our courtyard, the peaches, crabapples, lilacs, and flowering plums were in full glory, and Beihong also gradually managed to leave his bed and move around a bit. In spite of his illness he painted six pictures of galloping horses and had them sent to the Chinese People's Volunteers then fighting in Korea. They wrote back with gratitude, "We understand that these pictures convey the feelings of all our compatriots."

During his illness, Beihong never forgot his students at the institute. To keep himself informed of their progress, he personally went to call at their classrooms one by one. He was much alarmed to see students in all the classes drawing with hard lead pencils sharpened like needles. Sketches done in this way were smooth and fine, and, with much slavish rubbing and polishing, would each take dozens of class hours to finish. It tended to dull the students' feeling, deprive them of their originality, he said, and thus made for rigid, overelaborate works. Beihong strongly disapproved of it. He immediately called a meeting of teachers concerned, saying, "Like formalism, this is another pitfall. Once you fall into it, you won't be able to pull out." He demanded that they change

their method of teaching and stop the students from doing their sketches like that.

When, with the summer vacation around the corner, each department prepared to graduate some students, Beihong was anxious to go and offer them lectures. He said, "I must do my best to teach them what knowledge I have before they leave the institute, for otherwise they won't get another opportunity to hear me."

For each lecture in the classroom, he would often make a thorough search among tens of thousands of printed pictures in his collection for those to be used as teaching aids and for the students' reference. After marking them with their titles, names of the painters and dates, he would place them on display for a week in glass cases at the institute.

One day, among the printed pictures he had brought to the institute some were done by William-Adolphe Bouguran, a nineteenth-century French painter. One, a winged goddess entitled *Youth and Love* and painted in 1877, was in the collection of the Louvre. Another, entitled *The Virgin Mary* (1877) was also in the collection of the Louvre. Both were so smooth and fine that a teacher viewing them by his side could not help acclaiming them.

Beihong drew back his hand from inside the glass case into which he was placing a printed picture, and turning round, he told the teacher seriously, "They're no good! They belong to the academic school, actually the school of rural hypocrites, the most vulgar stuff!"

The teacher was aghast. Beihong, therefore, devoted some lectures specially to Bouguran, who had studied at the Ecole Nationale Superieure des Beaux-Arts in Paris, won the grand Roman Prize and dominated the French art circles of his time. Though once a painter of high renown, he has now fallen into oblivion. The murals he painted for the Grand Theatre and several big cathedrals in Paris are stiff, lifeless pictures with sentimental religious feeling. Though the pictures he painted in fine, smooth colours typical of the academic school were completely uninspired, some people of his time still placed his name on a par with Raphael. But the great Impressionist Edgar Degas condemned any painting done mechanically in fine, smooth colours as "Bouguranized," for Bouguran, who controlled the "official salon," had set up his fine, smooth style as the criterion of good painting. He

340

had always rejected works of the Impressionist school.

Beihong said, "The so-called academic style means the painting style of the academic school, which is also translated as 'Academismé.' With Bouguran as their typical representative, painters of this school made smooth, stiff, overelaborate, vulgar, outworn and inanimate pictures. During the nineteenth century, when the Classicism of J. L. David and Ingres, the Romanticism of Dalacroix and Gericault, the Realism of Courbet and the Impressionism of Monet were vying with each other for prominence and distinction, the academic style was really something quite inanimate. It's only a matter of course that people nowadays have forgotten all about it."

Standing on the platform, Beihong talked as energetically as he had always done, totally oblivious of his illness. He had not yet fully recovered from his hemiplegia. He often felt that his body was inclining towards the left and his left hand and foot were weak.

In the summer of the year, after students of the graduating class had left, Beihong began to lecture at the teachers' training class jointly sponsored by Central Institute of Fine Arts and Zhejiang Art College. The class consisted of sketching and oil groups, and Beihong was asked to instruct both of them. Among the dozens of teachers who joined the training class were Ai Zhongxin, Wang Shikuo, Guan Liang, Ni Yide, Dong Xiwen, Feng Fasi, Li Zongjin, Dai Ze and Liu Jiyou. All of them are painters of renown in present-day China.

Beihong took the figure oils he had painted to the oil group for their reference.

The students were impressed by his rich colours, artistic finish and rhythm, and precise modelling. They showed the colouring of Western impressionism and its integration with the precise sketching of classicism. The painter was rigorous but unrestrained, and stressed his method of generalization and making selections so as to grasp both "the overall" and "the exquisite and minute."

His oils demonstrated the unity of colour analysis and form analysis. Every stroke showed both form and colour, and his analysis, instead of being superficial, was deep and minute. He derived many, many forms from a whole and then integrated them again into a whole. Painters generally hesitate to make such deep analysis, for too much

341

analysis will make it difficult to integrate parts into a whole again. Beihong, however, handled it with ease, showing both scientific analysis, summation and abstraction.

He always had his colours so exactly mixed on a palette before spreading them onto a canvas that they fitted perfectly into the picture like the coloured pieces in a mosaic. While painting, he would quickly apply his colours to the canvas, stroke after stroke, with unerring precision.

Regardless of the hot weather, he would visit now the sketching group and now the oil group, stop to watch everybody's easel, put forth his opinions, and exchange views and hold discussions in a lively, harmonious atmosphere.

That was how he worked with redoubled efforts to fulfil the pledge he had made on leaving hospital, that is, to repay the great kindness of the Party, the government and the people.

Although Beihong had no time to visit the art shops in Liulichang again, they still occasionally sent people to show him calligraphy and paintings.

Knowing that Beihong was fond of Ren Bonian's paintings, the art dealers would come and show him any good paintings by Ren whenever they had found them. In September 1953, an art shop sent him twelve flower-and-bird paintings by Ren Bonian, of which one called *Wisterias and Kingfisher* struck him as superb. The interlocking twigs and branches of the wisterias had been painted with great ease and adroitness. Beihong pored over it admiringly and bought it then and there.

The works of Ren Bonian's later period also attracted me.

"Beihong, why did you buy only one picture?" I asked.

"The other pictures are also good, but unlike this one, which is flawless, they all have something amiss with the animals," said he pointing to one of them. "Look, the head of this cock's a bit too big, and in that picture the legs of the bird are stretched too far apart...."

"But I still think they're as a whole quite finished and remarkable. Am I right?"

"Yes, of course, all of Ren Bonian's works impress us as wonderful

imitations of nature. No matter what he painted — be they portraits, figures, landscapes, or flowers and birds, be they bold style or fine — he was always at his best. He was the number one painter since Qiu Shizhou of the Ming Dynasty, the star of his time. He was also something of a lyrical poet. Compared with ancient great poets, he was more like Li Bai than Du Fu" He would wax more and more eloquent whenever Ren Bonian happened to be the subject of conversation.

"Then, why not buy some more of his pictures?" I suggested.

Beihong agreed readily and selected seven more from among the twelve paintings. The remaining four were later bought up by the Palace Museum in Beijing.

Chapter XXX

When summer vacation ended, more work was waiting for Beihong.

In that year, enrollment at the Central Institute of Fine Arts was large and its attached middle school had also begun to take in students. Beihong attended the opening ceremony of the middle school, at which he encouraged the young students to aim high and make contributions to advancing art in new China. Wen Bao, a Young Pioneer, paid tribute to President Xu Beihong on behalf of her schoolmates. Wearing a short skirt, she held high her right hand in salute, her simple, naive eyes flashing with a sincere wish to study hard for the sake of people's art.

The Second National Congress of Art and Literary Workers was about to be convened in Beijing. Before it opened, Beihong went to call on Premier Zhou Enlai with me.

The Premier had a cordial conversation with Beihong in his simply furnished reception room. Beihong talked about conditions in the art world; about the question of developing traditional Chinese painting, carrying on its fine traditions and drawing on the experience of Western painters; and also about drawing as the foundation of all plastic arts. The Premier nodded agreement and said, "Art should develop with the times, otherwise it will become lifeless. Traditional Chinese painting can enrich itself by absorbing certain merits of Western painting." He went on meditatively, "Traditional-style painting need not necessarily be called traditional Chinese painting, for that sounds somewhat self-important in relation to other genrés of painting."

Beihong said, "We call it colour-and-ink painting at Central Institute."

The Premier nodded with a smile. Beihong mentioned the question of painters' professional ethics and art education. He expressed the

opinion that those engaged in art education should be themselves of exemplary virtue and morally worthy of the name of teacher. For instance, in time of national calamity, the moral courage of a painter in face of foreign aggressors should be considered a matter of prime importance. He therefore suggested appointing only those having both ability and political integrity to leading posts in art colleges and universities. The Premier fully approved of Beihong's opinion and nodded his head repeatedly. Knowing that we should not take up too much of his time because he was very busy, we then stood up to say good-bye to him.

As Beihong was still in poor health, the Premier told him repeatedly to take good care of himself and, accompanying him to the garage, helped him into the car. Looking out of the car window, we saw the Premier stand gazing after us. He waved to us with a smile.

After his visit to the Premier, Beihong busied himself making preparations for the convening of the Second National Congress of Art and Literary Workers. In spite of his poor health, he went to the hostel to visit painters just arrived from all over the country, including such well-known artists as Pan Tianshou, Guan Shanyue, Li Xiongcai, Yang Taiyang, Li Binghong and Chen Zhifo, whom Beihong greatly respected. He was excited with great joy while having a talk with them.

Beihong was present at the Congress from morning till night after its opening on September 23, 1953. On the afternoon of the first day, the Premier, looking as sharp-eyed and high-spirited as ever, walked to the rostrum amid thunderous applause. Beihong was seated on the platform. During the short recess, Beihong accompanied the Premier to the lounge. Zhou Enlai, thinking of Beihong's poor health, told him not to sit through the speech, but to go home for a rest. But how could Beihong give up the opportunity of listening to such a brilliant speech, especially when it was concerned with the question of intellectuals and hence had much to do with himself? The Premier was unaware, however, that Beihong had been attending the day's conference since early morning.

At the end of the day's meeting, Beihong went to the International Club to attend an evening banquet in honour of a Polish delegation. There he suddenly felt unwell. A woman cadre came over and guided

him by the arm to the lounge, where he lay on a sofa.

Two doctors from the first-aid station rushed to the scene. Tian Han, Hong Shen and many others also came to his side. Beihong was being paralyzed by another stroke.

I was then at home waiting for him to come back. It being the eve of the Mid-Autumn Festival, I was busy getting some dishes ready for the next day. Now, suddenly notified of his relapse, I immediately hurried to his side. I found him looking ghastly pale and very tired. He looked at me thoughtfully and asked, "Why didn't the children come?"

Meanwhile, he signified with his right hand that I was to find a pen to write down his will. The doctors, however, advised me not to disturb the patient lest his condition should deteriorate, saying that he was not in great danger because his pulse and breathing were normal.

Presently, an ambulance from Beijing Hospital arrived. They carried him into it, but before I had time to get in, they slammed the door shut and it sped away.

Hong Shen, who was then Director of the Bureau for Cultural Relations with Foreign Countries, took me to Beijing Hospital in his car, but the doctors stopped me from entering the ward. I was distraught, and about thirty minutes later, I broke recklessly into the ward. A foreign expert was examining Beihong. He told him to open his mouth and then put a tongue depressor into it. Beihong suddenly felt nauseated, and seeing me in the room, asked me right away to bring him a spittoon. He bent down vomiting. His condition had evidently taken a turn for the worse.

The foreign expert, who was seeing Beihong for the first time, had just been sent for by Beijing Hospital from the Friendship Hotel in the western suburbs. No emergency measures whatsoever had been taken to save Beihong since the doctor was sent for. Being completely ignorant of Beihong's case history, the foreign doctor had to conduct a physical checkup right from the very beginning. He was annoyed by what I had said and snapped impatiently, "It's my job to treat the patient. It's none of your business."

Beihong, breathing hard and groaning with pain, soon fell into a coma.

346

The doctor eventually began emergency efforts: releasing blood from Beihong's arm, placing an ice bag on his head, giving injections of medication

But there was little hope of saving Beihong, who remained unconscious. I stared at him blankly, agonized at being so helpless.

I kept watch by his bedside for two days and three nights. He was struggling in pain and his eyes were open all the time. But they looked dull and he could no longer hear my voice.

At 2:52 A.M., September 26, Beihong's heart ceased to beat.

I threw myself up on him convulsively and tightly hugged his still warm body, wailing. I could not bring myself to accept the cruel fact of having lost him! After we had travelled together such a long, arduous way, how could he now leave me alone? How could he die? I cried frantically, "Beihong! Beihong! Beihong! You come back! Come back! I'm waiting for you to go home with me! The children are waiting for their father! Why don't you answer me? ..."

People crowded to my side to comfort me. I did not know who had pulled my body, arms and hands from his body. I shouted wildly. I shouted to Heaven and Earth to give me back Beihong and never to let him enter the gate of death....

I do not know how I came home. While I was half asleep, I seemed to see many people weeping, and Tian Han sobbing with both hands covering his face and his shoulders shivering, and my little children crying piteously, "Mama"....

After I regained my senses, I saw Beihong's desk bathed in gentle sunlight; the green-corduroy cushioned chair before it was empty. I cried again when I realized that Beihong would never be sitting in this chair again.

Beihong's eldest son Boyang came back hurriedly from the Central Conservatory of Music in Tianjin. Poor Lili, however, missed the opportunity of seeing her father for the last time because she was having her second child in hospital. We did not break the ill tidings to her for fear she should be upset while in childbirth.

I walked tearfully with weary, heavy steps towards the mortuary as if I were going to my own grave. Beihong lay still as if quietly waiting for

me. The sunlight was flickering gently on his pallid face. His beautiful crystal-clear eyes were open, as if he were still gazing upon everything around him.

I began to change his clothes for the last time. I unbuttoned the grey twill jacket with shivering fingers to change it for a cotton vest which I had made for him. But I failed to get it on him because an arm had turned stiff. I said to him tearfully, "Beihong, let me put this vest on you! Otherwise, I'll be worried. Who's going to change clothes for you when you're gone?"

But he kept staring at me in silence.

In tears, I covered his belly with the vest.

Next to the watch in the pocket lay three pieces of candy, which he had probably kept uneaten at the banquet so that he could give them to me and our two children when he came home. They were three ordinary fruit drops, but there was in them his profound love and longing for his family.

Weeping, I nestled my head close on his shoulders for the last time and painfully recalled numerous memories of the past. I wished I could lean close to him forever.

Premier Zhou Enlai and Comrade Zhou Yang came. Deeply grieved in countenance, they gazed at Beihong's remains for a long time.

Beihong was like a fallen statue. There was the same look of warmth and depth in his eyes. Around his gracefully lined lips lingered a faint smile, which, now frozen, had been his regular facial expression. He seemed to remark enthusiastically, "How I love life! How unwilling I am to leave you!" Concealed under his bushy, dark eyebrows was his deep regret.

Several painters were silently making a portrait of Beihong, and Ji Wensheng, a sculptural technician, was standing on one side carrying plaster and tools in his hand. He was about to make a plaster mould of Beihong's face.

The Premier asked him in a whisper, "Sure you can manage it?"

Ji answered in the affirmative.

The Premier told him affably to act with caution. Then he said very sadly, "Xu Beihong was irreplaceable. His death is great loss to us! Why was he allowed to attend that meeting from morning till night? For now

on, we should let nothing of this kind happen!"

His voice, quivering a little, was at once sad and angry. Then, turning slowly towards Zhou Yang beside him, the Premier told him to keep vigil by Beihong's remains.

At the request of the teachers and students of the institute, Beihong's remains were placed on view in the auditorium of the institute where teachers, students, workers and staff members took turns keeping vigil beside the bier.

Many leading comrades, artists and writers from all over the country came to mourn the dead painter and, together with all personnel of the institute, escorted his remains to the Babaoshan Revolutionary Cemetery for burial.

Chapter XXXI

When I came home after laying Beihong to rest, I felt as if I had also entered a sepulchre. Everything around me seemed to have gone out of existence. The home in which Beihong and I had passed many a happy day now seemed totally void. A mere look on the past would double me up with grief.

Beihong's students, friends and many who cared for me came to console me. They told me to restrain my grief and take care of myself, and suggested that I should first travel for a time, which, they said, might help to relieve my agony.

But I moped about in the room like a phantom. The sight of everything of Beihong's — either a hat, or a garment, or a pen — would strike a chord in my heart and call up innumerable memories of the past. I would sit still for hours on end while my mind wandered in tireless pursuit of the shadowy past. I remembered how we had made the arduous journey on the Guizhou-Sichuan Highway and how I had doubled up with laughter when he cracked a joke. I also remembered how, when he painted his first oil portrait of me with the palette in one hand and the brush raised high in the other, he had gazed at me with concentrated attention, his eyes, encircled by crow's-feet, flashing like lightning.... In the course of my endless silent meditation, I was again with Beihong, in the small boat on the Lijiang River, on the bank of the Jialing River, in Panxi....

I heard him call to me. It was on that stormy night in Panxi that he had called out with a voice full of love, apprehension and anxiety, "Jingwen! Where are you? Jingwen! Jingwen! Where are you...."

Fangfang, who was not yet six, had come to my side quietly before I knew it. She nestled against me gently.

"Mama, what are you thinking about?"

She raised her head looking childishly sad.

"Mama, can Daddy come back to life?"

Her eyes, with their fresh, tender whites, were brimming with tears.

Outside the window, the trees planted by Beihong were swaying in a slight breeze. Sunlight filtering through the luxuriant foliage cast speckled shadows of the trees on the ground.

An oriole which had frequented our courtyard flew in blithely and perched on a persimmon tree bearing fruit for the first time. She kept peering around and twittering as if in search of Beihong.

Again my ears echoed with Beihong's voice, "Be careful, don't startle it! Let it fly freely." It seemed he was still with me.

At night, I found in my dreams that he *was* still living with me. I saw him bending low over the table painting with splashed ink the flying manes and tails of galloping horses

Suddenly, I heard in my dream Beihong pressing the electric-bell button in his bedroom. I had had the button fixed up in his room after his first stroke. Whenever he pressed the button, the bell in my bedroom would start ringing and I would immediately go to his bedside. Sometimes, he needed sleeping pills, sometimes he needed some drinking water, sometimes he wanted me to help him to the toilet I had grown accustomed to the summoning bell. How familiar it sounded! Now, waking from my dream, I hurriedly got out of bed, and went straight to his bedroom. But inside all was pitch dark. I turned on the light and found his bed empty. I stood stupefied over the bed, overwhelmed by irrepressible grief. I flung myself on the bed face down, sobbing bitterly

Sometimes, in my dreams, I also saw him lying in hospital critically ill with the agonized look on his face shortly before his death I would wake up weeping. All was quiet and dark. Sleeping by my side was my son Xiao Hong, who had just started his second year in primary school. He reached out his arm to embrace my neck.

"Ma, don't cry. Dad's already dead. It's no use crying."

He tried to comfort me, affecting the tone of a grown-up. Then he tucked himself in closer and wept.

My heart was throbbing violently. Welling up in my broken heart

was love and compassion for my children and a sense of responsibility for them.

I also remembered that Beihong had once told me in a roundabout way, "My father was a painter, and so am I. I hope one of our children will grow up to be a painter."

After a short pause, he resumed pensively, "But it's not easy to be a painter of real talent instead of one with an empty reputation! He must make great efforts to study and steel himself and he must have great willpower...."

He had always avoided mentioning death and what should be done after his death lest I should be upset. So he had pretended to be talking casually.

His remarks, however, reminded me of my heavy responsibility. For the sake of my children and fulfilling the task their father had entrusted to me, I had to pull myself together! I remembered what Beihong had said, "One ought to leave behind for the coming generations something lofty and valuable."

Yes, I must pull myself together. But I could not, for my sorrows were irrepressible. Everything in the room seemed to tell me mournfully that Beihong was no more; I could not avoid my grief. The only way out was for me to go away.

What path of life should I take? Where should I go if I left? I remembered how in Chengdu, after I discontinued my studies at Jinling Women's University to look after his poor health and assist him in his work, Beihong had looked upon my choice with disapproval and regret. But could I go back to university to resume my studies and plunge into the collective life?

The warm support and help given me by Zhou Yang, who was then in charge of the Ministry of Culture, strengthened my determination to be a university student again.

I prepared to enroll myself at Beijing University.

I looked over a large number of Beihong's works and his unique collection of valuable calligraphy and paintings. They were quite familiar to me because I had time and again taken them out of the cabinet for us to enjoy viewing together and then put them back. I fully

understood that all his works and collection, to which he had devoted his lifetime energies, were embodiments of his deep love for our country and people. Could I take forcible possession of them? No! Definitely not! I should offer all of them to the State.

When I informed my friends and relatives of my intention, some showed strong approval while some advised me to the contrary.

Some said "Why donate all of them? Your children are still very young. You ought to take their future livelihood into consideration."

Some said, "It's quite all right for you to donate most of Beihong's works, but you ought not to part with those pictures which Beihong inscribed with your name and gave you as keepsakes."

Some said, "While it's all right to donate all Beihong's personal works, I don't see why you should donate all his collection. You've got to have something to fall back on and guarantee your future life!"

I was grateful to them for their goodwill and solicitude, but I still decided to offer everything to the State, for Beihong had told me many times he was collecting these works of art for China. He had done all he could to buy and protect them from being sold away into foreign countries. As he was a people's artist, all his personal works and collection should belong to the people. And now I was to carry out his wish.

The decision having been made, I immediately went to the Ministry of Culture to present all the keys in my home to the Cultural Minister Shen Yanbing and ask him to send people to take over things left behind by Beihong.

I entered the Ministry of Culture in tears, and then left the place still weeping, for the sight of its gate reminded me that Beihong and I had together visited the Ministry only a few days before and that I was now all alone.

During those days, wherever I was, I was overwhelmed with grief by the same recollections and feelings. I had been accustomed to going out with Beihong, walking by his side, and quietly listening to him conversing with other people while I kept silent. But now I had no one to turn to or rely on.

Soon afterwards, in preparation for establishing the Xu Beihong Memorial Hall in Beijing, the Ministry of Culture, Central Institute of

Fine Arts and Chinese Artists' Association jointly sent people to take over Beihong's things, including over a thousand original paintings, over a thousand pieces of calligraphy and paintings by outstanding artists of the Tang, Song, Yuan, Ming and Qing dynasties and of modern times; over ten thousand valuable books, printed pictures and stone rubbings; and furniture and sundries.

Carrying a canvas suitcase and a bedding roll as I had done when I first came to know Beihong, I left home for Beijing University. I became a university student again at the age of thirty.

I tried hard to master my grief so that I could retrieve my lost youth. But how difficult it was for me! While sitting in the classroom, I could not hear the teachers' lectures, worrying over my two little children. How were they getting along with their lessons? Could they finish their homework?

Whenever I was informed by telephone of my children's illness, I would race home and anxiously keep watch by whichever one had been running a high fever, fearing that I might lose my children as well as Beihong. I, who had always been stout-hearted, had become very fragile.

One day, Mao Zedong sent someone to pay me a visit. I was summoned to the President's office from the classroom to see the man from the General Office of the Party Centre already waiting there. He handed me a personal letter from Chairman Mao, in which the Chairman kindly inquired after me. I sobbed and wept.

During those days, I received many messages of condolence from people, both in China and abroad. People everywhere were mourning the death of such an outstanding painter and art educator. It was the solicitude and encouragement shown by people far and near that enabled me to regain my self-possession.

In December of the year, a meeting in commemoration of Beihong and a memorial exhibition of his works simultaneously took place in Beijing. Zhou Yang, speaking on behalf of the Communist Party and the People's Government, pointed out the following: "Xu Beihong was an outstanding painter and art educator of the Chinese people. His death is a great loss to the art and literary world. He inherited the traditions of China's national painting and assimilated the realistic methods and

354

techniques of Western classic painting. His artistic creations show the combination of consummate technique and distinctive national features. Artistically, he always opposed formalism in favour of realism. His works show his ardent love for China and his sympathy for the people. Before Liberation, he took part in the Chinese people's movement for democracy. He made great contributions to art education. With his realistic method and his incomparably warm love and concern for artistic talent, he has brought up many artists of the younger generation. His spirit of utter devotion to artistic creation is exemplary. We should, therefore, commemorate him, learn from him, and study his works as an important artistic legacy."

Tian Han, Wu Zuoren and the student representative Yin Rongsheng also spoke at the commemoration meeting.

Premier Zhou came to the memorial exhibition. He entered the hall solemnly in a deep-coloured overcoat and stood before Beihong's portrait mournfully. Amidst the solemn, quiet atmosphere, while pointing at the two lines of Lu Xun's couplet in Beihong's handwriting, "Fierce-browed, I coolly defy a thousand pointing fingers; head-bowed, like a willing ox I serve the young," hanging each on one side of Beihong's portrait, the Premier told me thoughtfully, "This is the spirit possessed by Xu Beihong." And he suggested that in case I should publish a collection of Beihong's paintings, this couplet in his own calligraphy should be printed on the front page.

Zhou Enlai viewed all the paintings one by one, carefully read the inscriptions on them and, like a connoisseur, judged them precisely and spiritedly. He appreciated the fusion of ancient and modern as well as Chinese and Western techniques in Beihong's works, and praised his oils and drawings. The Premier's views attested to a profound knowledge of the art of painting. When he stood before the painting *Xi Wo Hou*, he took time specially to tell other visitors around him that the title, a quotation from *The Book of History*, meant that the people under tyrannical rule were thirsting for delivery. He also pointed out that this oil had been painted shortly after the September 18th Incident when large areas of Chinese territory had fallen into Japanese hands. Then he said, "It's a very good idea to establish a memorial hall devoted to Xu Beihong. These works must be well taken care of."

On September 26, 1954, on the first anniversary of Beihong's death, his Memorial Hall was set up on the premises of our former residence, and was soon opened to both Chinese and foreign visitors. Zhou Enlai inscribed a horizontal tablet with "Beihong's Residence." The vigorous, bold handwriting not only bespoke his achievement in calligraphy but also how he cherished Beihong's memory.

On display at the Memorial Hall were Beihong's sketches, oils and traditional paintings representative of the various periods of his art career, materials illustrative of his artistic activities, and his studio and bedroom in their original state. The trees he had planted also stood greeting people in silence.

Visitors from all over China and the rest of the world came to the Memorial Hall in a stream and wrote innumerable words of praise in the visitors' book:

"Xu Beihong's works are contributions to world culture."

"Xu Beihong's works will spread and live among the people like a language.

"Thanks to the Chinese Government for establishing the Xu Beihong Memorial Hall for the benefit of future generations."

....

I often stood before the gate of the Memorial Hall musing and telling myself that this was the people's highest honour and deepest remembrance for Beihong. As an artist, what more could he want?

POSTSCRIPT

It is with profound humility that I present this little book.

It first occurred to me to write his story soon after Beihong's death. However, for various reasons, it was not until today, twenty-nine years after his death, that my dream came true.

In 1956, when I was still a student at Beijing University, I took advantage of the winter vacation to visit Beihong's hometown in Yixing, where I called on his beloved fellow villagers and paid respects to his parents' tombs, thus fulfilling a desire that Beihong had long cherished but failed to carry out in his lifetime. For well over twenty years, he had been too busy to visit his hometown.

I left Beijing on the Beijing-Shanghai train and got off at Wuxi, taking a long-distance bus to Yixing. It was overcast and snowing lightly. Scattered snowflakes were whirling in the biting wind and beating against the bus windows. Gazing out of the window, I called to mind the dreary scene of Beihong, then a lad of nineteen, trudging all the way to Shanghai along this road. I seemed to see him labouring along the muddy road against wind and rain hanging his head and wearing a blue cloth long gown and a pair of white cloth shoes, mourning for his deceased father.

In his hometown, I met his good-natured fellow villagers and childhood playmates, and also his uncle, aunt, cousins, brothers-in-law and sisters-in-law.... They were very kind, warm and sincere with me, told me many things about Beihong's childhood and boyhood, and generously gave me his mementoes and handwriting they had kept as treasures for decades.

Winter in Yixing with its gurgling streams and green fields was still bright and charming. While stood on the riverside before the gate of Beihong's home looking at the dreary waves lapping against the bank, I

tried to catch a glimpse of young Beihong in my imagination. I also climbed up forested South Hill to walk where Beihong had possibly left his footprints long before. When I put up for the night in the small room where he had slept as a child, I seemed to hear the cry of a baby coming from the remote past.... It was late at night, and I could not sleep. So I got up and leaned against the glassless window to look out at the silent fields and the gentle moon and fancy him coming to me in the moonlight.

I toured the county seat of Yixing and many local villages. I also looked up the county annals of Yixing.

After I left Yixing, I went to Nanjing and Shanghai to call on many of Beihong's old friends and heard more about his past from them.

On a stormy day, when I stood by the Huangpu River, I seemed to hear, in the midst of the splashing of the waves, Beihong's words, "It takes a courageous man to be able to hold out against overwhelming adversity!"

In Shanghai, I ate no meals for a whole day except a rice ball early in the morning to experience the hardships Beihong had once undergone in the city.

After I became curator of the Xu Beihong Memorial Hall in 1957, I continued to collect materials about Beihong in preparation for writing this biography.

When I finally began to write this book, the "cultural revolution" began. My home was searched many times; the materials I had spent many years laboriously collecting were almost all destroyed; Beihong's gravestone was smashed; and the Xu Beihong Memorial Hall was demolished to make way for the new subway. I was distressed to see the sudden disappearance of Beihong's last residence and the felling of trees once planted by him. How attached I had been to every brick, every stone, every blade of grass and every tree on the premises!

In 1973, Zhou Enlai sent someone to inquire after me and asked to consult with me about erecting a new hall in commemoration of Xu Beihong.

Nine years have since passed, and I have witnessed the completion of a new memorial hall devoted to Beihong and the erection of a new gravestone. The completion of this book, too, has given me

indescribable joy.

While writing this book, I often felt as if Beihong were still alive. Often I would involuntarily lay down my pen and bend over the desk. My love for him is deep and lasting. Let this book be laid before Beihong's grave in lieu of white flowers.

THE AUTHOR
February 24, 1982
Beijing

Index

徐悲鸿一生

廖静文著　张培基译

*

外文出版社出版

（中国北京百万庄路24号）

外文印刷厂印刷

中国国际图书贸易总公司

（中国国际书店）发行

北京399信箱

1987年（大32开）第一版

编号：（英）10050—1206

00850

10—E—1947P